SOFT NUDE ~~FOR THE~~ DEVIL'S BUTCHER

SOFT NUDES FOR THE DEVIL'S BUTCHER

FICTION, FEATURES AND ART FROM CLASSIC MEN'S ADVENTURE MAGAZINES

PULP MAYHEM, VOLUME TWO

Edited by Pep Pentangeli
Design by Broken Fang Cryptography
Published 2014 by Deicide Press
ISBN 978-1-84068-667-8

Men's adventure magazines were a form of pulp publishing which flourished in 1950s and 1960s America, pandering to the cruelty and lust of young men with luridly illustrated stories of war, sleaze and savagery.[1] Some of them, such as **Battle Cry**, arose in direct response to the inauguration of the Comics Code in 1954, as a way of circumventing censorship by presenting material in a new, "adults-only" format.

As with pulp magazines from earlier decades, scantily-dressed women-in-peril were a favourite subject for men's adventure cover designs; but in the late 50s and early 60s, magazines such as **Man's Story** and **Men Today** saw sales rocket when they mixed this staple imagery with new, fetishistic and taboo elements of extreme bondage, torture and, in particular, the sinister sign of the swastika.

Some of the more risqué adventure magazines pursued this type of material to its permissible extremes during the ensuing decade. Publications such as **Man's Daring**, **World Of Men**, **Man's Book** and **Wildcat Adventures** revelled in lurid tales and supposedly true accounts of mayhem, and became known as "sweat mags". Typical examples of their cover art include a female prisoner about to be raped by Nazi-trained mandrills, two half-naked young women tied up by Nazis and about to be eaten alive by rats, a tightly-bound girl being threatened by a Nazi with a flame-thrower, and a she-Nazi hunting female concentration camp victims with chained wolves.

SOFT NUDES FOR THE DEVIL'S BUTCHER is a new anthology which collects some prime examples of text and artwork from a range of men's adventure magazines published during the key years of the genre. The book is divided into two sections: FEATURES includes a selection of semi-factual confessions and case histories on such sensationalistic subjects as rape in Soviet prisons, Hitler's secret sex life, prostitution, the persecution of witches, and other aberrations; and FICTION assembles a wild collection of garishly illustrated short pulp fiction, with categories including war, white slavery, Nazi horror, jungle curses, Red menace, torture, sadism and erotic carnage. The book also features numerous examples of interior art from classic men's adventure magazines, and includes a total of 35 features and stories, with more than 50 full-size illustrations, including 16 pages in full colour.

The prime years of the men's adventure magazine unleashed a deluge of exposed flesh, bloody mayhem and sexual delinquency beneath the all-pervasive sign of the swastika, representing a unique cultural phenomenon in US publishing and art. The texts and artworks presented in this anthology stand as testament to this phenomenon, and also as a reminder to the lurid but innocent fun which people once enjoyed, before the invention of "political correctness" by repressive, soulless and sexless religio-fascist vermin bent on pulling popular culture – and life – back into the dark ages of censorship.

1. A comprehensive history of men's adventure magazines has already been provided by two outstanding publications: **It's A Man's World** (Feral House, 2003) and **Men's Adventure Magazines** (Taschen, 2008). A website dedicated to the subject, **www.menspulpmags.com**, is also highly recommended.

FEATURES AND FICTION

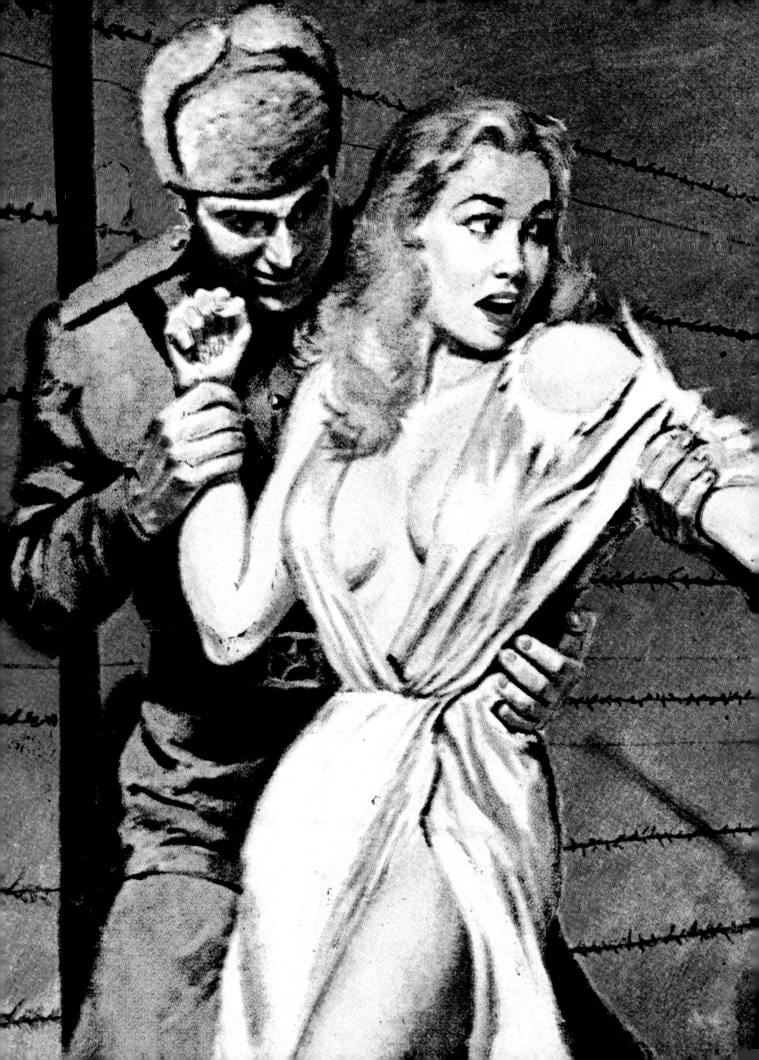

I ESCAPED FROM THE SOVIET HELL CAMP

In the ice-wastes of Siberia we were subjected to a nightmare of degradation, rape and torture.

OCTOBER, 1956, BUDAPEST – REVOLUTION!

We hoped it would be the beginning of a new era for our suffering Hungary. Instead it has meant, for my country, redoubled anguish under the brutal Soviet heel. And, for me, it meant two years of hideous defilement in a Soviet slave camp beyond the borders of Siberia.

I was 23 in that fateful October. That meant I was old enough to remember the terrors of the war years, but that most of my life had been spent in a Hungary ruthlessly compelled to serve the Red master. Like many young Hungarians I quietly resented the presence of the Russian soldiers in our cities. I despised the Stalinist puppets who ruled us, taking orders from the Kremlin.

All during 1955 and 1956, we had been whispering to ourselves. I need not repeat here the story of the Hungarian Revolution, except to say that my husband, Erno Lukacs, who was killed in the revolution, was among the leaders. Erno and I were both students at Budapest University, where many of the revolutionaries attended. We had been married in the spring of 1956, and we lived in a pitiful little dingy fiat in Budapest. Six months of married life was all that was to be allotted to us.

October 23, 1956 – the first open rioting, in the gardens of the National Museum, after a summer of ominous rumbling. Erno and I were there. With hundreds of other young Hungarians, we demanded the return of full national independence, the end of the Red puppet regime. You know how our cry spread throughout Hungry, how within five days we had almost completely liberated our country before the stunned dictators reacted.

By October 31, the brave general Pal Maleter, martyred by Khruschev's gangsters later, was in control of Budapest and the western half of the country. In the east, Soviet troops were hard put to defend themselves. The next day, Imre Nagy – also a martyr – declared Hungry a neutral country.

You all know the grim events that followed – how on November 4, just as we began to believe we had actually defeated the Soviet colossus, the Red tanks ground into Hungary, bringing death in their wake. Thousands died in the next week; more than a hundred thousand, realizing defeat was inevitable, fled across the border into Austria and safety.

That was the story of the rape of Hungary in 1956. Let me now tell my own story of Soviet shame.

MY HUSBAND Erno died in the fighting on November 7. I saw him struck down in the street. He died instantly. That night my friends urged me to flee across the border. "Come with us into Austria," they begged. "Hungary is doomed. There will be no help from the West, and we cannot hold off the Soviets ourselves any longer."

But I refused to leave. I told them I would continue to fight until my last drop of blood had moistened Hungarian soil. What could I gain by running to safety? I had nothing to live for, now that my husband was dead, nothing but the continued struggle for Hungarian freedom. And I could not fight that from exile.

The massacre continued for another week. But the Soviets, conscious of the terrible propaganda consequences of the brutal suppression of my country, and aware that they had been victorious already, decided to cease the murdering and to take prisoners instead. Hundreds of us were rounded up in a single 24-hour period. We were all taken to a large room in one of the government buildings, and there we were interrogated.

The interrogation was short and typically Soviet. We were questioned one at a time. If a man refused to answer, he was kicked in the groin. If a woman kept silent, her breasts were slapped. Further tortures were reserved for the most stubborn.

I came before the inquisitioner and stood silent as he asked me my name and profession.

"Answer!"

I glared at him. "Butcher!" I hissed.

He nodded. A subordinate ripped open my already tattered blouse. My breasts, which only my dead husband had ever touched, were bare before their lustful eyes. A hand rose; I felt a stinging burst of pain as the thick palm slapped me. I bit my lip to keep from fainting.

After five minutes of this treatment I whispered, "Anna Lukacs – student."

All students were set aside for deportation. The Soviets reasoned that we, the Hungarian intellectuals, were the most dangerous enemies, and had to be removed from the country. Together with a few dozen of my young comrades, I huddled miserably in a locked room, trying to hold the tatters of my blouse closed over my throbbing breasts.

None of us slept that night. At three in the morning we were ordered out into the bitter cold. We marched on foot under gunpoint to the Budapest railway station. The Russian overlords had the trains all ready. We were crammed aboard one of the so-called Stolopinskys. A Stolopinsky, named after a Czarist Minister of Security, is a railroad car long used by the Russians for transporting prisoners. There were eight cages facing a narrow hallway. In each cage were three wooden shelves nine feet wide, and into each cage went fifteen prisoners, five on a shelf. We lay flat on our stomachs, wedged tightly together, our heads butting against the bars of the cages.

The horrible trip went on for weeks. We were permitted to go out twice a day to the toilet, but the rest of the time we lay on our shelves, unable to turn around, unable to lift our heads more than a foot without hitting the shelves above us. The car reeked of sweat and urine. Men and women travelled together with no regard to sex.

It was now December. We crossed bleak and barren land, passed through cities, went ever eastward. We knew where our destination lay – in Siberia, that Godforsaken land of slave camps and mines.

After weeks of agonizing travel, our trip came to a halt. The women prisoners were taken off the train and were taken to a prison camp, while the men continued their lonely journey deeper into Siberia. In a strange way, I was grateful that Erno had been killed in the fighting. It would have been more dreadful to be separated like this, living in eternal doubt. At least this way I knew he had gone to his rest.

MVD troopers welcomed us to the prison camp, for women only. We were led through gates and taken to a huge building for indoctrination. After weeks of cramped travel, I was weak and found walking difficult, but I kept on my feet, for I noticed that whenever a woman fell she was forced back onto her feet by brutal kicks and blows.

Inside the big building, we were ordered in Hungarian to remove our clothes. Braced for any sort of atrocity, I complied. It was almost a pleasure to get out of my filth-encrusted rags after so many weeks. I dumped them in a rubbish barrel and tried to ignore the hungry stares of the fifteen male guards. I reddened, and tried to cover my, breasts, but my hands were thrust down to my sides by an angry MVD man.

When we were all naked, we were marched two abreast into a smaller room, where we were forced to get under an ice-cold shower. After that MVD men with shears chopped away our hair – "to prevent contamination," we were told.

Next came a brief medical examination, and – finally – the issuing of prison clothing. I was shown to my barracks. Many of the other slaves had been here since the days of World War II. They were withered, worn-out old hags. I was shocked to learn that the woman who had the lower berth of my double-decker hunk was only forty. She was a Rumanian who had been in the prison camp since 1945. She looked like a crone of sixty or seventy, with her stringy white hair and toothless mouth.

AND SO I entered my life as a Soviet slave. Since it was winter, there was no farming or mining possible, and instead we worked on clothing – making prison garments for other prisoners! We worked fourteen hours a day, under the supervision of MVD guards. When our work-day was over, I was happy to tumble into my bunk without a further thought.

The camp was well guarded. It was ringed by a fence twelve feet high, with machine-gun towers at regular spaces. A smaller fence was erected within the outer one. Any unauthorized person stepping over the inner fence would be shot without question.

For my first week and a half, I did nothing but work and sleep, work and sleep. My other Hungarian friends had been scattered all over the huge camp, to prevent any of us from getting together and hatching escape plans. Not that escape was a serious possibility. It was all but hopeless. Even if we could get over the barbed-wire fences, where could we go? It was a hundred miles of barren wasteland to the nearest large town, and it was thousands of miles, literally, to any free country.

I worked and slept, worked and slept. One day blurred into the next. I tried not to think about my old life, about the dead husband I had loved so much, about my mutilated country. I told myself that I would submerge myself in the backbreaking routine of work here, and pray for an early death and release from my toil.

But then a new aspect came into my life. I was tapped to minister to the lusts of my Soviet captors. Once each week we were taken to the medical area for a shower, and we were observed carefully by the women-hungry MVD guards. Most of the women were walking scarecrows. By comparison, I was a beauty, even after weeks of suffering in the railway car. My breasts still had firmness and texture, my thighs and buttocks still were fleshy and ripe. It was inevitable that I would attract the attention of one of the guards.

It happened my third shower session. I was drying off, shivering from the cold water, when a guard walked up to me and looked me over as though I were a prize farm animal he was considering purchasing. He nodded approvingly.

"Put your clothes on and come with me," he said in heavily-accented Hungarian.

Trembling nervously, I followed him out of the medical area and to a small shack near the guard dormitories. He closed the door.

"Remove your clothes."

I didn't dare refuse. I knew he could kill me on the spot if I didn't cooperate.

"Lie on the floor."

After this, I became a regular mistress for the MVD

guards. I learned that there were about twenty-five of us in the camp, out of the hundreds of women. We were chosen for our looks, and the guards kept us carefully nourished, so that we would remain attractive for them while the ordinary women withered and decayed. We were slipped extra food and sometimes we were allowed to leave work early. But in return for these unwanted privileges we paid in a terrible way. Any hour of the day or night we were subject to the lusts of the Russians. One, two, a dozen of them at a time might have us.

I remember what happened when one of our group rebelled. She was a Czech girl, a member of the resistance – a handsome dark-haired girl with high, full breasts and a magnificent animal-like body full of vitality. She was one of the most popular partners the Russians had. But one day in late winter she went on strike. A guard was about to have her in the shed when she kicked him painfully and hit him.

What followed was hellish. She was dragged out, naked, and hurled onto a snow-bank. There she was systematically beaten in the full view of everyone in the camp. She howled and screamed but guards held her. When they were through, they left her. She died that night of exposure and shock.

We submitted without rebellion after that, but without pleasure either. I developed a trick of blanking out my mind. While I was compelled to submit to the caresses of my captors, I would think nothing, feel nothing, experience nothing. The Russians hated this, but though they tried every sort of treatment from gifts to punishment they were unable to make us respond ardently to them.

I might have gone on like that for years, until I was no longer attractive enough to please them, and then I would have reverted to the status of just another prisoner and would have become a haggard crone like them. But good luck – and quick thinking – saved me from this fate, and eventually gave me freedom.

IT WAS a year after my arrival there. I had long ago lost every shred of self-respect. I was no longer a human being, merely a walking robot designed to give pleasure to my captors. And then, one day, the commandant of the camp entered the shower room while I was there.

My hair had grown in, and my body had filled out thanks to the extra food I was receiving. He was immediately taken by me. I saw him staring at my body for nearly ten minutes. Then he called one of his subordinates over and whispered.

That afternoon I was delivered to the commandant's quarters for his personal pleasure. He was in his forties, a refined-looking officer who sported a monocle.

"Undress," he said languidly.

I removed my clothes. Nude, I was forced to share vodka and caviar with him. Then we went to bed.

I might have reacted the way I did with the common soldiers. But an inspiration struck me – and, concealing my repugnance, I gave myself to him fully, imitating the passionate cries of a woman. He was surprised and pleased by this. And, the next day, I was informed that I was promoted to the rank of Commandant Kistbek's official mistress.

I pretended to be overjoyed. The Commandant had several mistresses drawn from the camp slaves, but he was displeased with them. I set out to please him to the best of my ability, and rapidly achieved my aim – that of making him dependent on me. I catered to his every whim. It made me hated in the camp, of course, but I tried to ignore this.

And then, the chance for which I had been waiting came, miraculously. Commandant Kistbek was given a promotion! No longer was he the commanding officer of a prison camp in desolate Siberia; he was brought back to civilization and made the head of a Soviet Army post in East Germany.

And I went with him!

It was as I had dreamed from the start. But I had never thought it would come about. Kistbek had been more pleased with me than with any mistress he had ever had. He could not bear to part with me. And so he procured my release, gliding over the fact that I was a dangerous Hungarian rebel, and – as a Soviet officer's mistress – I returned to Europe in style.

I bided my time, living in his household in Germany. submitting with false enthusiasm to his desires. At length he was given leave, and went to East Berlin, taking me along. We caroused all night, drinking champagne smuggled across from the free world. He was drunk: he sang and danced and laughed like a baby, and then he told me to prepare for bed. I was ready for him – with a knife.

His hands groped unsteadily for my breasts; his lips covered mine, his body surged against mine. As he became blindly frenzied with desire, he embraced me – and I jammed the knife deep into his back.

My husband is avenged, I thought.

The rest was simple. I dressed; I woke his chauffeur, who knew and obeyed me. We drove to the border.

No one questioned the official car. I crossed safely over into West Berlin. In the morning, I told my story to the authorities, and I was flown to West Germany.

I am now living in Western Europe, working quietly for the eventual overthrow of Communism as part of an underground refugee group. Perhaps you may say that it was immoral of me to do what I did, but I answer you that I am more valuable to the cause of freedom where I am now than when I was a prisoner deep in Siberia. And I have taken the life of an enemy of my people. Someday I will have the opportunity for further vengeance on the lust-inflamed butchers who suppressed the liberty of my country, and who sated their desires on my unwilling body.

And I have a feeling that the day of my revenge will not be long delayed.

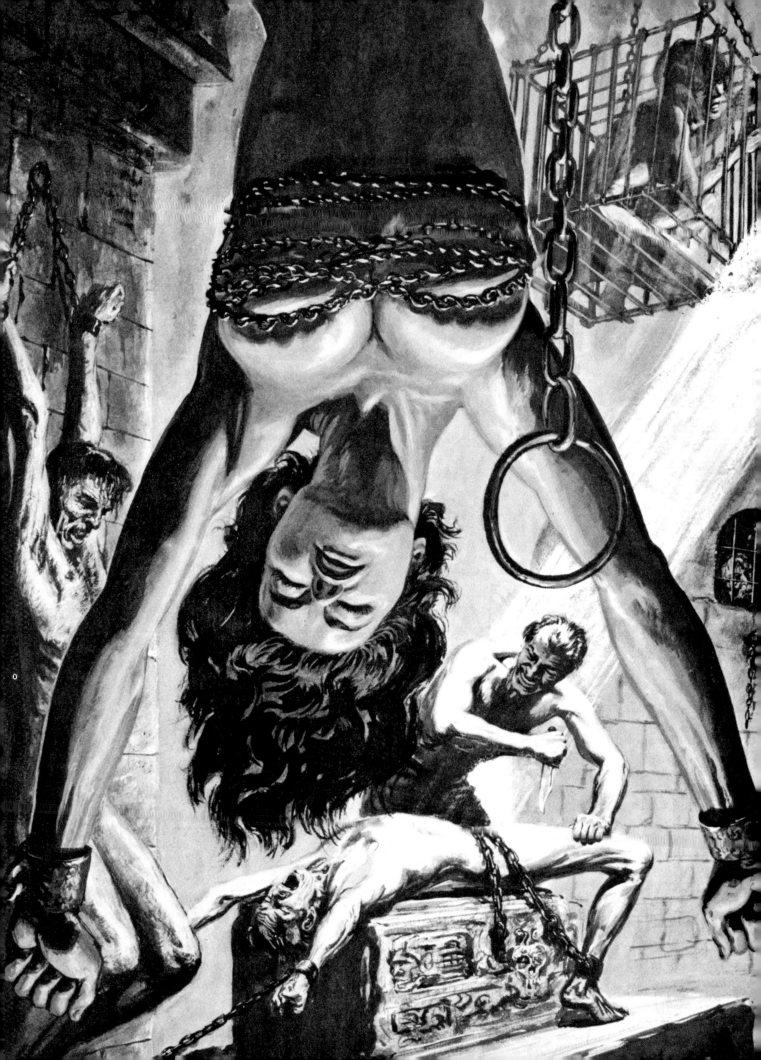

TWO-FACED DEMON
OF THE ANDES

He was the tyrant whose benevolent exterior concealed a heart of ice and a brain full of murder.

IF ANYBODY THINKS FIDEL Castro is the worst thing that ever lived in the Caribbean Sea, they should go back fifty years to the grandaddy of all Latin American dictators, the man who started it all – an incredible man named Juan Vicente Gómez, who ruled Venezuela for twenty-five years. Gómez was the prototype of all south-of-the-border despots, a weird mixture of evil and good who inflicted almost unbelievable horrors on his countrymen with one hand, while working miracles for them on the other.

This is the story of that strange man who was both fiend and angel, destroyer and builder. The story begins to take shape in a fashionable suburb of Caracas one night in 1910.

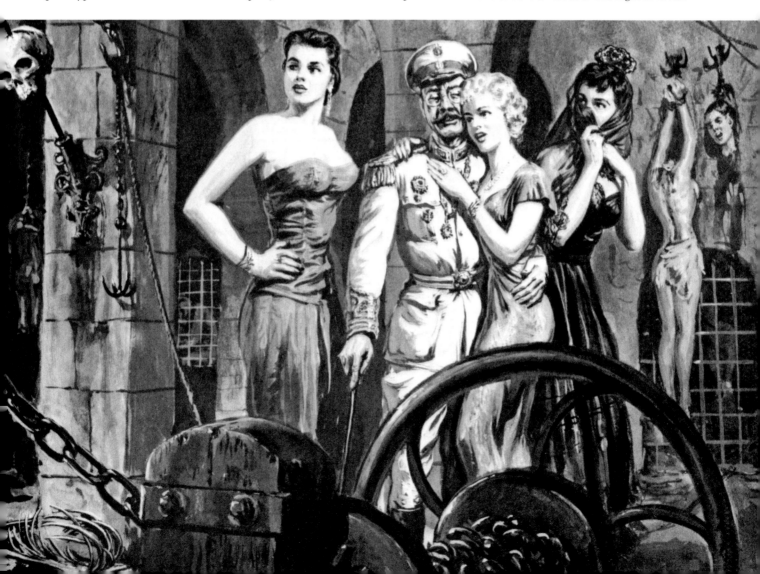

The pounding at the door of Arévalo Gonzalez was heavy and imperious, harsh with forebodings of arrest or death – or worse.

"*Madre de Dios!*" cried Señora Amelia González, making the sign of the cross. "*Brujo!*"

A daughter fingered her beads and her lips moved in silent prayer.

Arévalo González smiled reassuringly, rose calmly from the dinner table and drew his family to him.

"*Coraje*," he said quietly. "Courage and dignity, my little ones."

Then he nodded to a servant. "Open it before the beasts tear it down," he instructed.

The servant was hurled aside as the soldiers and secret police of Juan Vicente Gómez surged into the home of the Venezuelan newspaper owner.

Rifle butts and bayonets pried González from the arms of his terrified and bewildered family. Even as he was being dragged to a waiting police van, other of the diabolic dictator's thugs were swarming over the plant of González' newspaper, *El Pregonero*, slugging and bayonetting employees and destroying the machines that had dared print even a hint of the evil that was Juan Vicente Gómez.

At the same moment, with the relentless precision of a Hitler or Stalin-executed purge, the same grim drama was being enacted at the homes and plants of the publishers of *El Nacional* and *Sancho Panza*. They, too, had defied the monster who had decreed that in print he must always be referred to as *El Benemérito*, The Deserving, but was called *El Bagre*, The Catfish; *El Brujo*, The Witch Doctor, and worse, by the few brave enough even to whisper the loathing of all decent Venezuelans. Their arrests made absolute the power of Juan Vicente Gómez.

Gómez has no counterpart in history. The most malevolent and depraved tyrant ever known in Latin America, a fiend in human form, he posed as a benign, kindly, omnipotent father to his oppressed people.

Yet, he accomplished the impossible. Barely literate, he pulled his country from the verge of bankruptcy. He outsmarted the shrewdest business and legal minds in the world to negotiate international oil contracts that made Venezuela one of the richest countries on the face of the earth. Then he looted the country.

He was a bastard, literally, and his personal life was reprehensible, yet he was honored by foreign governments and dignitaries and the church. He did not inflict his evil upon the medieval world, but ruled and tortured and killed until 1935.

This was the man who was a malignant growth on Venezuela. This was the man who ordered the arrest of Arévalo González and his fellow publishers for even intimating the truth about him.

The three publishers and sixteen16 other prisoners were thrown into the hold of a gunboat. There was no trial, no stipulated sentence. The newspaper owners hadn't been told their offense or where they were being taken. But they knew.

TWO YEARS before, in 1907, while Gómez was still grasping power, his foster-brother, Eustóquio had been carousing with two companions from the Andes in a saloon on the outskirts of Caracas. Not only had the bullyboys been raising hell in general, but Eustóquio had started shouting vile and indiscreet political remarks. Because of the growing importance of Eustóquio's foster-brother, the Governor of the Federal District, Dr. Luis Mata Illas, had been summoned to reason with the revelers.

Eustóquio, a wild and bloodthirsty animal, received the distinguished public servant with exaggerated courtesy.

"Welcome, my good friend," he said, bowing low with a flourish. "Please do us the honor to join us in a friendly drink."

"*Con placer, gracias*," replied Illas, seating himself at the ruffians' table.

A drank was placed before the Governor and he raised it to his lips.

"Dog of a dog!" shouted Eustóquio. "You have come here to interfere with the enjoyment of the brother of the great Juan Vicente Gómez!"

Then the brutish lout whipped out a pistol and shot Dr. Illas dead.

Eustóquio had then fled to the mountains, finally to be cornered by a general who had been assigned to bring him in. Eustóquio's actions when cornered were characteristic of his breed.

"Don't kill me!" he pleaded. "For God's sake, don't shoot me! I'm all in. I'll go with you."

"Don't worry, I won't kill you," said his captor as he disarmed him. "I don't assassinate in cold blood as you do."

Eustóquio had stood trial and been sentenced to 15 years in prison, the maximum penalty under the law at the time.

Although his foster-brother was almost indispensable to Gómez by virtue of his very viciousness, Juan Vicente had done nothing in his behalf at the time. When he felt himself firmly established as master of life and death in Venezuela, however, one of Gómez' first acts had been to appoint a judge and a secretary to review Eustóquio's case, with a view to obtaining his foster-brother's release by "legal" means.

The two men, probably not fully aware of Gómez' recently consolidated power, upheld the sentence. Quicker than you can say *El Benemérito* they were in jail themselves – and Eustóquio was free by presidential order.

Gómez then recommended to the Minister of War the appointment of Eustóquio as commandant of the prison of San Carlos, one of the hell-holes that was to harbor thousands of his political enemies. The minister declined to name the dictator's foster brother to the post but a short time later did appoint one Evaristo Prato as commandant of the prison. Evaristo Prato, it soon developed, was just another name for Eustóquio Gómez, a happy coincidence that undoubtedly lengthened the life span of the Minister of War.

It was this rape of justice and abuse of power that the newspaper owners had dared hint at. It was this that made them know, without being told, that they were being taken to the prison of San Carlos to be under the care of Evaristo Prato, *aka* Eustóquio Gómez.

SAN CARLOS Prison is on a small island near the entrance to Lake Maracaibo. It took 36 hours for the gunboat to make the trip from Caracas. A storm caused her to be anchored for some hours, during which the prisoners were badly battered and buffeted by loose casks and other cargo. They were given no food or water.

At San Carlos the prisoners were greeted by Eustóquio, armed with a *verga*. A cross between a whip and a blackjack, the *verga* is a bull's penis covered with leather. It was to the Gómez henchmen what the rolled umbrella is to the proper Englishman.

Thirsty, hungry and sick, the prisoners were whipped into the prison by Eustóquio's *verga*. Inside the gates, chained to the walls were the remnants of what once had been whole men. The stench of the human excrement that was everywhere made the new prisoners retch blood. They could not vomit because there was nothing in their stomachs.

The cell into which the newspapermen were thrown was bare of furniture and overrun with rats and vermin. At high tide the sea water seeped into their black hole.

In the morning, after 48 hours without food or water, each was given a small cup of onion broth in which floated a single plantain, a small, banana like fruit.

The prisoners were fitted with *grillos*, one of the many foul torture devices conceived in Gómez' jails and reserved almost exclusively for those who opposed him. *Grillos* are U-shaped shackles which are placed about the ankles with the open end toward the heel. An iron bar, weighing as much as 80 pounds, is inserted in the back of the shackles and fastened firmly in place. Ropes are attached to the bar and passed over the prisoner's shoulders. Only by pulling on the ropes can the prisoner shuffle about. He cannot lie down in them without extreme discomfort. In time, the *grillos* make festering sores on the ankles, causing gangrene that results in amputation or death.

For months the publishers lay in their own, and others', filth, getting their single cup of slimy, thin soup on those days when Eustóquio and his fellow beasts were not too drunk or too indifferent to give it to them. One cellmate committed suicide with a knife he borrowed from a drunken guard.

Arévalo González eventually was released, but instead of fleeing the country as did most of those who had incurred Gómez' displeasure, he remained in Venezuela to try to bring the truth about the tyrant to his fellow countrymen. He spent most of the rest of his life in prison, with brief respites when he was released. He served 14 terms – one of them of nine years – before finally dying in 1935 from a disease contracted while a captive. As much as Gómez despised González, he did not dare kill him because of the affection the people bore the courageous publisher. There are, it seems, limits to what even a Gómez dares.

The punishment inflicted on González was mild compared to that suffered by others at the hands of Gómez, yet *El Benemérito* brazenly pointed to the fact that there was no legal death penalty in his country, as an example of his humaneness and love for the people!

WHAT INFAMOUS combination spawned the evil genius behind this desecration of a nation? In what barbarous nest was he nurtured?

Juan Vicente was born in 1857 to a Spanish gentleman named Evaristo Garcia and his mistress Hermenegilda Chacón – an almost pure-blooded Indian – in the village of Cúcuta, Colombia. The exact date of the dictator's birth is not known, but in later years he had records falsified to show he was born July 24, the natal day of Simon Bolivar, the great Latin American liberator, with whom he dared to liken himself.

When Juan was four years old, his mother walked out on Garcia and went to live with Cornelio Gómez, a rather gentle, kindly and ineffectual man who owned a small farm called La Mulera near San Antonio, Venezuela.

Being a bastard, the boy properly should have born the surname of his mother and been called Juan Vicente Chacón. But his mother's new lover, perhaps from kindness – or maybe because he sensed potential greatness the bright-eyed youngster – conferred his family name.

Just before he died, when Juan was 14, Cornelio told Hermenegilda: "Juan Vicente is the brightest. I want leave everything to him." Juan, with his mother, took charge of La Mulera, which then boasted a few acres, a few cattle, some scattered coffee bushes, and 13 illegitimate children.

Juan, who had no formal schooling, taught himself reading and arithmetic. He never was able to master more than simple sentences in print, but had such a grasp of mathematics – particularly mathematics involving financial matters – that he was able employ figures to his own advantage against the most accomplished and artful financiers. This was about all the culture he ever acquired until many years later, when some polish rubbed off on him from the sophisticated and well educated personages with whom he was thrown into as association as head of state.

He combined native shrewdness, good management, expert cattle rustling and ruthless acquisitiveness to enlarge La Mulera into one of the most prosperous and extensive estates in all Venezuela. He grew to a stocky five foot, 10 inches tall, and his complexion was dark, but lighter than that of the pure Indians with whom he lived. He refused to take part in the wild drinking and dancing orgies in which the other members of the Gómez flock indulges almost without interruption.

Juan Vicente's only excess was sex, a pastime in which he was outstanding even in the free-and-easy atmosphere of the countryside. By the time he was 25, he had fathered an uncounted number of bastards, many of whom were given a home on the farm. Hermenegilda gave birth to two more children without benefit of wedlock, and as the males grew up they brought their illegitimate sons to La Mulera. This automatically solved any possible labor shortage on the rapidly expanding farm.

The largest place this man, who was to rub shoulders with diplomats and negotiate international treaties, ever saw until he was 42 was San Cristóbal, a town of five or six thousand that he visited occasionally to bring cattle or coffee beans to market. On one of his trips there, when he was 28, his roving and voracious eye came to rest upon the alluring figure and attractive face of Dionisia Bello, the wife of an Italian

merchant.

Just how Juan swept Dionisia off her feet has not been recorded, but he did expropriate her the same day, carrying her back to La Mulera on a donkey that had been laden with bags of coffee beans. Her husband was left speechless with rage – and fear of the hoodlums associated with Gómez, who already had gained a fearsome local reputation.

Perhaps realizing this dainty creature was vastly superior to the dusky, dumpy and dirty mountain girls with whom he had been consorting, Juan Vicente installed Dionisia at La Mulera, the first woman he had ever taken into his home. He did not marry – he was never legally wedded to anyone – but he paid her the signal honor of having the births of the seven children she bore him registered with the authorities. Of the hundreds, perhaps thousands, of children he sired out of wedlock, these were the only ones accorded such distinction.

THE STORY of Gómez' rise to complete power in Venezuela reads like the libretto for a comic opera, with tragic overtones. He took part in his first revolution when he was 36, throwing all his money and resources behind a loser. This cost him not only all the ready cash he could raise, which was considerable, but La Mulera as well.

Fleeing La Mulera, Gómez efficiently salvaged everything that wasn't tied down, including women, children and other livestock, and a large supply of arms and ammunition which had been under his control as chief of commissary for the rebels. Everything was transferred to a site just across the border in Colombia, from which Gomez watched La Mulera go up in flames at the hands of government troops a few days later.

Once again Gómez became a revolutionary. He placed all his money, 30,000 bolivars, at the disposal of a man named, ironically enough, Cipriano Castro, leader of the new revolt. Then Juan Vicente assembled his entire tribe, 60 ruthless, bloodthirsty relatives and hangers-on in all, at his Colombia ranch. The arms that had been salvaged from the abortive attempt to overthrow the government were issued to the cut-throats. Juan Vicente was given his old job of chief of commissary. A few days after crossing the border into Venezuela the mob numbered 600 men. A few weeks later the ragtag army had swelled to 2,000. Before the fighting was over, there were more than 10,000 of them, and Juan Vicente Gómez, the ignorant *Andino* who had known nothing of armies and formal warfare, was a capable field officer.

The revolutionists entered Caracas, capital of Venezuela, in the fall of 1899. Castro was proclaimed president, Gómez named governor of the federal district.

Bit by bit, Juan Vicente began building power as bit by bit Castro degenerated into a drunken, dissipated popinjay. Gómez played dirty politics as only they can be played in Latin America. When it was to his benefit, Juan Vicente was fiercely loyal to Castro. When it was to his advantage to double-cross the president, he was just as fiercely disloyal.

In 1908 Castro was forced to retire to Europe to try to repair his health, and Gómez started his reign of terror with the seizure of Arévalo González and his fellow publishers.

With Castro out of the way, Gómez moved into the presidential palace and scattered his casual mistresses throughout Caracas. Dionisia had grown too old and fat for his fancy, so he replaced her as head of the harem with Dolores Amelia de Cáceres, the 16-year-old daughter of distinguished scholar and teacher.

Dr. de Cáceres died shortly afterward from grief, but Dolores Amelia lived to retire in great wealth to Spain years later.

IN APPEARANCE, Gómez the dictator became a far cry from Gómez the *Andino* ranch operator. He adopted military dress, the type depending on his current hero. When Theodore Roosevelt was in his heyday, he was the object of Gómez' admiration, and Juan Vicente dressed like a Rough Rider, complete with khaki uniform, puttees, flamboyant hat and glasses. His resemblance to the hero of San Juan Hill was startling.

During World War I, Gómez became an admirer of the German Kaiser. "He defied the whole world. I like men like that," Juan Vicente explained. During this period, Gómez trained his mustaches upward, in typical Kaiser fashion, wore uniforms and spiked helmets that were almost the exact duplicates of those sported by Wilhelm.

Meanwhile, thousands suffered and thousands died in San Carlos; in La Rotunda, in Caracas; and in El Liberatador, on a rocky promontory in the harbor of Puerto Cabello. And *grillos* and *vergas* were by no means the only instruments of torture employed.

One of the favorite methods of forcing confessions from men in Gómez' prisons was to hang them by the scrotum. Heavy men would fall, leaving their genitals dangling in the knot in which they had been tied. Lighter men might survive the hanging, but they were mutilated – and many committed suicide from the shame and degradation.

Women were hung by their breasts, and Gómez' inquisitioners devised other methods of torture far more Satanic than anything ever conceived by the Spaniards.

The *tortol* was one of them. This was a knotted rope which was placed around the head, above the eyes. When a stick was placed through the rope, the *tortol* could be twisted until the knots were driven into the flesh, or even the bone if the torturer felt particularly vicious and wasn't too drunk to apply sufficient pressure.

The *cepo*, or snare, was perhaps the most horrible of all the Gómez' sadistic torture devices. The thumbs of the victim were tied together and he was forced to squat with his elbows inside his legs and below his knees. A rope was passed around his neck and tied to his wrists. Then a rifle was passed under the knees and over the elbows, with its ends protruding on both sides. When the prisoner was securely trussed in this fashion, his brave antagonists jumped up and down on the ends of the rifle, placing an unbearable strain on the upper vertebrae and rupturing the abdominal walls. Of the few who survived the *cepo*, most came from the ordeal insane, stark, raving mad.

That is the way men and women who had displeased him even mildly fared in prison at the hands of the "benign" ruler but not all the punishment was meted out in *El Benemérito*'s jails.

He sometimes had his enemies hung up alive on meathooks along the public roads, and left as food for the vultures and an object lesson to those who would oppose him.

BY 1935, at the age of 78, the dictator had become a wizened old man whose drawn face and wispy mustache earned him the nickname of *El Bagre*, The Catfish. But his mind was not wizened nor was his cruelty abated, and he continued to rule with fear and cunning until December of that year, when he had a violent attack of prostatitis (which he richly deserved), complicated by uremia and diabetes. It was reported that he had died on December 15, but this was denied by his doctors. His death was officially announced on December 17, the date of the death of Bolivar. It is believed the date of Gómez' death was misrepresented to make it correspond with the day Bolivar died, just as his birth date had been falsified to coincide with that of the great liberator.

CHAINED NUDES
FOR THE DEVIL'S DUNGEON

The tormented beauties writhed in agony before the king's monster, shrieking wildly for the noose's tender mercy.

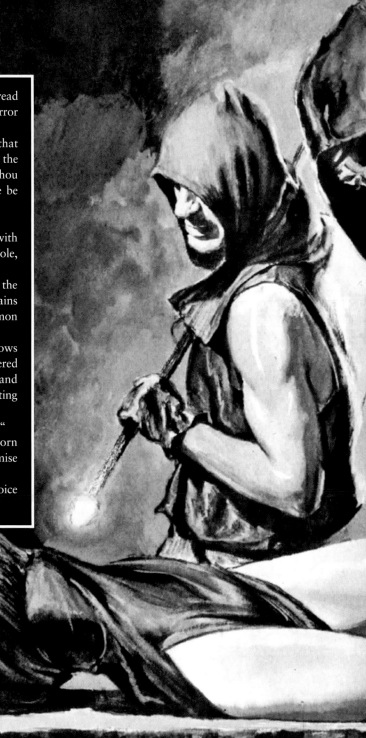

CHAINED LIKE AN ANIMAL, the beautiful young girl stared in dread at the dank walls around her. Even now, she did not grasp the full horror of her fate; that she was legally at the mercy of a sadistic monster.

The girl's name was Charlotte Howard, and she had that morning been condemned for stealing. She shivered as she recalled the judge's grim words after he had put on the black cap: "I order that thou be hanged by the neck until dead, and that before this sentence be carried out, thou be scourged and branded as a felon."

They came to fetch her that very night.

"On your feet," leered a brutal-looking jailer, rousing her with a kick. And half demented with terror, Charlotte was taken to the Hole, the grisly torture chamber of Newgate Prison.

The Hole's appearance was in keeping with its purpose: the walls were of stone, wet with humidity and blackened by fires. Chains hung down from the ceiling and the place was suffused with the demon glow of flaming braziers.

The man cloaked in black who stood wrapped in the shadows of the chamber was the incarnation of Satan himself. Reptile eyes peered evilly from out of a shriveled parchment skull. Stoop-shouldered and vulturine, there was about this ominous and terrifying figure the darting watchfulness of a great bird of prey.

"Strip her," the apparition ordered. "Tear off her clothes."

As if in a nightmare Charlotte felt the garments being torn from her back. Then her bodice was ripped off. Suddenly her chemise was gone and she was standing there in nothing but her stockings.

"Take her to the wall and bind her to the spikes." The voice was thick with excitement.

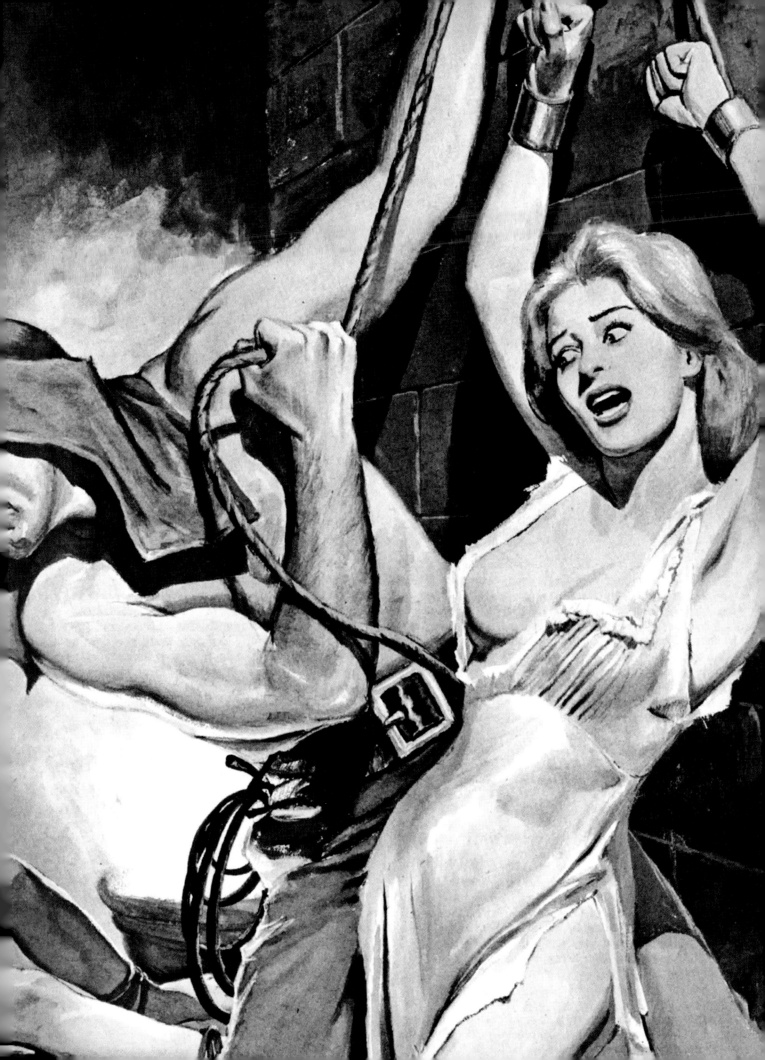

The jailers dragged the struggling girl over against the wall and bound her wrists to iron spikes so that she was forced to stand on tip-toe with her back toward them.

"Twenty lashes, and cut them deep."

Firelight shimmered over Charlotte's satin-smooth body, caressing her silken legs and the ivory whiteness of her well-kept flesh.

Sweat rolled down the glistening torso of the man with the cat.

"Why do you wait?" demanded the figure in the shadows. "Begin the punishment."

Taking the cat in both hands, the man struck Charlotte high across the shoulders. The knotted strands of rawhide sank into her soft flesh as if it were butter, and the blood spurted out.

"Mercy," screamed the girl in mortal agony. 'Mercy, for pity's sake."

But in that chamber there was no mercy.

Again and again the hellish lash whistled through the heavy air of the Hole, cutting across Charlotte's milky thighs, buttocks and back. Soon her entire body was criss-crossed with bloody lines and she squirmed and screamed in unbearable pain.

"More," roared the man in the corner, beside himself with excitement.

"No," Charlotte shrieked. "Merciful God, no more!"

Red blood was streaming over her white flesh, running down her black silk-stockinged legs.

After the twelfth murderous lash, she fainted.

But her sufferings had only just begun.

When she came round she was strapped face upward on a bench, and her eyes grew frantic with apprehension as she saw a branding iron glowing redly in one of the braziers.

"Oh God," she moaned. her pretty face a tortured mask of horror. "Not that!"

The man in black chuckled obscenely. He towered over her trembling body. "Yes," he gloated. "That."

Charlotte began to shriek for mercy, pleading to be spared the agony and horror of branding. But her tormentor's only response was a blood-chilling laugh as he held the iron in his claw-like hand.

"See how it glows," he taunted her. "I'm afraid it will spoil your pretty looks."

Charlotte twisted in uncontrollable panic till the straps cut into her flesh. Already she could feel the heat from the iron.

"Hold her head."

One of the jailers knotted a massive fist in her hair.

Then, with careful deliberation, the man in black slowly brought the fiery metal down onto the girl's sweat-covered cheek.

A ghastly shriek ripped through the chamber as the iron sizzled, burning and searing the girl's loveliness and convulsing her outraged body with bone-jarring spasms.

A sickening odor hung in the air.

The man in black stood back, chuckling at the horror of his handiwork.

A hush fell over the others.

The girl moaned and writhed.

No one – not even the most lowly scullion – would want her now. Now she was fit only for death.

THIS SCENE took place at Newgate Prison, London, sometime during the middle years of the 18th century. The man in black was the notorious Uriah Seeps. Beadle of the prison, one of the most inhuman monsters of all time.

Charlotte Howard was, as far as can be determined, a prostitute: one of the vast legion of girls who nightly catered to the perverted appetites of England's dissolute aristocracy.

For in Charlotte's day London was a city of vice, a great teeming mass of human pollution. It was a place of shocking contrasts, where magnificent mansions overlooked filthy hovels: where the rich wallowed in luxury while the poor starved for want of a crust of bread.

In such an environment, a beautiful but penniless girl such as Charlotte could do just one thing. And the avaricious madames of the period knew it.

From Hogarth's *The Harlot's Progress*, from *Fanny Hill* by John Cleland, and from other contemporary sources it is possible to reconstruct the life of these "girls of pleasure," and how they got that way.

The madames, aware of the demand for very young virgins, were experts at spotting girls like Charlotte, alone and destitute in the city. They were skilled at extracting information without seeming to ask questions.

They would find out if the girl had any friends in London, or any relatives in the country likely to make trouble. Then, if the field were clear, they would offer the girl a home in their own particular "house."

The approach of "Mother Stanhope," a well known madame and procurer of the period, ran like this:

"I like to be jolly myself and see others so. I'm getting on now – ain't what I was once. But as I says, I like to be jolly and always is. An old fiddle, you know, makes the best music."

Having wormed her way into the girl's confidence. Mother Stanhope always tried to get the name of some distant relative of the girl's. She would then exclaim in astonishment, "Don't tell me that Molly Smith is your aunt! Well, well, I know Molly well – although I haven't seen her for a year or two. So you're Molly's niece! Now you must stay at my house while you're in London. I won't charge you a penny and I'll write to Molly that you're with me."

Once there, the unsuspecting girl would be offered a job, often as a milliner. However, first it was necessary for her to sign a contract as an apprentice. As soon as the contract was signed the girl was drugged and raped by the establishment's "bully", or what would now be called the "bouncer."

When she recovered, she was told that she was now ruined and could hope for nothing but a life of shame. The contract was produced and in the fine print the girl discovered that she had signed herself entirely into the power of her "protector."

According to John Cleland, the first house to which a girl was taken was generally "a breaking-in house" or, as one of the girls herself put it, "a place where she was broken to the mounting block." Later she was sent to a regular house.

Occasionally, in cases such as Charlotte's, where the girl was extraordinarily pretty and voluptuous, she was set up in her own apartment, and the illusion was given that she was a lady of leisure who from time to time received gentlemen visitors.

Such a girl was supplied with fashionable clothes, a pet monkey, and a little servant boy dressed in Oriental costume, as these props were considered essential for a lady of fashion. But when she went out she was always followed by an older woman – often a retired prostitute – to make sure that she did not sell any of her finery and make enough money to escape.

It may be wondered why the girl did not cry for help as soon as she got out of the house. But it must be realized that few persons would have understood or cared about her predicament, and that most of the girls, having lost their virginity and having signed the contract, felt there was no other course open to them but a life of prostitution.

And for the few who proved difficult there was always the Law. It may seem ironic that the authorities of the day, far from being willing to help such "fallen women," were far more likely to believe any charge brought against them and to meet out brutal punishment.

It must be remembered that the 18th century "John Citizen" observed the double standard, and that while he might well have been whoring himself on Saturday night, he was quite capable of suggesting the most barbarous penalties for prostitution at breakfast Sunday morning.

It was a century ridden with superstition, hypocrisy and cruelty, a time when the London mob flocked to Tyburn and Newgate to see women and children executed for the most trifling offenses, and when many an innocent young maid died screaming at the stake as a witch.

There were literally hundreds of "crimes" that were punishable by torture and death, and in 1775, the year that saw the start of America's struggle against tyranny, over five hundred children were condemned to death in England for crimes as petty as stealing a few pennies' worth of food.

In those happy and lively days. when England was rising to her greatness, a man, woman or child under sixteen years of age could be hanged for such offenses as:

Causing damage to Westminster Bridge; appearing disguised on a public road; cutting down young trees; shooting rabbits; stealing anything whatsoever from a bleach field; returning prematurely from transportation; or breaking a legal contract.

The last mentioned played right into the madames' hands. No wonder they had little difficulty in disciplining their girls, and in having recalcitrant ones arrested and handed over to the brutes who had charge of the jails. For the beadles and jailers of the era were often little better than sadistic perverts, human fiends like Uriah Seeps.

SEEPS WAS a madman, a psychopath who today would himself be behind bars rather than in charge of an important penal institution. But the fact remains that George Ill saw fit to appoint Uriah Seeps Beadle of Newgate Prison, thus placing several hundred defenseless human beings completely at the mercy of a monster who can only be compared with his French contemporary, the Marquis de Sade.

Seeps' appointment as Beadle was the fruition of a macabre dream that came to him as a young man. Doubtless it was incubating when, as a small boy in the country, he ecstatically beheaded half his father's chicken flock, his eyes growing feverish at the sight of the blood, his laugh filled with hysteria and madness.

When he was about sixteen he was sent to the island of Jamaica as an apprentice overseer. There he soon caught the eye of the owners of the plantations, and before he was twenty he was a head overseer. At thirty he returned to England.

There, by dint of much connivance and because he was prepared to accept the post without payment, Seeps was put in charge of His Majesty's Prison at Newgate.

Already a grim and awful place, Seeps turned the infamous prison into a veritable hell. Night after night the subterranean chamber known as the "Hole" echoed with the shrieks of tortured prisoners. And if most of these prisoners were young and pretty girls, who cared! Were they not felons justly condemned by the Law?

This indifference enabled Seeps to indulge his unnatural appetites to the full, and he saw to it that his assistants were all men who shared his perverted desires.

Though a good deal of this monster's "fun" took place in the secret recesses of the Hole, much of it was carried out in the open, where the public could also enjoy it.

Unlike the scourging and branding, the execution of Charlotte Howard was carried out in public, before the gates of Newgate Prison. Charlotte's hanging was just one of hundreds conducted during Seeps' "Reign of Terror," but because she was a beautiful girl with a somewhat lurid past, it found particular favor with the London mob.

Details of this and other executions are contained in the *Newgate Calendar*, as indeed are many other points of interest about the prison's sadistic beadle.

THE DAY of Charlotte's execution, the West Gate of London was bedecked as for a gala holiday. Fleecy white clouds drifted across the midday sky, and the sun bathed everything in its life-giving glow.

It shone on the grim walls of the prison and on the gross faces of the crowd that waited in its shadow; it shone too on the spectral shape of the gallows, waiting and ready for its tender victim.

As the prison bell dolefully tolled the noon hour, the great iron-studded gates of the prison slowly swung open and a strange procession came into view.

In front was Uriah Seeps, a tall spare Satanic presence dressed entirely in black. Then came the chaplain, followed by Charlotte, in chains, and the sinister figure of the executioner complete with scarlet hood. Guards flanked them on both sides, and to the rear marched the Sheriff of the county and various other dignitaries.

"Serves the little bitch right," screeched a wrinkled hag staring maliciously at the terrible scar that disfigured Charlotte's lovely face.

"She's still got a nice neck for the rope," chuckled a

big red-faced man, momentarily looking up from a flagon of ale.

The procession mounted the scaffold and brutal hands reached for Charlotte. As she fought and struggled to avoid pinioning, the mob howled with merriment at her pitiful screams and hurled obscenities at her.

Then a hush fell as Seeps began to read from an official-looking scroll:

"Hear ye, hear ye, good people of London town, that I, Uriah Seeps, Beadle of Newgate Prison, am hereby authorized to deliver the person of Charlotte Howard to His Majesty's hangman to deal with according to the Law; and may Almighty God have mercy on her immortal soul."

The last words, uttered in a sort of pious chant, drew a rude cheer from the crowd.

"Get on with it then," shouted a voice.

"Let's see her dance," roared another.

Seeps looked knowingly at the sea of brutal expectant faces; he knew what they wanted. A grim and terrible smile curled his lips. "Let the execution proceed," he said solemnly.

The mob's enjoyment rose to fever pitch as one of the hangman's assistants ripped off Charlotte's filthy prison rags and exposed her firm young breasts to its lecherous gaze.

The girl was moaning for mercy now, begging to be spared the slow agony of the rope.

Even after the noose had been placed around her slender neck she continued to protest her innocence, but her frenzied words turned to a hideous gurgling scream as the harsh rope bit into her delicate skin.

And there were many men there who had known Charlotte's tempting body, among the mob that roared its approval, who watched in stony silence as the one-time prostitute slowly died.

WHAT WAS the reason for the brutality of bygone ages? Why the overpowering craze for morbid spectacles? No one is sure, although many psychologists have suggested various explanations. But one thing is certain, the desire to see suffering inflicted has always been present.

As far back as the reigns of Nero and Caligula, when depravity reached abysmal depths and infidelity was rampant, the punishment meted out to unfaithful Roman matrons and their lovers gave some indication of the cruelty that prevailed. The adulterers, male and female, were roasted alive.

These burnings often took place en masse as an added fillip to the bloody "games" organized in the great arenas to entertain the people.

The adulterers were led into the arena clad in expensive and suggestive garments made of highly combustible materials known as *tunica molesta.*

After the victims were set ablaze the watching crowd would experience an orgasm of sadistic pleasure as the flames exposed the naked, writhing bodies of the lovers.

Over seventeen centuries later men and women were still being burned, decapitated, hanged and impaled for the public pleasure. The Law always found some excuse to execute a steady stream of victims to satisfy the bloodlust of the mob.

During the 18th century, this craze for things gruesome was carried to fantastic lengths. To give an eerie quality to their estates, wealthy men planted dead trees on the grounds and hired hermits to live in specially dug caves. They even employed men to tame bats, vipers and owls to live in the artificial caves with the hermits.

The School of Terror appeared in literature, started by Horace Walpole's famous novel *The Castle of Otranto,* the original of all the haunted castles of fiction. It was followed by even stronger novels, such as "Monk" Lewis' horrible work in which a girl is locked in a cellar with a number of demented youths and slowly tortured to death.

There was a craze for vampires, ghosts, ghouls and werewolves, and some young men even insisted on drinking their wine out of skulls specially stolen for them from the gallows by body snatchers.

For the corpses of hanged men and women were left to rot outside the prisons, and men like Uriah Seeps saw to it that there was no shortage of skulls.

Seeps himself was killed in the Gordon Riots that broke out in 1780, but Newgate Prison remained intact until 1902, when it was torn down. It was the scene of one of the last public executions ever held in London, that of Lady Hester Stanhope, convicted of murdering her husband, Sir Edward Stanhope; and with her horrible death ended a long line of grisly spectacles that stretched way back to the early years of the 12th century.

"DAWSON'S BUILT-LIKE-A-BRICKHOUSE BORNEO WILD BITCHES"; detail from interior art, **TRUE MEN STORIES**, 01/62.
Art uncredited.

HITLER'S CALL-GIRL TEMPLE

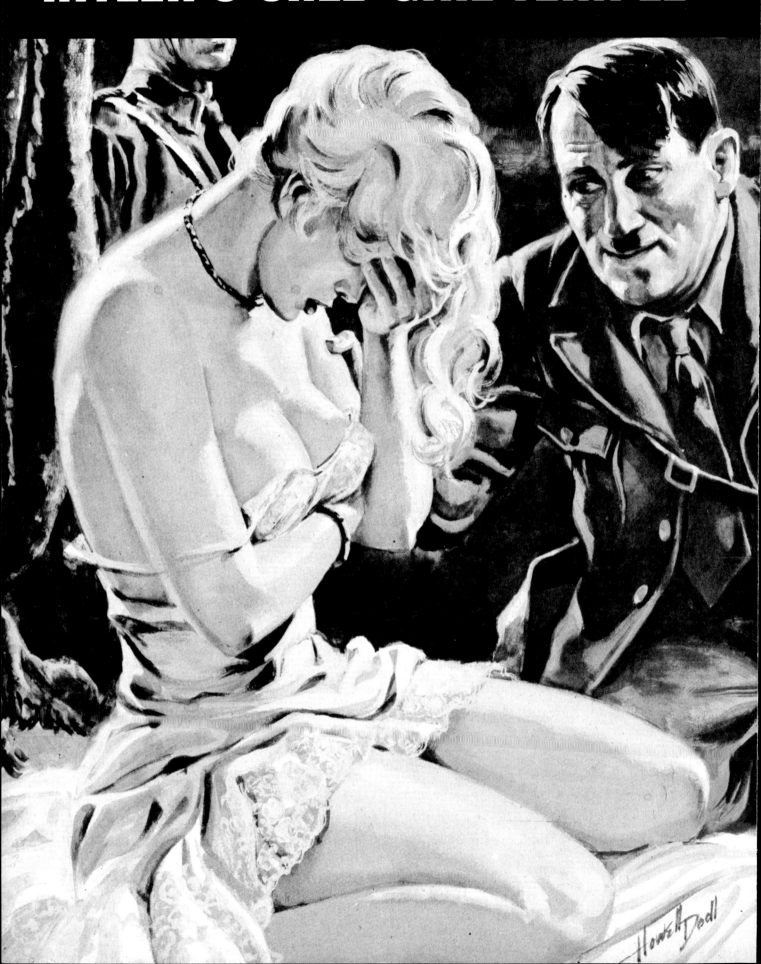

Der Führer gazed at her as if fascinated, and leapt towards the huge Celestial Couch of Aryan Blessedness...

HOW DEPRAVED WAS ADOLF Hitler?

The world has long known that he was a megalomaniacal madman, that he was perhaps the most brutal sadist in history and that he was constantly ridden by a torrent of inner torments. We know that he had a deep-seated inferiority complex, due to an early syphilitic experience, and that he was always surrounded by men who were themselves a weird combination of homosexual dilettantes and psychopathic killers. But was he himself sexually abnormal in the clinical sense?

Did he have affairs with hundreds of women, as has been alleged by his admirers in many cases? Or was he, as others claim, the disciple of a Spartan way of life, eschewing women and sex as he eschewed meat and alcoholic beverages? Were his so-called "affairs" with women merely a screen, merely a front to make it appear that he was 100% masculine? And, as has been said, were his relations with the opposite sex never anything but Platonic?

Although many years have elapsed since Adolf and his grubby *frau*, Eva Braun, died in a bomb-battered Berlin shelter, new light has been thrown on the odd sexual behavior of this arrogant madman. It is now positively known, for instance, that he was a sexual failure with women, and that this flaw in his personality drove him to periods of sadistic insanity.

It has been established also that, if he did not always live as a practicing homosexual, he had had affairs with other men, particularly the notoriously queer Capt. Ernst Roehm, whom *Der Führer* himself personally did to death in the infamous Purge of 1934.

It has been authoritatively disclosed that Hitler was sexually impotent. This of itself was enough to drive him to wild pitches of fury, for he had held himself up to the world as the very essence of masculine Aryan virility. On many occasion, according to his intimates, he tried to defeat his own sadistic-masochistic impulses by making love to women – but invariably without success.

Before World War II broke out, a Temple of Aryan Motherhood was set up in the German capital. Despite its lofty title, and its mystic hocus-pocus about prayers, incenses, herbs and weird rituals, the Temple of Aryan Motherhood was in effect nothing but a brothel.

The pretext was that the Temple was a shrine where young Nazi girls could learn the elements of pure Aryan motherhood. It occupied all four floors of a fine building in an exclusive residential section of the city, and the interior had been designed by one of the Nazi Party's most admired homosexual decorators. The "Hindu", assisted by an unearthly horde of sexual deviates, presided over the shrine and performed all the duties of maintenance.

In practice, the Temple was dedicated to but one purpose – catering to the lascivious desires of the Nazi hierarchy. The women who satisfied these desires were not always women – often they were homosexual men. But the girls who were used were never prostitutes for the very simple reason that it was not necessary to employ professionals. There were too many willing amateurs.

These amateurs were young German girls – in many cases virgins – who had already dedicated their souls to the National Socialist movement and were quite willing to lay down their bodies as well. They were told, among other occult things, that they would be expected to become pregnant by the "very cream of German manhood" and thus carry on the line of heroes for posterity.

What these eager young things didn't know, of course, was that when one of the Nazi brutes was through with her, she would be cast aside, pregnant or not. They didn't know, either, that they might be expected to engage in many strange, unnatural acts with their sweating, bestial companions of the Master Race. Most likely they didn't care, so completely had the Nazis indoctrinated them with the idea of subjecting themselves to every whim of the Superman.

The chief feature of the so-called "Temple" was the Grand Celestial Couch of Aryan Blessedness. This was a huge bed, perhaps twice as large as the average double, draped with magnificent silks in lush colors and situated in the center of a vast room, most of whose walls consisted of full-length mirrors. Oriental incense burned day and night; there were decanters of rare liqueurs on a table adjoining the bed. Everything about the Grand Celestial Couch was designed to stimulate the jaded sex appetites of the Nazi bigwigs.

A strange tradition – no doubt introduced by the "Hindu", who was well educated and had spent many years in the Orient – was calculated to appeal to the sadistic nature of the Nazis. It was this: an attendant stood outside the door of the Grand Celestial Couch while the sex act was being performed inside. When the Nazi had completed the act, he would snap his fingers, whereupon the attendant would quietly enter and hand him a sharp-pointed, razor-edged knife. It was the Storm Trooper's "Dagger of Honor."

With this awesome weapon, the Nazi would then deftly carve a swastika on the bosom of the girl as she lay panting and breathless after her orgiastic climax. Usually the penetration was deep enough to draw blood, but not enough to cause any real physical harm. The girl was supposed to be thus inducted into a secret order of Aryan Motherhood.

ONE MEMORABLE day in the Spring of 1937, the "Hindu" Temple Chief received a call that sent him into a veritable frenzy of excitement. He was ordered by telephone to make the Celestial Couch of Aryan Blessedness ready for the most celebrated visitor in the history of the Temple! The a guest, he was told, would arrive at 8 o'clock that evening.

Every employee of the Temple was immediately set to work preparing the brothel for their honored guest. The Celestial Couch was adorned with fresh, exotically perfumed sheets and deep, luxurious pillows. The liquor was removed, for the visitor was a non-drinker.

"Now, about the girl," asked one of the Hindu's assistants, a short-haired, bull-necked lesbian who ordinarily was in charge of procuring the Aryan beauties. "are we to furnish her for *Der...* for our guest?"

"No," he answered, "the girl will be brought along with our visitor by SS troops. I understand she was especially obtained for this occasion and that she is a creature of unparalleled beauty. Which is as it should be, for she is to lie with greatest man in the world!"

Promptly at 8 o'clock two long, black official limousines pulled up outside the Temple. From the first car stepped three husky, gun-in-hand SS men. When they had ascertained that the coast was clear, a small, slightly-built man darted out of the car and pranced up the steps of the brothel. Then the second auto disgorged its passengers – two broad-shouldered SS brutes and between them a figure wrapped from head to toe in a voluminous cape. All one could tell was that it was a woman. The troopers held her firmly, one by each arm, and half-carried her into the Temple.

In the Grand Celestial chamber Herr Hitler – for he, of course, was the "celebrated guest" – surveyed his luxurious surroundings with a critical eye. A half-sneer, half-grin crossed his face. "It is good," he snorted. "And now you may bring in the girl."

A sound of scuffling was heard in the corridor, then the door was thrust open. Two huge, 200-pound Storm Troopers held a girl in their grasp. She was breathtakingly beautiful. Her long, golden hair hung in disarray below her shoulders; her face was spectacularly beautiful in its flushed expression of exquisite hatred. Her eyes flashed contempt as she writhed in the clutch of her captors. Beneath her clinging night clothes one could see the swelling lines of a young, proud, voluptuous pair of breasts. She shrieked in protest.

Looking directly at *Der Führer*, she screamed: "There are millions of willing girls in the Nazi party who would be honored to lie with you. Why do you have to drag me from my house and bring me here, an innocent girl who has never had anything to do with you or your filthy politics?"

Hitler gazed at her as if fascinated, lips quivering and more than the suggestion of moisture under his abrupt mustache. It was apparent that he was reveling in this scene of violence and degradation.

"Place her on the bed," he curtly ordered, the guards, "and do not leave the room."

They flung the girl on the huge Celestial Couch. Without removing his Nazi uniform, but merely adjusting his clothes, *Der Führer* leaped on the bed to her side, clutching her to his body with all his strength. She struggled furiously. Hitler turned to the guards.

"Take off that nightgown she's wearing, you *dumkopf!*" he shrieked.

Placing a brawny hand over her lush mouth, one officer held her in a tight clasp while the other ripped off the flimsy gown that had covered her lovely, shapely body. Then they tossed her back to the Superman of the Master Race.

Hitler wrestled with the girl, who seemed to be his match in strength, until both were breathless. Then suddenly, the girl grew limp. Casting an eye around the room, noting how completely she was overpowered, she said to Hitler, with a scornful glance: "All right. I won't resist you – and your gentle friends – any longer. You may do as you wish with me, just as long as I am permitted to go home when you have done."

This simple statement drew a strange reaction from Adolf. Eagerly he grabbed the girl again. She had ceased all resistance and lay passively on the bed. But he could do nothing! Whatever desire he had had for her virginal young beauty was of no help to him. He was simply incapable of having intercourse with the girl.

When she realized that Hitler could not accomplish what he had set out to do, she shot him a triumphant look.

"Just as I had always heard." she sneered. "You're nothing but a weakling and" – she spat out the words – "a pansy!"

Hitler's first reaction was not the anger one would have expected, but a guilty, hang-dog look that made one think he agreed with her. Then, remembering that his SS guards were reacting with ire, he snapped to attention.

"Bring me the Dagger of Honor," he snapped. "I'll show this insolent hussy the meaning of true Nazi manhood!"

The lethal weapon was placed in his hand. The girl all but swooned in terror. Lunging at the beauty in his clumsy passion, Hitler tried to trace the Nazi emblem between the sloping hills of her generous bosom. But his aim was bad: he plunged the dagger directly into the left breast of the girl, bringing a spurt of blood. The sight seemed to madden *Der Führer* and he struck at her repeatedly until her chest and abdomen were a mass of slashes, bleeding profusely. The guards looked on stoically, in perfect silence, as if her wild screams of agony were but the rustling of the wind.

His passion finally abated, Hitler tossed the bloody knife aside. He clambered off the bed, adjusted his clothing, straightened his uniform and curtly ordered the guards to call his limousine.

By now the Hindu had quietly entered the Grand Celestial Couch. "The girl, *mein Führer*," he asked, obsequiously, "what do you wish me to do with her?"

"Keep her a few days," Hitler said, "until her cuts are healed. Then send her to Salon Kitty," naming one of the most notorious brothels in the Nazi empire. "My officers there will teach her what it means to defy a Nazi. When they are through with here, let her be sent to a brothel for my ordinary soldiers. That will be all she's good for at that time."

Without another word, *Der Führer* strode from the room, ignoring the upraised arms and the cries of "*Heil Hitler!*" flung to him by the army of followers who now thronged the

corridors.

While no one still identifiable has ever reported any further information about the unknown beauty, it may safely be assumed that Der Fuehrer's instructions were carried out to the letter. The young thing was undoubtedly thrown to Hitler's Nazi wolves – unless she had the good fortune to destroy herself before such a fate overtook her.

THAT MUCH of Hitler's sexual frustration was due to a syphilitic origin in was sued to by no less an authority than a man who for a long period was his personal physician, Dr. Kurt Krueger, M.D. Although his attack of the disease was conquered long before he seized power in Germany, it left scars on Hitler's subconscious that were never erased, in the doctor's opinion.

It has also been suggested that *Der Führer* suffered from a classic case of Oedipus Complex; that is, the adoration of his mother and an intense hatred toward his father. This stemmed from early childhood, when he often had to sleep with both parents. Most likely at one time or another he observed them in sexual play, and this had a devastating effect on his naturally weak psyche.

Hitler's intense, obviously insane hatred of Jews may also be traced to a psychopathic sexual background. In his muddied mind, the Jew was the sexual superior; the Jew was the rapist of women; the Jewish woman was the money-grabbing prostitute; the Jew was the scapegoat for all of his fiendish hatreds.

Long before he had attained the great heights. Hitler used to patronize a particular beer-hall in Munich. A Jewish girl named Sarah – this was long before all Jews were barred from such places – often liked to tease Hitler, whom she considered nothing but an ass. She was highly attractive, and his friends urged the future Führer to make a pass at her.

"I would like to," Hitler answered, edgily, "just to show you fellows I can do it."

Sarah proved unreceptive to Hitler's awkward advances. She openly sneered at him when he called at her apartment. which drove him into one of his proverbial rages.

"I wouldn't make love to you even if you begged me." he told her haughtily. "Because I think you have non-Aryan blood."

She laughed. "Of course, I have," she said. "I am a full-blooded Jewess. But let me tell you right now that I know a lot of tricks in bed that most of your stupid Aryan girls have never heard of."

The remark had a pronounced effect on Adolf. He leaped at her like a maddened animal, trying to clutch her, trying to press his gross mouth against her full red lips. She shoved him aside. Then came the supreme insult – the same as the one hurled at him by the young beauty many years later.

"I couldn't think of making love to you," she cried, "because you're not a man at all. You're nothing but a degenerate!"

Sarah accompanied the hot words with a resounding slap across the cheek of the Nazi. He uttered not a word, but sped from her flat.

Hitler's vengeance was swift, terrible – and typical. A week later, accompanied by half a dozen of his Storm Trooper cronies, he called back at Sarah's home. When she opened the door, she was thrust aside and all the mob entered.

Holding a gun to the poor girl's head, Hitler informed her that she would now have the opportunity to show him and his friends some of the sex tricks she had boasted of. She was then forced to perform an act of unnatural sex upon each of the men in turn – except for Hitler himself, who merely looked on and drooled through the whole nauseating performance.

When the men at last had finished with Sarah. Hitler himself batted her on the chin with the butt of his resolver, leaving her unconscious on the floor.

Was Hitler sexually sick? Draw your own conclusions!

KILL NOW PAY LATER

If you could afford a "dollar down and a dollar a week", you could take advantage of "Pretty Kitty's Credit Plan For Killing" – and a lot of people did.

AT ONE TIME OR ANOTHER, most people have wanted to kill someone, but have been deterred. Disregarding the moral principle, the reasons have generally been one of three: they didn't relish the idea of doing the actual slaying; they lacked the know-how; or they didn't have the cash to finance a hired killer.

Kitty Kappel made their dreams (or nightmares) come true, for it was back on October 21, 1928 that "Pretty Kitty" – as she was called by discriminating males who appreciated a streamlined, hour-glass figure topped by a piquant face – took the first step up the ladder to notoriety that eventually put her in a financial bracket of her own.

The Irish and Italian factions had been warring on each other for control of Hammond and East Chicago for exclusive rights to peddle their Prohibition-banned beer and booze when Matty Schedler was given the contract to eliminate Richy Kilfoyle, a confidante of Ralph Capone and Jake "Greasy-Thumb" Guzik. Somehow, there was a slip-up in the arrangements, and Matty went down in a hail of bullets.

Matty and Kitty had been lovers for a long time, and whether Kitty was motivated by revenge, or actually had double-crossed Matty to work her own way into the underworld is a moot point, but the fact of the matter is that she agreed to carry out Matty's end of the bargain for a pre-arranged fee. She had a girl friend blind-date Richy Kilfoyle on the night of October 21 at the Kit Kat Klub, and while Richy was making forward passes at her in a secluded booth, "Pretty Kitty" slipped a .32-clenching hand out of the curtain folds, pressed it against Richy's head and blasted it open like a ripe melon.

HER METHOD of quick dispatch earned her ample rewards, and during the months of December and January, she fulfilled several "contracts" of which at least seven are known. Five of them were shootings; one, a stabbing that drenched her own

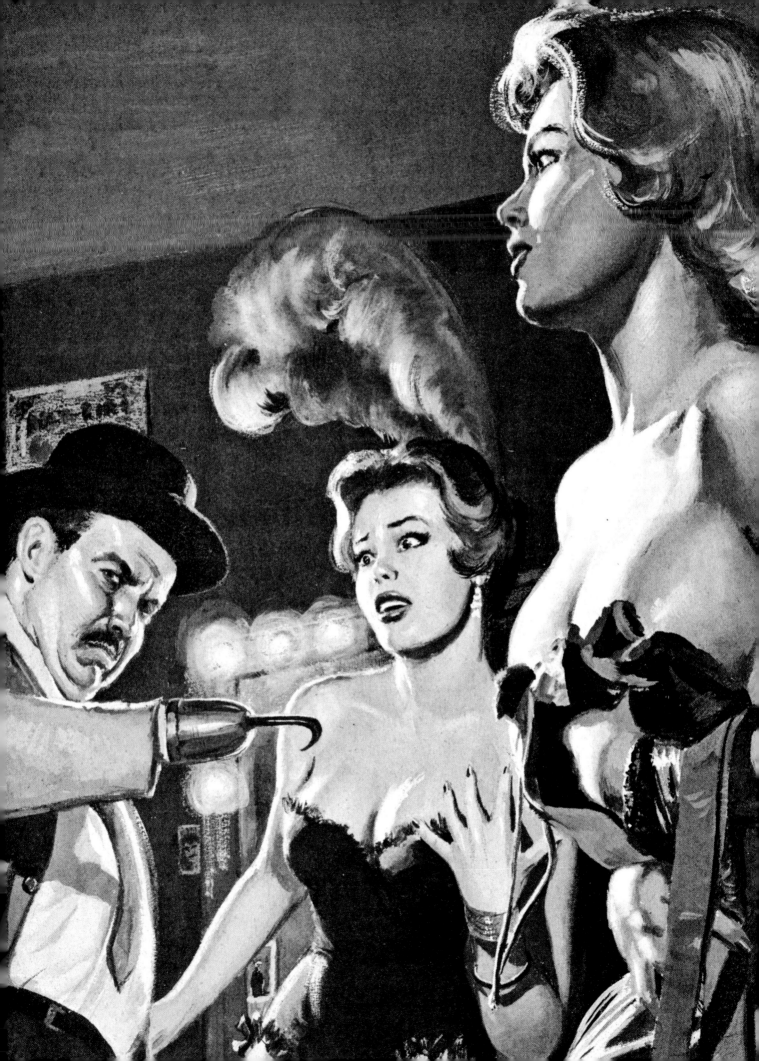

body with the victim's blood; another, a brutal drowning in which she kept her victim's head submerged until he floated off with the garbage on Fox River. If she was going to succeed in her new trade, Kitty realized that her system would have to be based on quantity, not quality. The big mobsters like the Capones, Guzik, Humphries, Rio, White, Volpe, Nitti, Moran, Giannini and Barker had their own triggermen, but there were a lot of small-fry goons who couldn't afford gunzels of their own, much less afford outright payments for a "contract."

These were "Pretty Kitty's" customers, who eagerly subscribed to her business propositions. Her system was one of killing-on-the-credit-plan, with several variations. For instance, when "Needles" Del Sio wanted someone crushed but lacked the green, Kitty's layaway scheme had him bank $25 with her each week until the required $500 was reached, then she went into action. Another time, she asked her client to pony up a substantial sum as a down payment, then deliver the balance when the job was done. A third method was to accept a down payment, with weekly payments to continue at a fat interest rate until one year after the job was done. She gave a sizable discount when she received cash in advance but demanded a bonus for a C.O.D. – in this case, Corpse On Delivery.

BY MARCH of '29, she'd built up a one-woman industry to the point of getting assistance. During her days as a burly-q stripper when she was having an affair with Matty Schedler, she'd become acquainted with some high-living, low-caliber girls who eagerly agreed to join her. Fanny Esposito was a hophead from Wilmette; Sadie "Sparks" Brennan was a convicted arsonist from Evanston; Vera Finney was a former madame of a brothel in Gary, who brought along two loyal call girls, Madeline Quimby and Blanche Bolger; and Sally Morelli of Aurora had done time for armed robbery and manslaughter. All six were as attractive as they were ruthless; they would kill for a buck, even less. "Pretty Kitty" Kappel had her gang of girl killers, and she vowed to herself that she would go places.

She went, and she went fast, with a successful combination of sex and slaying. Her policies of "kill now, pay later" paid off handsomely because a lot of the minor league racketeers were reluctant to pay cash on the line.

Kitty's proposals were ideal to them, and hardly a week passed that her guns or shivs weren't in use. It was only a matter of time before her successful operation was recognized by the big boys, and on the night of June 16, 1929, she was invited to a meeting of The Commission, which met periodically in a loft over a truck garage on Ogden Avenue in Cicero.

THE COMMISSION was the mob's dread Supreme Court, which arbitrated all disputes between gangs and held the power of life or death over key mobsters. The dozen men who formed The Commission met to discuss business which not only affected Chicago and the state of Illinois but the nation as well; the country was in the grip of a confederacy of gang groups, each of which was concerned with its own enterprise: vending machines, booze and beer manufacturing and sales, white slavery, narcotics, shylocking, labor union racketeering, bookie protection, and extortion. "Pretty Kitty" Kappel's activities had long been under observation by The Commission, and when

she began to cut into their torpedoes' trade, it was time to act.

"Pretty Kitty" had long ago learned the credo of the street-fighters: "If you can't lick 'em, join 'em!" She was prepared for The Commission's threat to dissolve her business by countering with a proposal to cut The Commission into her profits. When the chairman, Salvatore Angelino, accepted after conferring with his associates, who never turned up their beaks at snaring an easy buck, "Pretty Kitty" was in with the jackpot.

By September, "Pretty Kitty" had proved to be one of The Commission's most valued assets. How many killings could be credited to her gang of shapely she-devils couldn't be ascertained, and if it weren't for her uncontrollable ambition that ignored all caution, she might have set a record equalled in history only by the Borgias. But it was one of those small minor errors of judgment, ironically, that put her on the skids and brought about her collapse.

SOME TIME in October, a bespectacled, mild-mannered shop foreman from Hobart, named Paul Lubke, arranged with her to kill one Donald Applegate, with whose wife Betty he was carrying on an affair and wished to marry. Lubke gave Kitty a map, showing her the route to Applegate's home, and a note detailing his habits and working hours, along with a $250 down payment and a promise to pay $50 weekly until the agreed sum of $1000 for the murder was reached.

Recalling Lubke's boast that money was easily available to him, Kitty decided to engage in some extortion. On his third visit, she threatened to expose Lubke's plot to the police, along with his sketched route and explanation of Applegate's habits, removing herself from any involvement, of course. Lubke was so terrified that he frantically agreed to her blackmailing terms of delivering $500 a week. As treasurer of the company union, the funds were accessible. Lubke wrote checks to himself, cashed them and delivered the money to Kitty until by mid-January, he had emptied the till. When Kitty insisted that he continue the payments, Lubke desperately turned to Betty Applegate for advice. Aghast, she convinced Lubke to confess the full story to the police.

The case was assigned to Det. Lt. Thomas Beale, who listened to Lubke's fictional tale of having hired Kitty to get evidence against Applegate, who had an unbridled enthusiasm for dames, so Betty could obtain a divorce. Beale advised him to keep his next appointment with Kitty, but to contact him so he could apprehend her in the act. That date was set for Feb. 1. It was to be a day that would forever be burned in Lubke's memory, for instead of rescuing himself from the whirlpool, Lubke was to be sucked into the vortex that he himself had created. For when Matty MacManus, who represented The Commission's labor union racketeering division, found the treasury empty and was told it had been grabbed by "Pretty Kitty" Kappel, he took the stunning news to his bosses. Chairman Angelino interpreted Kitty's act as a brazen contradiction and affront to their credo of not cutting in on their operation. His proposal of removing Kitty met with instantaneous and unanimous approval.

TO PROTECT her blackmailing plot, Kitty used to phone Lubke shortly before their meeting to inform him of the time

and rendezvous place. The Feb. 1 date was set for 11 o'clock at the entrance to Abbott Park. Lubke relayed the message to the precinct, which informed him that Lt. Beale was out but would be given the message, then he nervously set out for his appointment. The night was cold and blustery with a threat of snow in the air. He walked briskly to keep warm, but the chill that coursed down his spine wasn't caused by the weather but by fear. He had just reached the intersection of 95th Street and South Park Avenue when a truck barrelled by, ground to a stop some 25 feet ahead of him. Under the gloomy perimeter of light cast by a lamppost, he saw Kitty, heard her cry out in surprise and anguish as two burly figures bolted from the truck cab and bundled her frantically fighting figure aboard. With a roar, the truck was swallowed up in the night.

A lone man walking his dog observed the truck barrel down State Street and swing into Garfield Boulevard, according to Lt. Beale who appeared shortly after on the scene in response to Lubke's call. The dog-walker could offer no further assistance, despite the lieutenant's questioning. Because of its abruptness and method, Lt. Beale suspected that gangland was taking action of its own against Kitty; this he hoped to avert so that justice could mete out its own decision.

MEANWHILE, KITTY knew by the manner in which she'd been seized, that she was headed for a showdown with The Commission. But instead of being driven to the hangout on Ogden Avenue, she was delivered to Angelino, his chief assistant and a couple of torpedoes at a construction site off Cicero Avenue. Angelino's accusation of a double-cross brought a firm denial from Kitty, who insisted that her arrangement with Lubke had been personal business, which had required no superior sanction.

"You didn't know you were muscling in when this creep Lubke was using union funds to pay you off? That dough belonged to us!" Angelino exploded.

"No, I swear I didn't. He never told me! You think I'd dare to do a thing like that?"

"From what I seen you do," Angelino said in a voice harsh with scorn, "you'd do anything for a buck!"

Kitty's promise to return it all met with contempt. At a signal from Angelino, two gunzels grabbed her and began to drag her to the foundation of the building under construction. It was then that she got sight of the concrete mixer truck at work. As the full impact of the fate awaiting her struck, her eyes widened in shock and horror. But she was dragged beyond the big, revolving drums, churning the cement, sometimes half-carried across some beams until they reached the vertical slats of a mold into which the cement would be poured for one of the building's concrete column supports. Kitty tried to stiffen her body against the shakes that had overcome her; her eyes rolled glassily in their sockets; her voice was paralyzed with terror. She felt herself being lifted, then dropped into the 15-feet deep mold that would become her concrete coffin. She stared up at the dark sky, heard the splash of cement as it flowed from the mixer into the wheelbarrows.

LT. BEALE'S constant hammering at Lubke and the dogwalker had drawn results. Lubke recalled some lettering on the side of

the truck, something that remotely resembled A and U, or it might have been a J, while the dog-walker significantly recalled the word, Construction. It came to Beale in a flash: A and J Construction Co.; he abruptly recalled having driven by a sign bearing that name several times at a building site off Cicero Avenue. He ran towards his car, speculating fleetingly on what maniacal fate would doom "Pretty Kitty" Kappel.

He parked the car some hundred feet away and walked quickly in the direction of the rumbling cement mixer. Police assistance would have been welcome, but the cop on the beat was nowhere in sight, and he hadn't had time to call the precinct. His .45 was made moist by his sweaty hand and the damp air. He strained to see in the gloom, spotted two men pushing wheelbarrows across a plank, shouted to them to halt, as he ran forward. A sudden gunshot behind him caused him to drop and spin simultaneously as he fired in reply. A sharp cry of pain erupted in the murkiness, and he could discern a figure collapse to the sidewalk. His feet beat a tattoo as he raced ahead, scurried onto the building's skeletal steel construction.

The wheelbarrow jockeys saw him. Beale aimed as he ran towards them, found his gum jammed, cursed, kept running. The first mug upended his wheelbarrow of cement at him, which Beale sidestepped, then leaned across to slam him hard on the jaw, hard enough to feel the grinding crunch of shattering bone. He made a flying tackle at the second hood, sending them both flying in midair to crash below on a strip of iron grill matting.

Beale landed on top, straddling the bruiser, who frantically found a niche for his clawing fingers, digging into Beale's eyes. Beale felt his eyeballs being pushed back into his head, saw blinding spirals of light, felt blood bead down his left cheek. He jack-knifed to his feet, his eyes feeling as if they'd been poked with a branding iron, and kicked out. His shoe caught the mug flush on the nose, grinding it back into his face. The mug cupped his blood-battered pulp of a face in his hands, rocking back and forth, wailing with agony.

Beale found a coil of cable, clambered up to the plank, dropped it down to Kitty and hauled her up just as precinct reinforcements arrived, summoned by Lubke. With her safety assured, Kitty's calm and confidence was restored. Salvatore Angelino had fled during the fracas and easily proffered an alibi when he was confronted next day for masterminding her brutal demise. The three hoods whom Beale had injured in one way or another were booked for felonious assault with intent to kill and treated at Mercy Hospital.

EAGER TO evade the whole mess, Lubke refused to press extortion charges against Kitty, but her detour from The Commission's demand to hew to their straight and narrow eventually caused her ouster. In probing her contribution to that organization, Lt. Beale uncovered sufficient evidence to bring her to trial on March 4, 1930 in Criminal Court Part 1 before justice Herman Rinehart, but lacking evidence or a *corpus delicti*, the court had to acquiesce to the defense's demand for immediate dismissal. Nevertheless, "Pretty Kitty" Kappel didn't escape altogether. Judge Rinehart had her committed for psychiatric observation and treatment to the State Hospital where, in November, 1942, she died of pneumonia.

THE PORNOGRAPHIC BLACKMAIL RACKET

Wanted: women for a dangerous degenerate!

THE WELL-DRESSED DOCTOR'S wife from Indiana was sitting at the respectable bar of a Manhattan hotel, one she'd been coming to on her shopping trips for years. She was sipping a whiskey-collins, taking her time. Dallying through a single cocktail, then turning in around 10 PM, was by now a comfortable ritual for her. Years ago, Hanna Fleming would have drunk four or five of the tall drinks and felt none the worse for it. But now, she was a graying woman, a grandmother content to quietly approach middle-age with a dignity that would befit her 49 years.

Mrs. Fleming had been in the swanky hotel lounge about 15 minutes when a young couple entered and sat down near her. The man was dark-haired and as handsome as the girl with him was beautiful. From their conversation, Mrs. Fleming could tell they were also staying at the hotel. The young people swapped witty stories back and forth, and laughed often and loud. When Mrs. Fleming could not help but chuckle at a remark the man made about an upcoming election, the couple began talking with her.

The man introduced himself as Frank V. Grolier, a photographer. His lovely companion, Sylvia, was not his wife but a sister. When the couple invited Hanna Fleming to have a drink with them, she at first refused. Then, with a little coaxing, she broke her long-time custom and consented to just one. She was wearing a rather daring black frock just purchased from a Fifth Avenue store, and it did seem a shame to limit the please it gave her to the mere half-hour she usually spent in the lounge.

After Hanna had returned their favour, it was almost 11 PM. She didn't feel the normal weariness at all. Indeed, she realized that she was having a grand time with the lighthearted man who was here to purchase photo equipment, and his vibrant sister. Finally, though her initial judgement was against it, the doctor's wife agreed to catch one nightclub show with the youngsters. They took a taxi downtown to Greenwich Village and picked an establishment where most of the patrons were tipsy.

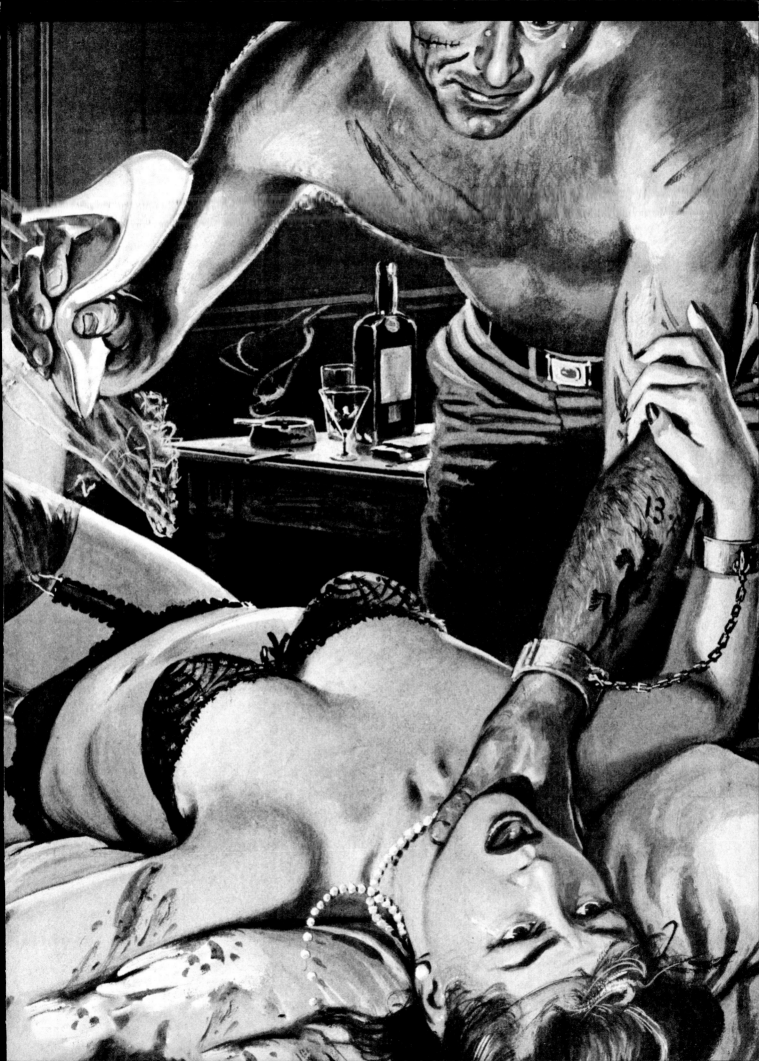

The newly-formed threesome lost little time in catching up, and Hanna was having the best evening she could ever recall on a New York visit.

She was disappointed when the younger woman developed a headache halfway through the lively show. Frank Grolier had said he had to be up at 9 and Hanna assumed they would all have to leave. But he didn't object when his sister begged both of them to stay and see the rest of the show. "I'll go back by myself," she said, "take a sleeping pill, and be out of this world before you two've even finished the next drink." Hanna was enjoying herself...

WHEN HIS sister left, the handsome youth snuggled closer to the doctor's wife, pressing his knees against her thighs. This didn't terribly alarm the 49-year-old. But when they were leaving and he was helping Hanna on with her coat, the photographer kissed her briefly behind an ear. Before the startled woman could complain, he laughed and said it was an impulse. The ride back uptown was something else.

In the privacy of the taxi Grolier had suddenly become intensely amorous. Again and again he attempted to draw the now-frightened woman to him and kiss her. After fending him off several times, Hanna was somewhat exhausted and momentarily relaxed her guard. After all, the boy probably just had too much to drink, she thought. Anyway, in ten minutes they would be back at the hotel.

But the youth was quick to sense the advantage. His hand went like an arrow inside her coat and began a frenzied exploration there. It did not stop until they arrived at the hotel. Mrs. Fleming's cheeks were flushed with indignation and her matronly bosom was heaving as they got out. On the sidewalk, the young escort insisted on seeing Hanna to the door of her room. He was being frightfully serious about the request and the doctor's wife was afraid there might be an embarrassing scene in the lobby if she did not get in the elevator with him.

Once they'd reached the room, Hanna unlocked her door and turned to say goodnight. "It really was a nice evening, Mr. Grolier," she lied. "Now, it must end." The young man nodded and said he'd leave right now, but the least she could do was permit him a chaste kiss on the forehead. Her patience was nearly exhausted, but in hope of getting rid of him, Hanna assented.

Frank Grolier put his hands lightly on her shoulders and made as if to buss the top of her head. But instead, he treacherously found the woman's lips and covered them again and again with several hard kisses. When the doctor's wife got back her speech again, she asked him to release her. "I'm a happily married woman. Besides, I'm old enough to be your mother," she explained. She was sure this point would serve to dampen the young man's ardor once and for all.

The photographer's answer was to tighten his arms around the defenseless woman and begin kissing her throat and neck, until she felt warmth she hadn't experienced in a long time enter her body and her breath was involuntarily coming rapidly.

Her reserve pierced, Hanna begged to be released from the embrace, but Frank Grolier slowly and firmly backed her into her room. He gently kicked the door half-shut, still keeping his lips fastened to those of the doctor's wife. In the unlighted room he said he was in love and he thought the older woman was, too. Hanna would have screamed but there was no chance. The amorous attention she was getting was steadily increasing in intensity. After a long, long while, the graying woman's rage had been manipulated, by the youth she was no match for, into a powerfully aroused desire.

Half undressed and frightened at the passion she felt in the darkness, Mrs. Fleming asked her lover-to-be to put on one of the lights. Frank ignored the request and encompassed the woman in an embrace which was to last till dawn. Several times during the night, Hanna Fleming could hardly believe what was happening to her. The very idea of that she was allowing someone other than her husband to touch her, truly amazed the housewife. Now, in an abandon and surrender which was completely incredulous to her, she found herself submitting to every whim of this youth whom she'd never seen until a few hours ago.

The two did not sleep much during the night, and when her young lover left the room at daybreak, Hanna's emotions were mixed and she was not sure she wanted him to go. But after the door clicked shut, she began to cry.

TOO EMBARRASSED to face anyone, the matron stayed in her room that day and had her meals sent up. At 6 PM she was still trying to put the welling shame out of her mind when Sylvia knocked on her door. She supposed the sister might be there with some kind of explanation for her brother's actions of the night before; certainly she had known where Frank had slept. But when the sister closed the door, the expected sympathy was not in evidence. "You might as well sit down," Sylvia suggested in a vulgar, hard voice which upset Mrs. Fleming. "You won't be able to take it standing up. They never do."

Frank Grolier had stayed in Hannah's room over four hours, submitting her several times to the kind of love most women would not have allowed. His "sitter" stayed but a few moments. When she went out, she had $500 in cash with her and left a broken, hysterical woman who would have gladly spent a night with ten men rather than those shattering seconds.

The doctor's wife had been forced to sit in a chair and look at eight glossy photographs which the "sister" – who got into Hanna's room and hid in a closet – had taken with infra-red film the night before. The man in the photos never faced the camera and only the woman in the photos could know it was young Grolier. The views of Mrs. Fleming were not kind. She'd been wearing a necklace which served now with cruel efficiency to identify her in each shot. But this "prop" had really not been necessary. The face, despite the many passionate distortions it had endured throughout the night, was unquestionably hers. Anyone who knew the woman would have little difficulty recognizing the plump, aged, yet strangely animated limb, face and torso of the 49-year-old grandmother. And her "lover" had taken the necessary moments to filch addresses from her purse of those he believed might like to see what Sylvia had thought "splendid likenesses."

After a time, Hanna Fleming gathered the eight prints together, turned them face-down so she would not have to look at them again, and tore them into tiny pieces. She ripped the

eight negatives, too, then took the pile and burned it. The vile celluloid faces of passion were gone, but an ordeal which no words could possibly characterize was just beginning for her.

She longed desperately to telephone the police, or anyone who could tell her what to do, how she must think. But Hanna was forbidden from soliciting outside help because of the additional existence of a short, 50-foot motion picture. She had not been shown the film – and would not be until she returned with $800 in cash, the sum she'd agreed to pay. When she purchased this, the Indiana woman would be allowed to forget the whole affair. This was what Sylvia Grolier had promised. Naturally, if Hanna didn't return to New York with the $800, her husband would receive the movie *gratis*. Blackmail is seldom less complicated.

FRANK GROLIER, a Brooklyn hoodlum, and Sylvia Bongiorno, a California B-girl who had become his partner in crime, had a good laugh over the plight of the doctor's debauched mate. She had been but one of 40 women they'd fleeced in three years of operation. The idea had come with ingenious ease to Frank, this switch on a racket which women had used to blackmail men with for years. With his knowledge of photography, it had been no problem teaching his pretty, ruthless mistress how to take clear photos in harried circumstances.

They'd already bilked a lot of unsuspecting older women, after the handsome young blackmailer had dedicatedly first built bonfires in their diminishing bodies. In Miami. In Los Angeles. In Atlantic City and ten other tourist centers. But they were still young and looking forward to a long and lucrative life of con.

The two had been made for each other. They both were completely without a sense of moral guilt and each liked the things that big money could buy. Sylvia, especially, liked fast cars and expensive jewelry. Young Grolier was a rare book lover and the proud owner of several costly first editions. The two even had the same perverse humor. This was exhibited in many ways, including the scrawling of profane captions on the backs of the prints they processed with their own equipment. Sometimes, when they were feeling extremely mean, they would also show the captions to their victims.

Except for a one-in-a-million discovery by a private detective who had no idea what he had found, there is every reason to believe Frank and Sylvia's career would still be going strong today. Actually, their con was "99% police proof," as the busty former B-girl liked to say, and their records as clean as those of the nice people they preyed on. The latter were picked with great care, after scouting resort and large city hotels. With a ruthless self-discipline, they concentrated solely on women 45 and up.

These, they reckoned, had two weaknesses not common in younger women: First, an older woman invariably felt she had more to lose in possibly being unmasked as an adulteress. Secondly, she would have quicker access to the money she'd have to produce.

By promising to never bother a victim after she had bought whatever film was involved, and keeping the take within reason, the pair's money would often come smoothly from savings hoards usually unknown to the victim's husband. There were instances, naturally, when a bilked woman would after the fact admit everything – sordid as it might be – to her husband. Such rare moments never troubled Frank and his moral-less mistress, however, as they'd be long gone from the city where the adultery had taken place. And, irate husband or not, actually there was never any proof that a crime had been committed.

Frank and Sylvia know it, but the 1960 fleecing of the Indiana wife was going to be loud soon. Doctor Fleming had been quick to detect his wife's personality change when she returned from her trip. While the exhausted woman had slept, he'd noticed several flesh discolorations on her body, the causes of which any medical man was familiar with. Before he could question her, though, Hanna announced she would be making another journey to do some shopping she'd not had time to finish.

This was the last straw for Fleming. Certain his wife was planning to leave him for another man, he engaged an Indianapolis private detective to follow her to New York. The instructions were merely to discover the lover's identity. The doctor said he was not concerned with standard divorce evidence. Although it would break his heart, he'd gladly divorce Hanna without a fight if that was what the investigation indicated she would soon be pining for. The doctor never once suspected his 49-year-old mate might be in serious trouble.

The detective followed Hanna to New York and the hotel he'd been told she usually stayed at. But she didn't take a room. Rather, carrying the make-up kit which was her sole luggage, she entered the hotel bar and sat down at a back table. The operative waited for the expected lovers' rendezvous. When not one person but two joined her, his attention perked up. At length, Mrs. Fleming took an envelope from her coat and handed it to the couple; the detective sidled down the bar for a closer look. There was no doubt that it contained currency. The younger woman was now counting, without removing it from the envelope.

Frank and Sylvia in brazen confidence had not even bothered to change hotels. The Indianapolis man had seen the pair originally enter the lounge from the hotel guests' side door and he knew it would be easy to pick up their names later. When he saw Hanna wander out of the hotel bar, minus a square-shaped package she'd been given and had dispensed with in the ladies room, he paid his bar check and followed. She led him back to the airport and when he saw her safely settled on an afternoon flight home, he got the doctor on the phone. Fleming gave the odd story some thought, then ordered his man to turn over all details to the New York police.

Within hours a watch was put on the young couple registered at the Manhattan hotel. The police assumed they were blackmailers, but didn't know what their specialty might be. They found out and were shocked at the new wrinkle of an old racket.

A hindrance in apprehending the duo was Dr. Fleming's message that his wife had absolutely refused to file a formal complaint. Within the, week, however, the blackmailing duo had visited another hotel bar and come across another likely victim – a middle-aged Virginia widow.

The game was on. Two alert plainclothesmen followed the three to a nightclub, watched the plain-featured widow get tipsy, stood by in the hallway when she returned – not to her own address, but the room of the young couple. The sounds that came from the room during the night were disgustingly familiar to the plainclothesmen, but hardly indicative of a crime.

Their hands were tied until dawn, when they accosted the widow as she was leaving the hotel. She broke down almost immediately. "They showed me the camera," she sobbed. "I'm to buy the pictures tomorrow or they're going to mail copies to the homes of my two children. I'll have to give them everything I've been saving for my retirement years."

With this development, the New York lawmen felt certain they could set a trap at pay-off time the next day which would furnish them conviction-caliber evidence. There was one thing they hadn't counted on. The widow, feeling her life had been sullied beyond cleansing in one mad evening's pleasure-orgy, hung herself in her hotel suite.

When the tragic death was discovered, two officers pleaded for an immediate arrest. But what was needed to shelve the two for life was an airtight ruse, one they would have to hope Frank Grolier would fall for before he could turn another woman into an adulteress. Meanwhile, the pair further complicated things. When they read of the widow's suicide, they promptly departed for an out-of-state seaside spa hours away.

Their movements in the resort town would be watched carefully, and a police trap could still be employed. Yet, the unusual nature of their crimes made standard approaches impossible. It took scant time to realize that Grolier and his accomplice really would not break one important law until a victim had been photographed. And, of course, before they would photograph her she would have to undergo several horribly revolting acts with the young "lover." Mulling a way out of this stumped the officers from two states for quite some time.

FINALLY, in a bold evidence-planting which no newspaper has yet been able to publicize and which is, to say the least, an unhappy first in American criminal investigation, a solution was devised. A known prostitute was brought from a local police-tank, where she had just begun a 30-day lockup. The 50-year-old "intended victim" had been selected from a dozen other candidates primarily for her promise of silence and her experience, so to speak, "in the field." Her pay, drawn unofficially from cash donated by two vengeance-seeking plainclothesmen, was the most Velma C. had ever been offered for a night's work in her illustrious career.

Despite a new hairdo, clothing, luggage and identity to match, the refurbished street-walker had to ply every flirtation she'd ever learned to get the attention of Frank V. Grolier. He had apparently been shaken by the Virginia widow's action. Velma was forced to "accidentally" wander into his vision many times before an immense paste-diamond wedding ring made a dent in his usually agile mind.

It was tedious getting Grolier into a motel room with a woman he thought was his victim. After this was done, the rest was as easy as falling into bed. Little Velma, posing as a love-starved retired manufacturer's wife, rose to the occasion and actually got carried away with the "art film" she half-believed she was making for posterity. She put everything she had into the assignment. Next day, when the films were developed, the Groliers saw they had some real dynamite. If these prints weren't going to break the heart of their passionate little errant wife, a sledgehammer couldn't! But when the "dynamite" blew up in their own faces, the two didn't even know who had set it off.

After the hushed-up trial, which had featured by agreement of the accused no jury and no official press coverage, Frank Grolier caught hold of Velma as she haughtily paraded out of the chambers. "Why?" he demanded, squeezing her tiny arm. "Why? I've never seen such passion as was aroused in you in that motel. You loved me then and you love me now, I can tell. It's almost as if you were working with the police or something..." The little prostitute's "screen test" had been of such professional stature, the conceited hoodlum couldn't even see the wisdom his own subconscious was handing him on a platter.

Thus in 1960, in a small southern city the reporter is not at liberty to name, the saga of one of the cruelest criminal cons ever created came to a not entirely humorless end. Can anyone say the out-of-state police methods were wrong? The judge involved thought not. "They merely fought sex... with sex!" he stammered after it was all over.

"PVT. ROCKLAND'S INCREDIBLE JAP-HATING GEISHA ARMY; detail from interior art, **NEW MAN**, 08/63.
Art uncredited; attributed to Norman Saunders.

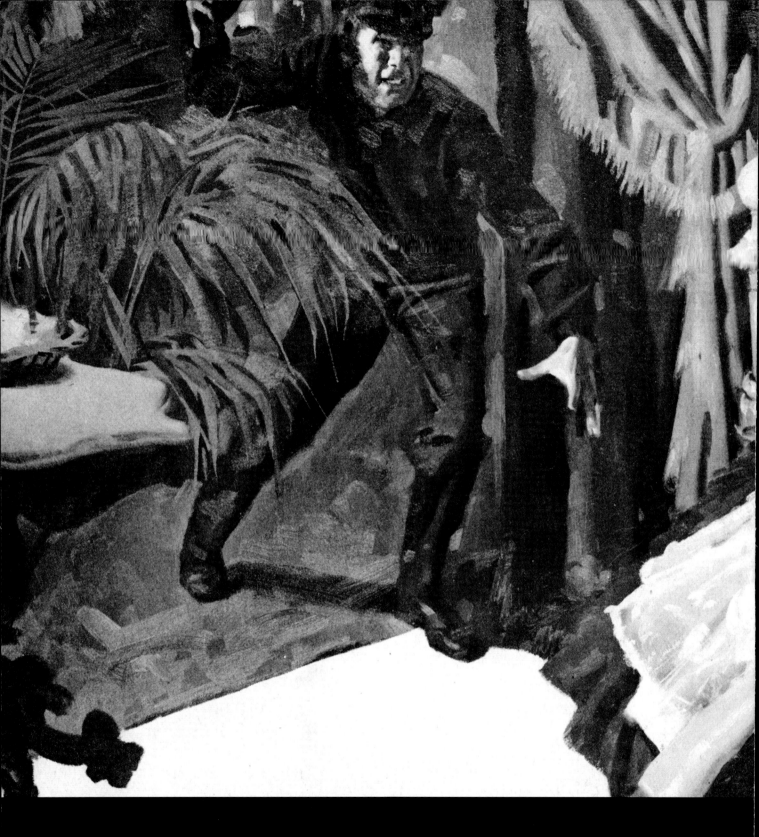

THE FANTASTIC SAGA OF THE BARBARY COAST'S
BLOODY MADAME

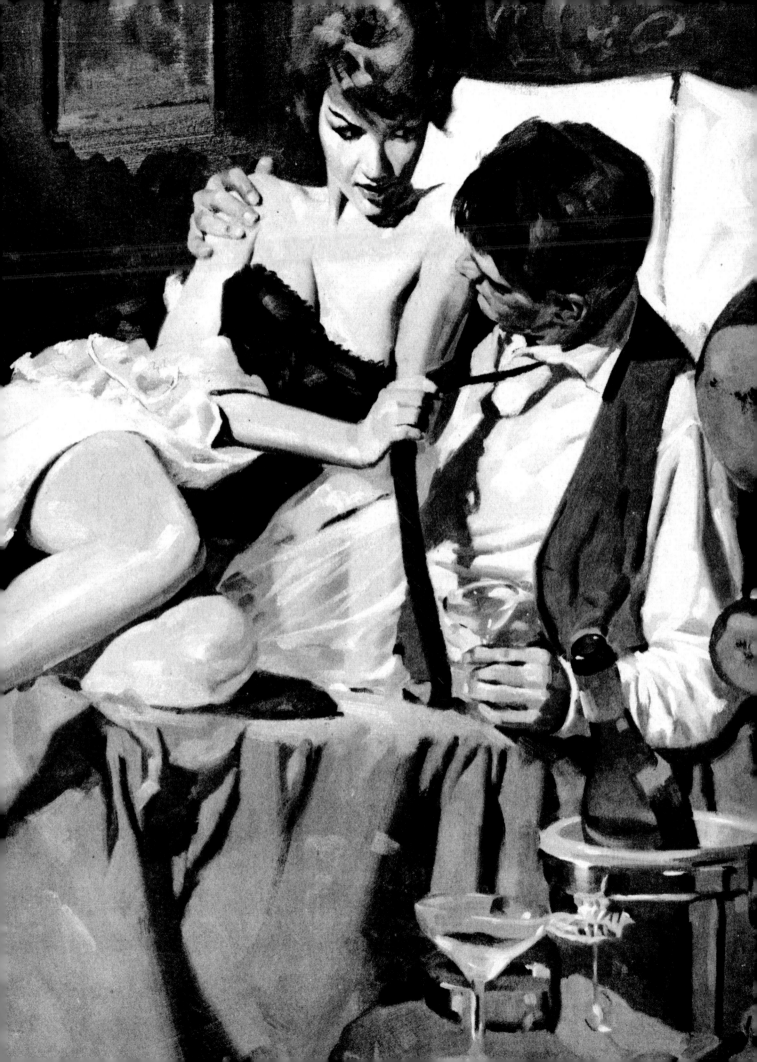

Lady Jane's caress was as soft – and deadly – as the kiss of a cobra. And no man could resist her.

ASK THE AVERAGE STUDENT of American history what Bull Run means to him, and he'll rattle off facts and figures concerning the two blazing battles fought at Manassas Junction in the sultry summer of 1862. He'll tell you in was at Bull Run that the Johnny Rebs slaughtered the Federals and sent them fleeing in confusion back to Washington.

But ask a connoisseur of American *sexual* history to comment on Bull Run, and he'll sigh deeply, with an expression on his face which combines the elements of longing, fear, incredulity and amusement.

He'll sigh, "Lady Jane Gray, Waddling Duck, Little Lost Chicken."

You may be tempted to recommend the nearest headshrinker; but take our advice – don't.

Your historian is merely reciting the names of the most sought-after cyprians of San Francsico's wild and wanton Pacific Street. He's asking the ghosts of lovely cut-throats to pass in review. He's bringing back to mind the sights and sounds of San Francisco's most notorious bordello – the Bull Run – and its denizens of the 1850's.

No "pretty waiter girl" better typifies the roaring post-Gold Rush days than does Lady Jane Gray, who served as madame of Ned Allen's infamous Pacific Street emporium.

Lady Jane Gray was certainly not her real name. However assuming the identity of one of history's greatest beauties, who had been forced to place her swan-like neck on an English chopping block, appealed to the San Francisco harlot's flair for the dramatic.

And if Lady Jane Gray (San Francisco vintage) was anything, she was dramatic. She also never made the mistake of letting the facts get in the way of a good story.

Jane first showed up along Pacific Street in 1851 looking for work. Nobody is sure where she came from or what her real name was. However there seems to be complete agreement that her flashing green eyes and titian hair set off a face which was indescribably beautiful. Her figure was of such proportions that it would have led the most zealous vigilante into a life of unrepentant debauchery.

The Galloping Cow, who was then holding forth as the madame of the Billy Goat, immediately saw Jane's potential. The dialogue of the interview went this way:

"Take your clothes off and let's have a look at you."

"But I'm a singer and dancer. I wear clothes in my act."

"Sweetheart, all my girls are singers and dancers. If they don't have talent, they don't work in my establishment. I don't care if you've performed at La Scala, you pay for your keep in the upstairs rooms and there you don't wear anything."

The Galloping Cow's inspection was nothing if not thorough. She examined Jane carefully. Finally she whistled her appreciation of her new waiter girl.

"You'll do," she finally said tossing a handful of Jane's fluffy feminine finery back in her new employee's lap.

Lady Jane narrowed her eyes. She reached out a slim hand and pointed at the high heeled shoes which were still clutched against The Galloping Cow's ample bosom.

The Galloping Cow shook her head from side to side. "Not these. These stay with me. That's the rule of the house. No new waiter girl wears shoes. I'm taking no chances on one of you running out with my night's take."

This shoeless precaution was standard along Pacific Street, and even in the tonier bordellos of the Upper Tenderloin. Were a girl to be daring enough to flee a *bagnio* without her shoes, she would immediately be picked up by the unsympathetic police of the day as a vagrant.

Lady Jane began work that very night as a "pretty waiter girl." In this regard it's interesting to note that San Franciscans had an aversion to calling a spade a dirty old rotten shovel. No prostitute was ever called a prostitute if some more flowery name could be given to her calling.

THE FIRST night on the job was a revelation to Lady Jane. She found out that the Billy Goat was no place for a lady – real or fancied. Besides singing on table tops with her skirts swirling high above her head, Jane was expected to sell drinks to the prospectors, sailors and assorted drifters.

In order to make a sale, a "pretty waiter girl" was expected to nestle close to her customer and run her hands up and down his chest while he sampled the potential delights she offered.

It was during the 15-minute band breaks that the waiter girls proved themselves. This was when they rushed their customers upstairs to an empty crib, relieved their anxieties (and sometimes their wallets) and returned to the dance floor below without ever having missed a bar of music.

In this manner, it was not impossible for one girl to service the needs of as many as twenty men in the course of an evening.

At this point in her career, Lady Jane Gray enjoyed her work. Word soon got around that while the other cyprians of the Billy Goat whispered meaningless words and went in for pretended passion, Lady Jane was something special.

Sitting in surly splendor in his own emporium (The Bull Run), San Francisco's most notorious pimp of the day heard of Lady Jane's reputation. He put on his checkered waistcoat and ambled down Pacific Street.

When the Galloping Cow saw her rival approaching, she wailed like a banshee and took after him with a meat cleaver which her Chinese cook had been using.

Ned Allen was no gentleman. He refused to stand still while the violent *bagnio* keeper sliced his ears off. Quickly he stepped aside, grasped her by the bosom and watched her double up with pain.

In an instant he had her arm twisted behind her back and his body pressed tightly against her struggling hips. The meat cleaver was now securely in Ned Allen's grasp.

"Cow, I'm going to make chopped meat out of you if you don't behave," Ned warned.

Looking over her naked shoulder at her nefarious assailant, the Galloping Cow saw the futility of further struggle. "What do you want, scum?" she gritted through clenched teeth.

"I'm taking this Lady Jane waiter girl for the night. We're not to be disturbed. That is if you don't have a hankering to be cut up."

The Cow cursed and moaned and promised vile retribution. But the Cow was not stupid. Although she knew she was about to lose her most productive cyprian, she realized it was better to give up one waiter girl than her own life.

Five minutes later, Ned Allen entered Lady Jane's crib and her life. Without a word of introduction, he stripped her clothes off, allowing them to flutter to the floor. Then he seized her and took her with a brutality that left her bruised, weeping – and wanting more.

Ned Allen had lighted a spark in Lady Jane's libido which fanned into violent flame. Never had she been so completely mastered by a man. Never had she felt so much the submissive woman. She fairly tingled all over with fulfillment.

As the faint rays of dawn streaked the Barbary Coast sky, Lady Jane Gray climbed aboard Ned Allen's buggy and entered a new phase of her career as a pretty waiter girl.

If the Billy Goat had been less than genteel, the Bull Run was a bloody pit of hell. The customers entered the *bagnio* at their own peril. More than one of them who were senseless enough to complain about the high-handed ways of the management wound up in the gutter, a gleaming carving knife protruding from their backs. This was Ned Allen's way of enforcing the house rules.

The *California Police Gazette*, a lurid tabloid of the times, recorded the hi-jinx with special flourishes. Artistic woodcuts of what went on at Bull Run embellished its pages.

The forerunners of the Committees of Vigilance met in the Cow Palace, and demanded municipal action to padlock the Bull Run. However too many of those attending the meeting were secret clients of the ill-famed *bagnio* to do more than pay lip service for the need for reform.

IN LADY Jane Gray, Ned Allen had found more than a willing paramour. He'd discovered a woman whose cunning and ruthlessness matched – and often outstripped – his.

It was Lady Jane who devised the introduction of potent aphrodisiacs into the bottles of whiskey which were sold at ten dollars a bottle. Taken in enough strength, her concoction was strong enough to kill. It consisted mainly of absinthe and loco weed.

Lady Jane was shrewd enough to reserve her violent dosage to those who had just landed on the Barbary Coast's teeming wharves after the arduous trip around Cape Horn.

Her reasoning was three fold. The newly transplanted Californians usually carried their life savings in money belts hidden under their clothes. This made it profitable. After months at sea they had no resistance to the blandishments of a titian-haired beauty whose every motion was the personification of sex. That made the approach safe. Nobody – not even the constabulary of the time – had any interest in protecting the new-comers. That made it safe.

Lady Jane also made friends with the more affluent Chinese. Knowing how bitterly they despised the way they were treated in San Francisco, she offered them her body in return for gooey clumps of uncut opium. Thus she was able to add to the delights offered exclusively at the Bull Run.

She also offered her many charms to the police without ever taking a cent in return. And they paid off in more important ways.

If a particularly hard-headed customer managed to stay conscious after having swilled down Lady Jane's witches brew and found her going through his pockets, he might take off like a bat out of hell for the nearest precinct house.

Instead of finding sympathy there, he would receive the business end of an officer's nightstick liberally applied. The very next issue of the *California Police Gazette* would feature his name prominently, along with the fact that he "had been sent down for three months as a common drunk."

Some policemen were not above splitting the take with Lady Jane and her pimp.

Lady Jane and Ned Allen developed a well coordinated method of rolling drunks.

The cyprian would meet her mark in the saloon on the first floor. She would offer privacy and a very special bottle which could be obtained on the second floor of the establishment.

Unlike many other cyprians of her day, Lady Jane wore the complete trappings of finery under her low-cut gown. It was not out of a sense of modesty, but out of a flair for timing.

The customer would lie down on the bed, taking huge gulps of fiery liquid into his belly. As he watched, Lady Jane would begin her indolent strip tease. She'd pace herself so that by the time she had unhooked the last clasp of her waist cincher, the man would be far gone.

Then with Ned Allen standing guard, a length of lead pipe bouncing against his open palm, she would strip her quarry and go through his pockets. Were the man foolish enough to protest, Allen took over. No skull was a match for the hardness of the pipe.

Things went on beautifully in this manner for several years. Every now and then a new ingredient of excitement in the form of an earthquake would lend spice to the operations.

It was on these occasions that the customers and the pretty waiter girls ran screaming from the *bagnio*. Most of them were as naked as on the day they were born.

Other San Franciscans would line the buckling streets, heedless of their own peril and cheer the Bull Run occupants

on. Such events gave the *California Police Gazette* some of its most interesting stories.

HOWEVER, IF most of San Francisco was titillated by the goings on at the Bull Run, a new group of humorless men which had been formed in 1856 didn't find things quite so amusing.

Calling themselves the Second Vigilance Committee, the men first constructed a gallows on Pacific Street and then marched resolutely to the Bull Run.

There they found Ned Allen comfortably ensconced in bed with Lady Jane. Unceremoniously, they dragged the pair from the *bagnio*. Ned Allen squirmed and cursed and pleaded. But the Vigilance Committee was resolute. They lowered a thick length of rope over his head, tightened it around his neck, sprang the trap door and let the force of gravity do its work.

For long minutes after, they debated loudly over the fate of Lady Jane Gray. The more determined of the men were all for her taking up the vacant spot on the trap door. However, cooler heads prevailed.

A bucket of bubbling tar, liberally sprinkled with feathers, was produced. Lady Jane screamed at its hot caress. Later she shrieked even louder as they bounced her out of town on a rail.

Some historians say that Lady Jane was never heard from again. But there is substantial evidence that some years later, Lady Jane returned to the Barbary Coast posing as a French noblewoman and set up a very exclusive *bagnio* on Portland Square.

If this is true, she did not try to recapture the wild moments of Bull Run. This was a wise decision, for the railroads had brought new prosperity to the west coast city and with it had come a move away from the brawling lust which had marked the Barbary Coast.

Any customer who visited Portland Square could be sure of receiving value paid for. The girls all were the soul of acceptable deportment.

The madame called herself Jeanne Blanc. Her hair was a titian hue and her figure, enhanced by maturity, was still diabolically provocative. However she remained shrouded in mystery. One can only hope that in reality she was Lady Jane Gray – and that she had learned the error of her bloodthirsty ways.

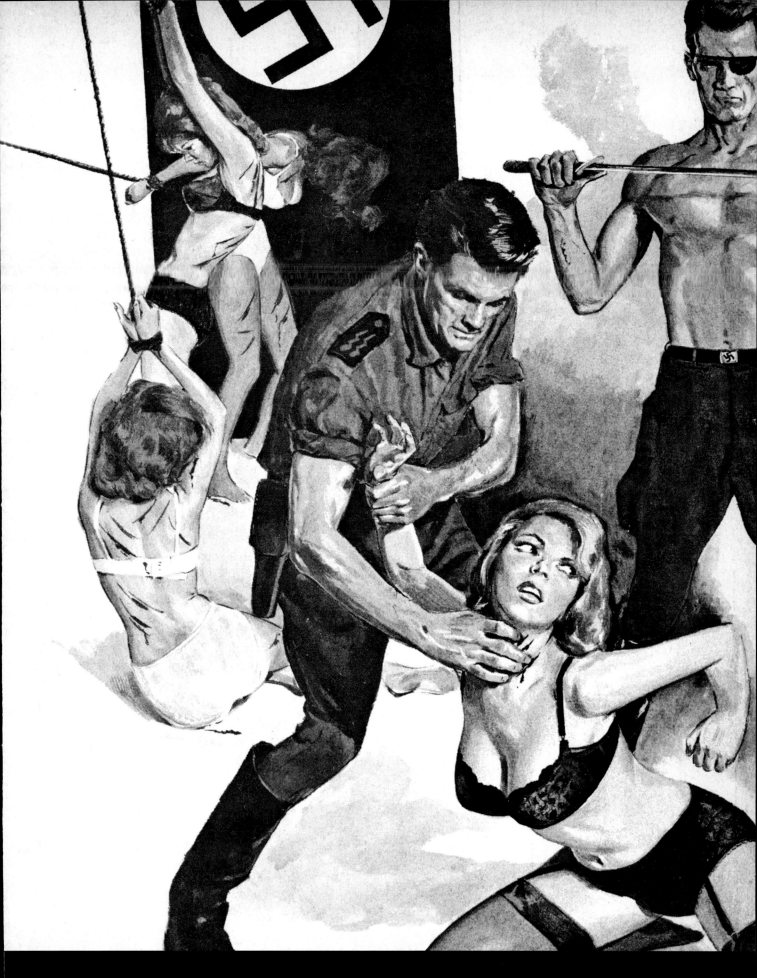

"THE BLOOD-STAINED STONES OF PARIS"; detail from interior art, **WAR CRIMINALS**, 10/63.
Art uncredited; attributed to Milton Luros (previously printed as cover, **ALL MAN**, 11/62).

I FOUGHT THE MAU MAU!

Not even the horrors of the primitive African death cult could stem my burning bloodlust for revenge!

DEATH STRUCK AGAIN just after darkness fell.

A single, unholy scream of terror, starting sharply at a high pitch and keening thinly away, brought me out of my camp chair. I grabbed for the loaded Westley-Richards .318 rifle that had been one of my brother's prized guns and headed out of the tent, shouting in Swahili.

Outside the tent, I paused, letting my eyes become accustomed to the night. Lights flickered in the cluster of mud-and-wattle huts across the compound. I shouted again and out of the darkness Njomo, the native overseer, materialized at my side.

"What is it, *bwana*?"

"You tell me!" I grunted. I didn't want Njomo at the moment. I wanted Kipruto, my own boy whom I had brought up with me from Nairobi and whom I could trust. I called again and then turned to Njomo. "Where's Kipruto?" I roared, gripping his arm.

He claimed he didn't know – just as he didn't know what had caused that single, spine-tingling scream of terror.

It was half an hour before we found the answer – and then it was too late.

Kipruto was sprawled face down on a narrow trail leading through a tangle of acacias and thorn bushes at one side of the compound. His back had been ripped open from the shoulders downward, marked by welling grooves of dark, clotted blood.

He was dead.

As I bent over his body I could hear the natives who had been searching under the direction of Njomo muttering uneasily. Then Njomo said, "It is the leopards again…"

I glanced up at him. I said evenly, "The same leopards that killed by brother, perhaps?"

He agreed readily – too readily. "*Ndiyo, bwana.*"

I wanted to yell up at him that he was lying in his teeth, but thought better of it. Turning the flash back on Kipruto I studied the vicious, lethal claw marks. At first glance, it appeared that a leopard had sprung down on Kipruto from an overhanging acacia as he passed underneath, the claws digging first into the shoulder muscles and then furrowing downward through the flesh. That was the way the signs read.

Only there were a couple of things wrong. For one, the ugly markings ran in two sets of parallel lines. They looked like a leopard's work, but there was a difference. For when a leopard strikes, at the end of its stroke the claws contract and the scratches get narrower. These didn't.

On top of that, the furrows of clotted blood had turned jet-black, like streaks of thick tar. And the wounds, ugly as they were, still weren't enough in themselves to cause death in such a short space of time.

Njomo spoke up again. "He was warned. Everyone has been warned that the leopards are on the prowl. It is because for too long there has been no rain. The sun is angry."

I didn't bother to answer. I had heard all that before. Njomo was a Kikuyu – and the Kikuyus were ruled by superstitions. When their ancient superstitions didn't work they made new ones, pulling out of a primitive past every sickening bit of black witchcraft ever born of ignorance. They worked on the supposition that no white man could plumb the depths of their evilness. Most of the time they were right.

BUT I KNEW. I had been weaned on the black arts of Kenya, and the years away from it at school in England, interrupted by two years of service, hadn't wiped any of it from my mind. I had returned to Kenya just in time to get caught up in the middle of the Mau Mau horror. The family farm in the highlands, up beyond Nyeri, had been directly in the path of the first wave of inhuman savagery and my parents were among the first bloody, mutilated victims.

That left only my brother Peter, who had thrown in his lot with the Kenya Police Reserve in an all-out effort to wipe out the native terrorists. Naturally, I joined up with him.

Even then Peter was fast on his way to becoming a legend – and a fairly ugly one. I tried to follow in his footsteps. We knew the breed we were fighting. As kids, our only playmates had been Kikuyus and Masai and Wakamba boys. We knew their dialects better than we knew English – we knew their habits and customs, their beliefs and their fears.

It was Peter who originated the business of going out on ambush disguised as a terrorist, wearing cast-off clothes and with face blackened and the old dark blue slouch hat once worn by the Kenya Police, but now outlawed because the Mau Maus had stolen so many of them.

"It's a nasty business all around, Dick, my lad," he told me the first time he took me out with him on one of these forays. "The military bigwigs back at Fort Hall seem to think a white man shouldn't go in for atrocities. To hell with that! The only way to fight these bloody *nugus* is with their own methods. That's all they understand!"

Peter was right. It did no good just capturing Mau Maus and putting them under guard in a cozy compound. For every Mau Mau captured there were two to take his place. For they didn't fear the whites any more – they feared only their own chiefs and the diabolical power they held over them.

For even in normal times the Kikuyu, who made up most of the worst of the Mau Maus, lived under the sway of witchcraft and phallic oaths. I could remember the number of times in the old days on the farm when natives had been under the spell of the *githathi* – the dreaded oath stone. The spell supposedly lasted for three years, and any violation brought death. Those taking the oath were forbidden to have sexual intercourse, and even their rams and goats were castrated.

"I understand that's prissy stuff compared to the oaths they are made to take now," Peter told me as we moved off into the hilly brush near the northern slopes of the Aberdare Range. "None of the captives will talk because there isn't anything in our book of rules that can make them spill their guts. So we'll do it their way. Remember – we want to take a few captives first. The killing will come later."

WE RAN across the first group late in the morning, flushing them out of the forest growth at the far edge of the Range. There were eight in all and they spotted us first and started firing. We brought them down with quick bursts from the light Sterling machine guns we carried.

All the time, Peter kept cursing, "Just cripple a couple of the bastards. Keep them alive long enough to talk!"

But I had been firing with automatic accuracy. Of the eight only one was alive when we reached them. Peter stood over him and shouted, "Who is your chief? Who gives you your oaths? What do you swear to? Talk, goddamn you!"

The Kikuyu just looked up at us from where he grovelled on the ground. Both kneecaps had been shattered and he was in too much pain to care what happened. Even when Peter reached down and picked up the man's *simi* and pressed the sharp point of the blade against his throat he said nothing.

Peter began jabbing away with the ugly *simi* blade, the way you jab a pin over and over again into a pin cushion. Blood spurted out of an aimless pattern of cuts, each one deeper than

the others. Still it did no good.

Finally in a burst of cold fury, Peter slashed viciously down across the neck, severing the man's head in a single blow, and we left him there as a token warning.

We had no more luck that day.

The next afternoon we did better. We were heading down through a small valley when we almost stumbled over a group of four – three men and a woman. Only two of the men were armed with guns and we took care of that by shooting them out of their hands and then smashing their arm bones.

After that it was just a matter of getting them to talk. Only like most of the other Mau Maus, they weren't saying anything. When Peter asked about oaths they just looked at him blankly.

"If that's the way you want to play, so be it!" Peter said briskly. "We'll just cook up a little counter-black magic of our own. You hold the gun on them, Dick, and I'll start the ceremonies going."

Gun or no gun, one of the wogs had different ideas and started to scramble away. Peter settled that effectively by grabbing up a *simi* and hacking away at his heels, severing both tendons. Then he did the same to one of the other men just to be on the safe side, before starting work on the third.

He stripped the latter's shirt and pants off, then held the sharp-pointed *simi* in front of the man's face. In Swahili, he said, "For the last time, who is your oath administrator? If you want to talk, make it fast. *Pese, pese.*"

But the Kikuyu wasn't hurrying. Peter shrugged. "So then, we'll make our own oaths. We make our own medicine man. We start with the eyes."

IN ONE sudden thrust, he gouged out first one eyeball and then the other. I must have made some involuntary sound for without looking at me he said in a matter of fact voice, "Remember, Dick, I saw what they did to our people. This isn't even the beginning."

I swallowed and said, "Keep going."

He did. He kept talking calmly in Swahili as he held the knife poised. The native's mouth was working but no sound came out.

This time, the native screamed as the knife slashed down. Now Peter paused and looked over the trembling natives. "Anybody want to talk yet?" he asked. "No? Then we must make our medicine man stronger." He turned to one of the other natives. "We need a liver now. A liver, and then a heart that is still beating, and then a tongue."

His knife sliced along under the ribs, enough to provide an opening through which he could reach. He said conversationally, "Remember how we used to do this with Thomson gazelles, Dick? Made very nice eating, too, once they were roasted."

He put the liver to one side, shook the blood from his fingers, then went on, "I think we'll take the tongue next. This one doesn't talk so he has no need of a tongue. The tongue and then the heart…"

The man began screaming in thin whines. Peter listened, then shook his head. "Just sounds. Not the words we want to hear." The native's eyes rolled dumbly, as he shrilled

his terror.

And then the screams died into a choking gurgle as Peter forced his mouth open and reached inside.

After that came the heart.

Absently, Peter wiped his hand on the ground and considered the remaining two. "We need some brains now. I have a feeling that the woman is the smarter of the two, but it would not do to mix the sexes. So we will just cut this man's head open and scoop out the brains that he is too stupid to use himself."

He picked up the *simi* again. He raised it – and suddenly the native started begging. "*Hapana, bwana. No. I talk…*"

"Who is your oath administrator?"

"The one called Karanja."

"Where is he to be found?"

"In the village at the head of the valley."

"And what is the oath you took?"

"*Ndiyo, bwana,*" he cried in terror. "No. That I cannot tell you. Please. Do not make me tell."

Peter raised the *simi* again. "In that case you no longer need your brains. I will take them for my medicine man."

"No, *bwana*. Wait."

It took time getting it all out of him, but finally we did. He had sworn never to reveal any secrets. He had sworn to kill whenever ordered to do so. He had sworn to cut off the heads of all his victims, gouge out the eyeballs, and drink the liquid from them.

That much was simple, horrible as it was. But the method of oath-taking was even more revolting. A mixture of the most primitive, barbaric superstition and the most disgusting sexual degeneracy that a human brain can conjure up, it left the participant in a sweat of shivering fear and exhaustion. After taking such a powerful oath, swearing by a "magic" that included all life and strength for a hundred generations, not even the most educated native would dare to disobey it. To fail would mean far more than to suffer mere pain and death. That much the man told us before superstitious fear stilled his tongue and he refused to go on.

But, for the moment, it was enough. With a grimace of disgust Peter straightened up. "You finish him off, Dick. Shoot him and the woman, too. They are of no further use to us."

I SHOT both through the head and followed Peter through the brush to a small stream we had crossed earlier. There, he stopped to wash the blood from his hands as well as he could. Finally, he said heavily, "There you have it, Dick. You heard it with your own ears, and I can assure you that we only were told a fraction of the sordid truth. How can you fight that kind of perverted evil with guns?"

The answer was that you couldn't. I didn't have to be sold on that. You had to fight savagery with savagery – horror with horror – atrocities with atrocities. It was all right for the British military forces that had come down from England to lend a hand to try to stick to the rule book if they wanted, but not for those who had a personal stake in Kenya.

And not for those who had a personal score to even

up, as Peter and I had.

So we went our own way, regardless of rules. Peter was the leader and I followed him, along with a couple of other men who felt the same as we did.

We did our share, too, although it was a sickening, bloody business.

From time to time, we brought in a few captives, just to follow orders, but we killed more than we took alive. Killed them only after we had tortured them to make them reveal whatever secrets they knew about where arms were cached, or who was supplying them, or where their leaders might be hiding out.

In due time, word seeped back to headquarters at Fort Hall of certain atrocities and we were hauled on the carpet for not behaving as proper white men. But there was never any real proof against us. Dead men don't talk and none of those we ever "questioned" lived to tell just how we went about that little job of extracting reluctant information.

And then at last the whole bloody mess was over. Not suddenly, but bit by bit it petered out.

I wasn't sorry. I was sick of horror and savage, inhuman violence. I was sick of the need of torture. I was sick of having to forget every decent human instinct – of making myself worse than any blood-thirsty beast of the dark jungles.

I said as much one day to Peter. I said, "I've had enough of it here, Pete. This is a sick and tragic land soaked in too much black blood. I want out. I've got a chance to go into an export-import house in Nairobi. After a year or so I can get transferred up to London."

Pete nodded. "That's all right for you. You've got a head for business. All I know is the land. Farming and hunting."

"You could become a White Hunter," I suggested.

"I'd like that," he admitted. "But there's something more important in line. I'm going back up to the farm, or what remains of it, and try to get it back into shape."

"You can't do that alone," I protested. "You told me yourself the buildings were burnt down. You need help."

"Our father did it alone," he reminded me quietly.

SO THAT WAS the way we had worked it out. Peter went up to the old farm above Nyeri. I stayed on in Nairobi.

And then, just three months later, word came down that Peter had been killed. Struck down by a leopard, the message said.

I got hold of Kipruto, one of the Kikuyu boys from the farm who had stayed clear of the Mau Mau terrorists and now took care of my bungalow in Nairobi, and headed up for Nyeri.

Somehow I couldn't believe that Peter had died by that kind of simple accident. He was too good a hunter. In the brush and the forest he had the sort of instinctive sixth sense that such men develop.

Now I was back at the farm – and now I knew that my hunch had been right. It had cost Kipruto his life just to show me exactly how right I had been, and exactly how Peter had been killed. Leopards, yes – but two-footed ones.

The Leopard Men!

I had realized almost as soon as I had studied the claw marks on poor Kipruto's back. I knew from the way they ran, and from the way they failed to contract at the end of the strokes, that they hadn't been made by any living leopard. By a leopard's claw, perhaps – but that was another matter.

That was the way the Leopard Men worked. Sometimes they wore carved wooden footpads to imitate the spoor of a leopard and carried claws fashioned of iron. And sometimes the claws were an actual part of a leopard's paw, carefully skinned and worn like a lethal mitten. Usually the claws were dipped in poison. The favorite one in these parts was one that Wakamutu had been brewing up about Ashanti times, made from the bark and sap of the *mrichu* tree boiled up with snake venom and poisonous spiders. It worked almost instantaneously and one of its properties was that it clotted the blood and turned it jet black.

The way Kipruto's fresh wounds had turned black.

That much I knew. The why of the Leopard Men was something else again They were a cult as old and mysterious as Africa itself. Sometimes they stayed dormant for years and then all at once there would be rumors seeping through the countryside that they had become active.

But why now? Why Peter as a victim? Were they seeking revenge because of Peter's activities in putting down the Mau Mau uprising?

Or was it because of Peter's legend for courage and bravery? Often the Leopard Men killed brave warriors in order to eat their hearts, following the old superstition that by so doing they could take on those same qualities.

Right now, the reason didn't matter. Peter had been killed. Kipruto had been killed. The chances were strong that I was the next on the list.

I WENT BACK into the tent that Peter had been using as a makeshift home. I pumped up the hanging pressure lamp, made a business of getting ready for bed, letting the light throw my silhouette against the tent walls as I took off my shirt and boots. Finally I was ready. I turned out the pressure lamp, headed for the camp cot, threw myself down on it with a protesting squeak of canvas.

I waited a couple of minutes and then silently eased off the cot. I took my boots with me as I moved across to a camp chair.

I sat down, put my boots on, reached out towards the table and felt the reassuring outlines of the rifle.

I waited.

I waited – fighting to keep my eyes open, fighting to keep awake.

Two hours passed before the moment came.

I barely heard the rustle of the tent flap. And even though my eyes were long since accustomed to the dark, I had difficulty making out the dark shadow that glided towards my cot.

I waited another half minute, saw a dark arm raised upwards over the cot, and then sprang silently forward, chopping downward with my gun butt.

The figure crumpled but I didn't take any chances. I could see the dark legs beneath me and I kicked up into the

crotch as though I were punting a football. I heart a faint groan and kicked again.

Then I reached for my flash, covered the glass with a handkerchief to dim the light, and flicked it on. As I suspected it might be, it was one of Njomo's boys. On his right hand he wore the macabre glove fashioned of a leopard's claws.

Carefully I took the glove off. The claws were covered with a thick, dark substance – Wakamba poison.

I wondered about trying it out on the native sprawled at my feet and then decided against running the chance of cutting down its strength. Instead I picked up my rifle, drove the gun butt at full force down on his throat a half a dozen times until it was only a pulpy mass.

Then I sat down to wait for morning.

WHEN DAYBREAK came I stepped outside the tent and yelled for Njomo. When at last he appeared I ordered him to call all the natives to the open compound before the tent. "There have been too many deaths," I told him. "We go on a leopard hunt today."

He gave me a curious look and then obeyed.

I waited until all the natives were gathered in a semi-circle before the tent. Then I called on Njomo to stand slightly in front of me and to one side.

I started talking in Swahili. "Today we hunt for the leopard that killed my brother," I said. "And for the leopard that killed your tribesman Kipruto. And for the leopard that you fear more than any four-footed one of the jungle."

I paused and listened to the uneasy murmur. I went on, "There is a Leopard Man that you all fear, for you have no defense against him. But that is only because you do not understand that he is a mortal like all of you." I paused again, then added sharply, "Is that not correct, Njomo?"

He looked at me with cold arrogance. "I do not know of what you speak, *bwana*. This thing of Leopard Men is a myth of the white man."

"Then you have no fear?"

"No Leopard Man will ever harm me, *bwana*," he said loudly and clearly. "Njomo is forever safe."

Suddenly, I stepped away from the tent and moved close to him, whipping my concealed hand from behind my back. The hand now wore the leopard's claw glove.

I raised it high for all to see. I said, "So you do not fear this, Njomo? You have no fear at all?"

I only needed the stark look of terror in his widened eyes as he stared at the poison-tipped claws to tell me that I had made no mistake.

He knew – he knew too damned well!

"No, *bwana*!" he cried. "No!" He tried to twist about and run but it was too late. My claw-gloved hand ripped down across his face once and then again. His body half turned and I ripped long furrows down his back.

The blood spurted, then thickened and turned black. I watched him take two stumbling steps before he collapsed. His body twitched twice and then was still.

I raised my hand and said loudly over the murmur of the natives, "There will be no more Leopard Men here to cause you fear. If any come again I will do to them as I have done with this one. They will only bring death to themselves. Now it is time to get back to work clearing the fields and the shambas."

I went back into the tent and picked up Peter's prize .318 rifle before going out to oversee the work.

It was a land soaked with blood – but some of it was the blood of my heritage.

"THE DEVIL'S FIVE MINUTES";
detail from interior art,
ADVENTURE, 10/58.
Art by Walter Popp.

Walter Popp

I FELT THE CURSE OF THE CROCODILE

The raging beast roared in my face – I knew I was the next victim of the ghost monster.

"DARKEST AFRICA MAY BE pretty black in spots," muttered Joe Martin, "but believe me, it's got nothing on this dump!"

His remark took me by surprise. he hadn't opened his mouth for nearly an hour. He had barged into the office which we shared at the Faber Oil Company's field headquarters in British Guyana, had slumped at his desk and drummed a nervous tattoo on its surface with his fingers.

"Something on your mind, Joe? maybe I ought to drop a hint to head office to shift you back to civilization?"

He didn't reply. He just got to his feet, went to the back of the office and opened his own personal safe. He returned carrying a small tobacco tin.

"Take a look inside that," he said curtly.

I took off the lid and found the tin packed with paper shavings. I took out the top layer. Lying on a pad of cotton wool was the tiny image of a crocodile. about two inches long. It looked so fantastically real that it made me jump.

I picked it out, put it on the palm of my hand and examined it carefully.

"Darn good piece of work," I said to Martin. "It seems almost alive. What's it made of?"

I scrutinized the thing more closely and ran my fingers along its back. What *was* it made of? It wasn't foam rubber. It wasn't wood, and certainly not either lead or ivory. Lifting it level with my eyes, I looked directly at the miniature head and snout. The tiny eyes seemed to gleam malevolently. The minute jaws seemed to be on the verge of opening and snapping with vicious savagery.

"It's uncanny!" I said. "Where did you get it?"

Martin gave me a twisted smile. "It gets you too? Well, I'm glad to hear it. It means I'm not imagining things after all."

"What is it made of?" I repeated.

Martin handed me a powerful reading lens. "Have a look through this."

I did so, but without picking the thing up. Martin watched my face. "Yes," he said. "*It's a real one.*"

"What... that size?" I queried.

He shrugged his powerful shoulders. "Ask the ancient Aztecs, ask the Chilean Indians. They can shrink heads till they're no bigger than apples. This isn't a baby croc. It's full-grown and developed in every detail. I don't know..." He broke off and I stared incredulously at the little image. I felt my scalp tingle as I reached out my hand to pick it up again, but snatched the hand back at once.

I could have sworn that those tiny eyes had given the momentary flicker of a croc's, just as it rushes its prey.

"Don't touch it! Watch!"

Fascinated, I kept still and watched. The thud of my heart and Martin's heavy breathing were the only sounds which broke the heavy silence of the room and the brooding rustle of the forest outside.

The tiny croc sprawled on the desk as though asleep, its forefeet spread out in repose.

I noticed something. "Look at its feet!" I gasped.

When a crocodile rushes to seize its prey the back legs creep forward by almost unnoticeable stages until they are almost touching the forefeet. Then it lurches forward in a flash.

The hind legs of the image were now in that position.

"Why the devil don't you shoot it?" I heard myself saying in a strange voice.

"Shoot it!" breathed Martin. "I wish to hell I could! That thing's been dead for years!"

Quickly he put the croc back in the tobacco tin and locked it up again in the safe. The fact that I had been so visibly affected seemed to relieve him. That evening when I ate with him at his bungalow he seemed almost cheerful.

HIS "BOY" had just withdrawn after putting coffee and a bottle of Benedictine on the table when Martin stared at me curiously.

"About that miniature croc," he said. "Nine weeks ago I went up the river to Annadawa to see about some mahogany concessions and to look into some diamond claims I'd heard about.

"You remember that in my last quarterly report I mentioned a crazy freelance trader – a half-caste Brazilian – who was floating around, recruiting prostitutes, swindling drunken diggers out of their best stones, slitting an occasional throat now and then, and generally making himself the nastiest bit of work in Guyana? His name's Manuel Viliesid. I'd already heard a few stories about him. One of them was that he'd been in cahoots with the medicine men in Haiti and had acquired a few of their bad attractive habits such as rapid mutilation and abduction. Anyhow, he was deported. Some of the Makusi villagers here say he has 'bad magic'... and between you and me, he has – *darned* bad magic, too."

Martin stopped and helped himself to a stiff liqueur.

"Exactly fifty-six days ago," he went on, "I reached the village of Rumupi to look at some diamonds I heard were on the black market. When I got there I met this guy Viliesid at the local rest house, which he seemed to be running.

"I've always pinned my faith, in such situations, in my ability to pull a trigger a split-second ahead of the other guy, but when this Viliesid looked at me I felt somehow – well, as though I'd need more than a gun to settle his hash.

"Viliesid sat down at my table, leering at me. He has yellow triangular teeth, just like a shark, and I could tell from his grin that he intended to try and make me look like a fool.

"'You've come for diamonds and women, haven't you?' he demanded. 'As for the diamonds, I've just brought in more than I can really handle, and I might possibly agree to sell you some. As for women, you can take your choice – I do.'

"He turned and motioned to some hoodlum standing by a concealed doorway. The hoodlum vanished, and in another minute four girls were paraded before us. Three were half-caste Indian girls, naked from the waist up. The other seemed to be a pure-bred Westerner. She was a good-looking girl, but she was scared stiff. Unlike the others she had covered the top part of her body with some flimsy muslin material.

"It was this that made Viliesid blow his top, and which indirectly caused me to blow mine too.

"He stared at her for a moment, his mouth working, then sprang to his feet and clawed at the white girl's scanty clothing until she stood there completely naked and trembling like a leaf. Then Viliesid deliberately slapped her on both cheeks, and I figured it was about time I got in the act.

"I had a *sjambok* rawhide stick with me that I carry to break the backs of snakes. Right then Viliesid was asking to have his back broken, so I let him have it right across the shoulders. I flayed him till he dropped, screaming, at the girl's feet. Then I high-tailed it out of there."

"Well, when I'd put fifty miles between myself and that slimy Brazilian I sat up all night with a rifle across my knees. I don't know what I expected to happen, but I was genuinely scared. There was a full moon, just like day. The river seemed to be seething with crocs. I saw them coming along the shallows in regiments.

"There were dozens of them lying in a series of semi-circles. One roared from the bank and the others roared a kind of chorus in reply. It made me think of a Witches' Sabbath! It went on for over an hour. When they stopped, the silence after that awful husky roaring was worse than the noise.

"Finally I stood up. There, lying at my feet was that miniature crocodile!

"I beat it back here as fast as I could, and from then on, try as I did, I couldn't get rid of that tiny croc. Fling it overboard and it'll float alongside you. Throw it in a fire and it won't burn. Roast it in an oven and it doesn't even scorch. Bury it six feet deep and you'll find it on top when you've filled up the hole. And all the time it stares at you! *I can't lose the damned thing!*"

Martin paused and looked at me oddly.

"After a bit I got used to having it around the place, but one day I tried keeping it in the safe here, and for some reason it never got out. When I locked it in the drawers of my desk it used to turn up in all sorts of queer places.

"I told you that I beat-up Viliesid just fifty-six days ago – the night of the full moon. Well, naturally, twenty-eight days ago it was full moon again. It had been a blistering hot day, and I'd decided to sit up and work all night while it was cool. As the moon shone into the office about two in the morning I heard the roar of a croc. I'm not – or at least I wasn't – superstitious, but I broke out into a cold sweat. I grabbed my .570 Express, but my fingers were trembling. I dropped two shells on the floor, trying to load it. I pushed open the office door with the muzzle of the rifle. Just as I did so the safe fell over.

"Then something began to beat about inside it until that heavy safe threshed about like a live thing. From inside it came the roar of a croc."

Martin suddenly stopped speaking. It dawned on me then what he was leading up to.

"You mean," I said, "that it's full moon again tonight, and that I'm just in time for the performance?"

"You guessed it! How about sitting it out with me?"

WE LET ourselves into the office a few minutes later. Martin collected the .570 Express and loaded both barrels. He shoved over to me a .455 Webley revolver and a box of cartridges. I loaded the Webley in every chamber.

"Open the safe and take out the croc," I said.

Martin did so and carried the tobacco tin to my desk. We sat there in silence.

"What time will the moon hit this room?" I asked finally.

"A bit after one," he said.

Soon after midnight the lights suddenly flickered out, and we stayed there in the darkness. Shortly afterwards a fetid, pungent smell became noticeable.

Then through the open doorway we saw the tops of the trees become bathed in silvery moonlight.

Suddenly in the distance I heard the roar of a croc. I could see Martin jump, and personally I felt a kind of creeping paralysis welling up from inside my body. The stench in the room became almost unbearable, and slowly the black shadows faded away from the doorway.

As the first streak of moonlight touched the threshold with silver, I heard something metallic clang on the table. The lid had been forced off the tobacco tin!

A crocodile roared, almost in my ear. In the desperation of blind panic I placed the muzzle of the revolver about an inch from the miniature croc's head, and fired. I heard a hoarse scream and the clash of jaws. Something swept me off my feet and against the wall. I lay on the floor, stunned.

When we managed to stagger to our feet everything was quiet again in the room. My revolver bullet had torn a deep furrow in the desk top, but of the tiny croc there was no sign.

Next morning we found the body of Manuel Vilicsid on the bank of the river, with half his head blown away and a .455 revolver bullet embedded in his skull. Martin, it seems, had sawn the noses off those bullets.

Perhaps Joe Martin is right – Darkest Africa may be pretty black in spots, but it's got nothing on Guyana!

CRUSHED BY THE CONGO MONSTERS

The tortured screams were driving me insane – but I was caught in the coils of a monster that was squeezing me to death.

WITHOUT WARNING THE GIANT man-eating python dropped from its arboreal nest in the huge moss-covered tree just ahead of me, reared back on its massive coiled body, and struck viciously with its tremendous head and wide gaping jaws at Koola, my gun bearer and tracker.

I had thought we had been tracking the tremendously large python through the maddeningly hot tropical rain forest of the Congo – but, in reality, the gigantic snake had been hunting us down, and lying in wait to slaughter us, and eat us while we were still alive!

Blood spurted from Koola's shoulder as the vicious python sank its strong, razor-sharp teeth into my boy's flesh, and I knew that one of the main arteries in the black's body had been severed – it would be only a matter of minutes before he bled to death.

Koola screamed in horrible agony. "Oh, bwana, bwana, save Koola!"

But, I was helpless – Koola had been carrying my Mannlicher slung over his shoulder and even as he screamed in terrible pain I saw the giant snake wrap itself twice around his body, and around the rifle! Before I could move I heard the crack as the wooden stock split in half, and I saw it fall into two useless pieces.

"Get back, Diane!" I cried to my French mistress who was only a few feet behind me on the trail. "Get back – don't let that monster grab you, too!"

"Coward!" she cried. "Are you afraid of a snake, something that should be destroyed and wiped from the face of the earth for all time?"

Before I could stop her Diane darted past me, running a few steps up the trail, closer to Koola – and closer to that lithe giant body that could suffocate her life in seconds. Diane was equipped with only a light sporting rifle we had, brought with us on safari to provide meat for our table.

Quickly she worked the bolt, released the safety, and threw the rifle to her shoulder. There was a sharp crack, and Koola screamed again – in her excitement Diane had missed the snake, and hit Koola.

Effortlessly, and with incredible speed, the snake coiled twice around Diane's slim, beautiful body, knocking the light sporting rifle from her hand, and pinning her helplessly to the ground.

I had to do something.

With the long-bladed knife raised I threw myself at the spring-steel coils of that python's thirty-foot-long body, and hacked at it with a desperation I'd never known in my years of adventure in the Congo.

But, even then I saw poor Koola's bulging eyes – they were literally being popped from his head like two rotten grapes, leaving bloody, sightless sockets in the skull – and his tongue, huge and purple and swollen, protruding from a mouth that bubbled a bloody froth and gasped horribly for life-giving air.

The python whipped its huge head about, and struck – I felt a blow of such force that even as I was knocked breathless and panting to the ground I could not help marveling at it. Before I could jump to my feet the snake whipped its body around mine, too, pinning my faithful boy Koola and me together in its grasp.

Blood from his body was smeared all over me. He

gave one last horrible death-rattle, screaming in a sickeningly hoarse voice, "Oh, bwana!"

IT HAD begun as a love affair, of course, not as a safari intended to bring back the largest man-eating snake the Congo had ever produced. But even before Diane had met me in that small bar where I always went in Leopoldville, when I came in from the bush, perhaps the idea of capturing the snake was already on her mind. The natives to the east were frightened of it, and you heard wild and exaggerated stories – how it had invaded small villages and settlements in broad daylight and carried off not only children and women, but grown men, strapping warriors six foot tall who were never without their spears and long knives.

Diane was, as I said, French, and the wife of a doctor vacationing in the Congo and pursuing his hobby of catching and cataloguing butterflies. She had time on her hands, and after she met me she decided to while away the long hot afternoons and evenings with me.

I hadn't wanted any part of a safari to capture the python when she first suggested it. There's no sport in a thing of that sort for a man who's gone after man-eating lions, and hunted everything from elephants to slender, delicate gazelles. I told her so, bluntly.

"Anyway, it's probably all a myth and a farce," I said.

Diane raised up on one elbow.

"How can you be so callous?" she said, disgusted with me. "The natives are being threatened, their lives are in jeopardy. You have the skill it takes to do this job as it should be done. Are you afraid?"

"Baby, there's nothing that walks, swims, crawls, or flies that I'm afraid of," I said. "And don't you forget it, either."

"This is goodbye, my friend. I find that you are without courage. That I cannot stand. I loathe and despise men who have not courage."

I stood up and took her by the shoulders. "Anything you want, baby, you can have. That's the way it is with me, see?" Then I added quietly, "We'll go on safari, we'll kill the snake for you if that's the way you want it."

"Oh, no, no!" she cried, a look of great excitement on her face. "You must first capture it alive. I want to put it to death, myself – slowly." And she pressed herself passionately against me, kissing me feverishly, as if she could never get enough.

Later that night I went down to the misery and poverty of the native quarter and hunted up Koola.

"We're going on safari, lad," I said. "You see about the equipment."

Koola's black face broke into a happy smile. Like me, he was most contented out in the bush, stalking game. It had been his life, too.

"Yes, bwana."

"We're taking along the memsahib, too," I said, and then I told him what we were going to do. "We're going after that python, Koola. We're going to take it alive."

But the giant python was an even better hunter of men. We'd been on the trail two months to the day, exactly, when it happened. And now the snake had killed poor Koola, and was crushing the life-giving air from my body, and from the body of the beautiful Diane.

Even as I was being suffocated a picture of what life would be like without Diane flashed through my mind. And I knew I'd rather be dead than live that way. I had to turn the python on me.

My right arm and hand were covered with my own blood, as well as poor Koola's blood and cold gore from that gigantic snake. My left arm was useless, pinned tight to my side by one of the steel-like bands around my rib cage constricting to crack all my ribs and suffocate me. But I struck with the knife, time and time again.

I hacked at the gaping jaws, at the head of the beast, and I kept after the eyes. I think I got one of them, but I wasn't sure because the python was striking at me with its head the way a boxer strikes with his fists. One of my eyes was closed – or knocked clean out of my head, I couldn't be sure which. My nose broke with a sodden, sickening sound, and I cried aloud in pain. But when that reptilian horror broke my jaw I almost fainted in agony.

I COULDN'T see, and my ears were buzzing and popping – a sign that in an instant I would be suffocated and dead. It was what I had wanted, because I had wanted the snake to eat me, so Diane could go free. But at the last moment I couldn't go through with it. Call it the will to survive, I guess, but I was at least going down fighting with every last ounce of strength I possessed. I wasn't going to give up.

I struck out with my long-bladed knife with a fury that came from deep inside me – and at that same instant the huge python unhinged its giant jaws, and my whole arm, up to my shoulder, disappeared into that evil maw. The snake began swallowing me and I realized he was trying to eat me alive, working his jaws so that his salivary glands would flow and cover me with his vile-smelling saliva so I would slip down his throat.

I couldn't help myself – when the hideously distended jaws closed over my head and shoulders I gave one terrified scream. I'd always had a horror of being buried alive, ever since I'd been a child, and I *was* being eaten alive! I was in that giant maw up to my shoulders, blinded and in the dark, my cries muffled and covered with the thick stinking saliva of that monster.

It only lasted for seconds... but it was the terror of that kind of death that did it. I struck out with a super-human strength, the kind that one possesses in great emergencies, when nothing but pure adrenalin is being pumped through the blood stream.

I was in total darkness with only a moment of life remaining in my body, and I was almost helpless to move – but I drove my long-bladed knife upward as hard as I could. I felt the giant python writhe in agony, and again and again I plunged the knife upwards.

We were rolling and tossing about on the rotting vegetation of the jungle floor. I could tell that much. Then I gave one last fantastically strong blow with my knife and felt cool air on my face! I had hacked my way out of that monster's gullet, I had my right arm free, in the open air. And he was in

the throes of his last and final death agony.

Dazed, I staggered erect. I was covered from head to foot with his cold blood, as well as my own hot red blood – and his thick slimy saliva. My left arm was crushed, and hung useless by my side – I knew that it would never again be the same strong arm it once had. I had more cracked ribs than I cared to think about, and my jaw was shattered – I knew if I tried to speak the pain would make me faint. I couldn't even speak to Diane, but I had to help her, somehow.

She lay on the jungle floor, as fair and as beautiful as ever, and still enfolded in the dead python's coils. But her face was dead white, her eyes terrified and staring, and her legs… there was something odd about the way they weren't bent. I leaned over her, unable to speak, and blood from my lacerated scalp dripped on her delicate face.

I got her to the truck, and farther down trail I ran into some natives before I passed out. We spent weeks with them before either of us was in shape to travel back to Leopoldville.

HER HUSBAND divorced her, of course. I take care of her now. I outfit safaris, to make a living, and since I spent most of my life hunting, I make a good thing out of it.

LUST VENGEANCE
OF THE REBEL WANTON

Men say that war is Hell – and the vengeful vamp guarded Hell's gates with her own naked body.

CHARLOTTE RANDOLPH CLOSED HER eyes and prayed. The great weight of his stinking body pressed into her, threatening to crush her in its fetid embrace.

Outside, the discordant notes of "John Brown's Body" wafted through the soft, flame-lit breeze. Everywhere was the stench of burning chicken feathers and the cries of the tormented civilians of Atlanta.

Charlotte's lips moved soundlessly as she felt the rough hands pawing at her bodice, stripping it from her.

"God give me strength," she pleaded. Charlotte knew better than to waste her breath asking for mercy or deliverance. She sought some inner steel for only one reason – revenge.

"No use to claw at me, you Rebel Witch. Relax and enjoy yourself. I'll show you what you've been missing with your Graycoat Dandies."

The whiskey fumes on the man's breath nauseated her even more than the sickening smell of slaughtered animals and burning buildings.

"For Chrissakes, Bruder, the wench can wait, give me a hand with this here jewel box," the man's companion shouted impatiently from upstairs.

"You take yours, McCallister, and I'll take mine," Bruder called over his shoulder.

"All right, but if you don't be quick about it, you'll have your rump roasted off. I ain't got all night."

"Hear that, little lady? McCallister ain't got all night. You and me, we don't worry about time, do we?"

"Swine. Foul-mouthed filthy swine," she hissed between clenched teeth.

"At least you've got more life to you than those sway-back geldings in the barn," Bruder guffawed. He slapped his dung-coated blue uniform pants with a loud smack.

A crafty light began to filter through Charlotte's clear blue eyes. Twin pinpoints of red colored her cheeks. She let the loathsome Yankee draw her to him. Her arms even slid around his waist.

"If I'm nice to you, you won't hurt me, will you?" she whimpered.

"I wouldn't hurt one little hair of your pretty head," Bruder grinned idiotically. "Of course, you make it rough for me and some of that fine brocade is going to get torn up," he said, pointing to the bodice of her gown.

Delicately, Charlotte disengaged herself from the cavalryman. Her slim white hands played with the fasteners of her dress. Bruder swiped at the little trickle of tobacco-stained drool which ran down his chin. His drink-fogged eyes had difficulty focusing on Charlotte's naked breasts.

Bruder swept her into his arms.

McCallister had just lit a torch to the window drapes when his companion's bubbling mortal groan of pain echoed through the Atlanta mansion. He only had time to see a whir of milk white flesh, soft and enticing, spinning across the room at him. He raised himself to one knee and put up an arm to ward off the flashing bayonet.

Warm blood spurted from his wrist and he withdrew the arm in panic.

"That's for you, Yankee," Charlotte's mad cry taunted him.

The murous bayonet tore into his unprotected throat, filling his whole being with white hot pain. He tried to stagger to his feet, but Charlotte's naked leg crashed into his chin, sending him sprawling over the blood-soaked carpet.

She had to be away from here. Atlanta might have fallen, but the Federals were a long way from the end of their march. There were the swamps of Georgia and Carolina. There were the extended flanks of Sherman's Kansans and Illinois and Missouri lines. There would be wolf packs forming even now to slash away at these flanks.

She remembered General Beauregard's order of the day to the citizens of Atlanta:

TO THE PEOPLE OF GEORGIA:

Arise for the defense of your native soil! Rally around your patriotic Governor and gallant soldiers. Obstruct and destroy all the roads in Sherman's front, flank and rear and his army will soon starve in your midst. Be confident. Be resolute. Trust in an ever-ruling Providence and success will soon crown your efforts. I hasten to join you in the defense of your homes and firesides.

G. T. Beauregard

Charlotte Randolph and the other Georgians needed no further rallying cry. Sherman had made his intentions quite clear when he had said: "War is cruelty, and you cannot refine it."

As Charlotte gathered her torn clothes around her and raced into flaming night, the reduction of Atlanta to a "pure military depot" was full force. Drunken Union soldiers emerged from the surrounding houses, their arms laden with silver, clothing, liquor and every other bit of finery they could carry. Others drove farm animals and horses down the dirt path of Peachtree Street. In the center of city a military band stood in parade formation, its instruments blaring Federal marches.

Hot tears flooded Charlotte's eyes. "They'll pay. I swear on my life they'll pay!" she cried.

A Union officer moved towards her. 'You're supposed to be at the railroad depot," he growled. "Hang around here and you'll get a bullet in your head – or worse."

Charlotte bit down hard on her lips to keep from answering the man. She had a score of her own to settle, and it would take time for her to mete out own brand of justice. She gathered her cloak more closely around her, hiding the stolen bayonet, and shuffled away from him.

But Charlotte didn't join the other weeping women and staggering old men and crying children in the dirge-like parade. Making the confusion work for her, she slipped quickly to the north of the burning city. Nobody was ever quite sure how she managed to avoid further indecencies during the night of November 15th, 1864.

CHARLOTTE RANDOLPH, at twenty-two, was as delectable a morsal of Southern womanhood as could be found in Georgia. She'd gained the reputation of being something of a spitfire, delighting in breaking a full-blooded stallion or a hot-blooded man to her will.

Raised in the lap of plantation luxury, she had been able to combine rare good breeding with a lust for boudoir dalliances which kept her suitors both delighted and exhausted.

At the outset of the Civil War it had been a deliciously bittersweet experience for Charlotte to stand along Peachtree Street and wave her tiny Confederate Flag at the long lines of gray-clad cavalry.

It had been a picture book war, filled with chivalry and fond farewells and stolen moments in huge canopied beds.

But all that had ended with the Pennsylvania Campaign, when Lee's forces had broken and bled and died along a low stone fence.

To the west a whiskey-swilling military genius had made his name at Vicksburg and been promoted to the command of all Federal Troops.

The stench of the Rebel Prison at Andersonville and the gruesomely high toll which the Union forces had taken of Rebel installations on the march northward from Louisiana had ended the picture-book war.

Charlotte had stood in the military hospitals which dotted the Georgia landscape. She had smelled the hideous odors of gangrene and exposed entrails. Her eyes had filled with burning tears as dying Rebels clutched at her skirts with trembling hands and pleaded with her to put them out of their agony.

Gone were the days of crinoline and lace. Survival to Charlotte took on an added purpose. Avenge these brave soldiers of Georgia.

With the memories of the rape of Peachtree Street firmly implanted in her mind, Charlotte swung northward. Her native shrewdness told her Sherman would wheel his column into South Carolina and then upward to Savannah and Wilmington.

Charlotte first showed up at Decatur on the morning of the 23rd. She had been able to make substantial repairs to her dress and had secreted her prized bayonet in the bed chamber of a wayside house.

Her plan was devilishly simple. Entice the Yankees with her charms. Fire their blood with the promise of her soft body. Freeze their blood with the coldness of her long knife.

Unlike most of the southern belles who hid in attics and prayed that the Blue Coats wouldn't discover them, Charlotte went hunting for Yankee fodder.

Her first victim was a half-drunk scout of the Third Illinois Brigade. At the sight of the Rebel beauty standing along the roadside in the midst of mud and ruin, he managed to rub a hand over his red-rimmed eyes and gather up his strength.

Charlotte stood stock still, her head cocked to one side and an impish smile playing at the corners of her mouth. To a foot-slogger who had heard nothing but the sucking sound of

Georgia mud pulling at his boots, the girl seemed like the promise of Heaven. Her words were soft and musical.

"Looking for something, Yankee?" she purred in her soft drawl.

The man swallowed his surprise.

This slip of a girl was different from the rest. There was no half-dead voice from beyond the grave. He didn't sense the feeling of loathing he had come to associate with Southern women.

The Yankee leaned heavily on his Joanne rifle, blinking and enjoying the hot sensation which flushed through his loins.

"That rifle must be awfully heavy," Charlotte teased.

"I'm strong," the farm boy turned soldier grinned.

"I'll bet you are. I haven't seen a strong man in years."

Charlotte moved towards him, letting him get a good look at the swelling mounds which poked their satiny ivory over the top of her dress.

"You crazy, woman? You're just inviting rape."

"It's never rape when two people want the same thing, soldier."

The Yankee pushed his cap back and swiped at the trickle of sweat which stung his eyes.

"What's your game?" he asked defensively.

"La, are you suspicious of a slip of a girl? Why you could break me in two with your hands." Her fingernails dug into the Yankee's bulging biceps, sending signals of ecstasy to his brain.

He remembered his captain's warning not to get mixed up with the civilian population. "To Hell with you, Captain," he muttered. That West Point bastard wouldn't know what to do with a woman in the first place.

Gently, yet with a sense of urgency, Charlotte rubbed her body against the man. "All I have left is a bed. But it's a strong bed for a strong man," she whispered.

The soldier let his arm slide around her waist. His dirt-encrusted fingers probed her soft flesh. He realized with delight that the woman hadn't needed any support for her magnificent body.

"Hurry, honey child. We don't want to be interrupted," she urged.

"Lead the way, ma'am."

Inside the house he watched with a mounting fever as Charlotte delicately stripped her dress off and worked at the draw strings of her pantalettes. The faint clean scent of her flesh was like an intoxicating nectar after the evil smells of bloated horses and decaying men and swamp mud.

He savored each provocative movement of her sensuous body as she removed the last of her clothes. He gasped in anticipation as she sank down in the downy comfort of the double bed.

"I heard you Kansans even wear your boots to bed," she teased.

The man felt shame at the filthy condition of his naked body as he lay down beside his beloved enemy.

It was the next to last sensation he was aware of.

Swiftly Charlotte's bayonet moved from its hiding place and did its murderous work. Not satisfied with feeling the sharp blade sink into his unsuspecting back, Charlotte did other things to him before death closed in the soldier. She howled with glee as she removed the last vestiges of manhood.

Now she had a perfectly good Joanne rifle to add to her arsenal. She waited beside the hideous corpse until nightfall, and then took to the road again.

WITHIN WEEKS whole patrols were detailed to track down the phantom killer of the swamp. Charlotte had ranged as far east as Augusta, leaving behind a trail of butchered cadavers. Her native intelligence made it easy pick out her victims one at a time. If there were more than one, she would set one soldier against the other. Like young seals, they fought each other for exclusive rights to the lovely Rebel.

There is no complete record of Charlotte's victims. Some say she killed twenty – others that it was ten times that number. Whether she was guilty of all the blood-letting attributed to her or not will never be known.

She might have gone on forever, taking her toll of the hated Yankees and carrying out the letter of Beauregard's command to the people of Georgia, if she hadn't been dealt a cruel blow by fate.

Her last victim, instead of being a member in good standing of Sherman's marauding forces, was a deserter with a price on his head. He had killed a guard in his desperate flight from the merciless justice of a military court.

The order of the day was to kill or capture him at all costs.

A roving patrol spied him entering an Augusta farm house and set up a siege line around the area. They didn't realize that Charlotte was busily at work upstairs doing their work for them with her proficient bayonet.

After assuring himself that his men were as protected as they could be under the circumstances, Lieutenant Bandy Gerson aimed his pistol in the air and fired once in warning.

His shot was answered by the *spang* of a rifle bullet from an upstairs window. Charlotte's final battle had begun. The Joanne bucked in her hands, its barrel growing white-hot with her feverish shooting.

In the end the patrol of thirty men stormed the house, expecting to find the deserter alone. They had difficulty making sanity out of the scene which greeted them in the bed chamber. The deserter's corpse lay on the bed, its arms wide flung, blood covering its obscene wound. Crumpled in the window, the Joanne still clutched to her naked bosom, was Charlotte Randolph. Even death had failed to rob her of the savage beauty which had lured so many men to their death.

Her sightless eyes seemed to be staring at the body of one of the platoon which lay on its face in the yard below. A cruel smile twisted her lips.

VIRGIN BRIDES FOR
SATAN'S LUST ORGIES

The damned beauties spent their wedding night in a hideous chamber of horrors, and death was their only escape from Satan.

NAKED EXCEPT FOR A torn shift spattered with filth, the fragile Nordic beauty fell on her knees before the hooded members of the sinister tribunal.

Dragged from the silken luxury of her perfumed bed, she had already endured nights of horror in the stinking dungeons under Manta Castle.

Yet those interminable hours in the nightmare darkness, lying in a muck of filthy straw, failed to dim the pale loveliness of the maid from Trier.

"You are accused of a fearful crime." The malignant

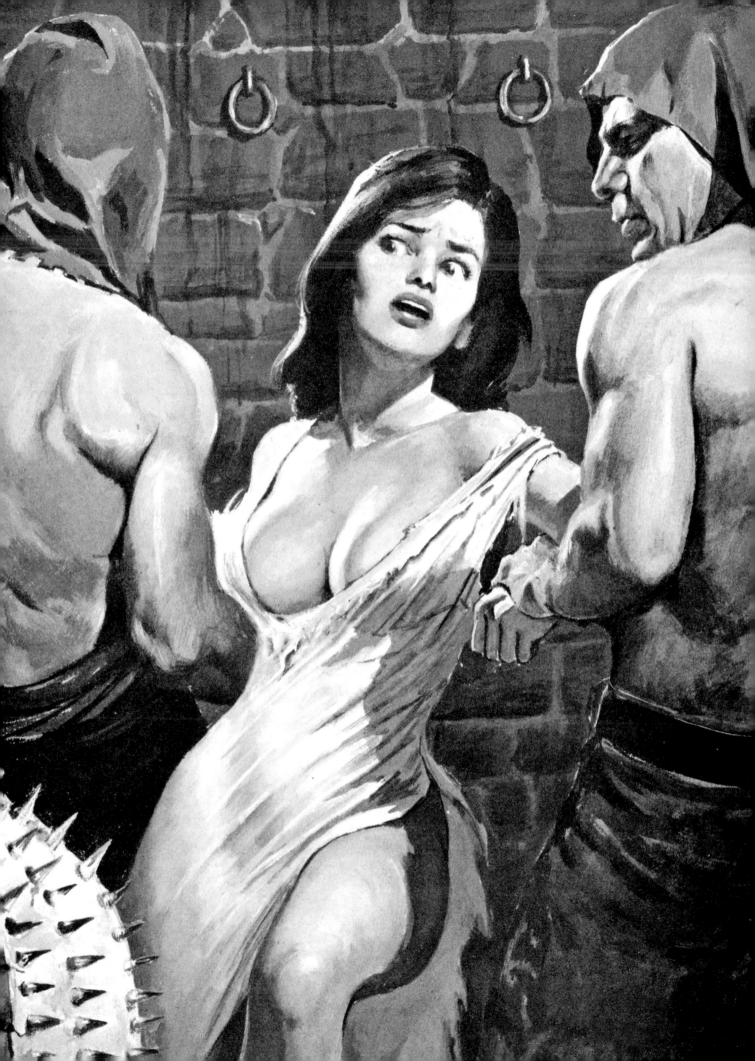

eyes of the inquisitors seemed to pierce her to the backbone. "You are accused of witchcraft."

The speaker was one of three black-cowled figures hunched over a long table covered by a crimson cloth.

"Are you guilty or innocent?"

A shiver of terror passed through the girl's slim body. Whatever she answered she knew she faced agonizing torture and a lingering death. With a sob her head fell forward, spilling her golden hair over her well-formed breasts.

"I... I don't understand," she stammered.

The inquisitor got slowly to his feet. He seemed to tower over the girl – tall, lean, high shouldered.

"You must answer yes or no. If you are stubborn..." He paused. "Look around you. Look carefully."

As if in a monstrous dream the girl obeyed. She saw the smoke-blackened walls of the torture chamber. With a gasp of horror she saw the twisted body hanging by dislocated arms... the horribly distorted form of a woman on the rack... the barely recognizable blackened thing twitching over a slow fire. She heard the groans... the sudden shrieks... the maniacal cries.

"Now you must answer – yes or no?" the vulturine inquisitor hissed in a snake-like whisper.

"I..." She struggled to speak.

"Yes?"

But the words would not come.

"Very well." The inquisitor conferred briefly with his two companions, then pointed a shriveled hand. "Guards, take her!"

"No... Oh God..." pleaded the fear-crazed girl. But her entreaties fell on deaf ears. Already eager hands were dragging her into the torture chamber, ripping the last remnants of clothing from her body.

THIS OCCURRED in 1491 at Manta Castle, stronghold of the notorious Duke Galeazzo Maria.

The blonde girl was his eleventh wife, the beautiful Catherine of Trier, known later as Catherine the Innocent.

Even as bestial torturers reduced her soft white body to bloody meat, the fiendish Galeazzo planned to debauch the teenage girl who was to become his twelfth duchess.

Known as *Il Ragno* (The Spider) because of the red hair that covered his misshapen body from head to toe, the Duke was one of the most diabolically evil men in history.

Born in 1469, he was a sickly and precocious child. From the first his nymphomaniac mother, the libidinous and tyrannical Francesca Maletestas, encouraged him in every form of voluptuous excess.

The historian Cattaneo tells how the spoiled youth would lie at his ease while painted ladies of the court attempted to arouse his interest with skillful and imaginative caresses.

Married first at the age of twelve, he tired of one young wife after another, destroying them all by means similar to those used in the case of the unfortunate Catherine of Trier.

By the time he met the ripening Maria Bisceglia, daughter of the Count of Aorta, Galeazzo was in the grip of satyriasis, the abnormal craving for constant and violent sexual gratification.

Portraits of this monster painted at the time show that he was horribly hairy, bloated and leperous.

Yet he seemed to be attractive to women. After their meeting at the coronation of Rodrigo Borgia as Pope Alexander VI, Maria wrote a letter in which she noted significantly that the Duke "fascinated her."

Galeazzo was delighted by the ingenious ways of this pretty girl, and immediately decided to get rid of Catherine and make Maria his duchess instead.

A few weeks after that first meeting, Galeazzo's army surrounded the Count of Aorta's castle at Nemi, demanding Maria and a dowry of 100,000 ducats as the price of the community's safety.

The Count agreed.

"It's like handing a lamb to the butcher," the cowardly old hypocrite remarked later, as his daughter set off for Manta Castle. "But at least her sacrifice will save the rest of us."

In this he was sadly mistaken. No sooner was she out of sight of her ancestral home, than the Duke's soldiers set fire to the castle and butchered every man, woman and child at Nemi.

MANTA CASTLE lies in a wild, desolate region of stinking swamps choked with sulfurous slime.

A macabre atmosphere hangs over the place, as if it were gradually rotting to death. And in this slow and lingering death the passing of centuries is of little account – the intrinsic horror remains the same.

It was this horror that Maria Bisceglia sensed the first time she set eyes on the castle.

Imagine a great medieval fortress with crenellated walls looming up out of the poisonous ooze of the Eruria marshes, the battlements mantled in exotic creepers and the air pungent with the stench of decay.

Picture dank cells where scores of wretched captives existed in stygian blackness, often chewed alive by gigantic swamp rats when at last they collapsed from utter exhaustion.

This was Manta Castle.

As Maria's carriage clattered over the drawbridge and under the great portcullis, a painted courtesan looked down from an upper casement.

"God help her, poor child," she muttered, as the doomed girl looked up fearfully through the carriage window.

Again we are indebted to Cattaneo for details of the events that followed.

From the first everything must have seemed strange to the innocent girl from Nemi, although she did her best to join in the merriment at a banquet held in her honor.

Perhaps she even managed to laugh with the rest at the obscene Ballet of the Chestnuts, when naked prostitutes grappled on the floor for hot chestnuts flung by Galeazzo and his cronies.

But we know that she asked to retire early and probably did so before the men started to gratify their lusts on the nude women.

She had already undressed down to her silken undergarments when the Duke, surrounded by drunken soldiers and prostitutes, burst into her bedchamber.

Terrified, the young bride-to-be stared at them.

Slowly Galeazzo moved toward her.

She read his purpose in his lust-filled eyes.

He seemed hardly human. She drew back against the bed, desperate.

Slavering like a beast, the hairy monster was almost upon her.

With a cry of fear, she turned and ran.

But the Duke caught her as she turned and dragged her back.

"Where are you off to, my pigeon?" he leered.

The girl came close to gagging.

"Galeazzo!" exclaimed one of the Duke's favorite *condottiere*, "what a connoisseur you are. I've been in every bordello in Italy and never beheld such a delicious morsel."

"Milord is insolent," Maria protested, for a moment forgetting her fear.

But the *condottiere*'s only reaction was to grab her thin wrist and lean closer.

Maria cried out softly in pain.

"Let me go, or I'll…"

"You'll do exactly what I tell you," Galeazzo roared, cutting her off. "These gentlemen are my friends, the ladies too." He gestured to the grinning whores. "Can't you get that through your stupid skull?"

Then turning to the others he bellowed, "Come, let's throw her on the bed."

"Wait," she panted, turning pale. "Wait! You wouldn't… I mean, not before… Stop! Oh for pity's sake stop… You're hurting me!"

Maria's mind swam. This couldn't be happening. Yet one of them had already pulled up her shift, while another jerked off her lace drawers.

She felt like screaming, but instead she tried to plead with them.

"Please, I've never…"

The Duke chuckled appreciatively.

"That's what your father told me."

"Please stop," she shrieked. "You're hurting me!"

"If you're hurting now, how'll you feel tomorrow," gloated a painted courtesan. She knew that after her master, the little teenager would have to satisfy every man in the keep! This was the custom at Manta Castle!

"Strip her," snarled the impatient Duke, unable to contain his lust another moment.

And as in a nightmare, the girl felt the shift roughly torn from her back.

WHY GALEAZZO bothered to marry her after such an orgy is extraordinary considering his fickle nature, but probably there were other reasons, such as the 100,000 ducats, that made such a step expedient.

Cardinal Perugia, who performed the wedding ceremony, wrote later that Maria appeared dazed and bewildered, went through the marriage service "as one drugged."

In his famous work, *Biografia della Bisceglia*, he wrote:

"A peculiar sense of oppression hung over the Castle at Manta, and throughout the marriage ceremony, that most sacred of Christian rites, I could not but feel that in some strange way I was taking part in a great abomination."

But poor Maria hadn't to endure the sniggers of her husband's harlots for long.

On the day before Christmas, 1491, she died of unspecified causes. Father Francesco, the priest who administered the last sacraments, said she "exuded the odor of death, her face ghastly and wasted, her eyes vapid."

Perhaps it was mere coincidence, but it was at this time that Galeazzo came under the influence of El Kaba, an authority on poisons of every origin.

The girl's corpse was hardly cold in its grave when the Duke's lust was aroused by the charms of the Princess Sanchia, whose brother, Alfonso, was married to Lucrezia Borgia.

From the second he laid eyes on this voluptuous Neopolitan, Galeazzo set out to win her. At first she seems to have spurned his advances, but he finally managed to capture her interest.

Sanchia was a sadist and a lesbian. In *Psychopathia Sexualis*, the eminent sexologist Krafft-Ebing tells how she had naked captives whipped to death for her pleasure.

The Duke must have appealed to her jaded appetites, for they were married early in 1492.

Guicciardini, one of the *condottiere* who were present at the wedding feast, tells how it was the Duke who started the ball rolling with a request.

"We would like to watch an exhibition of your skill," he told his voluptuous bride. "Would you care to dance for us?"

The lascivious dancing of the princess was famous throughout Italy, and a drunken cheer went up as someone started to strum a guitar and Sanchia's full hips began to sway.

With slow and suggestive motions she reached up and loosened the sapphire clip that fastened her raven hair.

She closed her long-lashed eyes, intoxicated now by her own barbaric passion. Putting both crimson-tipped hands to the back of her slender neck, she, swept her hair upward in a pile and held it there.

Moonlight streamed in through the high arched panes, illuminating every motion.

The music swelled to a crescendo of strumming passion.

Unbidden, a low shriek of animal desire escaped from Sanchia's wet lips.

Galeazzo lurched drunkenly to his feet.

"I'll have you now, you exciting black-haired witch!" he bellowed.

AMONG THE guests who witnessed the Duke publicly indulging his lust with the lascivious Sanchia was Cesare Borgia, now Captain of the Papal League and Galfalonier of the Church, and hence one of the most powerful men in Europe.

Cesare never forgot the charms of the luscious princess from Naples, and determined to make her his mistress.

Sanchia must somehow have learned of his interest in her and welcomed it; for within a few months of her marriage, she was plotting the destruction of her ugly husband.

This time the spider had caught a wasp!

Ironically, she used the same weapon the Duke had used to remove so many of his wives – the charge of sorcery.

Early in 1493 Galeazzo was arrested by order of the Holy Office. Sanchia was the chief witness against him.

Now although his arraignment before the Inquisition was undoubtedly because the Pope's bastard son desired it, there is evidence that the Duke did dabble in sorcery, black magic and alchemy.

At that time Italy was full of wizards, sorcerers, alchemists and the like.

One of the great quests of these dabblers in the occult was to produce the Philosopher's Stone – an imaginary element supposed to be capable of changing base metals into gold.

Aside from sex, Galeazzo's great obsession in life was the search for this mythical stone, and scores of magicians and alchemists attached themselves to his court.

But when they failed to produce, the Duke got rid of them – all but one.

El Kaba, a Berber, gained a powerful hold over Galeazzo. The records indicate that this sinister figure did possess some sort of esoteric talent. But it is obvious that the main source of his power lay in hypnotism. This was in those days unknown for what it is, and was considered to be magic of the highest order.

The green-eyed Berber so impressed the Duke that he signed an agreement in blood, swearing obedience in all things in return for knowledge and power.

It was perhaps only a coincidence that El Kaba required the blood of young virgins to propitiate the Satanic forces. But it is certain that Galeazzo enjoyed this aspect of the occult to the full, and under the guidance of El Kaba practiced unprintable outrages on maidens and peasant girls from the villages round about.

It seems likely that the wily El Kaba only encouraged these crimes in order to increase his hold over the Duke. But maybe his interest was more than this. After all, the victims were all young and pretty.

On February 14, 1493, Galeazzo and El Kaba were brought before the tribunal of the Holy Inquisition on orders of His Holiness Pope Alexander VI.

It was the same tribunal the Duke had so often used to condemn his discarded wives to torture and death.

At first nothing much seems to have occurred, and Galeazzo must have hoped for an early release.

How wrong he was!

The procedure continued relentlessly.

When he was brought before the tribunal for the seventh time in less than a month, he lost his composure and raged, "I do not acknowledge you as my judges. And now I vow I had rather be executed this instant than be forced to undergo the humiliation of being judged by you."

As was general, the tribunal listened patiently to his ravings. In most cases that came before the Inquisition the inquisitors seem to have shown an almost benign forbearance to the defendant. Needless to say, the latter inevitably wound up getting the worst of every argument, the tribunal being, in its own judgment, infallible.

Galeazzo, who had at first passionately denied all the charges, now decided to admit that he had practiced alchemy. Everything else, he said, had been invented to ruin him.

It was at this point that El Kaba was put to the rack.

This instrument – a favorite of the Inquisition – was used gradually to dislocate the limbs. If this failed there were always the red hot pincers, the boot, and the scalding water torture.

El Kaba was sharp in mind but weak in body. When they brought him before the tribunal on March 12, he had to be carried on a litter.

He told everything – the black magic, the search for the Philosopher's Stone, and the hideous cruelties that took place in the secret chambers of Manta Castle.

The Duke was then brought before the tribunal again. Now the evidence was quite sufficient to convict him. But for some reason the Inquisition always preferred a personal confession. Since Galeazzo continued to deny his guilt, his judges ordered that he be subjected to torture.

This monster who had ordered the torture of so many others seemed unmoved by this – until actually confronted with his own horrible torture chamber.

Then he broke down. He fell on his knees and begged his torturers to do him no harm.

"For Jesu's dear sake, give me a short respite," he begged. "Give me time to think on this matter and perhaps you shall be satisfied."

The Inquisition gave him exactly one hour.

WHEN THIS time expired, a whining Galeazzo offered a full and explicit confession. This remains to this day on view at the museum of Terni. There the world can read to what foul depths a man can sink.

El Kaba was also brought in – now a dying man. Both prisoners solemnly confirmed the other's words. After this the Duke was a broken man.

Galeazzo is even quoted as saying, "My humiliation will perhaps be the means of winning forgiveness hereafter."

Both men were formally condemned for apostasy, demon-invocation, sacrilege, murder and unnatural crimes against women.

But their ordeal was still not over.

According to the Scriptures, the Church cannot take life before sentencing a man to death.

The entire proceeding had to be repeated in the secular court.

Finally, on May 8, both men were found guilty, and judge Ludovico dei Catanei sentenced them to be burned at the stake.

On the morning of the execution a huge crowd gathered in the cobbled square of Terni.

One of the most interested spectators was the treacherous Sanchia, who had bribed the executioner not to suffocate her husband, as was the custom, but to let him die agonizingly in the flames.

"It is better for his immortal soul,' she explained.

As the fire enveloped his feet, this sadistic and lovely woman is said to have sniffed the air eagerly for the smell of burning flesh.

"*Benissimo!*" she was heard to shriek, as the flames licked upward.

And so, on the whim of a woman, one of the world's most inhuman sex monsters perished.

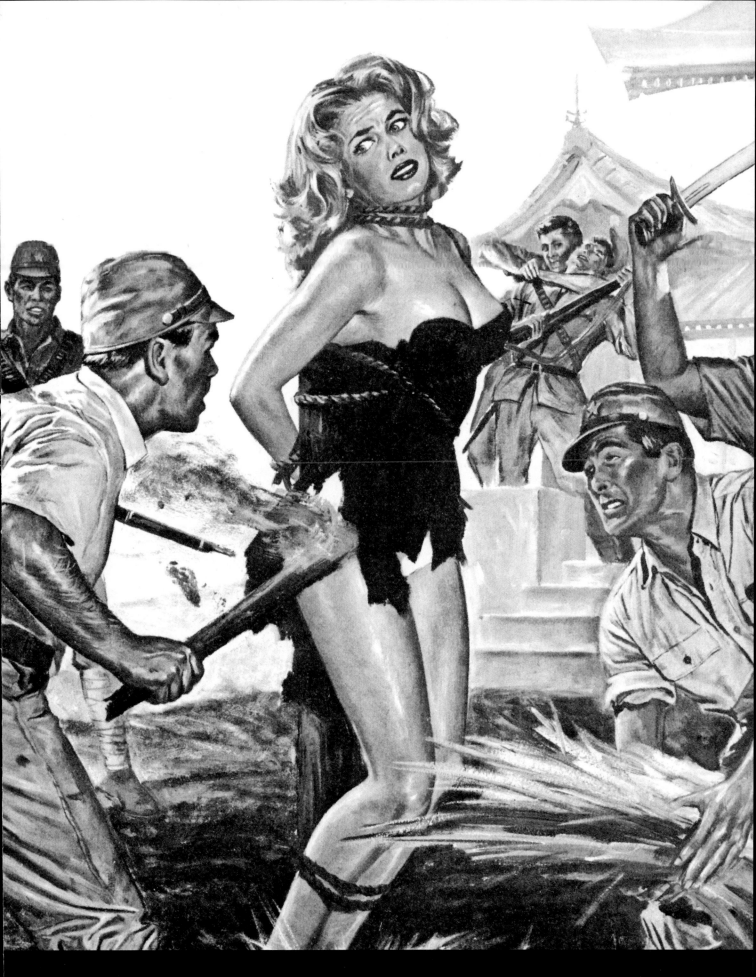

"AMERICAN WOMAN, YOU WRITHE, SCREAM AND DIE!"; detail from interior art, **MAN'S STORY**, 06/61.
Art uncredited; attributed to Norm Eastman.

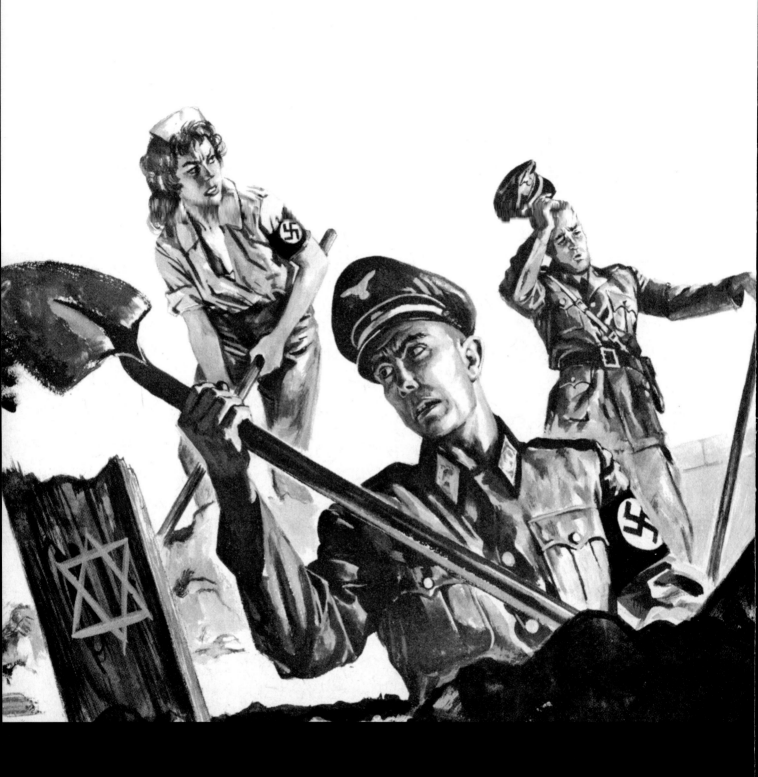

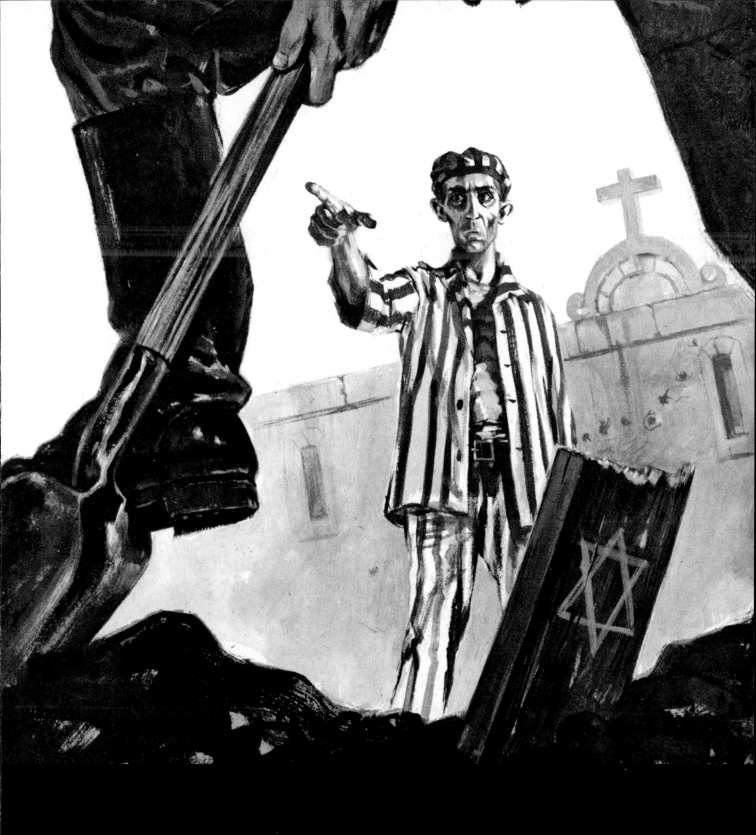

"INCREDIBLE VENGEANCE OF THE DOCTOR FROM DACHAU"; detail from interior art, **SEE FOR MEN**, 07/61.
Art by Ted Lewin.

BRIDES OF PAIN

FOR THE RUSSIAN

MONSTER

In their agony, the writhing beauties begged for merciful death. The diabolical fiend watched their struggles with mad eyes. Death would wait.

MADNESS GLITTERED IN THE sick man's eyes as he looked down at the naked girl prostrated before him. She knew only too well the horrors that probably awaited her, and she extended her hands beseechingly in a last desperate attempt to escape.

"Lord Tsar, I – I'm innocent."

Slouched in a curule chair, his face hideous with running sores, Ivan Vasilovich, Russia's first Tsar, looked like something out of a nightmare. Known to history as the Terrible, he was one of the bloodiest tyrants the world has seen. He looked at the girl indifferently.

"Take her to the dungeons."

"No..."

Grinning evilly, two Cossack guards jerked the girl off the floor. She struggled fiercely to break free, but the hands that gripped her were like hands of steel.

"Let me explain..."

"Explain to my torturers," Ivan snarled impatiently as they dragged her from his presence.

Ivan's brain was a ferment of suspicion and hate. He was convinced that the girl had something to do with the death of his beloved Anastasia. The Tsarina had died at the monastery of Mozhaisk under mysterious circumstances, and the event had

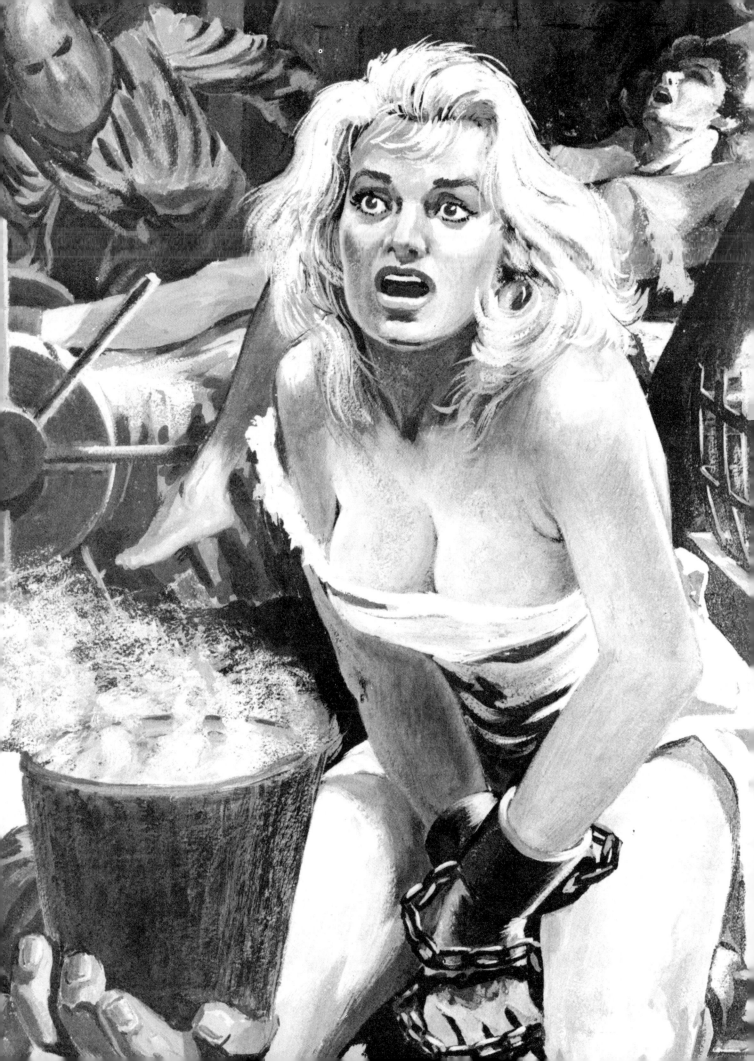

completely unhinged him.

Never wholly sane, he seemed now quite mad. For ten days he had sat howling like a wounded animal and screaming her name out loud.

"Anastasia... Anastasia... Anastasia..."

Neither food nor wine had passed his lips since her death, and there were those in the Kremlin who feared that he would die of his grief.

He was a human monster, but he had loved Anastasia.

But there was no love in his heart when he thought of the girl who had begged him for mercy. A thousand golden ducats had been discovered in her room. Where could such a humble peasant wench have gotten such a fortune?

Still slumped in his chair, the Tsar ran a trembling hand over his fevered brow. Everything was so confused. He tried to remember.

The abbot of the monastery was talking to him.

"Highness, the Tsarina is ill. If I didn't know better I'd think it was–" the old man's head shook back and forth dolefully.

Ivan recalled how he had clawed the abbot's white robe as he implored, "Was what, man? Was what?"

He struggled to hear the answer – to drive out the red fog that clouded his mind.

The white-robed abbot was talking again.

"When I was a young monk I was sent to Rome to observe certain rituals of the Western Church. I saw a man die of poison there. In just such a manner as that man died, your Anastasia..."

"No!" Ivan sat bolt upright in his chair, his eyes mad and staring. He tore at his long matted hair in despair.

Dear God! If it were true. If this girl had poisoned his beautiful Tsarina–

But no. Why should she kill Anastasia? She had been one of his wife's favorite servants. It made no sense.

Ivan groaned in despair.

There was only one way to get at the truth.

SLOWLY HE got to his feet and made his way to the dungeons. The peasant girl was already stretched on the rack.

Looking at her, the Tsar felt more than the need to get at the truth. He felt the overpowering urge for vengeance, the craving to witness the mutilation of soft flesh.

"Make her talk," he ordered harshly. "Do anything you like to her."

The torturers were Mongols – shaven-headed fiends out of hell. The Tsar preferred them to his other torturers since they were experts at inflicting every imaginable variety of human suffering without actually causing death.

Slowly they began turning the winches, gradually dragging the girl's delicate bones from their sockets.

She began to cry out.

"I earned the money honestly... they paid me to feed you... to prepare tasty dishes... you hadn't eaten since the Tsarina died... they were worried."

Listening to this outpouring, Ivan gnawed his bloated lips in frustrated rage. The bitch was lying. He knew there were those in the Kremlin who had worried about his prolonged fast.

They might have paid this cook to get him to eat. After all, their own health depended on his own. But a thousand ducats!

The torturers continued to strain at the winches.

"Ahhhhh – stop! No more! The pain – I can't stand it!"

Dripping with sweat, the girl lay shuddering convulsively, arms and legs already stretched inches longer than normal. The joints of her body were swollen horribly and the distended skin around them was already black.

Ivan looked pitilessly into the girl's pain-wracked eyes. "Where did you get the money?"

"I – I told you. They paid me to feed you."

"A thousand ducats!"

"Yes–"

Whatever else she intended to say turned into a piercing scream as once more the winches began to move.

"Highness," shrieked the girl, "no more! Please, no more! It's as I said. They paid me to make you eat."

"And for what else?"

"Well – Aaaaagh!"

Ivan held up a staying hand and the ropes and winches groaned to a halt.

"Now speak," he hissed, bending over the girl's body.

"I was the Tsarina's favorite cook," she gasped.

"I know that already," snapped the Tsar impatiently.

"When she was ill her friends paid me well to prepare delicacies and take them to her with their compliments."

Ivan nodded. It seemed likely that the boyars might try to curry favor in this manner. He looked at the girl slyly.

"Did you cook for her at Mozhaisk?"

The girl nodded weakly. "Yes, the Tsarina always hated the tasteless monastery food. Princess Sheviref gave me some special herbs with which to season her food."

"Fool!" bellowed the Tsar. "Or poisoner!"

"Just herbs," the girl gasped. "Harmless herbs. The princess bought them from a passing caravan."

"And for that she paid you a thousand ducats," Ivan screamed, berserk with rage. "You lie, you whore! For such a fortune you must have done more. Far more. Murder, perhaps. Eh? Answer me!"

Momentarily stunned, the girl remained silent.

Her silence enraged the Tsar even more.

"What are you waiting for?" he snarled, turning to the torturers.

Like something that crawled from the bowels of the earth, one of the Mongols moved to a flaming brazier that stood in a corner of the chamber, heating iron pincers till they glowed redly in the shadows.

"Oh God! Ahhhh! Aaaagh – eeeee!"

Inhuman shrieks ripped out of the girl's mouth as the fiery pincers gripped her and smoke hissed up from her mangled flesh.

Even Ivan grimaced in disgust as the darkened chamber filled with the sickening stench. But when he spoke his tone was implacable.

"Her eyes," he said hoarsely. "Now burn out her eyes."

"No," the girl moaned dully. "I'll tell everything –

anything." She was at the limit of her endurance. She didn't care what she said.

"Tell me about the herbs the princess gave you," Ivan demanded.

"Poison–" panted the girl. "But it wasn't intended for the Tsarina."

"Who then?"

"Highness–" she finally stammered.

"Yes?"

"It was meant for you."

"Ah!" The Tsar's green eyes flushed with mad triumph.

Ever since he could remember he had always hated and mistrusted these aristocrats, these boyars who had never really accepted him as Russia's supreme sovereign. So the lovely Princess Sheviref had murdered his Tsarina with poison intended for him! Well, her beauty would not save her. Her punishment would be even more horrible than that of her accomplice.

FEW PERSONS today fully comprehend just how appalling conditions were in Russia during the time that this scene took place.

Until Ivan's coronation as Tsar in 1547, Russia, or *Rus* as it was then called, was ruled by a grand duke, the Grand Duke of Moscow. But the real power was in the hands of the boyars – aristocrats like the young and beautiful Princess Sheviref.

Sadism and depravity were rampant, and even children were encouraged to indulge in every conceivable form of vice. The boyars were particularly cruel, enjoying torture for its own sake; while the morals of most of the women would make a prostitute of today seem like a holy woman by comparison.

Into such a world was Ivan Vasilovich, son of Vasily the Conqueror, born. Saint, madman, lover, tyrant – he has been called all of these and more. Certainly at the time of his coronation there was no hint of the monster he was to become.

Instead, under the gentle influence of Anastasia, he had devoted his life to good works; become the champion of the common people against the tyranny of the boyars.

Ivan met Anastasia Zakharin-Yuriev a few months after his coronation as Tsar.

It was love at first sight.

In her silken dalmatic, modeled after the Byzantine style, she looked very desirable – slim-waisted and big-bosomed.

Ivan was delighted.

Now, thirteen years later, in his rare periods of complete sanity, Ivan could recall that first meeting.

He had held her fur coat while she had slipped into it with a sideways glance of her blue eyes. There had been a musky perfume about her that still inflamed his passion.

They had had little to say to one another as they strolled arm in arm beside the Moskva River. Ivan had felt tongue-tied, so great was his love.

"Well, my Lord Ivan? Do I please you?" this golden girl had asked him.

And then, suddenly, she had been in his arms, and he had paid no attention to the open-mouthed *muzhiks* who stared at them in astonishment. He had slid his arms around her, over her shoulders, down her hips, crushing her against his wolfskin *shuba*.

He remembered the feel of her smooth flesh under the silken dalmatic, and he groaned aloud in an agony of loss as he realized that never again would he take her in his arms; she was dead, decaying in her Kremlin tomb.

Perhaps it was the death of his Tsarina that finally threw Ivan on his final bloody rampage. We do not know. We know only that the confession of the peasant girl incited the Tsar to commit an act unequaled in its barbaric atrocity.

Convinced that the boyars had plotted his death, had killed his Tsarina, Ivan swore to exterminate every one of them, every man, woman and child.

But first he would wreak bloody vengeance on the soft-bodied aristocrat who had supplied the poison; the torture of the peasant girl would be mild by comparison with what his Mongols would do to the lovely Princess Sheviref.

How well he remembered that beautiful woman.

He had first set eyes on her at Shumerlya during the siege of Kazan. She had invited him and a few of his officers to her *khoromy*, and had danced in their honor. She had been little more than sixteen at the time.

She had appeared suddenly in the firelight, poised half-naked with one hand flung above her magnificent head, a gleaming saber between her slender fingers.

She had been barbarically beautiful.

Her dance, the traditional sword dance, had been flashing fire. One instant she had been serene, lazy almost; the next a wild leaping thing with the lean grace of a Siberian wolf.

Then suddenly she had been in his arms, pushing her burning breasts against his love-starved body.

Vainly he had fought to withdraw his mind from the girl's animal intoxication, to think of his Tsarina, his Anastasia, waiting for him far away in the Kremlin.

But she had brushed aside his protests with a toss of her raven-haired head.

"I can make you forget any woman," she had whispered.

And for that passion-filled night she had.

It was this lovely creature, this wanton jezebel, who had poisoned his Anastasia.

IT WAS at least six weeks after the torture of the peasant girl before Ivan was ready to start liquidating the Boyars. And for that purpose he forged a diabolical weapon – the *Oprichnia*.

At that time the Tsar had no real army of his own; only the wild Cossack guards who defended the Kremlin owed their allegiance to him.

Ivan had once intended the wipe out the Tartars as he now planned to massacre the boyars. Ironically it had then been the boyars who urged him to be merciless, his own gentle Anastasia who pleaded with him to be merciful.

How delighted those hypocrites had been when he had declared a holy war against the Tartar descendants of Genghiz Khan's original Golden Horde. Not from patriotism,

but because they were eager to share in the plunder of fabulous Kazan.

They had supplied him with money and troops, and when the Tartar city had fallen, they had openly sneered at him, the Princess Sheviref included, because he had spared the women and children in deference to the Tsarina's wishes.

Well, now Anastasia was dead. The victim of their greedy ambitions. There would be no one to extend the gentle hand of mercy this time. He would do what they wanted. He would be merciless.

And this time he had his own army. They came from all corners of Russia, no of no souls and misfits, craving excitement and pleasure.

These were the nucleus of his *Oprichnina* – his bloody fist of power to forge Russia's future in a furnace of destruction.

The night before he set out on his orgy of blood he held a great banquet for his *Oprichnina*. Dressed in their scarlet robes, the two-headed eagle of Rus embossed on their gleaming cuirasses, they gathered around their leader, their Red Tsar.

"I'll make each and every one of you rich," he promised. "Rich with gold, rich with jewels – and surfeited with the bodies of beautiful women."

His raucous laughter rang out above their own.

"What must you do, you ask? Obey me in everything. Obey me with your lives. In return, I swear to do everything that I said. But first I must ask you four questions. First – would you kill for me?"

"Yes!"

"Would you burn the boyar estates?"

"*Da, da!*" They howled.

"Would you steal gold and jewels in my name?"

"Yes, yes!"

"Would you rape and torture any woman I might name?"

They laughed at this and as one man they bellowed, "Yes, Mighty Tsar – yes!"

THIS LAST thunderous "yes!" spelled doom for the lovely woman breakfasting in bed propped up on creamy satin pillows. She was the Princess Maria Mastislavsky Sheviref, and it was noon of the day following the *Oprichnina* banquet.

The princess was staying at her villa, some fifty miles out of Moscow. She had no idea of her imminent danger.

She was very beautiful, with a dash of crimson on her sensuous lips, her raven hair cascading over her bare shoulders, and her smooth white belly showing wickedly above the frothy pile of silken sheets. She didn't look like a poisoner.

"Shura," she called to the buxom serving wench who hovered in the background, "prepare my bath."

"Yes, milady," said the girl, scurrying away to do her bidding.

But the princess was far from easy in her mind. While she was completely unaware of the red nemesis closing in about her, strange rumors had filtered through to her from Moscow; vague intimations that it might be well for her to spend some time at her *khoromy* near Kazan.

Something was wrong, she felt it in her blood.

How right she was.

As she sat there in her silken bed, her arms crossed over her naked breasts, drumming impatiently with the tips of her long polished fingernails as she awaited the preparation of her perfumed bath, fifty scarlet-draped horsemen were galloping across the snow-covered steppes, drawing closer and closer to her villa.

Like their leader, Tsar Ivan, they paid no attention to the icy *buran* wind that howled across the frozen plain. The princess was to be their first victim. Anger, lust and greed warmed their blood, making it pound in a molten torrent of hate and madness through their veins.

In the sequestered luxury of her boudoir, their intended prey slid her slender legs from under the silken coverlets and stood in all her nubile splendor before the gold-framed mirror that hung by her four-poster bed.

"Your bath is ready, milady," announced the serving wench.

And just as the princess was stepping into her bath, the red-robed riders drew rein before her villa.

What followed was an orgy of horror.

The Tsar, his satanic face cankerous and ghastly, cantered his horse forward till the outer gate was before him. Then, sliding his glistening saber from its jeweled scabbard, he slashed savagely at the barrier.

"Death to the boyars," he roared.

And at this, his followers rushed forward.

In the courtyard a dog barked furiously and a *muzhik* looked out to see what was amiss.

At the sight of the horsemen the old retainer froze.

"Soldiers," he gasped.

Meanwhile several of the horsemen had charged the outer gate with a pine trunk suspended from ropes, smashing it the first time from its hinges. As the gate fell inward their companions galloped through, the Tsar in the lead.

A well-aimed ball from Ivan's pistol dropped one of the *muzhiks* who ran out to meet them. Half the fellow's throat was torn away and he fell, choking on the blood that poured from his mouth.

Calmly Ivan reloaded, sitting in the crimson-draped saddle of his nervously dancing steed, watching his *Oprichnina* cut down all who stood against them.

In less than five minutes it was all over, and the courtyard was strewn with dead and dying men.

"Now for the princess," roared the Tsar, turning to his men.

The ram was brought forward. Again it smashed into timber as the ornate door to the villa shattered in half.

There was no opposition. The men were all dead.

The princess was still naked when Ivan, surrounded by his men, burst into her bedchamber.

"Ivan Vasilovich," she screamed, terrified by the madness in his eyes.

"Yes, it's I, you bitch," said Ivan with quiet menace.

And there was that in his tone which sent a shudder of icy terror through the princess's beautiful body.

THEY BROUGHT her back to Moscow strapped naked to a *droshky*; then dragged her through the frozen streets of the city

tied to the tail of a horse.

For weeks she endured the black horror of the Kremlin dungeons, spared no indignity by her fiendish Mongol jailers, her lovely body theirs to do what they liked with.

Then came the torture.

Day after day the ravished princess was dragged back to the dark horror of the torture chamber.

The strappado, the boot, the thumbscrew, lighted splints under her long almond-shaped fingernails; all these she experienced in a carnival of screaming agony.

But it was when Ivan ordered that she be flayed alive that the girl went berserk with terror. Shrieking and sobbing, she flung her body at the feet of her jailers, begging their yellow-skinned fiends to put her out of her misery, spare her this last unthinkable ordeal of horror.

But the only response of these monsters was idiotic chuckles. Torture was their business. They enjoyed it. Slavering like beasts, they pinioned her to the bloodstained flaying frame.

Then started a nightmare of butchery.

Each time one of the slant-eyed demons made an incision with his razor-sharp skinning knife, the princess screeched in a frenzy of pain.

Slowly, bit by bit, the smooth white skin was stripped off, and what had once been a vibrant, beautiful woman became nothing but a squirming blob of raw and bloody flesh.

And so it was, in one of the most sanguinary scenes in Russia's long and brutal history, that the princess perished. Whether or not she and her accomplice really did try to poison the Tsar, we shall never know. The girl's confession was worthless under the circumstances, and the Tsarina might have died of any number of causes.

But through his destruction of the boyars – his *Oprichnina* went on to exterminate them in an orgy of rape, torture and blood – Ivan made Russia strong, building the foundation of the great Red empire of today.

AFTER HE had finished with the boyars, the Red Tsar turned his armies first east, then west.

In 1571 he utterly defeated the Tartar horse archers of the Great Khan, leaving over fifty thousand of them dead on the battlefield, and bringing as many more in chains to Moscow. The Khan himself was taken, and Ivan ordered that he be roasted alive outside the Kremlin for the entertainment of the Muscovites.

A few years later, spearheaded by his scarlet *Oprichnina* and twenty thousand Cossack warriors, his armies routed the famous winged knights of King Sigismund of Poland, cutting them to ribbons on the frozen wastes of Lake Sniardwy.

Finally, at the battle of Pinz, the victorious Tsar crushed the terrible Teutonic Knights, sending those perverted warriors of the Devil's cross staggering back to their Germanic homeland after their greatest defeat since Alexander Nevski chased them back over the Neva river.

But although by 1584, the year of his death, the two-headed eagle of Rus was flying over a sixth of the world, a mighty empire that stretched from the headwaters of the Danube to far away Mongolia, he had offended his God. Nature punished him for his cruelty.

For the hideous disfiguring disease that made his life a hell was passed on to his children.

And today we know that his sickness was syphilis of the brain – the dreadful malady known as paresis.

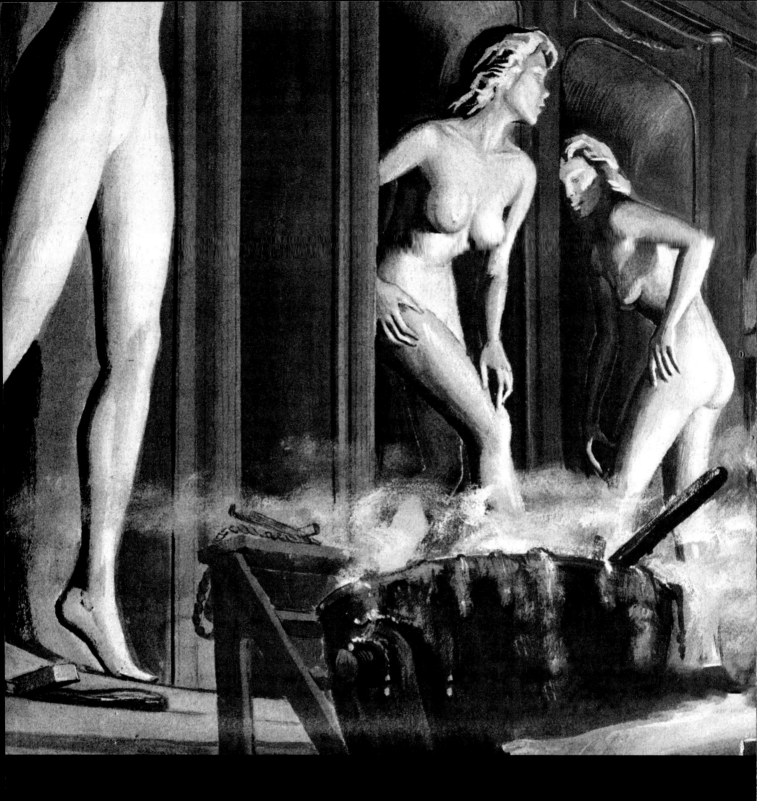

THE NINE NUDES
OF COUNT PEREGRINI

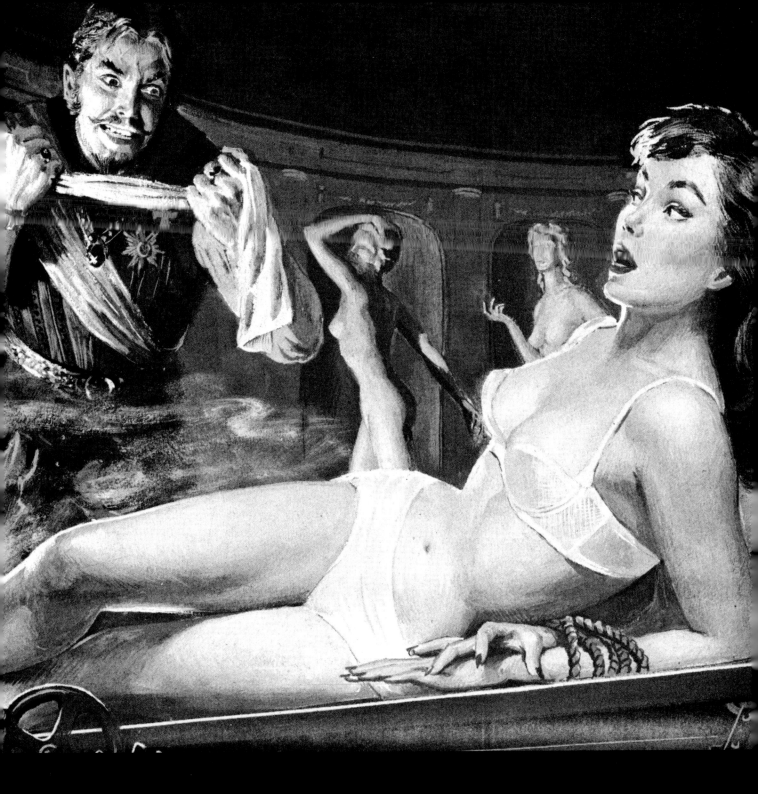

Once the wanton lusts of the terrifying beauty-butcher were sated, he immortalized his victims' naked bodies.

THE GIRL WAS THE loveliest sweetheart he had ever had, but Count Alfonso Peregrini was getting tired of her. Not that he was bored with her special brand of hungry love-making; it was simply that she was getting more and more possessive and increasingly nosy about his affairs. And, much as he enjoyed the girl, this was a situation Count Peregrini could not abide.

That night, the last of their affair, she lolled seductively on the *chaise longue* in her room at his castle. She was polishing her blood-red fingernails when he walked in. She was dressed the way he liked to see her; in long black stockings topped by broad pink garters, her pleasantly round shape encased in a lacy negligée draped over her body – so lacy that

the fullness of her bosoms showed through. Count Peregrini always marvelled at her figure; despite its plumpness, all of it was magnificently firm. As he stood there that night, he already regarded the girl with a sense of loss. Well, he thought, he could at least keep *looking* at her figure if nothing else – after their affair was finished.

"You are beautiful, my chicken," he said, handing her a glass of bubbling champagne. "I can't get enough of looking at you."

She smiled with pleasure, sipped her drink, and stretched lazily on the couch. The negligee slipped from one sun-browned shoulder.

He sat down beside her, put his glass on the table and ran his fingertips over her exposed shoulder. She shivered with pleasure. "Chicken," he said, "you must be mine for ever. You will stay with me always, by my side in the chateau."

These were exactly the words she wanted to hear. Not only was the Count an expert lover, the kind of man she needed with her lusty temperament, but he would make a wonderful husband – a fantastically rich one anyway, one of the richest of South America's many fabulously rich.

"I am so jealous," she pouted. "You will get rid of all those statues of your old mistresses then? Please, for me?"

"No," he said. "They are too valuable. But I promise that I shall make a special statue of you. It will stand in the most honored place – in my own bedchamber."

"Oh, darling," she said, snuggling up to him with gratitude. 'Do kiss my neck. You always like to do that, don't you?" As for all those life-size statues of his former mistresses, they could wait until she was the Countess Peregrini. Then she'd be rid of them quickly enough. The old boy would be surprised. She shuddered with the thrill of victory and passion. Not every poor little Rio de Janeiro showgirl ended up with such a man!

AN HOUR later, as was the Count's custom, he carried his mistress to his room. Usually she giggled when he put her down into the pool in the center of his huge room. This time she only moaned softly. Her eyes were half-open and their whites showed through the narrow slits. She was breathing tortuously. Count Peregrini smiled with the pleasure of accomplishment; he had calculated the quantity of the narcotic in her champagne to absolute perfection – she had been lively and lusty just exactly as long as he needed her that way, and she had dropped off into deep semi-consciousness immediately afterwards.

Quickly, the Count ran ice-cold water, from the castle's special refrigeration tank, into the pool. He turned up the air conditioner and went into his bedroom to fetch ice from his freezer. He added them to the water for good measure. He had to bring down the girl's body temperature. This was necessary for his plan. She lay moaning in the water. Her skin slowly turned a blueish hue. When he figured she was cold enough, he emptied the pool.

Then, humming softly, he took a quart can of paint from a closet. It was silver metal paint, airtight when properly applied. He took his brush, dipped it in the can and started painting the girl's ice-cold body. Her ripe flesh was lifeless in his hands. He admired her delicious contours as he covered them inch by inch, strangling the girl in a way that left no ugly

finger marks or rope burns – by making it impossible for her skin to breathe.

When she was all covered from the roots of her hair to her little toes, the Count washed his hands and went to bed. He was tired. It had been a long day, and the painting had been painstaking work. He fell asleep immediately. He wasn't worried about the girl waking up. The narcotic would last eight hours, and by that time she would be dead – but dead without contortions of the face and body. Her corpse would look as beautiful in death as her body had in life.

THE NEXT day, after a hearty breakfast and a morning ride in the tropical mountain air, the Count ordered his valet – a primitive Indian from the Amazon country – to carry the girl's corpse to his workroom. Now the real artistry began.

Once more, Count Peregrini painted his latest love – this time with a satiny soft wax that clung in a thin layer to the silver paint. Before the wax dried he arranged the body the way he wanted it, in the posture of love. Then he took a couple of hours off. The part the Count loved best would take several days: painting the wax figure with authentic human coloring, painting every detail matched to his memory of the girl. Only the eyes could not be duplicated. The final step was to cut her dead eyes from her head and replace them with false orbs.

At last, the job was completed.

It was the best one yet, so life-like that at first glance one could not be sure. And the Count was a man of his word. He had a second bed moved into his chamber, and that's where he placed the statue with the corpse inside.

The girl, Cara Fortaleza, had been his ninth victim. The other eight – in less lustful poses – stood upright on pedestals in the magnificent entrance hall of the castle, their perfect life-like nude forms serving as delightful conversation pieces whenever the Count gave one of his famous parties for the elite of three continents. To newcomers he always explained with becoming modesty that, indeed, he had "made" these girls himself. "Just a hobby," he would say. "Quite unimportant. If I had real sculptor's talent, I wouldn't have to work for a living."

This remark always caused delighted laughter, for everybody knew that the Count didn't have to work at anything, ever. From his father, he had inherited a string of gold, silver and tungsten mines in South America and Africa; as a young man he had added to this wealth by cornering the, strategic metals market just before World War II and then selling the ores first to Germany and later to the United States at many times the prices he had paid for them. He retired at the age of 30 after developing the first uranium mine in South America.

The Count had first discovered his liking for nude girl sculptures from life when, in one of his smelting plants, a woman had fallen into a tank of boiling hot wax. He was amazed at the life-like perfection of her corpse when they pulled her out. He decided he would go in for that most unusual hobby.

THE FIRST girl was Rio streetwalker, a girl fresh down from the provinces whom no one would miss. He took her back to

his luxurious chateau near Porto Alegre where already everything was in readiness. She was a pleasant enough creature in the clinches, and he enjoyed the primitive Indian rhythm of her love making for a couple of nights. Then he poisoned her and dunked her in wax. A few days later, however, the wax flaked off; the flesh underneath had begun to decay and the stench was horrible. He ordered his valet to bury her, did a little thinking and then came up with the answer of the preliminary metal cover which would not only suffocate the girls while they were unconscious, but also guarantee that the wax would stick.

To find his victims, the Count periodically prowled the cheap music halls of Rio and Sao Paolo until he found a girl whose looks pleased him. He would offer her money and jewels, always making a generous down-payment on the spot, and take her back to the chateau with him. If the girl's personality pleased him, she would stay alive for a few weeks of romance. If she annoyed him, her first night at the chateau was also her last.

By 1955, after the Count had been at his "hobby" for three years, his entrance hall held eight nude statues. The only one of his 40 servants who knew the Count's secret was his valet, who was no security risk whatever. For one thing, he could not talk – a war party from a neighboring Indian tribe had cut out his tongue when he was still a child; the Count, furthermore, had saved his life and was extremely generous to him, both with money and women. Thus the valet was loyalty personified.

THE COUNT loved to stroll through the great hall in the soft light of a few cleverly mounted candles. By that light, the wax statues made it appear as if the girls quivered with sexual anticipation. Count Peregrini would walk along, caressing the smooth thighs of his statues, running his hands over the figures of life-like sculptures. Often he would become frantic with lust.

But the statues also paid off when the Count was in the company of untouchable women – untouchable insofar as his hobby was concerned, since they were too well known. It was part of his love play with society women to take them for walks in the nude gallery at night while their husbands snored off champagne and cognac in the guest bedrooms.

The hot-blooded, sophisticated *senoritas* became lustful with vicarious excitement when the Count – "in a joke" – pretended to make love to the nude figures. One prominent beauty in her late twenties became so excited at the sight that she forgot her reputation and social standing and went into a hypnotized strip to the soft music that always played in the hail.

With dreamy eyes, she slipped from her dress, assumed the stance of a statue and pleaded with Count Peregrini to make love to her next. He did not need a second invitation.

In this way, the Count spent a happy few years, until, a few months after Cara Fortaleza had been wrapped in silver paint and wax, he was ready to acquire another statue. Once again, his pilot flew him to Rio in his private plane, and once again he went to the city's tenderloin district which sports the world's loveliest, lustiest girls.

At the second place he went to, his attention was caught by a tall, blonde strip-teaser, a Swedish girl with a slender, sleek figure unlike any of the full-bodied, soft Latin-type girls already in his wax harem. Helga Wenlund – that was the girl's name – had become quite well-known for her tantalizing act in which she played a bashful but healthily lustful bride disrobing for her wedding night; but well-known or not, Count Peregrini decided that he had to have her.

The first part was easy enough.

Helga was in the business strictly for money, and in any event the Count was an attractive man in the prime of his life. He was not a tall man, but Helga always had liked men about an inch shorter than she was herself. This usually matched them perfectly she found because her length was in her magnificent legs.

Two days after their first meeting, Helga returned with Count Peregrini to his castle, and for a week the affair was in full swing. But there were three factors the Count had not reckoned with. One, was that Helga was insatiable; two, that she had a vile temper; and three, that she liked to drink – and that the more she drank the more insatiable and temperamental she became.

The time for turning Helga into wax was still a long way off, and after a particularly tiring session of love-making the Count had returned to his own bedroom to snore in peace. But Helga, sleepless, sipping midnight champagne, decided that she was not yet finished with the Count. She pulled her filmy robe around herself and, made her way to Count Peregrini's off-limits bedroom. As always, the Count had a small nightlight burning, casting an eerie yellow over the room.

HELGA lurched through the door. The first thing she saw was the nude body of a girl lying invitingly on her back on a bed beside the Count's. She looked at her lover snoring nearby. Then she looked at the girl again, and her temper mounted. She was, of course, familiar with the statues in the hall, but it did not occur to her that this might be another waxen figure.

Helga gnashed her teeth in anger. She rushed to the bed where the girl lay, and she reached out and with a yell of passionate anger she grabbed the girl's hair to yank her out of bed.

"You animal," she screamed, reverting in her excitement to her native Swedish. "You filthy animal!"

For a few seconds, she did not realize that the hair she had pulled had come out of the skull and stayed in her hand. Screaming, she raised her shapely leg, her negligée falling open from her swaying body. With the pointed toe of her sexy, spike-heeled bedroom slipper she kicked the girl off the low bed.

There was a crack. The wax-and-paint shell that had covered Cara split open. The shells fell off the shriveled, blackened corpse. Smell of decay filled the room, and at that moment Helga recognized what lay before her on the floor, and her scream of anger changed pitch to one of terror.

Groggy, half-asleep, Count Peregrini had raised himself on his bed and was looking at the yelling Swedish amazon. Then he saw that she had smashed his latest acquisition. There was but one thing to do. He had to kill Helga. And quick.

The Count jumped from his bed. From behind, his

powerful hands grabbed Helga's slender neck. His fingers squeezed. Her scream changed into a choking gurgle. Grinning, the Count increased his pressure, relishing the feeling of her squirming back as he held her flailing body pressed tightly to his own. But he had not counted on Helga's healthy Scandinavian upbringing.

She reached back with her long arms, and suddenly the Count felt himself lifted as Helga jackknifed forward, instinctively practicing a judo hold she had learned in gymnastics class in Stockholm. Count Peregrini flew over Helga's head, out over the bed where, until this night, Cara had reclined in a frozen posture of lust, and when he came down, it was over the wooden edge of the bed. He hit it squarely with the small of his back. There was a loud crack – it didn't come from the bed but from Count Peregrini's spine, which had snapped in two.

BY THAT time, the noise had brought Peregrini's loyal valet to the door. But there were other servants too, and in the excitement he did not think to keep them out. He was loyal, but not very bright. And that was the end, not only of Count Peregrini, but also of his reputation as a gentleman. The stench in the room, and the sight of the shrunken corpse of the girl beside the slabs of wax in female shape told the story at a glance. Later, dismantling of the other nude girl statues in the hall told the rest.

Peregrini lived for three weeks – long enough to dictate a complete confession. Then, on the night before his arraignment for which the judge and the attorneys were to come to his hospital room, Count Peregrini loosened the traction that held him precariously together. His spinal cord snapped, and he was dead. His valet, convicted as an accessory, is still in prison. He will serve another 20 years if he lives that long. Helga is back in Sweden.

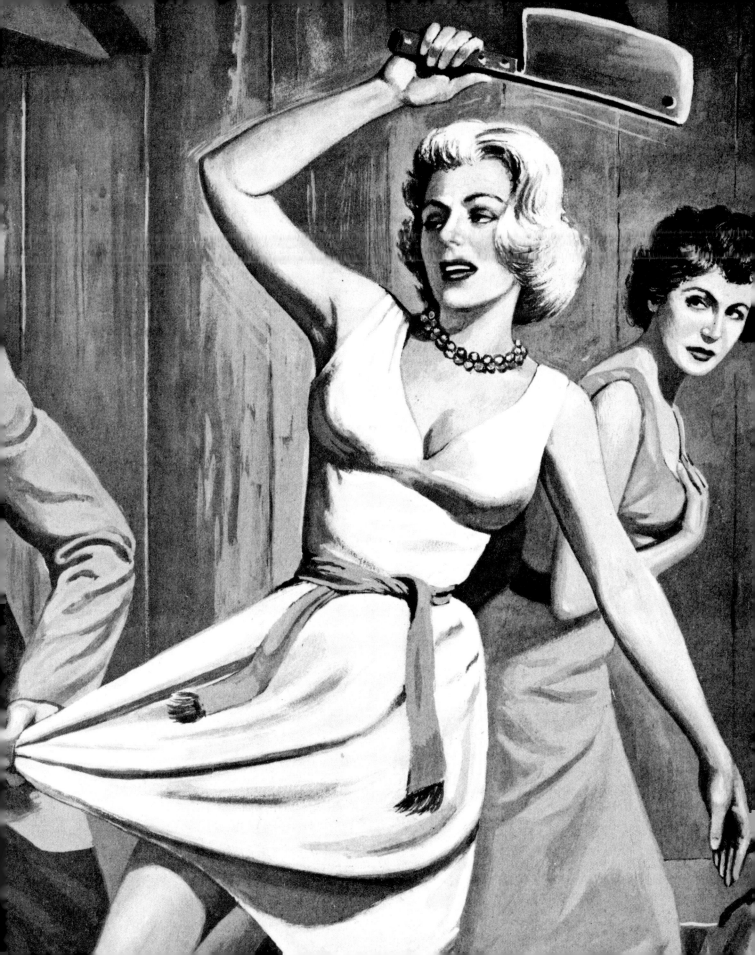

PASSION SLAVE OF THE WHIP GODDESS

Red Hogan would stay alive – for as long as he could satisfy the nympho's needs.

IT WAS MORE THAN the wild gyrations of the nearly-naked belly dancer which caused the weak giddiness to flow through Red Hogan's veins. He took another swig of rum and passed a shaking hand over his eyes. A little voice was warning him that he'd better get some fresh air quick, before he became violently sick.

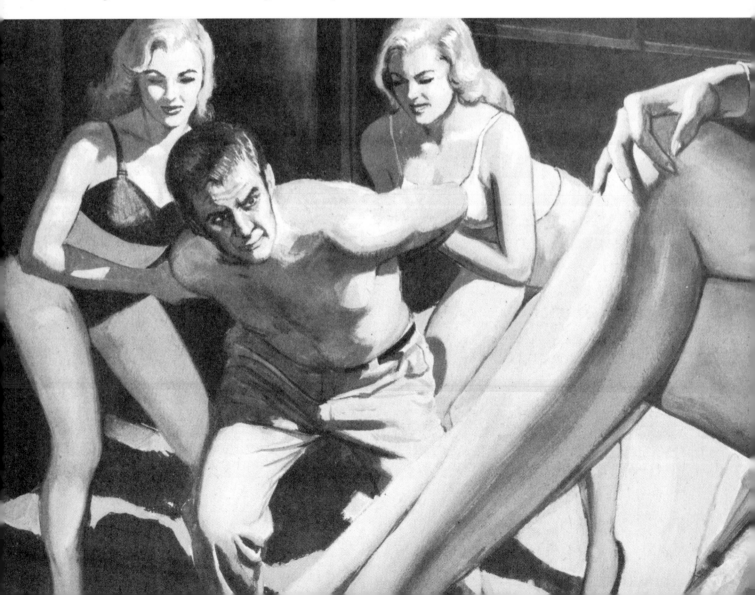

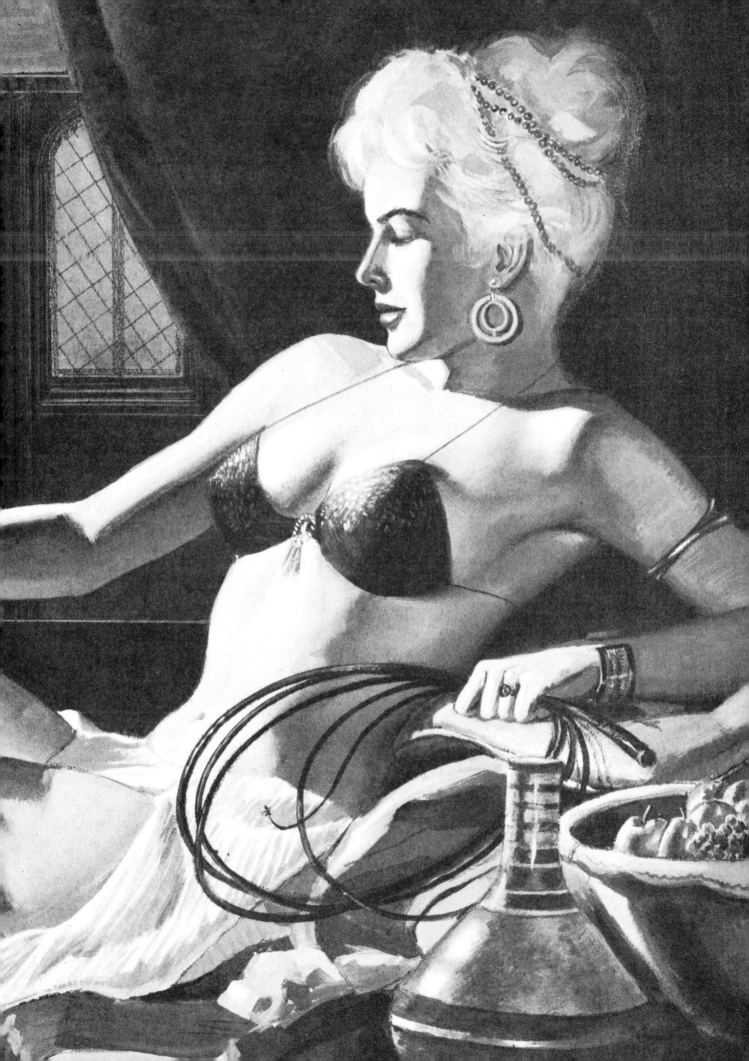

But the belly dancer seemed to have eyes only for him. The glittering diamond she sported in her navel seemed to have the power to mesmerize him. He blinked stupidly at it. Somehow he knew he should be getting back to the *Vulcan*. But he was powerless to make his limbs move. His last waking thought was, *I wonder who'll take the second dog watch.*

Hogan had no way of knowing how much time had elapsed before he became aware of the cool night breeze bathing his sweating face. He was far more interested in the violent pain which lanced between his eyes. He was conscious also of a sharp pain in his ribs. He shifted his weight restlessly. His hand touched something silken and smooth. He'd had enough experience in these matters to realize it was a woman's calf – and a well turned one at that.

"What the hell?" he groaned and once again the night exploded in a brilliant shower of stars. He bit his lips to hold back the nausea. His brain spun in a mad whirl.

He knew he was on the floor of a curtained limousine. He knew some kooky dame was using his body as a foot rest. He knew he'd been drinking in a waterfront dive which was pretty much like any other in Mersa Matruh. He knew he had a hell of an urge to get back aboard the *Vulcan*.

A wheedling voice reached him from above.

"This one is a real find. He should be worth much."

"I am not in charge of that," a woman answered angrily. "You will get your fee from Helga as always."

"May Allah will that she be generous."

The faint hint of a guttural accent came to Hogan. "Helga won't be kept waiting. Tell your driver to hurry."

The weight on his body shifted somewhat. Hogan heard the man say something in Arabic to the driver. The limousine leapt forward. From the agonizing jarring, he knew that they were traveling over wildly uneven cobblestones. He rested his head against the floor and speculated on the owner of the silk-clad leg.

Finally the car made a few tight turns and eased to a stop. Hogan felt himself being lifted bodily. Sharp fingernails dug into his biceps, burning his flesh. He staggered weakly, his knees buckling under him. He heard the iron gates of the mosque slamming shut behind him.

New hands reached for him. He leaned heavily on a pair of delicate shoulders. Slowly his vision was coming back to him. The musky nearness of heady perfume tickled his nostrils. To hell with the *Vulcan*, he thought happily.

But his happiness was short lived. A heavy door opened before him and he felt the hard marble under his feet. The sharp nails prodded him forward. Still weakened by the effects of the drug, Hogan slid across the smooth surface of the floor. He came to rest before a pair of delicate, sandaled feet.

Slowly his eyes worked their way up over the seductive contours of the sandal's owner. He blinked several times, trying to assure himself that this was happening to him. He had never been in the presence of such beauty before.

The vision rose slowly before him. The blood red lips were twisted in an expression of sheer animal hatred. The woman stood spread legged glaring down at him. Her jeweled fingers fondled a hideously coiled rawhide whip.

"Insolent swine!" she screamed in rage. "You dare look at Helga Bremer as if she were a common prostitute? You must be taught your position here."

With unbelieving fascination, Hogan watched the girl's arm slide backwards over her head. The uncoiled whip slithered its black way across the floor. Agony seared his chest as the lash cut through his shirt. He heard the insane laughter of the guards who had conducted him into the throne room. Maddened with pain, he let his temper get the best of him.

Quickly he twisted, his hand grasping the whip and dragging Helga toward him. He was aware that her gown had fallen away, revealing her full, high-thrust breasts. Their bodies collided with a force which drove the breath out of them. For an instant a look of complete abandon burned from Helga's eyes. Just as quickly it was erased by the vicious fury which turned her face into a gargoyle's.

Now Hogan felt arms and legs swirling around him. Inexorably they bore him to the floor under their weight. He heaved mightily against their soft flesh. But tenaciously they held on pressing his body to the cold marble. He heard the clank of chains and felt his wrists being manacled. At last he struggled to his knees once more, only to be greeted by the sight of Helga Bremer towering above him, her bloody whip poised over his sweating back.

WHEN IT was over the other women came for him and dumped him into a cell in the dank basement. He sat miserably on the floor trying to make some sense out of the weird turn of events.

For three days he was kept in the cell. From time to time he'd heard the soft sandaled feet of one of the women sliding over the stone floor. A trap door would clang open and a bucket of food would be shoved into the cell. He knelt miserably on his haunches like a mangy dog, wolfing down the watery stew. The remainder of the day he lay on the straw bed and wondered how he'd been stupid enough to get mixed up in this thing.

On the fourth day he heard the click of the lock and his cell door swung open. He'd never seen the two women who stood before him. But he had no doubts they were as mad as their mistress. Who else would run around Egypt ten years after the war sporting swastika-festooned Hitler Mädchen Uniforms? If they were play acting, the Mausers clasped in their fists certainly gave no evidence of being stage props.

Without a word, the guards swaggered before him, teasing him with their skin-tight blouses and skirts which revealed every rippling muscle of their lush bodies. Wordlessly they motioned him out of the cell.

Helga Bremer was waiting for him in the throne room. Her arrogantly sumptuous breasts rose and fell provocatively under the tight sequined gown which seemed to be painted to her skin.

With the utmost disdain she motioned to Hogan, the ever-present bullwhip punctuating her unspoken desires. Slowly she approached him, her full hips undulating slowly. She walked around him, measuring him the way one might measure a prize bull.

"You'll do," she said at last. "Remove your clothes."

"Go to hell," Hogan spat. He felt the crack of the lash across his cheek. Rage, rather than pain, filled his whole being.

"When I was a wardress at Auschwitz, I kept a

prisoner alive until I had flayed every inch of skin off his back. He begged and pleaded to be put to death. He crawled before me like some broken insect. The same will happen to you," Helga snarled.

Now it was becoming clear to Hogan. This wild woman, like so many other top Nazi war criminals, had made her way to Egypt. Here, while the government looked the other way, she had set up housekeeping in her own diabolical fashion. There could be no doubt that she financed her wanton debaucheries with the vast sums she had appropriated from her hapless concentration camp prisoners.

Hogan glared at her, his mind crawling with revulsion for the beautiful she-demon. "I'm an American citizen," he warned. "You can't get away with holding me against my will."

"But who's to know?" the mad beauty chuckled. "When your body is found floating in the Mediterranean, you will be just another deck hand who was washed overboard. Nobody will lose a moment's sleep over you, Herr Hogan. Now if you would prolong your miserable life, you will make me forget for the moment that I must kill you."

Helga's long fingers stroked his face. Slowly the fingers curled into long claws. She raked her nails over his cheek drawing blood. Her wild laugh answered his cry of pain.

In desperation Hogan seized her to him. His strong hands gripped her bare arms. The fragrance of her exotic perfume intoxicated him. Loathing for her mixed with a passion that he could not explain.

"I could kill you!" Hogan breathed as their bodies entwined.

"One scream from me and you're a dead man," Helga sneered. "My *mädchen* would enjoy putting an end to you."

Hogan knew the truth of her statement. There was no question that the women of the mosque were lust-crazed devils who had become addicted to human suffering. More than sex they needed to dominate and humiliate the male. Like queen bees they would rip a man's guts out in their love making, and when he could no longer satisfy them, they would destroy him completely. These were the things that had been whispered about in the Mersa Matruh gin mills. The stories had seemed like so many fairy tales. But Hogan knew now they couldn't match the mad truth of the situation.

Now Helga backed away from him. Her long fingers worked at the clasps of her gown. The overhead lights caught the shimmering sequins as Helga lifted the garment over her head. She wore nothing beneath.

"Your life depends on your prowess as a man," she whispered as she thrust her naked body into his arms.

AS THE days wore on, Hogan fought to maintain his sanity. He moved be tween the degradation of Helga's bed and the bone-rotting squalor of his cell. His back was raw from the cuts inflicted by Helga's bullwhip. He had never known the murderous hatred which now burned in his heart. One thought drove all others from his mind. He must have his vengeance against this devil.

He forced himself to crawl before his mistress. His mind was alert to changes in attitudes. He began to see the insane jealousy flooding into Helga's eyes. No longer would she allow her erstwhile Hitler Mädchen to fetch him from his

dungeon. Now she came to the cell herself, reveling in the sight of him wolfing his food from the slop pail. Her diabolical taunts were even harder to take than the stinging whip blows. In the hours he was left alone, Hogan paced his narrow prison the wheels of his mind spinning out a plan of escape.

At last it came to him. Here in the stone-shrouded basement, sound would be muted. Helga's female guards would have no idea of what had happened until it was too late. If only he could make his one desperate move against the Nazi she-beast.

For her part, Helga's interest in her rugged captive had not flagged. Hogan was more man than any she'd ever known before. Her visits became more frequent, her ardor more demanding. She now moved around the dungeon in her SS uniform, posturing in her high heeled boots, cracking her whip in the manner of a lion tamer. Then she would sink to the straw couch and demand that Hogan make love to her.

"You are lucky, *schweinhund*," she'd sneer. "So far I have not grown weary of you."

It was on one of these occasions that Hogan put his plan to work. Helga had become lax in her security measures in her eagerness to satisfy her lust. She'd thrown herself on the bed, swinging her silk clad legs high in the air, her lips moist and waiting. She'd felt Hogan's arms slide around her in the accepted ritual of the slave reverently disrobing his mistress. She'd lost herself in the delights of the dank air caressing her firm breasts. She'd arched her back like a giant cat as Hogan had slid the black lace panties over her thighs.

Her whip had lain beside her unheeded. Not until she felt the thong tightening around her slim neck did she understand the malignant quality of Hogan's fury. Her eyes bulged in their sockets as he'd drawn the whip taut. "You will never get away with it," Helga managed to gurgle.

Hogan grunted his reply and twisted another loop around her neck. He was aware of the diabolical retribution being inflicted on his tormentor. It was altogether fitting and proper that the lash should become the means of her destruction.

Helga's body heaved violently. Her legs thrashed out at crazy angles. Her fingers clutched her throat, the nails drawing rivulets of blood. Slowly her struggles weakened. At last, she lay very still.

Hogan thrust the beautiful pervert from him, knowing he would no longer be contaminated by her touch. With Helga Bremer's ring of keys in his hands and the comforting heft of her Mauser tucked in his belt, the seaman made his way through the mosque to freedom. Although he had vowed to blast any *mädchen* who tried to stop him, none got in his way.

At first he thought of telling his story to the Egyptian Police, and then decided against it. Even if he were believed, there was much too much love between the Nasser Government and the little clique of German war criminals who had found sanctuary in Egypt for him to become involved.

He often wondered what happened when Helga's body was discovered in the dungeon. But Hogan shipped aboard another freighter without ever knowing. The land of the Sphinx guarded its newest secret in silence.

THE BEHEADING OF ANNA

The Nazi informer brought death to Anna and – unwillingly – to himself as well.

IN MARCH, 1944 MY regiment – the XII Wehrmacht Army – was transferred from the miserable Eastern Front to garrison duty in the Saarbrucken sector of the Siegfried Line.

About a month later, on the morning of 17 April, I was summoned to the company command pillbox. Hauptmann Luehrs, his eyes boring into mine, said, "Twenty months ago,

after your traitorous fiancée was executed you babbled of murdering the patriot who informed on her. That stupidity cost you, among other disciplines, a furlough. Now that we have been assigned to this garrison duty there will again be furloughs. If you have come to your senses – because you fought bravely against the Russians – you may be included in the first

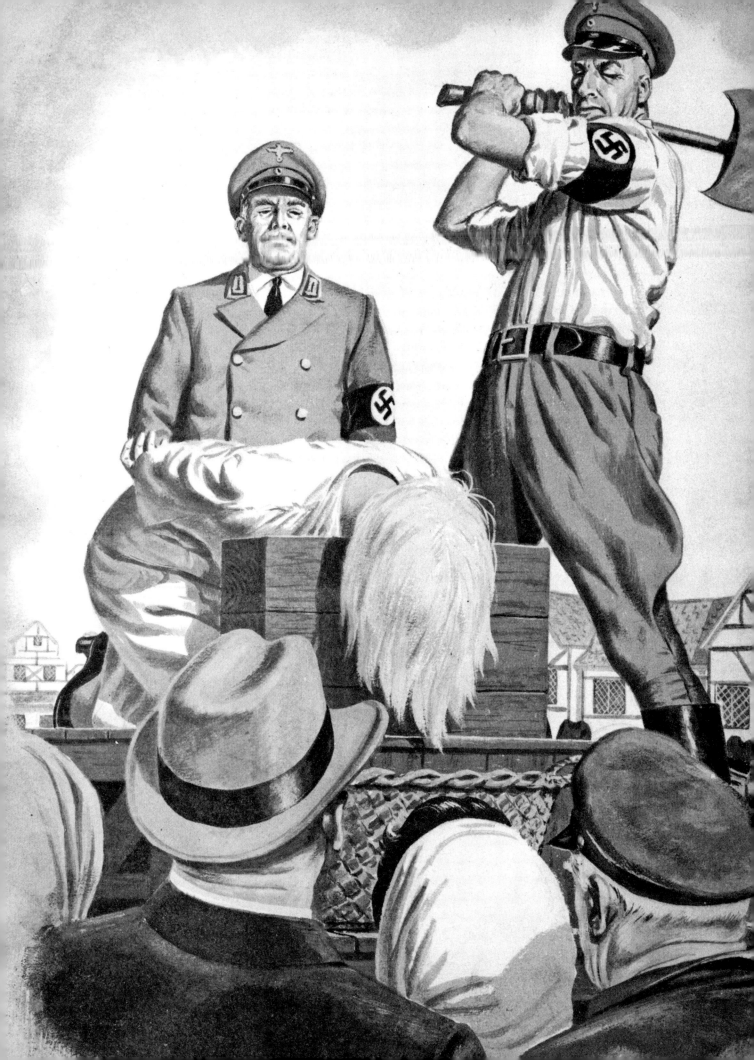

group."

I assured the Hauptmann that I now realized that the beheading of Anna had been for the good of the Reich and that I no longer felt revengeful. These were monstrous lies but Luehrs believed them – so three days later, for the first time in two years, I was in Erlangen – a city of about 50,000 population.

I visited with my mother for two days; my father, who was too old for military service, had been drafted into the Arbeitsdienst and was somewhere in Mecklenburg.

The evening of 21 April, carefully watching to make certain that I was not followed by the Gestapo, I went to the house of my dead fiancée's mother; before I did what I had to do I wanted to hear, from someone who would know, exactly what had happened. I did not want to kill the wrong person.

When Frau Pfeiffer came to the door she looked into my eyes for a few moments. Then she began to sob. I led her into the house. She told me the almost unbelievable story of Anna's betrayal by the man next door – Adolf Gerhardt – and of her brutal execution for the crime of listening to a British news broadcast.

These things confirmed what I had heard, and when Frau Pfeiffer finished I put on my hat. I would now begin to set a trap for Gerhardt, in which he would die slowly and savagely.

That middle-aged, overweight swine was a clerk in the office of Erlangen's Police President. He was a filthy hypocrite. The last time I'd been home on furlough I'd spent most of it with Anna. We decided to be married when the war ended and we announced our engagement to Anna's mother and the neighbors in a little party in the yard.

None of the neighbors seemed as thrilled as Gerhardt. He brought beer for all of us and he yakked that he wished he had a son who could serve, like me, in the glorious army of the Reich. And he wished even more that he had a lovely daughter like Anna. "Don't worry about Anna while you're away, son," he boomed. "I'll see that nothing happens to her."

Two days later I went back to my outfit.

Sometime in August, 1942 the Ministry of Defense issued an edict forbidding German civilians to listen to foreign broadcasts. Anna, who had taught English in the same school in which – before I was drafted – I was an instructor in Russian, often listened to broadcasts from England, not because she was unpatriotic but because she was amused by the propaganda dispensed by the British, in which their agents told of victories by the English and Americans – which every German believed to be crude lies.

After the edict Anna unwisely continued to listen to these broadcasts. Gerhardt heard them. He told the Gestapo. Early the next morning – it was August 27, 1942 – two Gestapo Unterscharführers arrested Anna.

SHE HAD the unenviable distinction of being the first German citizen to be arrested for violating the ban on foreign broadcasts. The judge of the Erlangen Peoples Court, a frustrated little lawyer named Gustav Frammelsberger, was an opportunist who would betray his own mother if it would advance his standing with the Nazi Party. This despicable little bureaucrat saw in Anna's arrest an opportunity to attract the attention of the important Nazis in Berlin. "You will be publicly beheaded by the axe," he told Anna.

He would invite photographers and writers from the Ministry of Propaganda to attend the execution and, if he appeared in the photos and got his name in the news stories, it would not impair his standing with the Nazi hierarchy.

Two days later Anna, manacled like a common criminal, was led out of the municipal jail and made to walk to the square in front of the Peoples Court. A throng of citizens milled in this square. Anna was prodded by bayonet-armed SS soldiers onto an elevated wooden platform. Then Judge Frammelsberger and Gerhardt climbed onto the platform.

Frammelsberger began a speech in which, after making sure that the Ministry of Propaganda correspondents had spelled his name correctly – and the photographers were taking newsreel photos – he announced that no more loyal Nazi than he existed. "It was not easy to condemn to death one whom, in this small city, we all personally know," he said. "But as a Nazi who places the glory of the Reich – *Heil Hitler!* – above all else I have naturally thought foremost of our great Führer and his noble ideals." Then he praised Gerhardt for informing on Anna and put his arm around Gerhardt's shoulder while photographers took pictures.

Then an ugly-featured, crippled Gruppenführer of the Peoples Army (a home-guard organization of the "physically defective") shoved Anna to her knees. "Lean your head forward, traitor," he snarled. He picked up a double-bladed axe and, for a moment, dramatically held it over his head while photographers snapped his picture.

After looking around to make sure that no more photographers were interested in him, he brought the axe down. This brute was inept at his grisly trade. The axe plunged into Anna's shoulder, severing her right arm. She screamed horribly. The Gruppenführer raised the blood-dripping axe and brought it down again. This time it sank into Anna's neck. Her unconscious body tremored and convulsed so violently that the Gruppenführer had to hold it with a boot on the spine while he hacked, twice more, at her neck. Then, with her head severed at last, he held it up by its bloody blonde tresses while photographers took pictures.

I read of this – and saw the horrid photos – a week later in *Volkischer Beobachter*, the official daily newspaper of the Nazi Party. I was stunned. Then, insane with rage, I made many indiscreet remarks, among them that I would cut Gerhardt's throat at the first opportunity.

Naturally, some favor-seeking swine in our barracks told our company CO, Hauptmann Luehrs, the things I had said. I was immediately arrested by our own MPs and dragged to Luehr's office. "For remarks unbefitting a soldier of the Wehrmacht," the Hauptmann snarled, "you are herewith reduced from Unteroffizier to Gefreiter. You will be confined to the guardhouse for 100 days and you are denied your next furlough. Further," he added, fumbling through the mail on his desk, then opening a letter, "as betrothed of the traitor, Anna Pfeiffer, you must pay the executioner's bill. It is 300 Reichmarks. This will be deducted from your pay."

The day after I completed my guardhouse sentence the XII Wehrmacht Army was ordered to the Eastern Front. The

following months were hideous – the Russians were ruthless and without end in numbers. But we made them bleed and, like the other soldiers, I picked up battlefield souvenirs – among them a Russian Zhorkov grenade.

Eventually I was promoted to Obergefreiter. Then, to our great solace, the XII Wehrmacht was withdrawn from the Eastern Front. Almost immediately, as I have related, I was granted a furlough – my first in two years.

AFTER CONFIRMING the facts of Anna's betrayal and butchery from her mother, I went to my house. There I composed a letter in Russian to Adolf Gerhardt. In this letter I thanked Gerhardt for the information he had supplied concerning the German attack upon the Russian garrison at Roslavi – which, because somehow the Russians had been tipped off, was a bloody catastrophe for the Wehrmacht.

"You and Gustav Frammelsberger will be paid the usual amount for your services, at the usual time and place," I wrote. "Your next assignment, for which you will be sent a grenade: Annihilate your Police President. A dark street, perhaps when he is in his car. Or when he gets out of his car to enter his house."

I signed this letter "Ghorkov."

The following night, about 2 AM, by alleys and gloomy streets, I went to Gerhardt's house. Entering it was uncomplicated; Anna and I had been in this house numerous times. I crept to the bedroom. Gerhardt and his young blonde wife were asleep. I slipped into the parlor and put the letter behind a picture which hung on the wall. Then I concealed the grenade – the one I had picked up on the Eastern Front as a souvenir and which I had brought to Erlangen for this purpose – in the piano, underneath its mechanism.

The next morning I went to a public telephone and called the Police President, a colonel of the Gestapo. "Adolf Gerhardt is a Russian agent," I mumbled. "You will find proof of this in his house." Before the colonel could ask who I was, I hung up.

The Gestapo was an efficient organization. Within 15 minutes a Mercedes squad car screeched to a halt in front of Gerhardt's house. Five enlisted men and an *oberleutnant* went to the door and entered it.

The trial of Gerhardt and Frammelsberger was held the next day in the Peoples Court. The Police President presided. Tears ran down Gerhardt's fat cheeks. "I don't know anybody named Ghorkov," he babbled. "I'm a loyal Nazi. I love the Führer. *Heil Hitler!*" he squealed, hoping to prove his point.

Unfrocked Judge Frammelsberger, now a defendant in his own court on a charge of treason, was almost as hysterical as Gerhardt. "We've been framed!" he shouted.

But the letter and a Russian grenade had been found in Gerhardt's house – and the fact was indisputable that someone had betrayed the Nazis in the Roslavi campaign. All this, so far as the Police President was concerned, was conclusive evidence of the guilt of these men. "For treason against the Reich," he intoned, "you are both sentenced to be executed by the garrotte." (This was a mode of strangling a condemned man by an iron collar attached to a post; in Nazi Germany only outstanding traitors rated this hideous means of execution).

The next morning, in the square in front of the Peoples Court, the condemned men were lashed to posts which had been especially erected for this occasion. The town's official executioner, the crippled Gruppenführer of the Peoples Army, put an iron band around Frammelsberger's throat. Then he began to tighten a huge thumb screw at the back of the post. This lout must have been a sadist because he tightened the screw slowly, so that Frammelsberger was a long time dying.

Then the Gruppenführer shuffled to the post to which Gerhardt was lashed. He began to tighten the screw. I was standing about 15 feet from Gerhardt, but behind a fat old woman. I stepped from behind this woman. "Do you still wish you had a son like me?" I shouted.

Gerhardt's bulging eyes looked into mine and, suddenly, he knew that I had been the one who framed him. But he could not scream an accusation – the executioner had already tightened the screw to the extent that Gerhardt could no longer even babble.

His eyes, bulging more with each turn of the screw, were pleading. The only way he could, he was begging me to save his life. Then his tongue protruded. A few seconds later his face became purple. Soon, his body tremored and – in a moment became limp for all time.

I lit a cigarette and walked toward a beer garden.

NAZI MADHOUSE ZOO

As well as murder and mayhem, the Nazi sadists added a new form of torture to their growing list of ways to make prisoners talk – with blood-curdling results.

PIERRE DULOIS WENT FIRST. And then I followed.

We stood on the chair in the kitchen, pulled ourselves through the opening in the ceiling, and then put the trap door back in place. We crossed the attic to the short flight of stairs that took us to the door to the roof. We opened that, passed through, and shut it carefully behind us.

We were stepping cautiously, and had gotten halfway across the roof when we heard the unmistakable roar of German vehicles. Pierre and I both crouched, and then crawled to the edge of the roof and looked down. The streets were swarming with the Nazis. They had pulled a surprise raid, and this time they had almost caught the local members of our underground group, *Ceux de la Resistance*, the freedom fighters of the town of Ferlanc in Occupied France.

We hung on the edge of the roof and watched the admirable if unpleasant efficiency of the Germans. They blocked off the streets and sealed off the houses. Then, house by house, they made their search.

Directing the search was the infamous Rudy Merode, the local Nazi commander. We watched him stride back and forth in the center of the street in front of the house on whose roof we were hiding, bellowing out his commands. We could only hope and pray that Merode, with his strutting, his black gloves and black jackboots, would miss the companions we had left behind in the apartment below.

"Just give me ten seconds with my hands around his throat," Pierre crooned.

And then it happened. The door to our house flew open. The two girls came stumbling out into the center of the street, thrown there by two of Merode's Nazi henchmen. Rita Dulois, petite, black haired, with a tiny feminine figure that was perfectly shaped, sprawled in the center of the street at Merode's feet, taking the skin from her knees. She was my fiancée, and Pierre's sister. Next, falling on top of her, was Helene Mouton, the blonde tigress, a legendary figure of the resistance, the betrothed of Louis Sebal, the leader of our group.

And finally, Louis came out himself, his face already puffing from the beating he had taken at the hands of the Nazi goons. Louis was defiant as always, his hands clenched into tight fists. If the Nazis gave him only one small opening, he would attack without hesitation or regard for his own life.

Colonel Merode stood over the girls and watched them pull themselves painfully to their feet.

"What will he do to them?" Pierre asked.

"Don't worry," I said. "We will pull all of them out of this somehow."

Merode suddenly strutted to the two girls. Coldly, as if he were sizing up two hunks of raw meat, he ran his hands over their bodies appraisingly. The girls shuddered and tried to draw back from him, but his grip was like iron. The sight of Merode holding his fiancée, Helene Mouton, by the arm, while he appraised her body, drove Louis Sebal berserk.

Before our eyes, Louis Sebal tore himself loose from his Nazi guards. One of them swung with his Schmeisser machine pistol and cracked Louis across the back of the head. Staggering, Louis launched himself across the road, his hands reaching out blindly for Merode's neck. The Nazi chieftain calmly moved back a step, waved his men back, and moved his hand towards a black leather sheath that hung from his belt.

The Nazi pulled a knife from that sheath. Its blade gleamed in the sunlight. He waited until Louis had closed to within one step of him and then he stepped in under his arms and sank the knife with all of his strength in Louis' gut. Rita and Helene screamed with horror. For when the Nazi pulled the knife out, it took Louis' guts with it.

PIERRE AND I were both sickened by what we saw, and we retched on the roof as Louis Sebal clutched at his belly and tried to stuff his vital organs back inside his body.

As we watched Merode look fondly at his bloodied knife, we realized what it was. The knife had a jagged, serrated edge. It had been filed so that its cutting edge was filled with saw teeth. It was sharp enough, and vicious enough, to cut through wood or human bone. Or if plunged into a man's belly, the way it had been into Louis', its saw-teeth hooked into and tore the flesh when it was ripped out – in Louis' case, the saw-teeth had hooked onto his organs and torn them out, pulling the worm-like intestines through the wound.

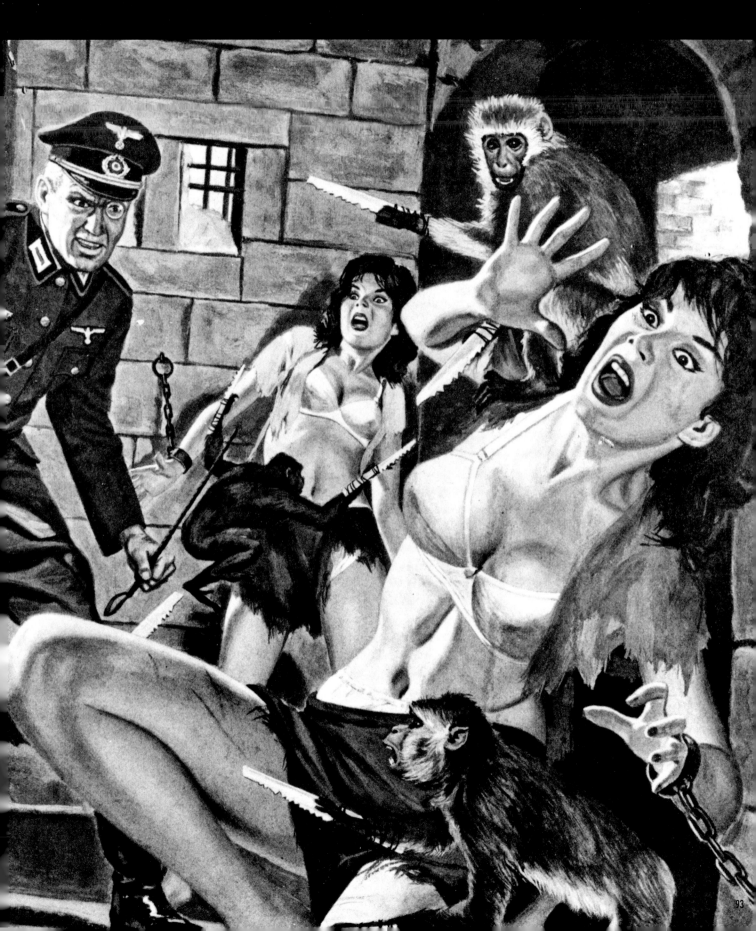

We watched as Louis sank to the ground in agony, his body settling in a pool of his own blood. The Nazi officer, Merode, turned his back on him and snapped his fingers. One of Merode's troopers came running up with a monkey on a leash, and handed the leash to Merode. The monkey jumped on the Nazi's shoulder. The monkey was one of the beasts Merode had taken a fancy to at the old city zoo where he had set up his headquarters. He had trained it to his command.

Leaving Louis Sebal in the dirt where he had fallen, the Nazi brute, with the monkey on his shoulder, strode across the road to Rita Dulois and Helene Mouton where they stood in shock at Louis' death. The Nazi ran his hand over them defiantly and then pushed them towards a covered van. When they came briefly out of their shock and tried to resist, two of Merode's men roughly threw them inside the van and drove them away in the direction of the zoo.

THAT NIGHT Pierre Dulois and I painted our now famous *couper la main* warning on the side of one of the houses in Ferlanc. This was the message that warned Colonel Merode that if he dared to lay a finger on the two underground women he had taken prisoner, we would cut his hands off.

Merode had been furious when he had seen the sign. He had held his pet monkey high in the air to look at the sign. Then he had summoned the mayor and the people of the town to the square. "I will teach the underground a lesson they will never forget for this!" Merode had screamed. "They will have their girls in parts like chickens if another of these signs goes up!"

The humor in the Nazi's hysterical outburst was not apparent to us at the time. All we knew was that our threat had done no good. If anything it had put Rita and Helene in greater danger in the hands of that madman.

We had no choice. We had to make an effort to break into the Nazi compound, into the old zoo they had commandeered as their headquarters. And from that death trap our task was to rescue Rita Dulois and Helene Mouton from under the noses of a score of Nazi guards.

Two nights later, Pierre and I made our way to the old stone wall that enclosed the zoo. As a child I had often sneaked into the zoo through a secret entrance when my parents, for one reason or another, had not given me the price of admission. Now I led Pierre through the darkness to that secret entrance.

On the west wall of the zoo, just a few yards from the giraffe compound, the branches of an overhanging tree lay on the top of the wall. Pierre and I climbed that tree, taking a long pole with us. When we dropped to the top of the wall, we balanced the pole at an angle to the ground from the top of the wall, and then slid down the pole inside the zoo.

OUR FEET had hardly touched ground inside the zoo when we heard something coming towards us, crashing through the bushes. The moon came out, and in that instant we saw a huge black dog racing for us, saliva dropping from its jaws. It hurtled at us and then leaped. I shoved Pierre out of the way as the dog shot through the air on a line with our throats. Desperately I put my arms around the pole down which we had just slid from the top of the wall to the ground. Holding the pole like a spear, I twisted its pointed end around in the direction from which the dog had launched its attack.

The dog's jaws were wide open. I lunged toward him, and rammed the end of the pole into his gaping mouth. The pointed end of the pole drove right down his throat, deep into his bowels. The dog let out a horrible choking cry, and then the end of the pole drove through its soft belly. For a few seconds the dog twisted and screamed, and then finally its struggles ceased and we knew that it was dead.

The dog's growling and agonized screams had drawn the attention of one of the Nazi guards making his rounds in the western section of the zoo. I saw him running down a path now to investigate the noise. I slipped behind one of the bushes and waited while Pierre stood his ground.

The guard came to a halt a few yards from Pierre. He brought his Schmeisser pistol up and trained the muzzle on Pierre's belly. "Who are you?" he grunted. "What do you do here?"

I slipped in behind the guard. He did not hear me; his attention was concentrated on Pierre in front of him. I smashed my fist against the base of his neck. The Nazi staggered and Pierre wrenched the Schmeisser out of his hands and dropped it to the ground. I got one hand around the Nazi's head, clamping his mouth shut, and with the other twisted his arm behind his back. Then Pierre stepped in close, and before the horrified Nazi's eyes, he slit his throat. I let the Nazi go, and he slid to the ground, the blood gurgling out of his throat, his jugular vein and his vocal cords cut.

We kicked the guard's body into the bushes and then moved into the zoo itself. Cautiously we went from one shadow to the next, running and then dropping to the ground to make sure that we had not been observed. We went past cage after cage of wild animals, the lions, tigers, monkeys, all nervous, all scenting the blood that had been spilled that night.

We headed on a broken line for the administration building. We could see a light in one of the rooms there, and we figured we would find Merode and the women there. Only one thing stood in our way at that point – the guard who paced back and forth in front of the entrance to the administration building.

THERE WAS a wide apron of concrete around the entrance. It was impossible to hide behind a bush and take the guard from behind by surprise. This would have to be a frontal assault.

I waved Pierre to the side. He nodded at me, his knife between his teeth. Then I stepped out on the concrete apron in full view of the guard. I was doubled over, my hands clamped over my belly. I moaned with pain and staggered towards the guard. He stiffened with surprise and aimed his gun at me. I staggered towards the guard, praying that he would wait, that his finger would not suddenly tighten on the trigger and bring my little ruse to a bloody end.

Two steps from the guard I pitched forward and fell face down on the ground in the moonlight. The guard studied me cautiously for a moment. Then he stepped forward, crouched at my side, laid his weapon down, put his hands on me, and rolled me over. It was a fatal mistake.

I reached up and pulled him down with me. At that

instant Pierre left the shadows and raced towards us, his knife glinting in the moonlight. The Nazi cursed in my arms, desperately trying to free himself, clawing for his gun, cursing his own stupidity. I saw Pierre towering above us, his arm held high, and then sweeping down. The Nazi stiffened in my arms as Pierre drove his knife into the German's back, right up to the handle. The tip of the knife came out through the front of his chest and pricked me through my clothes.

I rolled away from the dying Nazi and got to my feet. Pierre wiped the blood off his knife. Together we moved into the old administration building. We edged down the dark corridor, our senses straining for some sign of the presence of Merode and Rita and Helene.

AND THEN we heard it, the low moaning of terror. At my side, Pierre stiffened. "That is Rita," he said. "I know her voice anywhere."

The moan of terror turned into a piteous little cry of pain that ran our blood cold.

We threw caution to the winds. We ran from one corridor to the next, seeking out the source of the cries we heard. Finally, down one long dark corridor, we saw the beam of light coming from underneath a door.

Pierre and I ran down the corridor. We braced ourselves, and then hurled our bodies at the wooden door. It splintered inward before the assault of our bodies, and a scene of horror, created by the sick and diseased mind of the Nazi, Rudy Merode, burned itself into our brains. The Nazi had apparently taken our warning literally – that if he laid a hand on the girls, we would cut his hands off. He was not laying a finger on them. For that job he was using the little animal he had trained – the monkey he had taken as a pet.

For Merode had just let the monkey out of its cage, turning it loose to attack Rita and Helene. And the singular and horrible thing about the monkey was that Merode had tied knives to its hands and feet – serrated knives with saw-tooth edges like the one he had used to disembowel Louis Sebal.

The monkey was swarming all over the girls. Its wild, erratic hand and foot movements were moving the serrated knives like saws – cutting into the exposed flesh of the girls, drawing blood. The knives were catching in their clothes, ripping them apart, exposing their naked and bloodied flesh.

PIERRE WENT for the monkey while I dived at Merode. Pierre picked up the little beast and flung it against the wall where it smashed with a sickening thud. It lay lifeless against the wall.

Together Pierre and I disarmed Merode. Then we untied the girls. The Nazi was indifferent to the fact that his fate lay in the hands of two desperate men who were willing to stop at nothing, including murder, to get the two girls out of that horror house alive.

He taunted us. "Kill me," he said. "I do not care. It will be for the Fuehrer. And when the Gestapo finds my body they will come in to this town and destroy it and every living being in it. What I have done here is nothing as compared to what they will do."

Merode chuckled at the picture forming in his evil mind. "The Gestapo," he said, "will put every man, woman, and child to the torch."

We shoved Merode out into the corridor and then took him down the hall and out of the old administration building. "You are right," I said to him, "about what the Gestapo will do if they find your body."

Merode smiled. "Now you are sensible," he said. "Turn me loose. Throw yourselves on my mercy."

Pierre laughed a short, brutal laugh. "The Gestapo will never find your body," he said.

"You underestimate the power of the Gestapo," Merode said suspiciously. "I tell you they will find me."

UNFORTUNATELY FOR him, Rudy Merode, Nazi, murderer, sadist, had underestimated the inventiveness of the underground. Pierre and I ran Merode along, and the two girls trailed behind us. When we came to the high fence behind which the lions were pacing, we slipped open the door and flung Merode into the lion compound. The beasts threw themselves on him and tore his body apart, devouring him before our eyes. In a short time, Rudy Merode was no more.

We rushed to the fence, got the girls over the wall where the tree branches touched, and then got them to a doctor sympathetic to the underground.

Time proved that one mystery the Gestapo never solved was the disappearance of Rudy Merode, the sadistic prince of the town of Ferlanc in Occupied France.

1,000
NAKED BEAUTIES
FOR THE
DEVIL'S PLAGUE

The raging epidemic gave the beast his opportunity to carry out a hideous plan of agony and murder.

FOUL PESTILENCE CREPT across the land like a curse, leaving a hideous trail of death and madness in its wake. Sparing neither rich nor poor, it struck both master and serf alike, decimating half the kingdom and turning those who survived its fearful ravages into babbling maniacs obsessed by superstitious dreads.

Throughout Guyenne, Gascony, Languedoc and all the southern provinces of France, grim prophets of hell and damnation howled their doleful tidings of baleful things to come: "Damned! Damned! All are damned unless the wicked are punished! Hellfire and burning! The sky is falling and all are doomed… doomed! Take heed and slay the heretics!"

Nowhere were the voices more strident and demanding than in the ancient city of Toulouse, capital of the Languedoc. Here the demented dirge of hate rose in unison, swelling to a crescendo of vile vituperation, inciting the citizens to a frenzy of bloodlust, playing on their fears of guilt and doom. And always the target of this invective was the same – the Albigenses.

Known also as Bogomils and Cathars, these unfortunate and harmless followers of a forbidden and esoteric sect were doomed to perish in one of the most savage massacres to shame the blood-soaked pages of medieval history. Damned as heretics by the Church, these simple disciples of an outlaw cult were fated to be made the scapegoat for a senseless civil war and the outbreak of one of the most terrible plagues ever to blight the fair face of France. Toulouse, whose dungeons and

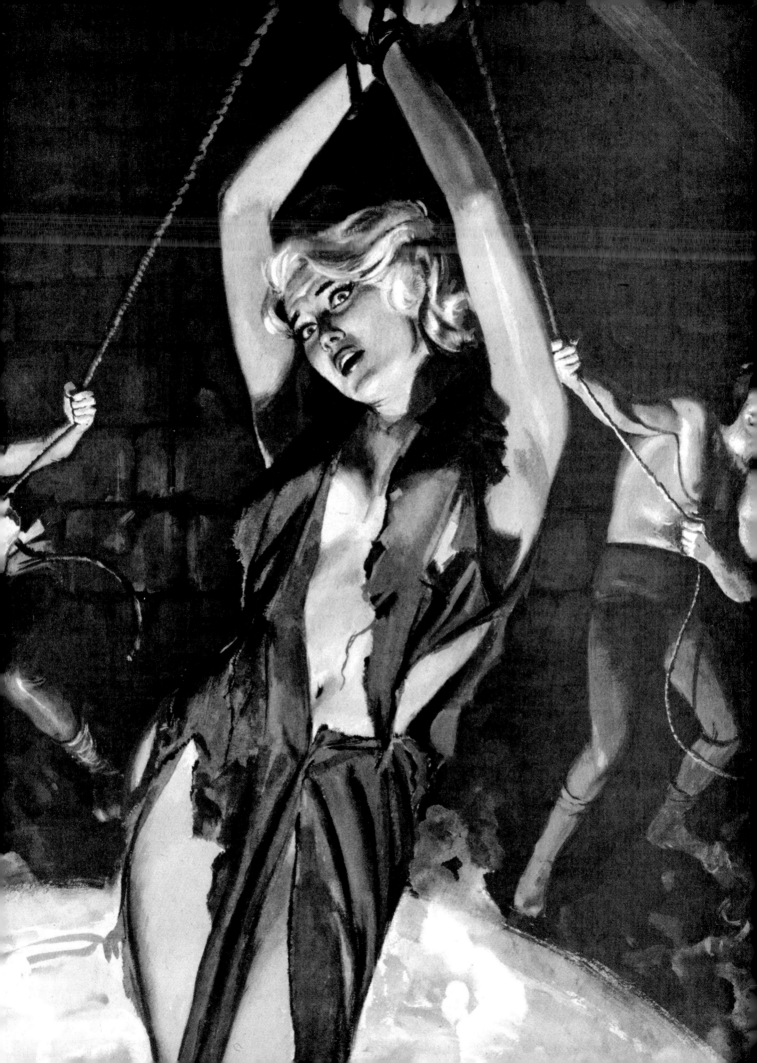

torture chambers were soon to echo with the moans and screams of the Albigensian martyrs, had been the haven of these much persecuted heretics. Now it was the stronghold of their sworn enemy, Simon de Montfort.

Fanatical warlord and religious zealot, de Montfort had defeated Raymond VI, Count of Toulouse and protector of the Albigenses, at Muret. The Count had managed to flee to England, but his wife, the ravishingly beautiful Anne-Marie, had been captured.

On being proclaimed Lord of Toulouse and Montauban, de Montfort had been enjoined by Pope Innocent III to massacre the Albigenses. This the conqueror did, turning the lovely Countess of Toulouse and other suspects over to the Holy Inquisition.

Spread like a spider's web across the face of medieval Europe, this sinister brotherhood turned day into night in its efforts to wipe out all heresies, creating a hell on Earth as it strove with fire and rack to shackle men's minds. In Toulouse, Beziers, Carcassone and other centers of the Albigensian heresy, the scarlet torturers worked overtime.

And at the hub of this insidious network of fervent assassins crouched the loathsome figure of the Grand Inquisitor, Pierre Gui.

If ever the popular conception of Inquisitors as sadistic monsters gloating over the agonies of their innocent victims was justified, it was by this fiend in human form.

A misshapen hunchback of truly monstrous appearance, Pierre Gui was a bloodlusting ghoul who satisfied his unnatural lusts under the cloak of legal sanction.

It was this perverted beast who now had the young and beautiful Countess of Toulouse in his power. If he could force her to confess that she was herself one of the Albigenses, thus implicating her husband, this would serve as a pretext for the Count's excommunication.

HUNCHED OVER a long table covered by a scarlet cloth, Pierre Gui looked like some hooded bird of prey, his cowled and vulturine figure dominating the chamber of interrogation. Eagerly he eyed the Countess who stood before him in chains.

Even the dungeons had failed to dim Anne-Marie's radiant loveliness. She stood there numbly, clad only in a tattered silken shift, facing the Grand Inquisitor with downcast eyes and mouth trembling in mute appeal.

Pierre Gui's dark eyes narrowed behind the folds of his purple cowl, as he etched away the flimsy garment the girl was wearing to give himself an imaginary picture of her youthful body, soft and sleek, full in breasts and hips, tapering away on long, flawlessly-made legs.

He saw a little tremor go through her under his lustful scrutiny, and he caught his breath sharply at the thought of this enchanting young woman chained and naked in the torture chamber… completely at his mercy… her smooth, well-kept flesh his to mutilate and destroy.

He cleared his throat and said in a voice deceptively benign: "My child, we have been very patient with you. We've given you time to meditate and reach a decision."

The Countess lifted her eyes to meet those of her Inquisitor. "Yes."

"Have you reached a decision?"

"Yes."

"And do you now confess that you are a member of the heretic cult, as was your traitorous husband?"

"No."

"You understand that if you confess your sin and abjure you'll not be tortured?"

"I understand."

"Yet you refuse to confess?"

"I am innocent."

"Is that your final statement?"

"Yes."

"Then we must force you to recognize your wickedness."

"I – I pray God will give me strength."

Chuckling inwardly to himself, Pierre Gui turned to the guards at his back. "Take her to the place of mortification," he hissed.

And Anne-Marie, knowing what was coming, swooned.

MOISTURE GLISTENED on the red-lit walls of the chamber. The place was airless, dank and stiflingly hot. The Countess's nostrils were filled with the stench of sweat, burning sulphur and the acrid smoke of fires that shed an eerie glow over everything.

Though she did not yet fully appreciate where she was, her grim surroundings paralyzed Anne-Marie with terror. Her every sense detected the presence of evil.

The hellish flames disclosed a number of rusty chains looping down from the smoke-filled ceiling of the chamber. They were terminated by thick manacles that shone with human gore. In a corner, the Countess saw an empty iron cage – evidently too small to hold a human being. Yet some sixth sense, some intuition told the frightened girl that people had been locked inside it… or what purpose she could not, would not guess.

But now she knew – with a stomach-churning certainty – what manner of place she was in when she discerned through the hanging curtain of smoke a monstrous crucible, bubbling with a molten lava of boiling pitch. And she guessed the moment she saw it what the pulleys and chains and the iron cage were for, and she knew that this place of fiery horror was that nadir of human misery – a torture chamber.

Out of the swirling sulphurous fumes a familiar voice addressed her, its source a looming figure standing in the murky shadows. It was the Grand Inquisitor, Pierre Gui.

"I will give you one last chance to confess," he called in ringing tones. "Abjure and save yourself."

Two demon figures moved into the Countess's line of vision. They wore hoods of black cloth and their heavy masculine bodies were stripped to the waist. Glistening beads of sweat ran through the matted hair of their chests.

"Do you confess?"

"No," Anne-Marie replied dully, her voice seeming far away and unreal.

The Grand Inquisitor inclined his head and one of the men dragged down a set of manacles on chains. Quickly, he

locked them on the Countess's white wrists. Meanwhile, the other had begun to turn a crank; slowly, the chains straightened and lifted and the girl felt her arms rising. In a few moments she had been lifted off the floor and her lovely naked legs were kicking in the air.

NOW THE full horror of her situation penetrated Anne-Marie's mind, as the horny hands of the hooded torturers swung her chained body over the lip of the crucible.

She hung there, her nude body rotating slowly over a hellish brew of boiling pitch, staring in mind-numbing terror through a blue haze at the bubbling inferno below her. Monstrous blisters rose and burst upon its scummy surface, giving the impression of some gigantic devil's cauldron.

"Dear heaven!" she shrieked. "You can't leave me here!"

A mocking laugh was her only answer, and the Countess, glancing fearfully in the direction of the sound, saw Pierre Gui's demented face grinning up at her from under his cowl.

"Confess," he screeched. "Confess your abomination and you shall be spared."

The monster clutched a whip in his hand. Multi-thonged, barbed, blood-encrusted, it was the dreadful scourge of the Inquisition, the nine-tailed *flagellum*.

Fear was a sickening knot in Anne-Marie's belly as she saw the monster's arm jerk savagely up and she felt the agonizing cut of the lash across her soft and naked back. Pain burst before her eyes in a white hot flash, and the supersensitive flesh of her nude body writhed in excruciating torment above the seething surface of the molten pitch.

Pierre Gui stood across from her, whip in hand, a grotesquely humped and purple-shrouded figure intent on his victim's humiliation, pain and misery.

"Confess," he cackled. "Confess, you harlot of hell."

Again and again the vicious lash streaked out, biting into the Countess's soft shoulders, slashing the smooth and tender hips, making her satiny thighs jump under its vicious caress.

Pierre Gui watched her gloatingly, noting how the glow from the fires cast a ruby sheen over the girl's suspended body. Delightedly, he observed how the flickering light of the flames moved across his victim's ivory skin, starting at her ankles, moving up her long thoroughbred legs, her sleek young thighs, her voluptuous hips, over the gentle heave of her belly, across the thrusting peaks of her fantastic breasts to the twisted mask of agony that had once been a beautiful face.

The Countess hung there, fully conscious, a column of martyred beauty in that fiery chamber of ugliness. Her long and lustrous blonde hair that had been her husband's special delight spilled over her bare shoulders in a golden tide of waves and curls, and her lovely body, criss-crossed by a network of livid red gashes, writhed in a way that made her breasts rise up higher and firmer.

Sobbingly, the girl prayed for the mercy of unconsciousness that never came. The whip flayed her unmercifully and still she remained conscious – fully, horribly aware of the agony of her body. Waves of intense and painful

heat engulfed her and she was almost suffocated by the smoke – almost, but not completely.

Through the blazing pain that rippled almost visibly before her eyes, she found time to marvel at her own fortitude and to wonder why she hadn't confessed. "Give me strength," she groaned.

Just discernible now in the smoke that filled the chamber, Anne-Marie could see the Grand Inquisitor observing her with pitiless eyes. Like something out of the Inferno he loomed, watching her driven by the searing heat of the flames to the threshold of madness, the hellish glow lighting his evil face in Satanic ecstasy.

From time to time the monster demanded, "Do you confess, you creature of damnation?" And when she did not reply, he sent his diabolical lash snaking out to flay her blood-spattered body, shouting to the torturers to lower her nearer the bubbling surface of the boiling pitch.

"Confess," he howled. "Abjure while there yet is time."

Slowly, agonizingly slowly, Anne-Marie lifted her pain-wracked eyes.

"No," she croaked.

Her answer seemed to drive Pierre Gui berserk. Madness, red-lit and infernal, shone out of his eyes. "Die then..." he ranted. "*Die, you blasphemous witch... die... burn... die!*"

With a howl of rage, he pushed the torturers out of the way and grabbed the crank himself. There was a sudden whir of the winch, a rattle of chains, and all at once Anne-Marie was falling, and the bursting black bubbles were rushing to engulf her as she plunged toward the gyrating eddies below.

Inhuman shrieks tore from her mouth as her feet touched the boiling pitch. Her brain exploded in an eruption of blazing agony too excruciating to bear as the scalding viscous liquid slid over her tender body...

"Die..." yowled Pierre Gui, his enjoyment rising to fever pitch. "Die... burn slowly... die..."

THUS IT was, according to the French historian d'Espaignet, that the lovely Countess of Toulouse perished at the hands of the odious Pierre Gui, beautiful martyr to a cause she knew little of. For the irony of it was that Anne-Marie was as good a Christian as ever stood upon the Earth – the innocent victim of a monster who really did the Devil's work.

But Anne-Marie did not die alone. Thousands of those her husband had protected were to die, too, in one of the greatest slaughters of the innocents of all time.

Blood ran like water, as men, women and children were put to the sword. Estimates of the victims run as high as 50,000 – and these were the lucky ones. Thousands, like the beautiful Countess, died horribly in the subterranean chambers of the Inquisition, where the rack, the strappado, the boot, the lash and the hideous iron maiden were just a few of the vile tortures used on those suspected of heresy.

And what was this Albigensian heresy for which so many died? To discover that one must return to the dawn of mankind.

The subtlest and most remote of all the influences that

infiltrated Christendom came from the East, and as it moved westward it assumed many different forms. But the original concept behind the appearance remained unchanged. It was a ruthless and uncompromising dualism. It was based on the idea of two principles of light and darkness which were held to have existed from the beginning of time. They were held to be absolutely opposed and in continual conflict. In time this unresolved dualism was modified by the supposition that the principle of light, Ormuzd, would overcome that of darkness, Ahriman. Medieval men, like those today, probably recoiled from the concept of a universe in which nothing was ever settled.

This war in heaven between impersonal forces became in time an organized religion. Known as Manichaeans, Cathars, Bogomils and Albigenses, the believers of this Mithraic doctrine of the indeterminate struggle between black and white were soon Christianity's most dangerous rival – or so they were seen by the hierarchy of the Church.

Eventually, after years of internecine warfare, massacres, tortures, and a pogrom as ruthless as any inflicted on mankind, the Albigenses were exterminated, though the Great Manichaean Heresy lived on through the centuries to degenerate in time into the loathsome creed of Satanism.

HARSH AND and unrelenting as the Inquisition was, it would be a mistake to believe that monsters such as Pierre Gui were typical Inquisitors. Most were truly zealous men of ardent faith whose only concern was to save souls from eternal damnation; only a few used the cover of their office to indulge abnormal appetites.

And it is gratifying to discover that most of those who did, came to a sorry end. As the old adage runs, "The mills of God grind slowly, but they grind exceedingly fine."

This was certainly so in the case of Pierre Gui. How many beautiful young women died for this fiend's private pleasure will probably never be known, but d'Espaignet estimated that the number might run into the thousands. Hence it is a strange and particularly apt stroke of fate that it was the death of one of these young women, the ill-fated Countess of Toulouse, that spelled the butcher's doom.

For when Raymond VI was restored to his realm, the Grand Inquisitor was faced with the difficult task of explaining to the Count just what had befallen his wife.

In vain did the now terrified Grand Inquisitor offer bribes of gold in an attempt to silence those who rushed to testify against him. Uselessly he protested his innocence. Shocked beyond all measure by the terrible accusations piling up against Pierre Gui, the church, far from defending the wretched Inquisitor, insisted he should be tried by a special ecclesiastical tribunal.

Half-crazed with terror, this butcher of countless innocent young women was cast into a dungeon to await his fate under the greedy eyes of starving rats. When finally he collapsed from exhaustion, these loathsome rodents chewed off pieces of flesh from the extremities of his body.

The days passed slowly, a living hell of horror and degradation, and the thought of God's punishment was never far from the monster's guilt-ridden mind.

In his misery he banged his skull against the fungus-covered walls of his dungeon, mocked and jeered at by the guards because of his hideous humped back, screaming his abject terror out loud. Exhausted he slumped back onto his filthy bed of straw, prodded by the guards for the amusement of the wenches they brought to watch him.

Finally, looking more like a beast than a man, Pierre Gui, Grand Inquisitor for Languedoc, was led in chains before the special tribunal set up to judge him.

Found guilty of abhorrent and unnatural crimes, he was sentenced to be burnt alive.

The day of Pierre Gui's execution, the city of Toulouse was bedecked as for a gala holiday. Great fleecy white clouds drifted across the morning sky, and the sun bathed everything in its golden light.

It shone on the grim walls of the Chateau St. Michel, where the doomed man was imprisoned, and on the happy faces of the crowd that waited to see him die.

As a solitary bell dolefully tolled the dirge of death, the gates of the castle slowly swung open, the great portcullis lifted, and a solemn procession came into view.

In front was Raymond, Count of Toulouse, a tall spare man with a crusader's red cross upon his white scapular. Then came a group of Benedictine and Cistercian monks in black and gray robes, their heads bowed in prayer. These were followed by the wretched figure of Pierre Gui, broken by torture and barely able to walk, and the sinister executioner dressed entirely in scarlet. Spearmen flanked them on both sides, and to the rear rode the Archbishop and two Vicars General of the Holy Inquisition.

Pierre Gui had to be carried the last few yards to the stake, so great was his fear. Hastily he was shackled atop a great pile of tinder-dry faggots and the pyre was set ablaze. Unlike many persons burnt alive in medieval times, the renegade priest was not suffocated first. He was made to die slowly in the flames.

As the monster began to jerk and dance and cry out in pain, the crowd, made up almost completely of women, pressed near to watch him die, screaming with laughter at the spasms of his death agony.

Slowly, as slowly as the skill of the executioner could effect, Pierre Gui died, paying for his foul crimes with pain as great as that he inflicted on countless victims, twisting and writhing and clawing in unendurable and prolonged agony.

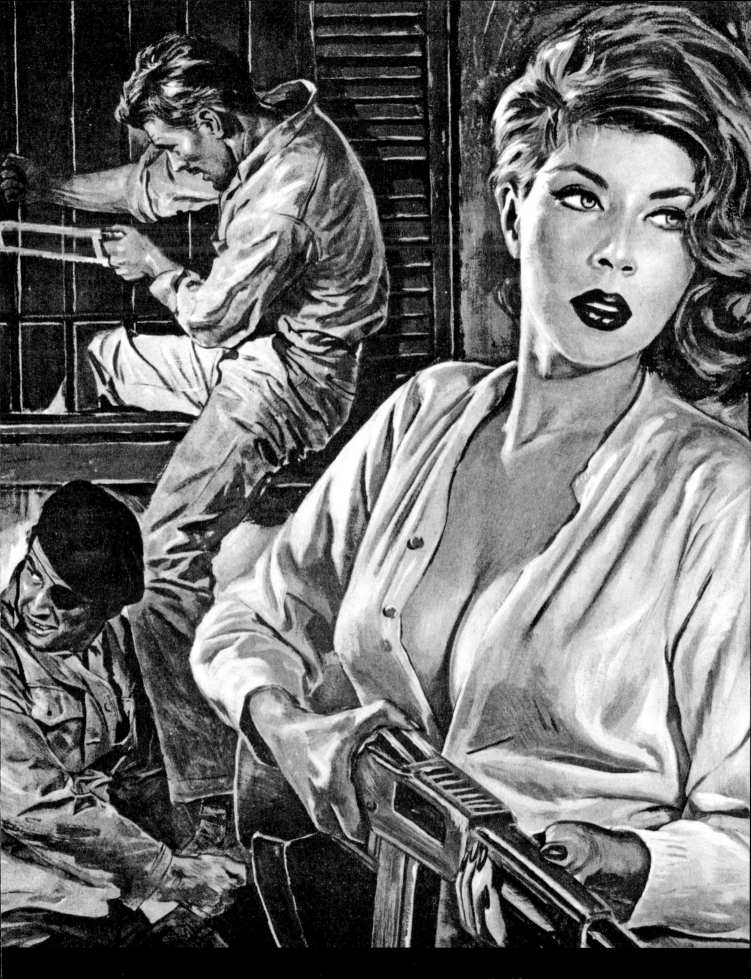

"I LED THE HARLOT LEGION OF ALGIERS"; detail from interior art, **MEN TODAY**, 09/62.
Art uncredited; signed Norm Eastman.

THE STRANGE REVENGE OF WHEELCHAIR CHARLIE

He was only half a man – but when the chips were down, he called all the shots!

I'VE GOT TO SET it down on paper; it's the only way to communicate with the outside world because my family (what's left of it) and my former associates on both sides of the law must never know what became of me. I changed my name and went out west where I succeeded in becoming a mink rancher – because I can't ever go back. It's been many years since I turned in my badge and fled, but there are still men waiting for me, patient and vengeful, with sullen faces and deadly trigger-fingers.

I was a good cop, with a zeal for my work and proud to be on the force, until Charlie Cianelli took it away from me – or, rather, until I sold out to Charlie when I became a cop on the take. By the time I knew him, I was a lieutenant, capable of reassigning men to beats where he and his punks could work unmolested.

The end of prohibition in 1933 forced mobsters into other channels of crime: gambling, graft, girls, moonshine and narcotics. Charlie Cianelli made a specialty of extortion. No businessman was safe from his shakedowns, and if any dared to brazen it out with him, he retaliated in such a way as to discourage others.

A wholesale butcher was reported missing for three days until on the morning of July 5th his body was discovered hooked through his throat, hanging in one of the refrigerators in his market at 12th Street off the Hudson River, his spilled guts frozen to the floor slats. A garment manufacturer made the mistake of defying Charlie and ended up a month later incapable of ever challenging anyone again. His tongue had been ripped out, leaving him only the ability to utter animal-like sounds.

That was Charlie Cianelli, bold and ruthless, buck-hungry and power-greedy. He was tall and slim with fiercely burning coal-black eyes, and his resemblance to Rudy Valentino was heightened by his expert tango. He was smooth, all right, and he used to say if it hadn't been for his success as a racketeer, he'd have turned pro. He had 100 pairs of shoes, each shined to a mirror-finish, which he used to switch several times a day.

Charlie was going great guns – .32s, .38s, shotguns and sawed-off tommy-guns – when the turning-point came in his career in October 1934. Recognizing his notable achievements in pressuring merchants to pony up monthly payments, the big boys made a play to bring him into their inner circle. Joe Kulak, Lepke Buchhalter, Bull Hanlon and Babe Martino each tried to swing him into line, but Charlie refused their offers.

"I'd rather be a big fish in a small pool than a small fish in a big pool," was his repeated reply.

But these terrorizers had their own methods of persuasion. A torpedo named "Scars" Scarletti, imported from St. Louis, was sent to Charlie's Central Park West apartment to change his mind. But Charlie was a master of the squeeze play himself. Scarletti's bullet-ridden body was dredged up from the Gowanus Canal the next day, which demonstrated to everyone that Charlie wouldn't tolerate being in the pressure cooker any longer.

Still, Charlie made one mistake that was to have a permanent effect. Instead of leaving well enough alone after he'd proved his point, he decided to put Babe Martino on the receiving end. "I'm going to move into Hoboken and take over his territory. Let's see how he likes it when the shoe's on the other foot!" he boasted.

"You think that's smart?" asked Midge O'Bannion, one of his stooges. "Martino's a punch-drunk powerhouse. You're askin' for trouble!"

"Not asking, but *giving* trouble! I want to teach him a lesson so no mug will ever try to muscle in on me again!"

ON THE night of November 5th, Charlie, Midge and a couple of goons rode out to Hoboken to deliver his ultimatum. Martino listened in sinister silence to Charlie's invasion plan, which he detailed as he squeezed the crease of his trousers and examined the high shine on his shoes. Martino eyed him like a tamed wild bull, let Charlie and his cronies walk to their Packard parked at the curb, gloating over their easy triumph – then the murderous chatter of a tommy-gun cut through the

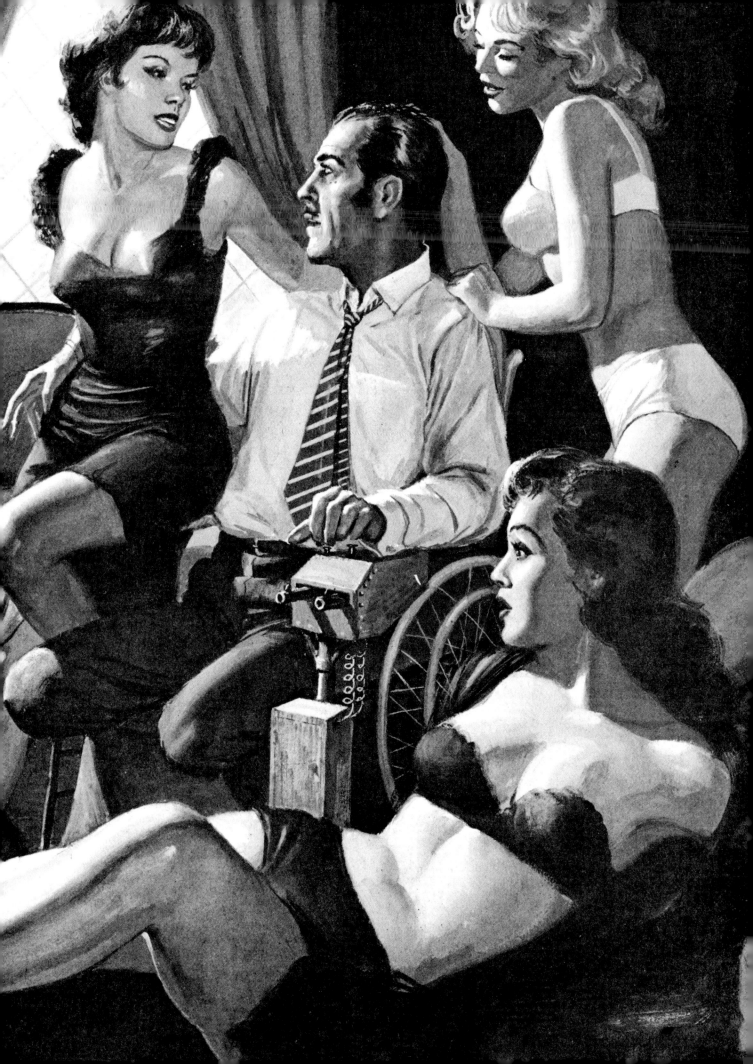

lonely boat whistles echoing from the Hudson. Midge fell face forward, blood pumping from his back as if it were a sieve. One of the gunzels was decapitated, the wide-eyed look of horror frozen in a final expression on his pimply face: the other was ripped across the stomach. But Babe Martino reserved a special fate for Charlie Cianelli. Nothing so humane as sudden death. No, he wanted to give him something to remember him by every waking moment. Tommy-gun lead chewed right through Charlie's knees, sending him sprawling onto the sidewalk like a guy toppling off a pair of stilts, a sob of agonized pain choking in his throat.

Between surgery and transfusions, the doctors did a good job of saving Charlie's life. Since I was on his payroll, I took the chance of slipping up to see him one night, using my daughter Nina for an excuse in case I was spotted. We were visiting one of her friends, was my pretext. Charlie lay there, pale and quiet as a ghost, never taking his eyes from the two stumps under the thin blanket. He never uttered a word until we were ready to leave.

"Nina, wait!" he suddenly whispered.

His eyes gave me the cue to exit. I closed the door but I wish to heaven I could've closed my ears. They'd been carrying on for some time without my knowledge, that hood whose $200 suits, manicured nails and 100 custom-made shoes still stamped him a dirty mug, and my daughter, my darling Nina with the cool gray eyes and hair like a cloud of smoke, whose 18 years belied her worldly experience! What a bitter pill that was to swallow! I'd condemned myself in my own eyes, taking Charlie's payola to send her to the best schools, to give her the best clothes, to nourish her with enough love for two parents when her mother had died!

And now, this cultured girl, with the curves of a Petty model and the prettiness and poise of a magazine cover girl, had slipped into the slime. If opposites attracted, these two had come together with the power of a magnetic force. And all the time, the deceit had been going on in front of my own face. I remembered the closed door to Charlie's bedroom, the fresh fragrance of expensive perfume, the lilting soprano singing in the shower, the black lace negligée thrown carelessly over a chair, the lipstick smear on his cheek as he emerged from the bedroom.

I wanted to run when I heard Charlie's voice behind that closed hospital door. "You got to forget me, baby!" But my feet were cemented to the floor.

"No, I won't, sweetheart," Nina said. "You're still more of a man than most men with... with..." she faltered.

"Go on, say it – with two legs!" he snapped savagely. "Are you kidding? I'm a freak, a cripple! Sure, it's okay for you to say it now, but what are you going to say when I tumble – yeah, fall on my backside into bed alongside of you? You'll get sick to your stomach! Go on, beat it, baby! We had it, and we had it good. Let's remember how it used to be, and let it go at that."

"You're not getting rid of me so easily, darling. They amputated your legs, but you still have the most vital part which interests me."

I couldn't face Nina when she came out. I raced down the corridor, ran down the steps two at a time and into the oblivion of night.

Once or twice, I tried to bring up the subject at home, but I couldn't confront Nina. I broke with Charlie Cianelli without any elaborate explanation. I merely stayed away, and the first inkling I got that he was back in business at the same old stand was in January of 1935 when a bulletin reached the precinct concerning the discovery of an attack victim reputed to be Babe Martino in an alley off South Street. I hurried down to Gouverneur Hospital. In that bed was Martino, all right, or what was left of him. Charlie's revenge was the most horrible I'd ever witnessed in 21 years on the force. Martino's legs were gone, so were his arms. Charlie's hatchetmen had reduced him to a quadruple amputee, a head mounted on a torso without arms and legs; a basket case, a helpless hunk of humanity that had been spared a merciful death so that he might live out the end of his days in this incredibly brutal manner!

IN THAT same month, Charlie began his moves to recover the ground he'd lost to the syndicate, which had moved in during his absence. He returned to business with a bang, the bang of an automatic when anyone dared to oppose him. Guns were the quickest weapon in his arsenal, but intimidation was the most effective. When Nick Fortunino, a Bronx building contractor, refused his shakedown demands, Charlie saw to it that he was permanently embalmed in the building under construction. Still alive after a severe beating, Fortunino was dumped into an upright pillar mold, the cement poured onto him. News of the victim's disappearance and the concrete tomb prompted other contractors to kick in without a murmur.

Charlie's bizarre and brazen tactics offended the syndicate, which tried to operate without newspaper publicity. They decided to meet the threat head-on and get rid of him. Charlie had phoned me that day, curious about my long absence, and had asked me to drop in that night. On the way up in the elevator, I vowed to make a break – before I killed him in a reckless, desperate moment and bring death not only to myself but to Nina at the hands of his hired assassins.

I shook off the exuberant shoulder clasp of the gunzel at the door who admitted me, and walked into the lavish, book-lined living room. Abruptly, from down the corridor, I heard Charlie's raging voice:

"I told you to get rid of 'em, every pair of those blasted shoes! I never want to see 'm here again, or I'll ram 'em down your throat!" A few minutes later, he rolled himself into the room, a pitiful figure, half a human huddled in a wheel-chair, a blanket draped over his sawed-off knees.

"Long time no see," he greeted me. "What's been bugging you? You playing it hard to get for a bigger bill every month?"

I had to wrench my eyes from his wheel-chair. My throat was dry, my tongue heavy. I was trying to splutter a reply when the gunzel announced that four syndicate hoods wanted to see him.

"Let 'em in! I been expecting them," said Charlie, baring his teeth in a narrow smile.

What was he doing, committing suicide? I asked myself. How could a helpless invalid protect himself from an obvious attempt on his life? The gunzel thumbed in the four

visitors, made them sit down despite their objections. The reason was obvious. "Wheelchair" Charlie didn't want anyone taller in his presence. And the reason for their arrival also was obvious. The boss wanted Charlie to curl up in a corner and stay there.

"Listen, you slobs! You go back and tell your keeper that Wheelchair Charlie is still king of the rackets – even if he's still sitting in a pushmobile. Tell 'em to stay out of my way – or Martino will have a few playmates!"

Aware of Charlie's helplessness, two of the mugs pulled guns from their shoulder holsters. Their look of surprise turned to terror as Charlie suddenly and surprisingly triggered a panel on his chair's arm rest, unleashing a fusillade of fire from the guns secreted under the arm rest. The other two never reached the door they fled to. Charlie had only to tap a switch than the wheelchair's motor roared him forward, and bulletproof glass panels slid up around him to deflect the slugs one of them protectively fired back. Again, the guns under the arm rest let loose a fatal blast.

Charlie smirked as he surveyed the four carcasses through the cloud of cordite. "Wheelchair Charlie's still the big wheel, thanks to this baby," he said, patting the side of the chair. "We're inseparable. Yeah, I got all the comforts of home. You know something, copper? I ain't as bad off like some other guys. Come on, I'll show you!" He wheeled himself out of the room, motioning me to follow.

The flattened-face flunkey was nervously packing the last of his shoes as we entered the bedroom. Charlie showed me the shower that had been altered to accommodate his chair, and other personal necessities which had been suitably changed. But his proudest possession was an electrical pulley device, which lifted him onto the bed, then proceeded to put him through some interesting but obvious motions. Charlie's cunning mind had enabled him to circumvent his misfortune by creating a machine to help him make love!

And I knew who his partner was! Through my mind danced a grotesque picture of my Nina, lying there nude, her beautiful body curved in wanton ecstasy, with wanting and welcoming arms, outstretched to embrace her hovering lover. God only knew to what extremes of perversity his insatiable lust forced him to since he couldn't make love like a normal man! I blotted the nightmare from my reeling mind and stumbled from the room.

I heard the purr of a motor behind me and pivoted as Charlie braked to a stop. "You're still interested in payola, ain't you, copper?" he sneered. "I got a coupla things lined up, but don't call me. I'll call you."

"I'm not for sale any more," I said, trying to keep my voice steady. "My palms have stopped itching. I'm cutting out, Charlie, and don't try to stop me!"

His eyes narrowed to pinpoints of hate. "Don't turn on me, copper! Remember, the bigger they are, the harder they fall!"

"If I fall," I said, looking back at him evenly with a resurgence of courage, "I knock over a lot of the garbage with me!" And I walked briskly, unhesitatingly, out of the apartment.

And right into Nina, about to enter. She'd moved out of our place a month ago, and now she seemed like a faun startled at coming face to face with a stalking hunter. The knowledgeable looks we exchanged made words unnecessary, but I said: "What do you see in that broken body? The idea of my own daughter consorting with a cheap hood like that was humiliating enough, but now..."

Nina paled. "It was all right for you to play footsie with him, Dad, wasn't it? It was all clean, innocent fun, wasn't it?"

What could I do? Excuse my former actions, explaining I'd done it all for her? How corny can you get, even if it's the truth, and the truth hurts? But Nina knew, yes, she knew.

"I didn't have to go to that fancy Connecticut finishing school after Mom died, then to that fashionable academy for young ladies to prepare me for Wellsley. It didn't make me into a lady, Dad... because I'm just like you. I like to make it the easy way. I'm a chippie off the old block!"

My head was spinning. I felt sick, a ball welling up in my stomach to spear from my throat. As I walked to the elevator, her voice knifed through the air:

"And don't worry about Charlie's capabilities. He doesn't have to stand on two feet to be a man. When he lies down in bed, he's just like any other man – in fact, better!"

I knew right then and there what I had to do. I went down to the precinct and filled out the forms requesting immediate retirement, refusing to answer Capt. Bissell's queries concerning my sudden decision; then alone in the locker room tried to pull my scattered thoughts together to form a plan to rid the world of Charlie Cianelli, the wheeler-dealer, the twin-threatening monstrous mobster who terrorized legitimate businessmen and triumphed in illegitimate love.

THE NEXT sequence of events began that night, when Charlie telephoned to tell me Nina had been so upset by our chance meeting, she was returning to me for good. She would meet me at the 85th Street entrance to Central Park at 11 o'clock. I hung up dumbfounded, confused by the sudden twist of events. But the thought of Nina coming home erased all doubts from my mind. It was only as I walked towards the park later that night that a strange suspicion began to nibble at my happiness. Wheelchair Charlie wasn't that generous; anytime he took something, it was for keeps, and if it wasn't useful to him any more, he destroyed it. His connections would've made it easy for him to learn that I'd requested retirement, a certain prelude to my exposing his corruption of me as well as others. Something smelled, and it wasn't fish – but rat!

Few strollers were out that brisk night of March 12th. The wind whistled eerily, trees and their swaying branches made mottled, mysterious shadows along Central Park West. Under the arc of the lamp-post, I saw Nina and quickened my pace. So it hadn't been a gag to smoke me out in the open, I thought. The light was dim but enough for me to see the quiver of her lips and the tears welling in her eyes. She threw out her hands to embrace me. An unobtrusive sedan, which had been slowly coming down the street, suddenly with a spurt roared past us, a tommy-gun spitting lead from a side window, biting into the wall behind us. I slammed Nina to the sidewalk, grateful that she hadn't been hit, until I heard a faint whimper

and saw crimson fingers fan out from her prostrate form.

Nina's operation at Lenox Hill Hospital lasted for two torturous hours before the doctor emerged from surgery. She would survive, all right, but one of the slugs had struck her spine, making it impossible for her ever to use her legs again. The irony of it! In using Nina to decoy me, to set me up as a clay pigeon for his hired gun, Wheelchair Charlie had crippled his sex-mate instead!

It wasn't coincidence that two days later, the corpse of the professional killer, shorn of all identification, was spotted and hauled aboard a barge plying the East River. Unable to nail him in the mug file at headquarters, I put out feelers until the FBI shot back a positive ID. He was Sammy "Silky" Webber, a Pittsburgh torpedo.

I now had the information to box in Wheelchair Charlie. He'd always sneered I was a smart cop, but how smart he was going to find out soon enough. Knowing he wouldn't use the telephone in his place to call Webber and "make the contact" because of the possibility of a wire-tap, I combed the building until I came up with the answer in the basement garage. There was a pay phone on the wall, fringed with penciled telephone numbers, which had been hastily jotted down.

Capt. Bissell and a couple of officers accompanied me when I confronted Wheelchair Charlie with my accusation, and to make the arrest. His eyes opened with wonder and innocence when I finished. "Me kill that clamhead?" he asked with a snort of disgust. "I didn't even know him!"

"I can prove otherwise," I said grimly. "Let's go down to the garage."

"Wait a minute, copper! What are you trying to cook up?"

"A seat for you," I replied. "A very hot seat!"

In the garage, I pointed to the numbers scribbled around the wall phone, with Webber's far below, about four feet from the floor. "This proves my point. You got his number from Information and called Webber!"

"You're out of your mind," Wheelchair Charlie exploded, angrily. "Just because you found his number written here don't mean I did it. It could've been anyone!"

Capt. Bissell nodded in agreement, a little disappointed. "That's right. It's only circumstantial."

"No it isn't, sir. He's the only one with a motive who measures four feet seated in his wheelchair. It's an accepted fact that anyone writing on a wall holds his pencil at a height corresponding to the height of his eyes. If you'll roll his chair over here, alongside the phone, you'll prove my case!"

My eyes darted to Wheelchair Charlie's hand edging towards the trigger-concealing arm-rest. I brought down the hard side of my palm in a vicious chop on his forearm. His grunt of pain was the last mortal sound I was ever to hear from the notorious cripple who ran his crime empire from a wheel-chair.

"Wheelchair" Charlie Cianelli was tried in Criminal Courts, Part II, before judge Edward J. Hofstadter in April and sentenced to die in the electric chair, ironically, for the murder of his own triggerman, June 3rd. The day before he was executed, by special arrangement with Warden Lewis E. Lawes,

he was married by Father Donovan – who was scheduled to give him the last rites next morning – to Nina, who, I later learned, had visited him frequently after her discharge from the hospital. I didn't have the heart to attend the wedding, but the ceremony of both bride and groom seated in adjoining wheelchairs was the strangest spectacle ever witnessed in the death house behind the gray, gloomy walls of Sing Sing.

Wheelchair Charlie's death didn't catapult me back to a normal life. His gunmen, inspired by Nina's twisted loyalty, were out to get me. My world had crumbled when she'd reverted to his world, but a man clutches onto life. I had to run, to flee, to escape God knows where, and I've made it. I found a new way of life out west, but every time my phone rings, the postman stops at my mail box, or an auto approaches, my heart trip-hammers in fear and I check the chambers of my old service pistol. Will they find me...?

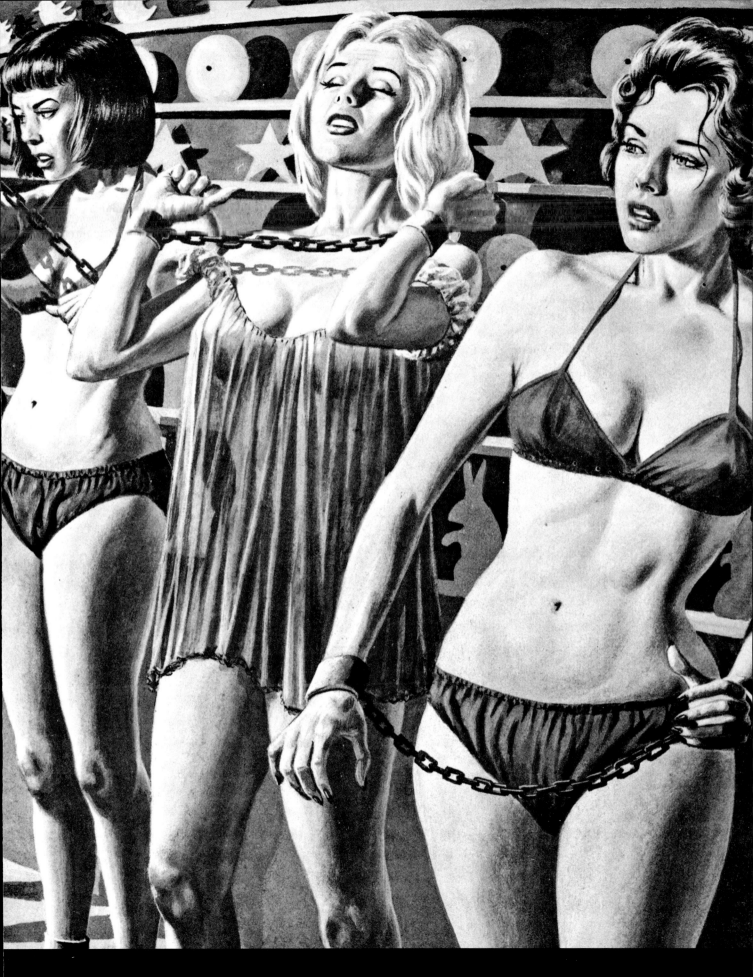

"PROFESSOR SAMSON AND HIS GALLERY OF NUDES"; detail from interior art, **MAN'S DARING**, 09/62.

TEENAGE NAZI
SHE-WOLVES OF BERLIN

They were caught in a riptide of jack-booted hate that only death could assuage.

WORLD WAR II WAS over. It was September of 1945, and I was stationed in Berlin with a signal company. I was on my way back to the apartment house our company had commandeered with Bud Williams, a kid from Arkansas. It was a fairly dark night. We were coming down the last bombed-out block when we saw a scuffle under a street lamp up ahead of us.

We figured a couple of G.I.'s had been drinking it up and were now fighting it off. Or maybe gotten themselves into an argument over some Mickey Mouse watches they had sold the Russians.

But as we got closer, we saw that we were dead wrong. Three German civilians were giving a G.I. his lumps.

The Germans had the G.I. backed up against the lamp pole. One of them had his arms pinned behind the pole so he couldn't move or defend himself. And the other two Krauts were around in front of him, pasting the hell out of him. A girl was running away from the slaughter. She came past us, white faced, tears streaming down her face. "Help him!" she cried in a German accent.

Bud Williams and I broke into a run. The hard rubber soles of our G.I. boots slapped against the pavement and the Germans heard us coming. They watched us for a brief second, gauged the amount of time they had left, and went back to working over their G.I. victim. They waited until the last second and then took off, letting the soldier slump to the pavement.

We bent over him. He was a new kid in the outfit and we didn't even know his name yet. All we knew about him was that he'd been made the battalion runner. His face was a mess, blood flowing from his nose, his eyes swollen and turning black. His face was cut up all over with little Nazi swastikas that somebody had worn on a ring when they punched him.

"Who did it, buddy?" I asked.

The kid was just barely conscious. "Young Nazis," he said. "Jumped me because I was out with a German girl. These guys just don't give up. Werewolves. Hit me with a brick on the back of the head. I didn't know it was coming. Then worked me over. Cut me up."

WEREWOLVES. WE'D heard that word before when we'd first fought our way into Germany. And we'd wondered about it. It was supposed to be the name of the die-hard, fanatic outfit Hitler had planned in case of defeat. Young Germans were supposed to be its members. They were supposed to continue the fight against the Allied armies from underground.

Another G.I. came running up. We told him to take over. We could still see the young Krauts who'd done the job. They were down towards the end of the street and running. Bud and I started running after them.

At the end of the block the three Krauts split up, one going to the left, one continuing straight, and one cutting off to the right. "Let's stick together, Bud," I said. "Let's go after the same guy. The one who went down the street to the right. We'll make sure of him."

We started to close on the kid. The Germans were eating mostly potatoes in those days, and that didn't make for many sprint men. We followed the kid across a lot that had a big bomb crater in its center, running on the soft crumbly earth of the rim. Then we tailed him through the ruins of an office building. Then he cut down an alley between two buildings and went over a plank fence at the end. The kid was slowing down. We were almost on him.

We went pounding down a narrow street, and then into a cobblestone alley. The kid – about eighteen or nineteen – was just a couple of steps ahead of us. He got his hand on the door of the house, and then we grabbed him and slammed him back against the wall of the building so hard his teeth rattled.

We thought the German kid had just picked out a house at random he was going to duck into. We didn't know

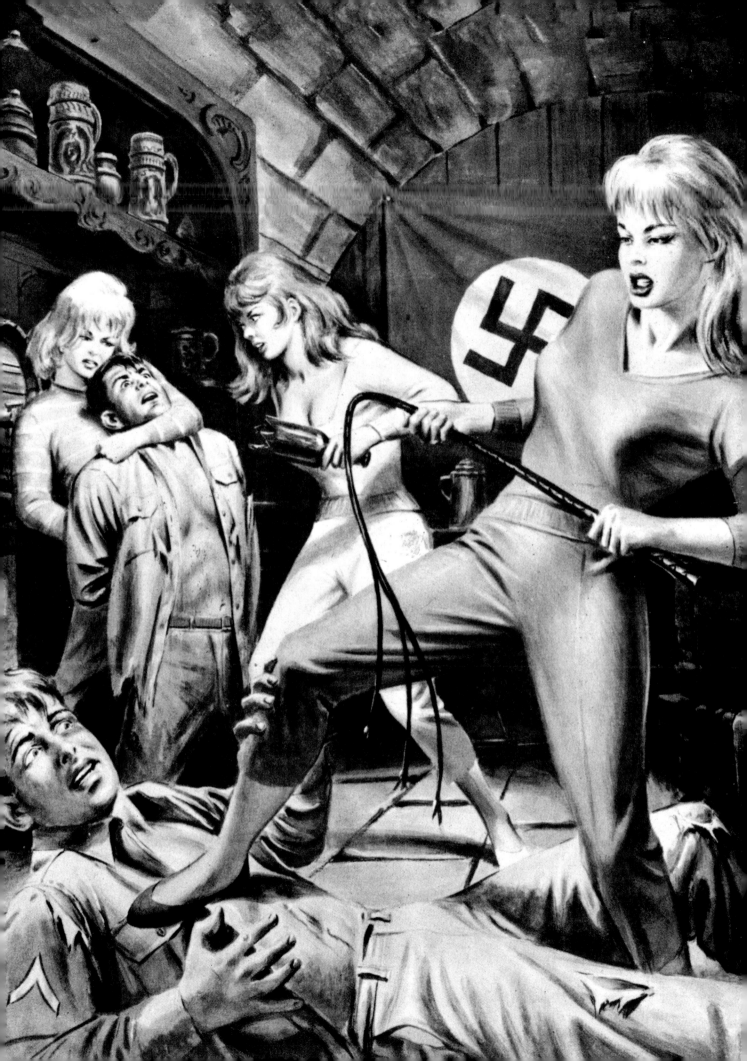

then that this was the house he had been heading for, and that we had played into his hands, been sucked into a trap right on his own home grounds.

We stood him up against the wall. The kid was soaked with sweat. His eyes were filled with hate as he watched us. Our mouths were wide open, and we were heaving the air into our lungs in long deep gasps.

When my heart had slowed down a little I reached out and grabbed the kid's pockets and ripped them off his jacket. A silver-colored SS knife bounced on the cobblestones and I kicked it down the alley. I tore a swastika armband he had in a pocket into small pieces. But he didn't say a word all through my search. Just his eyes followed my every movement. He was like a hunted animal, full of hate, ready to kill at the first sign of an opening.

Then I saw the gleam on the kid's finger. I grabbed his wrist and turned up his hand. There was a razor-edged swastika cut into the ring on his finger. This was what had cut up our battalion runner's face. I pulled the ring off the kid's finger and threw it down the alley and into the street.

When I did that the German kid collected a big thick glob of phlegm on the tip of his tongue and flipped it into my face. He cursed all American soldiers in general. "*Schweinhund!*" he yelled at me.

I looked into that kid's face. I saw there all that I had hated in the Nazis – because of whom I'd had to sweat out five years in the Army. It was the same look you see in the face of a sergeant who thinks he's a little tin-pot dictator. Something snapped in me. I started to slap the kid's head back against the wall. I set my weight evenly on the balls of my feet then, doubled up my fists, and then belted the kid for all I was worth. I pounded away at his face, smashing the nose and cheek bones. I split the skin over his eyes, and a curtain of blood leaked down over his face. And into that red raw mess I slammed home punch after punch.

"Let me get a piece of that," Bud said. He moved in on the German kid, too. We smacked him back and forth to each other, bouncing the kid off the wall between punches. His face was no longer recognizable as a face. And suddenly he was no longer standing in front of us.

He was down on the ground, slumped in a heap on the cobblestones, a bloody mess. For a couple of seconds, we weren't sure if we had killed him or not. We just stood over him, our chests heaving from the exertion of the beating we had given him.

Behind us a couple of windows slid open. We looked up. There were three German girls at the windows, leaning out. They were about seventeen or eighteen years old. Good-looking girls with fully developed bodies, their breasts jutting out challengingly. In G.I. slang, you could say they were stacked, their bodies firmly shaped – good-looking, but in a hard sort of way.

"*Schwerd arbeiten, ja,*" one of them said. "Hard work. The two big Americans beating up a young German boy. So that is what they train American *soldaten* for. Perhaps we would be better off with Russkis in our sector of Berlin."

"He was a Werewolf," I said to the German girls. "For Hitler. *Nicht gut*. He beat an American soldier tonight.

We had to do this." I touched the Kraut's body with my toe. "He was no good," I said.

The German girls looked at each other. They chattered in guttural German too fast for us to follow.

"Perhaps," one of them said, "you like German girl better than German boy."

The blonde in the window undulated her hips at us, a sort of bump and grind. "Come on," she said. "We have a little party. What do you say?"

Bud Williams nudged me with his elbow. "Let's get out of here," he said. "I don't like the set-up."

"Come on," I said. "Let's have a ball. We earned it tonight. We knocked the stuffing out of a Werewolf, didn't we?" I looked up at the three shapely broads in the window. "I want some of that. They're fair game. Maybe we can make a steady diet out of this. I hear the top-kick has got his own girl already. Why not us?"

"Okay," Bud said grudgingly.

We yelled okay to the girls, and asked if we should come up. "No," one of the girls said. "Not here. We'll come down. We'll go places where we can have a party. Music. Drinks. Have a good time. Maybe a little dancing."

We tried to clean ourselves up a little while we were waiting. Then the three girls came down. The blonde hooked her arm in mine. The other two took Bud.

We started out. The girls led us through ruins, up and down alleys, across lots. We were completely lost after ten minutes. Then we came to a bombed-out building, and the girls started to take us into this building.

Bud Williams pulled back. "What's this?" he asked. "What could be in this wreck?"

"*Bierkeller,*" one of the girls said. "*Trinken*. We can have a good time. Beer cellar. It not touched by bombs. We found it. Plenty of beer in barrels. A hand-wound record player. We will light candles and have a good time. Then – who knows what will happen?"

I hesitated for a second. My blonde saw the hesitation and she grabbed me and backed me up against a wall. She put my arms around her hips and pressed up close against me. She put her half-open mouth to mine and gave me a deep, hard kiss, her bosom jutting against my chest. "Who knows what can happen?" she said. I felt myself being swept away on a strong surge of desire.

"Okay," I said. "Let's go."

The blonde led me down the stone steps. A smell of beer hit my nostrils. It was dark. She took me down one corridor in the cellar after another. I was completely lost. I only know I was going because the girl's hand was guiding me. Her body bumped sensually into mine, her hand low on my back, and mine on hers.

And then she stopped and turned me. I sensed that she was pushing a door open. A cool draft hit me in the face. The beery smell was strong now. Her hand was on my back, urging me deeper into the gloom. Then there was a candle aflame and I looked around. There was a big Nazi flag on the wall, a bar at one side of the room, with rows of *steins* and beer barrels on shelves. And then it all blacked out just as I heard Bud Williams cry out. The back of my head seemed to explode. It felt like it

was tearing off. I could feel myself sinking to the floor, going down into a deep pit.

WHEN I came to, the blonde was standing over me. I couldn't move. I seemed paralyzed. The back of my head was wet with blood. The blonde jammed her foot on my chest and shoved a Nazi swastika armband up on her arm. Then she cracked a whip in her hand.

There was a noise to the side. I managed to turn my head. Bud Williams was pinned up against the bar. One girl was behind him, her arm locked around his neck, under his chin. The other girl was in front of Bud, ready to ram a broken, razor-edged bottle into his face.

"They broke a full bottle of beer on the back of your head," Bud said. "And then they got the jump on me. If I move or try to put up a fight, they're going to shred my face for me. I can't help you, Jack. We were a couple of suckers to let ourselves in for this. So fercrissakes, take the whipping this nutty female wants to give you, and let's pray we get out of here alive."

I looked up at the cold hatred in the blonde's face. "But why?" I asked her. "You were so friendly. I thought you wanted a party."

"Ja," she said. "We're going to have a party all right. That was my brother you butchered in the alley tonight. We are members with him of the local *jugend* group. Werewolves. We are sworn to Hitler to continue the fight, even after our armies were defeated. We do not give up. We fight. We will destroy the invaders..."

And then she cracked down with the whip across my mouth, splitting my lips open. The sight of the blood only whipped her into an insane frenzy. She beat at me, with all her strength, crying, "*Heil Hitler!*" She began to sing one of the German youth songs and crack the whip on me in rhythm to the song.

I could feel the whip biting into my flesh, stinging at my body. She lashed me across the ribs and in the groin. But even this savage cruelty was not enough to satisfy her sadistic desire for revenge. She reversed the whip, and began to beat at my mouth with the butt end of the whip. She knocked several of my teeth out, and then went after my eyes with the butt. I tried to twist my face out of the way as that black stick jabbed at my eyes.

Then suddenly I heard a terrible scream. Its shrill piercing sound galvanized my body. The control of my body and the movement of my arms and legs returned with a powerful surge. I twisted around. I saw one of the German girls twisting the razor-edged glass of the beer bottle into Bud William's face. Then she pulled it away, taking raw flesh with it. Bud's face was lacerated horribly, a mass of raw flesh that drenched blood.

The girls were taking us one at a time. They thought I was finished, and had gone after Bud.

I turned my attention back to the blonde, who was still jabbing at me with the butt of her whip. I reached up and grabbed the whip and jerked down hard. She held on, and came down right on top of me. We rolled about, thrashing at each other, half-wrestling, half-punching. Finally I got my knee in

her groin, and jabbed my leg hard up into her body. She turned pale and gasped for breath, but her nails, like claws, were sunk into the flesh of my neck and she held on like a terrier. I reared back, my hand doubled into a fist. Putting my whole body behind it, I deliberately punched her below the belt, right in the belly. I felt my hand sink into her. Her mouth flew open. Her hands released their tight grip on the flesh of my neck. Her face was contorted in a mask of pain.

I took my opportunity. I shoved her away from me. I got my hands on the whip and scrambled to my feet. Out of the corner of my eye, I could see Bud struggling with the two girls who were chopping him up. But I couldn't help him then. I had to finish my blonde off first.

I kicked the dame over on her belly with the toe of my G.I. shoe. She groaned with pain, but rolled over. Then I brought the whip cracking down on her back. I paid her back stroke for stroke, lash for lash. I went out of my mind. All I saw was that quivering body below me. I laid into it with the whip until her shirt and pants were in shreds.

Then, when she was no longer struggling, I threw the whip down on her. I went over to help Bud Williams. He was flat on his back. He had put up a fight and lost. One of the girls held his arms over his head, while the other was down on her knees, preparing to cut a swastika in the flesh of his face and mark him for life. She was using the broken-edged bottle with its razor edges to do the cutting.

I came up behind this girl and booted her right in the seat of the pants. I drove her halfway across the saloon floor and she ended her slide on her face when she smashed into the wall and knocked herself out. The other girl looked up at me open-mouthed. It was too beautiful a target to resist. I kicked out again. I caught this one flush in the mouth with the sole of my G.I. boot and flipped her into a backward somersault. I made certain that they were out cold, then we pulled out.

About half an hour later we staggered into the battalion aid station. The medic dusted our cuts with sulfa powder and bandaged us up.

"Fercrissakes," he said, "what did you tangle with?"

"Three Nazis," I said. "Werewolves."

"They must have been pretty big ones to do all this damage," the medic said.

Bud Williams and I looked at each other. "Yeah," I said, "they were big ones all right..."

LET'S NAIL THE
NUDE BITCH
ON THE BOULDERS!

The naked, raven-haired girl proved a grim apparition of nightmares and death.

SHE'D POISED ON THE cliff moments before, before, waving seductively. Korde had seen her first as we approached the northside ledges. She was nude, a raven-haired sibyl prancing among the boulders like some stripper from the next world. Korde had roared then. "See, you bastards? Told you this detail would pay off!"

"Kill her!" Chapin screamed, the BAR stitching defiantly at a Jap .50 blazing down from the cliffs. There were two of us now. Partington and Baker were dead; big Korde, out of circulation, lay slumped in the rift tangle coughing blood, his face a red maw from a machine gun bullet in his left eye.

"McCall! Cover me!" Chapin growled, crawling over

and yanking his sheath knife. "I'll get her my own way!"

Then he was gone, a blur blending with the greater blur of Saipan's topography. The sun flayed the limestone rift with a stony relentlessness, and the girl on the machine-gun sprayed us again.

When we'd planned it – two sailors and three marines – we weren't interested in necklaces of human ears. All we wanted was samurai swords and a mess of Jap battle flags. Big market on the ships and among the doofers coming to the island. For a good flag we cleared $100, and for a sword maybe twice that. Whatever the traffic would bear, those who had guts cleaned up. It was safe – a lead pipe cinch, Korde averred.

Marines and swabbies, backed by the 27th Infantry, had swarmed ashore on June 22. 1944 and set up beach Red 1 at dawn. With Task Force 52 clobbering the airfields and gun emplacements, the way was softened – but only so much. Then came the fight for Mount Tapotchan and Nafutan Point, and the blistering napalm attack on General Saito's north force.

The last *banzai* had come at 0430 on July 8, but the U. S. perimeter had held, and finally on July 10 the flag was raised over Holland Smith's HQ in Charan Kanoa. The island was ours, presumably. Now all we lacked was souvenirs!

Yet in that connection things were rough, too. Cases of beer and samurai swords were booby-trapped all over the hills. A number of curiosity-driven gyrenes and sailors died in the attempt. Nevertheless, a booming market was a booming market (besides, there was nothing better to do) so we risked it. It was all big Korde's idea, and the way he explained it made sense. He had a "borrowed" mine detector!

I'D BEEN a CRM radioman in the Pacific for two years. When the harbor was secured, the first duty I caught was in Garapan Harbor. It was good duty. There were acres of lower ratings and a cramped quonset for a shack. Being a chief and coming with a recommendation for light work, I had it made. I'd put in an appearance, checking schedules, then killing the rest of the day playing ball and drinking warm beer.

Garapan Harbor was a glut of shipping, yet the brass still found room for a rec hall. Here, one miserable morning shortly after the flag raising, Roger Partington got me together with Korde and his fellow marines. They were rough boys, Baker and Partington especially. For decorative purposes, each had a string of Jap ears strung necklace-fashion about their sweaty throats. And when they drank green beer, they had a way of making the ears wiggle.

I told them the samurai-battle flag part was okay, only I didn't have the stomach for their brand of neck-gear. "S'all the same to me," Corporal Partington shrugged. "I'm looking for a new hobby anyway..."

We cleaned up on our initial forays and then, after much finagling, got a collective 72 which gave us time enough for a trek to the far hills. Besides BAR's and .45's, mine detector and grenades, we were two sailors and three crazier marines – and we hadn't seen a woman in more than a year. The appearance of our doll baby on the cliffs was a trifle too much.

We were working our way up a ledge facing the bright morning sun bathing the dense island verdure in the rift. Korde and his detector, with PFC Partington assisting, were first. Then

Joe Baker, cursing under a load of BAR's. Then Chapin, a chief motor mechanic, and finally, me. Big Korde's right hand jerked up toward the far ledges. "Cow! Holy cow!" Korde screamed. "I don't believe it – *I don't believe it!*"

The girl must've ducked as soon as Korde spotted her. He had a hell of a time convincing us it wasn't the sun affecting him. It was shortly after 11, and we were all beat up from the climb. We broke for rations despite big Korde's yowls. "I should die on the spot!" he swore, wiping sweat that gushed down his hairy chest like a tidal wave. "*I saw a naked woman, goddamnit!*"

"Too much Saipan!" Partington's tongue clucked sympathetically. "Eat your chow, Serge. If your September morn's still up there she'll keep."

"What'd she look like, Serge?" Chapin whispered hoarsely. "Was she built? Was she–"

Big Korde laughed quietly. We squinted up at the thick green fringing the cliff and all laughed. Korde knew a pharmacist's mate on one of the destroyers and he had an in for good alky. Someone said "Serge, I'll give you 50 bucks for a bottle of what you're drinking these nights." Korde just gave the detractor a glare. But after a bit he scratched his stubble and grunted. "Maybe you're right – maybe it's what they call war fatigue."

We finished chow and started up again, in the same order, Korde first. Chapin, in front of me, was about 40. He was the oldest man in the party, and the toughest. The chief motor mechanic had survived two tough ones, Savo and the carrier action at Midway – both times having gone in for a big drink. Yet on land, and when it involved the little business we were in, he was as spry and relentless as our marine partners.

"Hold onto ol' Chapin!" he'd grin when the climb would get rough. "I'm half mountain goat, Sparks!"

"I'm not!" I rasped, clawing at any shrub that would support me. "Korde! Where the hell's your mermaid now?"

As if on cue, sweet naked death appeared almost directly above us. For a brief second the detail saw her pirouetting and waving sensuously. Then she disappeared, and we started up the steepest part of the rift. Then yards later, the raven-haired nude Jap opened up with her .50 caliber machine gun.

A jagged race of fire spewed Partington and Baker from the head of the pass, dead instantly. Big Korde's hands clawed his face as he tumbled backward, blood sheeting down the bridge of his nose, screaming. Witheringly, the girl machine-gunner plastered the narrow pass, raking it as I went down, desperately shoving the wounded Korde behind shale. The gun stopped abruptly, and the only sound was the retching of the wounded Marine beside me. I fired on an empty clip, reloaded, waiting for the stabbing flashes again.

Suddenly she appeared on the cliff, her arms waving maniacally. Chapin jumped up blasting, screaming, "Kill her! Kill that Nip bitch, McCall!"

I put six bullets into the spot but she vanished again. The motor mechanic slithered over to me, pushing a BAR. "All right, kid. Get plenty of gun handy!" Chapin snarled, sliding out a long sheath knife. "I'll get her my own way!"

Chapin scampered away yet, an instant later, the

machine-gun spitted the verdure with sadistic fury anew. I emptied one BAR at the gun embrasure, then grabbed another and checked fire while the girl concentrated on me. I figured it gave Chapin a chance to gain the ledges, and for a while I was right.

Suddenly the motor mechanic appeared left of the machine-gun, like a lizard crawling up a mud bank. I saw vague movement at the lip of the eminence, then began firing again. *Here, you black-haired sonuvabitch!* I kept cursing to myself. I'd never killed a woman before, never thought I'd ever want to – but now I did, and with a frenzy that matched hers.

Above, abruptly, the jagged race of gun flame swiveled left stitching along the ledge. Chapin was up, the knife held short, racing toward her, screaming like a *banzai*. He fell short. Fifties sliced along his belly, jerking him straight up, spinning and pile-driving his thick body toward the ledge. Mercilessly, she kept it up until only a red moving thing toppled over the five yards into the rift.

"She got him. Korde!" I sobbed. "Korde, if you can move, cover me–"

The dying man beside me pulled his wet bloody hand from his mouth, painfully taking up the BAR. Then I moved out. There was the glazed vagueness of death in his eyes but he understood.

I propped the gun on a small rock and told him to fire as I reached the ledge. He did. He emptied the gun before she killed him.

In the naked silence of the deep rift, the only thing I heard was the cascade of frenzy sweating up my brain. And the only thing I saw, lying there pressed against the lip, was the dead Chapin. I had a faceful of gravel from the mad scramble and my eyes burned like hell, yet I didn't dare move. I put the hot wet .45 on the shale, and hugged the ground. Nothing happened. *Strictly a no-return island* – a marine had coined the expression. They're committed to death one way or the other. Either they kill you or they die – *Shichisei Hokoku!* ("Seven lives for the Emperor" – they screamed it during *banzai* charges.)

AN ETERNITY later, still nothing. I inched a yard on my belly to the jagged facing of the ledge, and stopped. In another eternity, I clawed myself silently up, and again stopped.

The ledge backed to sheer rock, concealed along the lower height by thick berry shrubbing. Somewhere no further than 40 feet away was the gun, and the girl. But I didn't budge; I didn't have the guts to budge. I lay there squeezed close to the ground, the .45 pronged out before me, praying.

Ants started crawling up one leg, biting hell out of me. I jerked my leg instinctively and the sound roared out over the ledge. Nothing happened. I squeezed the service gun so hard my hand hurt, but the girl nor her gun materialized. Slowly, trembling, I stood up. The gun was right where I figured it would be, commanding the wide sweep of the rift.

Soundlessly, I moved along the mountain facing until I found the cave. I went in on my belly, snaking through the pall until bright sunlight shafted down from the far end. The place was small, cluttered with boxes, stinking from the glut of decaying flesh. Near the far embrasure two nearly decomposed

soldiers slumped with swords in their bellies, suicides. I gagged up the K-rations and snaked along. At the entrance, I wiped the spate of sweat from my eyes, and the gun on my pants, and lay there, wondering what part me was to move out first. And why. And finally I did, gun first.

She was sitting against the cliff, staring at the Pacific below. A long below. She was nude, her hair falling long and raven on her full breasts. When she saw me standing there, she half-shrugged and stood up. I didn't fire. On the second step towards her she smiled faintly, folded her arms across her chest and jumped.

All the way back I kept smelling the vomit on my fatigues. I made it back by nightfall, and the following night a detail of Graves Registration guys brought out the bodies. They found hell of a lot of loot in the cave – samurai swords, battle flags, human ears, beer and guns. And a girl's pink kimono. I came back and sweated out the rest of my time in the radio shack.

A NIGHT OF
LUSTFUL HORROR

Among these wretched women, in this seething snakepit of naked lust, would come an unforgettable night of blood and depravity.

I SAW HER WHEN they first brought her in. She was a strikingly beautiful girl with the body of a goddess. She had long black hair that came down to her hips when it was allowed to fall loose. Her face had finely chiseled features that looked as if they'd been made by a master sculptor, lips full and appealing, a small nose, and shell-like ears. Her breasts rose full and firm, a match for her long and slender legs.

Everything about her was perfect – except for the eyes. The eyes were vacant, tortured, revealing that the mind behind them lived in another world.

To an old hand like myself, it was obvious that a girl that looked the way this one did was in for trouble from the beginning. The men would be lusting after her, never letting up the pressure on her until she submitted to their will.

Her husband had brought her in the company of his personal physician. He was a fine-looking man, young for the troubles he was burdened with, and you could see that he was heartbroken when he left her behind. We watched him go, his shoulders shaking with sobs. If he were extremely lucky, he might see his wife come back to him again to their home. But if he weren't lucky, she was condemned to another world, one full of its own horrors, shock treatments, hydrotherapy, and drugs. There would be drugs to calm, and drugs to stimulate. And through it all would go that beautiful body and beautiful face, the prison in which a mind in a world of its own had been locked.

THE INSTITUTION that this beautiful girl had come to, where I worked as an orderly, was a state hospital for the mentally insane. Like others of its kind, it was a miserable hellhole. It was understaffed, one man doing the work of a dozen. Humans were jammed into some of the wards like cattle. The physical plant was neglected; roofs leaked, ceilings were moldy, walls were decayed. The patients had to sprawl on the rotting floors because there were no seats or benches. About all was the thick odor of neglected human beings, some sprawled in their own filth. There was roughly one attendant for every hundred patients. The orderlies were paid about a hundred bucks a month. Some of them came under pressure – dragged out of the local courts after a drunk or a petty offense and offered the choice of going to jail or going on the asylum payroll.

I had been standing near the main admitting building with Harvey Gill – just the kind of rummy that works at the state mental institution to keep out of jail – when the beautiful girl I have just described was brought in.

"That's for me," Gill said when he saw the girl. "I'm going to get me some of that before I leave this hellhole."

"Leave her alone," I said to Gill. "Leave all the women alone. Only an animal would touch one of them. All you can do is hurt them – drive them deeper into their own private hells."

We had reached our barracks by this time. Gill spat on the ground and took a slug of liquor from a bottle he had smuggled on the grounds. "You stick to your amusements," he said, "and I'll watch my own. I know just like everybody else around here that you got an understanding with one of the nurses."

"Don't forget," I said. "I warned you."

Gill laughed harshly, and we didn't talk about it anymore. I forgot the whole thing until that night when I went on duty in building C. I was just going through the entrance into the center hall when I heard the women patients screaming somewhere in the building. There was terror, an unreasoning panic, in their voices. It was fear, pure and undiluted, an uncontrolled hysteria.

I RAN through the wards and the corridors, one flight at a time, trying to locate the sound of the terrified weeping and screaming. My first guess had been that it came from the incontinent ward. I burst in there, but I saw nothing other than the usual mess. Women stood around, many of them naked, irresponsible, unable to take care of themselves. Some had no shoes on their feet. They stood around or sprawled on the floor, crooning or moaning blankly to themselves. As I ran broken field through this room, hands clutched at me from all sides, slowing up my progress.

At the end of the ward I hit the staircase and took it three steps at a time. The sounds of the women screaming was getting louder and stronger all the time. Finally I reached the upper floor where the newer admittances were put in with some of the old hands who weren't too badly off.

I slammed into the swinging doors and burst into the top floor ward. Here the screaming was at its loudest. I saw a cluster of shrieking women at the far end of the ward. Some of them had the clothes half-ripped from their bodies. As I ran towards them, I took in the whole scene at a glance – and I was sickened to my stomach at what I saw.

It was Harvey Gill who was responsible. He had the beautiful girl who had been admitted to the asylum that morning backed up against the wall, and he was tearing at the shift that covered her body, trying to pull it off. He already had it down over one of her shoulders when I came into the ward. The girl was terrified. She wept, the tears rolling down her face, staining her shift and her exposed body. Although she wept, she didn't do a thing to fight Gill off, just stood there backed up against the wall, submitting to his lust. Gill was all over her, slavering, kissing her, pulling her down. The only thing that was keeping him from getting what he wanted was the other women who were trying to help the girl.

Screaming wildly, they were pummeling him, beating at his back, grabbing at his hair, his ears, scratching and biting at him. One of the women wailed wildly, her arms locked around Gill's waist, trying to pull him away from the girl. And Gill, driven by his lust, had tried to ignore them in his haste to get his way with this poor beautiful girl with the clouded mind.

But now Gill saw that it was hopeless. He could not possibly succeed doing what he wanted with all the women worrying at him. He turned the girl loose, slamming her up against the wall with a curse, and turned on the women who harried him. His hands were clenched into tight fists, and there was an insane lustful look on his face.

He started flailing blindly at the women clinging to him. He walloped them with an insanity of his own. He pounded them in the faces, the breasts, in the belly, a powerful brute who didn't care what punishment he inflicted on the women who had frustrated him. He locked his fingers in the hair of one woman, jerked her head back, and smashed in the neck with his fist. She sank to the floor without a sound. Elsewhere he drew blood, beating the women down to the floor savagely.

And the girl Gill was fighting for just stood there, her shift ripped down its front, her head just turned to the side, unmoved by the horror in front of her. She was a lost spirit, untouched by the savage cruelty and the flailing fists of Harvey Gill.

Gill picked one of the women up, lifted her over his

head, and hurled her sliding and skidding across the floor until she smashed into the wall and lay there unconscious. He punched at the face of another until it was a bloodied mass, but still the women of the ward came at Gill, scratching and beating at him.

GILL WAS standing there, two of the women down on their knees, clinging to his thighs, exhausted by the beating he had given the women, when I landed on him. I knocked him sprawling, and then went after him. I wrestled him to his feet and pinned his arms behind his back.

"Have you gone mad?" I asked him. "Do you realize what you were trying to do up here – and what you'll get if one of the doctors learns about this?"

Gill was swearing incoherently. I dragged him away from the women and down the ward. He was struggling all the way. "I'll get that girl yet," he swore over and over again.

I wrestled him out into the hall and then rushed him down the stairs. I got him out of Building C, and then across the grounds to the long, low barracks-like building where we lived. Once inside the door, I let Gill go, shoving him at one of the bunks. The minute he was free, he grabbed a chair and tried to brain me with it. I ducked in under the chair and punched him one low in the belly. He sank down on one of the bunks, clutching his stomach and moaning.

I stood over Gill. I had no pity for his pain. "If you ever lay a hand on one of the women again," I warned him, "and I find out about it, I'll turn you into the authorities and over to the police. They won't go easy on you for raping one of these women."

Gill stopped moaning. A look of cunning crept over his face. "Okay," he said. "You just don't interfere in my business again, and I'll keep my nose clean. And we'll forget you butted in tonight where you weren't wanted."

HARVEY GILL moped around for a couple of days after that, drinking heavily. He was in a stupor until he ran out of the stuff. And then he was surly and mean until his day off. That, day he went into town – and I assumed it was to get a fresh supply of liquor which he planned to smuggle back in on the institution grounds.

I myself spent the afternoon when Gill was in town napping. Towards evening I had my dinner. It was already dark out when I started towards Building C to go on duty.

I was walking across the lawn in front of that building when I heard a piercing animal-like scream. I recognized Gill's voice immediately. It came from C, the women's building, right in front of me. Instinctively I knew that something terrible was happening to Gill. I ran for the building. Once inside the doors I headed for the violent ward, figuring that Gill had gotten into some kind of trouble there, something that was a little more than he could handle. I figured maybe one of the patients had taken him by surprise.

I ran into the violent ward, but there was nothing there that I could see that was out of the way. There were patients strapped to their beds with leather thongs. Others were rigid in chairs to which they had been tied hand and foot. Still others were immobilized, wrapped up in restraining sheets.

Some were in steel handcuffs, others on drugs.

Still I heard those terrible screams of Gill's.

I tried the hydrotherapy room. I thought maybe a patient slated for one of the baths in luke-warm water constantly swirling about his or her body to calm her had taken Gill into the water by surprise and somehow overpowered him. But there was just one naked woman sitting in one of the baths there with a surprised look on her face when I walked in. She, too, was listening to Gill scream.

Where, I wondered. Where had Gill been trapped and what was being done to him that was driving him to scream in this agonized manner?

And then the possibility that Gill had been trapped in the seclusion room came to my mind. This was the padded room into which were put seriously disturbed patients. I remembered that one female patient had choked another to death in that room when they had been locked up together by mistake. The room was ordinarily locked – but you never knew. Gill might have done something foolish. All it needed was one careless moment with a patient there.

I ran down the hall, took the stairs three at a time, and reached the seclusion room. The door was standing slightly ajar. I pushed it open the rest of the way. It was dark in the room – the seclusion room with its padded walls has no windows.

I heard a whimpering, moaning sound from deep within the room – Harvey Gill's voice. But there were other sounds – heavy breathing. And then suddenly – a wild peal of insane female laughter, at the peak of hysteria, that sent a chill through my body.

I reached inside the door and flipped the light switches. The sight that met my eyes froze me in my tracks.

HARVEY GILL was on the padded floor on his back. He was in a straitjacket. It had been clumsily tied, but nevertheless it was doing its job, and he was unable to move, at the mercy of any one who wanted to get at him.

The beautiful girl whom Gill had tried to assault a few days before was in the room with him. She was swarming all over Gill and she was completely naked. She was tearing at his throat with her teeth, and when she raised her head to look at me with her blank eyes, I saw that her mouth and chin were stained with blood.

The other female patients of the ward were in the seclusion room with her and Gill. They were gathered around the couple on the floor, encouraging the girl, urging her on. Some of the other faces were swollen and bloodied – for Gill must have put up a terrific struggle before they strapped him in the straitjacket after luring him into the seclusion room with the girl he had been after. Gill was a powerful man, but in his drunken condition he had been no match for the women after they had enticed him into the room with the naked girl and jumped him.

Then the women became aware of me. For a brief moment there was the light of intelligence in their eyes. They saw the chance to inflict punishment on Gill passing. With that realization they fell on him with a vengeance, beating savagely at his face, turning it into one bloody mass. The naked girl had

not been working fast enough to please them.

With Gill's terror-stricken screams in my ears, I ran out of the room into the hail. I got the fire hose out of its cabinet and then went back into the seclusion room. I turned the powerful stream of water on the women and drove them away from Gill's body. Then I shepherded them towards the door and drove them out into the hall with the powerful stream of water.

I GOT to Gill finally and got him out of the straitjacket. I hurried him out of the building and then over to one of the institution doctors to sew him up and stop the bleeding.

But only the physical damage to Gill could be repaired. The time he had spent in the seclusion room at the mercy of the women he had lusted after had taken its toll. His mind just refused to accept the reality of the horror of that experience. Today he is a patient in the same mental institution where once he had been an unwilling orderly. He flees at the sight of any female, even one of the staff members. And the sight of an undressed woman is enough to drive him into violent hysterics.

It was indeed a strange and ironic end for the man who had been devoured by his own lust.

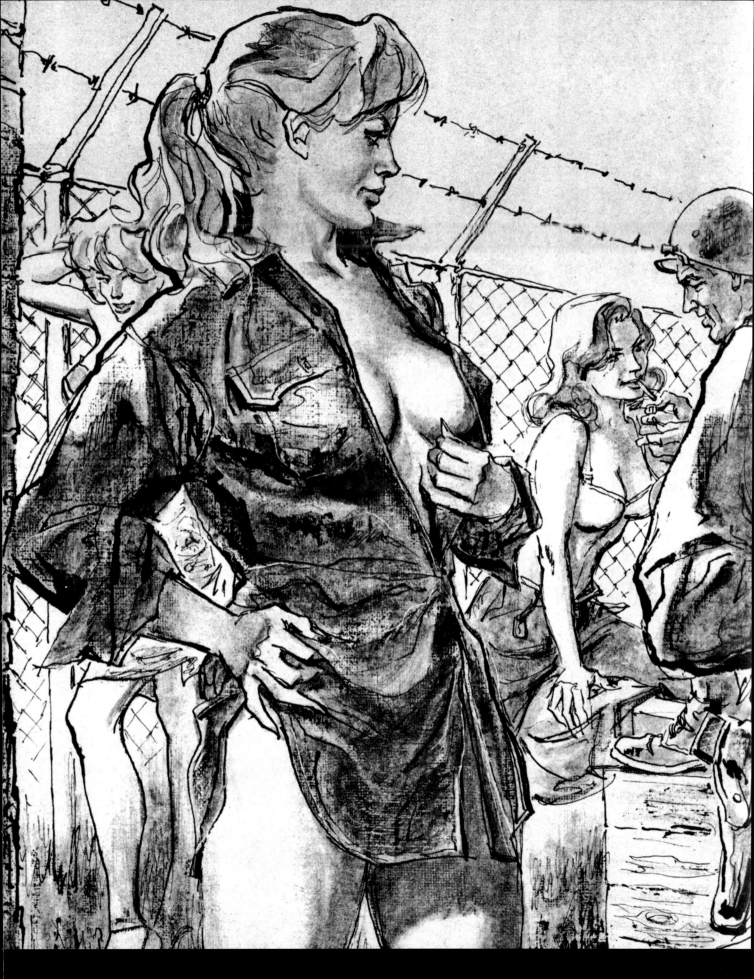

"PRISON OF SS GIRLS"; detail from interior art, **A-OK FOR MEN**, 01/63.
Art uncredited; signed Howell Dodd.

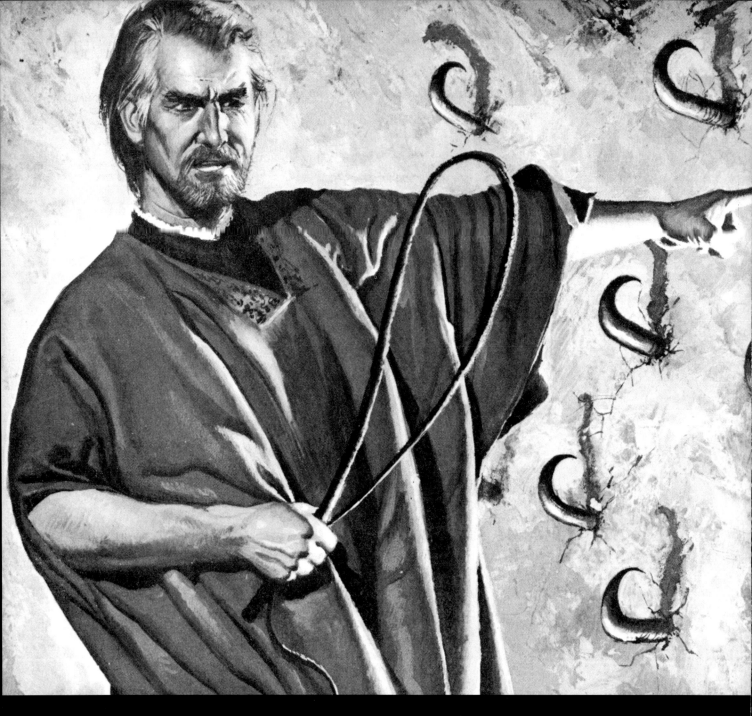

SOFT NUDES
FOR SATAN'S DEN OF TORTURE

Writhing virgins were Kian's evil offerings to a depraved audience who revelled in debauchery.

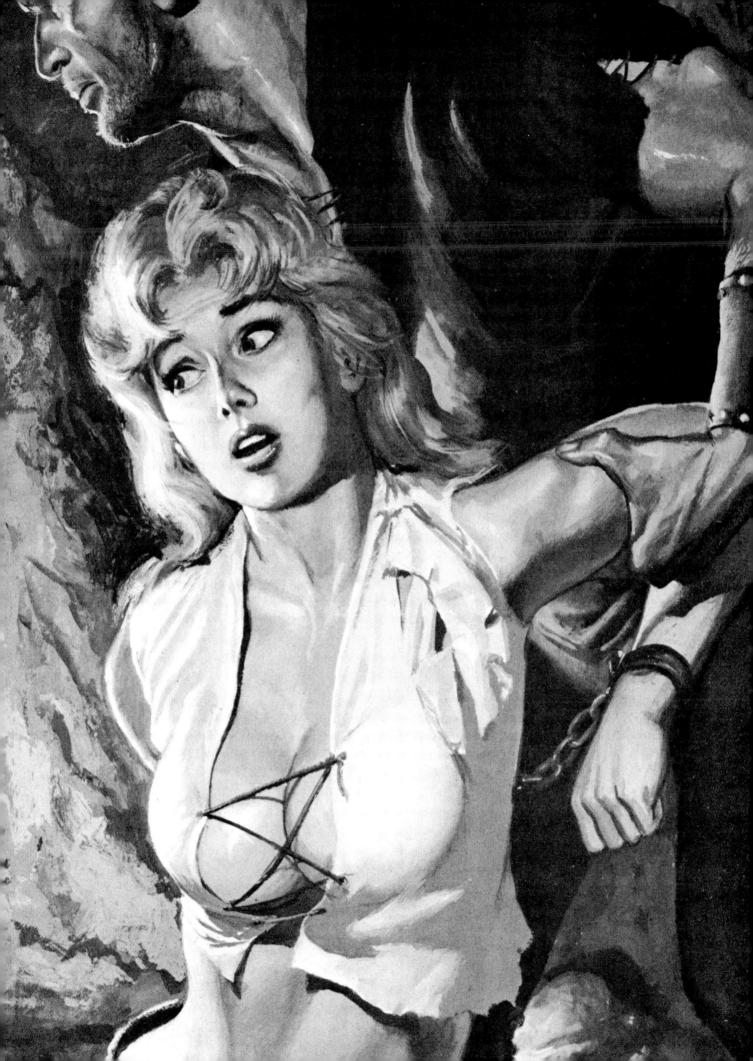

THE JUNK WITH THE silhouette common to Swatow rode low in the greasy water of the Macao. Her creaking decks were lined with five black coffins whose lids were tied securely with coils of heavy hemp.

Chang Kian stood on the deck, surveying the shipment. His goatee'd mouth twisted, showing broken yellow teeth. "So, this is the consignment of diseased for burial!"

The bloated junk captain Koko Hwong licked his lips. "Please to hurry and remove cargo," he cajoled. "Please also pay one thousand English pounds as we agreed."

Chang Kian's laugh was derisive. His eyes gloated as they regarded the captain. "You will be paid," he said, after the corpses have been examined."

Koko Hwong bent closer, shielding his face from the two Portuguese policemen who patrolled the pier. "These are outstanding," he whispered. "Two British from Hong Kong. One French from Hanoi. And two whose identities I am not sure of. But they are all exquisite."

"They had better be, or the agreement's off," Chang Kian warned. He began supervising the crew as the caskets were raised with a winch and lowered to an ox-drawn cart which stood on the pier.

The Portuguese officials moved towards the macabre cart. The one in charge spoke briskly. "Remember, the caskets are to remain sealed. There is to be no inspection of the dead," he ordered.

Chang Kian smiled ingratiatingly. "This miserable embalmer will comply with the health laws," he sing-songed. "Even one so humble as this stupid one has heard of the cholera in the north."

His voice mocked the Portuguese police. He despised the European overseers. But then, they had their purposes. There were those among the foreigners who would pay well for the type of delights he offered. There were those who would go on paying the rest of their lives for having met him.

He scraped low, his hands folded under the huge sleeves of his gown. He wanted no more truck with the officials. The five caskets represented much work and much profit. Tonight the swirls of opium smoke would rise in his exotically appointed basement. Tomorrow the more debauched among his Chinese and European customers would be willing to pay substantially higher fees to be allowed to return.

He mounted the cart and ordered Sing Muh to whip the indolent ox into action.

A HALF hour later, each casket lay on its own bench in its own small crypt-like room. Chang Kian and Mai Kim, his number one concubine, stood to one side as Sing Muh cut away the ropes which held the coffin. The man's bulging muscles corded as he pried the lid open. His eyes burned with a depraved fever when he saw the form in the casket.

A heavy gag covered her mouth. Coils of rope wound around her arms and legs. Her face was dirt-stained and her eyes red and swollen from weeping. But there was no doubt that she was a beautiful woman.

At Chang Kian's orders, the girl was lifted from the coffin and stood against the wall. A heavy iron collar was clamped around her throat and chained to the wall. Once she had been secured, the gag and bonds were cut away. The girl stood shivering, rubbing the circulation back into her limbs,

licking her dry lips, staring in fascinated horror at her captors.

"She will need new clothing."

His concubine moved to the captive's side. The Chinese harlot's dagger-shape nails raked out and snatched the thin cotton dress from the chained girl. The Englishwoman screamed in mounting horror and did her best to cover her half-naked body from the lascivious eyes of Chang Kian and his assistants.

Sing Muh seized the girl's wrists and held them high over her head. She shrieked and kicked at Mai Kim. But the harlot was well schooled and found little difficulty in wrenching the satin bra from her European victim's breasts. One last move of defilement was left. The pink silken panties were ripped down the girl's quivering thighs and pulled from her thrashing ankles.

"You can't get away with this," the girl shrieked. "I am a British subject. I have friends in Hong Kong. I'll be missed. They'll behead you."

"Please to save your strength," Chang Kian ordered, his voice cutting like a whiplash and making the English girl cringe in dread. "You are Agnes Morrison. You were visiting Hong Kong. You rode in a rickshaw. Nothing more will be found of you."

The finality of the words struck like blows against the girl's consciousness. It came back to her now. Once again she was riding down the twisting streets. Once again the rickshaw was surrounded by evil-looking men and a wet cloth was being held to her nose as she was dragged bodily from her seat.

Once again she was locked in the dark cabin of the junk, not knowing why she had been kidnapped or where she was being taken. Days went by, and they were marked off only by the number of times the cabin door opened and a bowl of brown rice was shoved through to her.

Once again they came and two of them held her while the third bound and gagged her. And then they were lowering her into the coffin and she thought they were going to bury her alive.

Now, standing stark naked, the cruel collar digging into the flesh of her neck, she wished they had killed her. But for some diabolical reason which was not hers to understand, they wanted her alive.

Mai Kim was almost gentle as she sponged the encrusted dirt off Agnes' perspiring body. Almost gratefully Agnes received the new clothing which was handed to her. It consisted of sheer silk black panties, bra and a tight smock-like dress which buttoned down the front. She found the iron collar no impediment when it came to dressing herself.

However Chang Kian, the brutal-looking Sing Muh, and Mai Kim stood surrounding her, watching every motion of her soft body, their inscrutable eyes reducing the girl to a frenzy of fear. At last when she was fully clothed, they left the chamber. Agnes Morrison was alone with her terror and the horrifying sounds of the dank basement.

The darkness was all around her. Weariness flooded through her limbs. She longed to rest. But the iron collar had been fastened to a short chain which made it impossible for her to sit down. From time to time she heard soft scurrying and the squeals of hungry rats around her feet. She kicked out at the little beasts and moaned her terror.

In four other crypts the same preparations were taking

place. Chang Kian viewed his prizes with growing delight. Five such beautiful women would bring huge prices from the opium smokers. Their torment would enrich him beyond all expectations. All was well with the world in Chang Kian's view.

Chang Kian prided himself in being an expert in everything which is base and depraved in human nature. He understood the morbid fascination of pain. He had been schooled on it in his youth when he had ridden with the bandits.

He recalled the lightning raids on the small villages north of Honan, the nights of the men of the village being beheaded as they knelt before him, the cries of the women as they were put to the most hideous tortures imaginable. He reasoned that what had appealed so greatly to him, would also appeal to others of affluent circumstances.

And in 1937, the bandit turned "mortician" busily went about proving himself right in the putrid port city of Macao. He had established a network of slavers who plied up and down the coast, making off with unescorted women and bringing them to his lair. He paid well for the captives, and the network grew quickly. Kidnappings and disappearances mounted throughout China. Chang Kian offered special bonuses for European women, as he took secret delight in subjecting the arrogant foreigners to special punishments as a reprisal against their condescending ways.

And now in his labyrinth of underground dungeons, five European women stood like beasts, chained to the wall, waiting for something so vile that it defied imagination.

He thought of the depraved Europeans who would join his Chinese customers and the thought gave him even greater satisfaction. Baseness of spirit was universal. And this baseness would make him rich beyond his dreams.

As he waited for darkness to fall, he dwelled happily on these dreams. Mai Kim, the wantonly beautiful paramour lay beside him on the silk covered couch, bringing wave on wave of lecherous delights to his fevered brain as she ministered to him with her practiced hands. He gazed on her with maniacal worship, knowing the cruelty which lay deep within her. Now she stretched her provocative body with an animal-like grace. Her lips were hot on his, her hands goaded him to further action.

"My lord will outdo himself tonight," she murmured in his ear. "He will make Mai Kim come alive as she has never come alive before. Then she will come to him when the blood has flown and the dawn shines red as flames. Until then, we will wait."

He cursed the woman in his immediate need. He knew that one move with his powerful arms could break her to his will. But he did not move. It was better to torment himself with expectation.

"The arrogant one, the one who calls herself Agnes Morrison," she whispered. "She will be mine to do with as I please."

"She will be yours," Chang Kian repeated.

HOURS LATER, Agnes Morrison was plucked from her semi-conscious state by the deep, swelling sound of a huge gong ringing somewhere in the house. Her body quivered to the gong's capillary-splitting vibrations. She lunged in terror as the door to her cell swung inward, revealing a group of robed Chinese led by Chang Kian and Mai Kim.

"It is time," Mai Kim intoned. In her hand she held a silken cord. She nodded at the guards.

Agnes Morrison saw the men clearly for the first time. They were hideous in their robes. Huge open sores erupted on their faces. Their grinning lips housed blackened gums and rotting teeth. She shrank from them, shrieking out her terror. The rough stone of the wall gouged into her back and she could retreat no more.

Their repulsive arms, feeling like a thousand reptiles encircled her, testing the thinly covered firmness of her breasts and flanks. Her belly heaved with nausea at the fetid smell of their unwashed bodies. She fought against them with her tiny fists.

But Mai Kim had stepped behind the English girl. Swiftly she caught Agnes' trembling wrists.

Agnes felt the heat of their stinking breath around her naked legs. They tied her ankles loosely so that she could take small hobbling steps. Then the collar was removed from her neck and she felt herself being prodded forward, propelled down a long cavernous corridor towards a room which was bathed in an eerie green light.

Screaming hysterically, the English girl was dragged into the room. Her eyes widened in disbelief at the sight which assailed them. Figures reclined on silken pillows, their faces staring at her in a zombie-like stupor. Clouds of opium smoke swirled around the ceiling, the stinking odor permeating everything.

But most horrifying of all was the fact that not all the opium smokers were Chinese. Sumptuously gowned European women lay with their heads in the laps of dinner-jacketed European men. Their pupils had been reduced to the merest pinpoints.

Agnes felt as if she were losing her mind. This could not be happening to her. Her countrymen wouldn't allow her to be sacrificed by these beasts.

"Save me!" Agnes cried in heart rending sobs. "In Heaven's name, save me!"

Her answer was a swelling snicker. She felt herself being forced into a chair. Heavy ropes were passed over her breasts and tightened against the chair's back. Mai Kim supervised the guards as they held Agnes' writhing body. Another rope was hitched around the girl's supple hips and thighs. She strained against the bonds, but silk as they were, she was no match for their strength.

From far off the gong sounded again. Now Agnes' screams were joined by another's. The girl was tall and willowy. She had been dressed in the same type of smock dress. She had been bound in the same manner and as she was led into the torture chamber, her reaction was equally as panic-stricken.

Chang Kian gave an order, and the dark-haired girl was forced to stand on a raised platform which accommodated a huge table, and above it a brass gong.

Slowly, drawing out every excruciating moment, the girl was stripped of the smock. Her graceful form, clad only in the sheerest black panties and bra was lifted to the table and despite her heroic struggles she was finally bound to the altar, her arms stretched to the breaking point above her head, her ankles securely strapped to the bottom of the table.

The diabolical plan didn't become apparent at once. One of the Chinese reached for the rope which ran to the gong's

clapper. He pulled mightily on it. The room exploded in sound.

The girl's fettered body jumped alive. The ropes which held her grew taut. The bell rang again. Her face turned into a distorted mask of agony. Sweat shimmered on her limbs. The gong kept up its diabolical death toll.

Slowly the capillaries in the girl's body were being ruptured by the vibrations. The exotic torture of the bell had begun. Her mad cries of agony rose above the constant peal. For what seemed like hours, she thrashed and moaned. Little flecks of blood danced on her lips as she bit through them.

The girl's cries were answered by the mutterings of the opium smokers.

A European woman in a stupor rose to her feet. Mindlessly her fingers reached for the hem of her expensive evening gown. The fabric ripped. She gyrated around, flaunting her nakedness to her companions. A group of arms reached up from the silken pillows and she fell among her debauched lovers.

At last the girl under the gong heaved mightily and lay still. From the ceiling, a curtain rustled. It descended, blotting out the diabolical tableau.

Almost immediately another girl was brought in. She was stripped and bound spread-eagled to a metal frame. One of the black-toothed Chinese approached her holding a gleaming flaying knife. He stood staring at his victim for a full minute.

The knife flicked out, touching her flesh at a point below her breast. The cut was small and couldn't have caused that much pain. Yet the girl threw herself around with the abandon of a mad woman, her struggles making her body a column of sensual movement. The knife flicked again. In horror, Agnes remembered stories she had heard of the death of the thousand cuts.

The night seemed never to end. For long hours, Agnes sat in her chair praying that her captors had forgotten her. But slowly the realization dawned on her that they were saving her for something too hideous to contemplate.

At the they came for her, tearing the ropes away. They dragged her, kicking and screaming to a spot between two wooden pillars. She stood unable to defend herself against the raging taunts of the opium-drunk audience as they removed her dress.

Chang Kian's horny hands ran over her body, pinching and probing. With a sudden wrench, he stripped the bra and panties from her. She felt herself being hurled viciously to the floor.

Agnes' wrists were cut free and retied before her. The ropes were wound around the pillar. Then another set of ropes were attached to her ankles. As the bonds were tightened, she felt her body being drawn taut and lifted from the floor. She hung suspended about three feet in the air, every muscle and nerve stretched beyond endurance.

She couldn't see the preparations for her torture. She had no way of knowing that a thin bamboo rod had been taken from the wall and now hovered above her stretched legs. All she saw were the smirking faces of Chang Kian and his mistress floating before her.

The bamboo rod merely tapped her. The force of the blow was so light that it was soundless. Yet the pain which shot through her legs was beyond belief. Again the rod tapped her,

this time high on the thighs. Agony lanced through her brain, blotting out all else. She prayed for death, but knew the torment would go on forever.

WEEKS LATER, Agnes Morrison returned to her coffin and her weighted body was dropped into the South China Sea, to join the ranks of many other beauties who had disappeared from the face of the Earth.

Chang Kian's bloodbath continued until early 1942 when the Imperial Japanese Army overran Hong Kong. Never one to put patriotism above opportunity, the fiendish torturer immediately offered his services to the Kempeitai and proved his loyalty to them by demonstrating the death of the thousand cuts on his paramour, Mai Kim.

As the woman lay in the metal frame, writhing and shrieking against the bite of the flaying knives, she called on Buddha to make his death agonizing beyond belief.

But Mai Kim's vengeance meant little to the bandit. Impassively he worked with his flaying knives, gloating in the awed respect paid him by the Kempeitai men. When at last Mai Kim resembled nothing human any longer, he accepted an on-the-spot commission in the Imperial Japanese Army.

This ushered in an era of bestiality previously unheard of. Chang Kian moved forward with his new masters, reveling in the fact that he no longer had any reason to dread the authorities.

While he carried out his depravities, he continued his traffic in opium, bringing wealth such as few men know. But he failed to reckon with the perseverance of the British.

Whether it was his consummate arrogance in the belief that nothing could ever touch him, or the fact that the beaten Japanese would not sacrifice a prized spot on a barge to a Chinese, will never be known.

But when at last the Japanese evacuated Singapore, Chang Kian was left behind at the compound.

Although it is not recorded in any of the documents of the war, it is well-known that his woman prisoners, reduced to an animal state, turned on him.

They captured him outside the shack that passed as a mess hail. Their emaciated limbs bore him to the ground and held him there while one of their number sharpened a spear out of a bamboo pole. The point was heated over a fire until it smoldered. Then as Chang Kiang pleaded for mercy, it was plunged into his eyes.

Shrieking and blinded, the monster was raised to his feet and dragged to a tree. There he was hung by the heels, the blood from his sightless eye sockets falling into a vat of boiling oil.

So ended the diabolical career of one of history's worst monsters. No one can be sure what turned him into a sadistic fiend. Perhaps it was the innate cruelty of the Mongolian tribesman. Perhaps it was the hatred of those who lived off the sweat of the rice bowl.

And in the areas where his memory lingers, women will never go out into the streets unescorted – for there still may be some vestiges of his kidnapping ring in operation.

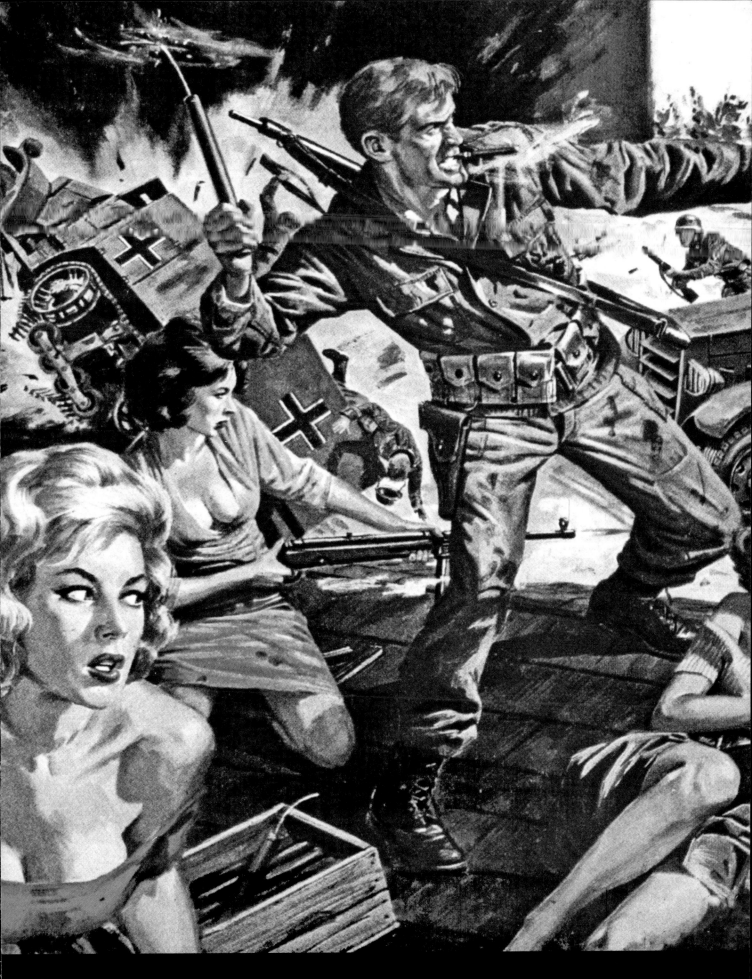

"THE DESPERATE RAID OF WILSON'S LACE PANTY GUERILLAS"; detail from interior art, **WORLD OF MEN**, 03/63.
Art uncredited; attributed to Bruce Minney.

SHACKLED NUDES

FOR THE MONSTER'S COUCH OF AGONY

The fiend's nuptial couch had been designed in Hell – and only the most beautiful knew the agony it held.

THE SOLDIERS CAME UP the road, walking slowly because of the summer heat. They no longer looked much like soldiers, their uniforms dusty and torn with the passing months, and their bearing far from military. They approached the town of Ulmdorf near sunset, and the leader seemed to grow more erect. In a town, they might get food and lodging for the night. Slowly, the little band swung into Ulmdorf.

Near the entrance gates, the Mayor waited with a picked group of armed men. The soldiers stopped. The Mayor asked: "Who are you?"

"Soldiers. We were once with the army of General Wallenstein–"

The Mayor cut the leader off abruptly. "Get out of here. Leave us in peace."

"We only want a little food, a lodging for the night–"

"Get out."

The townsmen raised their guns threateningly.

There was no sense in a pitched battle. The soldiers turned and moved off. The leader, perhaps, never knew why he had been ordered violently out of Ulmdorf, never knew that Ulmdorf had been one of the victims of another troop of soldiers, a troop formerly with General Wallenstein and now turned loose to rape, torture and murder across the German countryside.

But the town would never forget. The year 1635 was burned into the memory of Ulmdorf forever, and bands of stragglers or deserters learned to avoid it, and the other towns that had once been visited by Caesar Wurdmann and his men. No member of Wallenstein's army was welcome in those towns.

Wurdmann had been one of Wallenstein's men.

It began for Ulmdorf in late March when the country was still recovering from a severe winter. The townspeople were staying indoors as much as possible, and when Wurdmann marched in at the head of his men the place seemed deserted. He went to the door of the largest house in town, assuming correctly that it belonged to the Mayor, and pounded on the door with his gun-butt.

The Mayor, a fat man named Fehlersohn, blinked at them from a half-opened door. "Yes?"

"We need a place to stay," Wurdmann told him flatly "We're taking over your house. You're moving somewhere else."

The Mayor didn't believe them at first, but the sight of a troop of men with loaded guns convinced him soon enough. At gunpoint, he was marched out of the house into the cold street.

"Who else is in your family?" Wurdmann asked.

"My wife – my daughter–" the Mayor stammered.

Wurdmann smiled. His flat, heavy face creased with the change of expression. "All right, then," he said. "We'll keep them for a while – until we get tired of them."

The Mayor stammered: "You – you can't mean–"

"That's exactly what we mean," Wurdmann said.

The Mayor charged him suddenly. Wurdmann stepped aside and hit the fat man at the back of the neck. The Mayor sprawled in the street.

Then Wurdmann shot him. He stepped over the Mayor's body and, followed by his men, went into the Mayor's house. Inside, two women began to scream.

The Mayor's wife was a pleasant, mild-mannered woman in her late forties; the daughter was nineteen. The two women were repeatedly raped by Wurdmann's troop, until, in shock and exhaustion, they lay collapsed in an upstairs room.

"They pass out too easy," one of the men complained.

Wurdmann had a remedy for that: he always did. He had the women dragged to their beds, and their arms tied over their heads to the bedposts. Then he stuck splinters of wood under their fingernails.

The women woke and screamed with the pain. Staring wildly, the Mayor's wife pleaded with the men, promising them anything if they would only let her daughter alone. But Wurdmann laughed at her.

"We'll have everything we want from you," he said, "and from your daughter as well." Then an idea struck him. "Take the old woman out – let her watch what's going to happen to her precious child."

Two soldiers took the mother from her bed, fettered her hands and feet, and marched her down the hall to the girl's room. There they tied her to a chair. The girl, already tied, lay naked on the bed, moaning with the pain of the splinters Wurdmann had thrust into her.

Her mother watched in horror as Wurdmann signalled to one of the soldiers, who came forward and slapped the girl's face, trying to waken her more fully. But she was in shock. She moaned and muttered semi-conscious pleadings.

Wurdmann grinned once again. He lit a match and set fire to the wooden splinters. As they burned down the girl began to scream.

TWO HOURS later, her hands a mass of burns and her body marked with a hundred bruises and bloody scratches, the girl was dead. The mother, unconscious, was cut loose from the chair: Wurdmann did not bother awakening her before he shot her.

The bodies were put out into the street. Wurdmann's soldiers began looking for any food that might be in the house.

They had taken the place over. Ulmdorf, like other towns before it, had been conquered by Caesar Wurdmann, one-time Sergeant in the army of General Wallenstein of Austria.

The long agony of Ulmdorf had begun.

Wurdmann, in the opinion of his superior officers, had been a good sergeant, perhaps a little inclined to brutality and not recommended for promotion because of his occasional riotous moods, which could come on him suddenly and last for hours.

However that may be, Wurdmann seemed very happy in the army. He chafed a little at restrictions, but that was natural, and if on his occasional passes he was less than kind to the girls of the various local towns, that might be natural too. It had been rumored that he had killed a town girl on one such pass, for no discernible reason. The girl had not been the most virtuous in the town, and her disappearance might have meant no more than a removal to other and more prosperous quarters.

And then General Wallenstein deserted.

Near the end of the Thirty Years' War, Wallenstein, fighting for the German court, suddenly switched sides and took his army with him. Many men refused to go, some joining other armies for the Court, and a good many simply giving up the fight and deserting in the direction of home.

Bands of soldiers began to straggle through the countryside, and one of them was led by Caesar Wurdmann.

As an independent commander, he had what he seems always to have wanted, complete power over any town he visited, and the ability to perform any act whatever on any of the girls in the town.

Wurdmann needed power – and power, for Wurdmann, meant pain and death.

He began to find both in plenty, in nearby towns at first and then gradually progressing northward. Behind him he left burning houses and the memory of incredible acts.

He had staked a fourteen-year-old girl out in a field "as a lesson" to a family which had refused his men shelter. The girl, stripped naked and spread-eagled on the bare winter ground, had been smeared with honey. When daylight came, the honey attracted fighter ants.

The girl, screaming endlessly, took fifteen hours to die. Her father and two brothers left an older sister at home and attempted to attack Wurdmann.

They were shot. The older sister, seventeen, was given to Wurdmann's soldiers until, half-mad with pain, shame and exhaustion, she longed for nothing but death.

Wurdmann had her tied naked to the town's gates. Then he instituted bayonet practice with the girl's jerking, blood-smeared body.

When he left the town, two weeks later, he left her corpse still hanging from the front gate.

There were always other towns – and other women.

Somewhere, the war was still going on, but the war didn't interest Wurdmann any more. He had found a career he liked better – the brutal career of a small-time conqueror and torturer.

Perhaps he, too, remembered, only with pleasure, the events of those months: the two women he had burned alive in a barn when they refused his soldiers, the fifteen-year-old girl who had been whipped to death with a cartridge belt as an "experiment." Wurdmann had bet that he could keep her alive and conscious for five hours.

The girl was still alive, still conscious, though barely sane, her entire body almost flayed by the whipping, at the end of seven hours. Then Wurdmann, tired of the sport, cut the girl down from the rafter-peg to which he had tied her. She fell helpless to the floor.

And while she still moaned, half insane with agony, he threw himself on her. The weight of his body, pressing her broken and bleeding flesh into the floor, roused her to a new series of agonized shrieks.

He raped her while she screamed. Then he used his bayonet to cut her throat.

THE CITIZENS of Ulmdorf weren't long in discovering the bodies of their Mayor and his wife and children. For a while, it looked as if Wurdmann and his men would be besieged in the Mayor's house, but they had armament and training, and the townspeople had neither.

It took Wurdmann two days to establish his total authority over the town. He was a dictator, without any effective resistance.

Ulmdorf, like many smaller German towns, was fairly isolated from anything resembling a main point of government: the war had done a good deal to disrupt communication, and in 1635 really rapid travel and communication simply didn't exist even at the best of times. The town, under Wurdmann, was completely cut off.

And he and his men had a carnival. Any girl who struck their fancy was propositioned or simply hauled off, depending on the whim of the soldier involved. Any man who refused them food, money drink or shelter was dispatched.

The town was under Wurdmann's martial law.

One of the townsmen, Johann Schacht, decided he had to put an end to the madman's reign. His wife had been among the first to catch the eye of one of Wurdmann's soldiers, and he had found her body the next day, naked, bruised and horribly mutilated, in one of the gutters. He had been nearly insane with grief and rage for days, and he had been cared for by his daughter, a twenty-year-old girl named Gerda. Perhaps the fact that Gerda had to stay entirely in the house during those days saved her from attack in that first brutal wave of carnage and rape: she was a blonde-haired, tall and slimly-built girl whose attractions were greater than most of the Ulmdorf's maidens.

When Schacht began to return to himself, he forbade Gerda to leave the house under any pretense whatever. He went out to do any needed shopping. Gerda stayed indoors, hidden from the ravening soldiery.

Schacht had only one driving desire: he was going to wipe Wurdmann's army from the face of the earth. Even that didn't seem to him sufficient repayment for what they had done, but it was a goal to fight for, and to live for. Every minute not spent in the bare necessities of living went into a fierce, single-minded concentration on a plan.

The best one he could come up with, though, involved Gerda – and called for such split-second timing that for some weeks he hesitated over putting it into effect. But at last he found himself faced by the choice either of forgetting his revenge or of using the plan he had constructed.

He explained matters to Gerda. "I'm not afraid," she said. "I know you'll make everything all right."

Next, he went to talk to other townsmen. Their part of the job was risky, too, and a few didn't want to join. But most of them had wives, daughters, relatives who had suffered horribly under Wurdmann's reign.

One, Willi Heutner, had been forced to open their tavern late one night when the soldiers had felt like a few drinks.

Marie Heutner had screamed curses at the soldiers at first, while they whipped her back and legs. Then the whip tasted the more delicate portions of her quivering body, and her curses changed to wails of agony. The whipping never stopped. When one soldier began to tire his place was taken by another. For Marie, it meant hours of endless, repeating torture as the lashes struck, one after another, raising welts at first and then drawing blood in trickles and in streams from every inch of her flesh.

She was begging for death, and calling Willi's name in a delirium of torment, when, after four hours, she died.

The soldiers let Willi go. His sister's death, they thought, would be a lesson to him, and from that day on he would keep his tavern open whenever they wanted it.

For the rest of his life, Willi heard his tortured sister's voice calling his name. He, along with others, joined Schacht's band.

THE NEXT night, Gerda went out of the house for the first time since Wurdmann's men had arrived.

She walked up and down the streets for an hour, trying to look as if she had business there. At last she was noticed by a roving soldier, who approached her walking a little unsteadily: he had been drinking at the tavern.

"Want to come along with me, honey?" the soldier called.

Gerda tossed her head. "I don't want you," she said. "I want to find Wurdmann."

"I'm not good enough for you, honey?" The soldier looked at her threateningly.

"Maybe later," she said, tossing her head. "But I want to find Wurdmann. He's the one–"

"He send for you?" The soldier looked suspicious.

Gerda shrugged. "Maybe he did," she offered. "Why not take me to him and see?"

The soldier didn't dare take a chance, in spite of Gerda's charms. Wurdmann's vengeance could turn on his own men as readily as on the townsfolk. "All right," he said roughly. "Come on along with me." He grabbed her wrist and pulled her down the street.

"You're taking me to Wurdmann?" Gerda asked.

"That's what you want, isn't it?"

"That's what I want," she said, just as loudly. Word

would get around. Her request was unique, and news of it would spread quickly, helped by Schacht and his men. That was step one.

'You'll get more than you bargained for," the soldier shrugged. "He's in an ugly mood tonight."

And that wasn't in the plan at all.

Wurdmann was drinking alone in an upstairs room of the Mayor's house when Gerda was brought to him. "She said you asked to see her," the soldier reported.

Wurdmann stared at her, "Ask to see her?" He shook his head. "Maybe I did – and if I didn't, it doesn't matter." He was drunk and brutish. Gerda shivered in spite of herself. "Pretty – too pretty. Where's she been hiding?"

"Hiding?" Gerda said. "I've been right here in town."

"Find out where she's been hiding," Wurdmann muttered, "and maybe we find more, like her there. Make her tell us where she's been hiding." He waved the bottle he held. "Make her tell."

The soldier grinned. This girl had led him on a wild-goose chase. It would be a satisfactory revenge to see her naked and screaming for hours or days before Wurdmann tired of his game. "I'll take her downstairs," he offered.

"Downstairs," Wurdmann said. "Get her ready. Put her on the bench."

The soldier grinned more widely. The "bench" was something Wurdmann had constructed, and it hadn't yet been used. He was anxious to see it in operation. Gerda, wide-eyed with fright, was hauled downstairs.

There before her was a long, low wooden bench studded with small spikes.

The soldier, with the help of his comrades, stripped the girl swiftly in spite of her struggles and pleas. Naked before them, she was dragged protesting to the bench, and thrown down upon it.

The spikes bit into her flesh as her wrists and ankles were tied to the corners of the bench, and one more strap passed over her waist so that she was held down against the torturing points. She struggled – but every motion tore the spikes deeper, and she was screaming in pain when Wurdmann came down the stairs.

Still drunk, he was prideful and bloated, strutting into the room with the pride of generations of Spanish *hidalgos*, the strutting gait of a peacock. The gasping and quivering girl on the bench made him grin momentarily, and then he stepped forward.

"You like the nice rest we give you on the bench?" he asked.

Gerda gave him no answer. She tried to keep herself immobile.

"Maybe you tell us where the others are now, eh?"

"There are no others," she whispered. Even the motion of talking made the spikes bite a little deeper into her skin, and she tried not to scream.

Giggling, Wurdmann leaned down to caress the shrinking body obscenely, and in spite of herself Gerda tried to jerk away from him, and screamed.

"You want to keep still, eh?" he said. "Well, we find out how still you can keep now." He motioned to a soldier, and the man came scurrying over with a wide, fiat whip of black leather.

Gerda closed her eyes and tried to pray.

"Maybe you keep still when I whip you, eh?" Wurdmann said. "Then it hurts a little less. But after a while you move anyhow – I whip you an hour, maybe, or more."

Gerda prayed silently for rescue – but no rescue was in sight. There was only Wurdmann with his devilish whip, and beneath her soft body the spikes that tore into her with agony.

Wurdmann brought the whip up, and lashed it down.

Gerda jerked uncontrollably as the whip sang into her flesh, and the spikes ripped her body. She screamed in torture as blood began to soak the wood of the bench – and Wurdmann brought the whip down again.

The leather covered the most sensitive parts of her body, and no matter how she tried to keep an iron control on herself she had to move a little – her body jerked with every lash. Constant pain kept her screaming, and with the pain she was weakening and losing control – soon, she knew, she would be writhing against the spikes, tearing the front of her body to tatters while Wurdmann's whip worked on the rest of her.

And she would not die – she knew that. She might live for many hours while the torment went inexorably on!

The whip sang down again and buried itself in her flesh. Her screams rose. Her eyes were rolled back in her head, her body sheened with sweat and her own blood. And the torment continued.

SUDDENLY THE door burst open and Wurdmann turned – to face a horde of townsmen armed with pikes, hayforks, anything they could get their hands on.

The soldiers were all in the house, as they had hoped, called there by curiosity over this girl who had asked for Wurdmann himself.

They didn't have a chance: everything was happening too fast.

But the entire fight Gerda went on screaming and screaming, locked to her bloody bench of agony. The whipping had stopped – but the spikes settled gradually deeper into her, and her body quivered with her own screams...

The fight took half an hour. Then, and only then, was there time for Gerda.

Tenderly the men untied her and lifted her from the spikes. When they saw what the madman's torture had done to the beautiful girl they fell silent in horror.

They carried her away.

Then, with most of the men dead, and Wurdmann unconscious in the house, they set fire to the place. Wurdmann awoke in the flames and died there: his screams could be heard throughout the entire town.

And Gerda was taken to her father's house, for whatever aid they could give her.

Two days later, quieter but still delirious, she died. The town had been freed of Wurdmann's reign of terror, but Gerda had paid the price. The townsfolk gave her a funeral that matched the funerals of heroes... and, months later, it was Johann Schacht who, as Mayor, guarded the city gates against any faint possibility of the return of a troop like Wurdmann's.

For Wurdmann was dead – but there were others, and perhaps others like him. And neither Johann Schacht, nor Ulmdorf itself, could ever forget.

"BRING BACK THE BLOODY ANGEL OF ALGIERS"; detail from interior art, **MAN'S BOOK**, 02/63.

BRIDES OF TORMENT FOR THE SS BEASTS

Beatrix had offered her body for Zoepf's "cooperation". Now, in the fearful crypt which stank of sweat and blood, she was to learn the horrible price of his foul caress.

BEATRIX VAN NOSTRAND STOOD before the SS-Obersturmführer, her clear blue eyes downcast, her fingers wringing the tiny lace handkerchief she held.

The Nazi slammed his fist down on the table. "Impossible!" he bellowed. "It is out of the question! You have read Seyss-Inquart's directives. There is to be no travel between cities."

"But certainly for my *grandpère*'s funeral. He was a good man and he dreamed only of being buried in Zaandam. I ask no petrol. Merely permission to carry his coffin on a farm cart. My sister will accompany me."

"I told you it is out of the question!" the SS-Obersturmführer roared.

Boldly, Beatrix pressed the point. She threw the shawl back from her long golden hair, allowing the Nazi the full benefit of her beauty. She could see his eyes narrow in appreciation.

"But it has been arranged for others, has it not?" she asked.

"The others had money or some other special influence," the Obersturmführer replied. "If we allowed the same privilege to every Belgian peasant, the roads would be so clogged, we wouldn't have room for military vehicles. It's out of the question."

Beatrix blinked her eye, forcing a tear to squeeze out. She dabbed at it with her crumpled handkerchief. Her firm breasts rose under the tight confines of her blouse, threatening to spill over the material. The sight was not lost on the Nazi who now emerged from the sanctified position behind his desk.

"I don't have money," Beatrix sobbed. "But I will do whatever I have to for clearance to Zaandam." She stared directly into the Nazi's eyes, her chin held level, the silent promise blaring from her trembling lips.

She felt the Nazi's sweating palms stroking the nakedness of her shoulder, working its way under her tight bodice. It was as if a million maggots crawled over her skin, but she stood her ground. His body pressed into her back. She looked over her shoulder at him.

"I could be very nice to the man who allowed my sister and I to take my grandfather to his grave," she breathed. The sweetness of her breath blew warm on the Nazi's cheek.

His eyes darted around the SS office. He looked like a weasel, ever alert to danger. "Come to my billet tonight at nine," he said as he scribbled an address on a piece of paper. "The permit you seek may be arranged."

A half hour later, Beatrix stood in the cellar of a small frame house which looked out on the North Sea. Although it was May, the cold still clung to the damp walls, causing a deadly chill to invade her bones. She looked at the coffin standing in the middle of the floor, the lid resting against it.

Wilhelm Koersel smoked nervously, the ashes from his cigarette sparking around his fine peasant's beard. He waited for Beatrix to finish speaking. The others clustered around, their faces gray with concern.

"So tonight I go to his billet and receive the clearance. Then we take my grandfather by cart to Zaandam. Hendrick will have his men in the graveyard. The transfer will be made."

"It is too dangerous," Wilhelm argued. "Two women alone on a wagon with a coffin. There will be no protection. If you are found out, there is nothing we can do for you."

"The British took certain risks to get the guns this far, didn't they?" Beatrix asked stubbornly. "Our people in Amsterdam are taking certain risks waiting for the ammunition, are they not? Is our risk any greater?"

A pregnant silence greeted her question. The others shuffled their feet and stared into the half-filled coffin. Whether

they wanted to or not, they had to admit that a hundred Bren sub-machine guns were of the utmost importance to the Dutch Resistance in Amsterdam. Since the English sub had put the guns ashore at Zandvoort, it was up to the Dutch to move them inland.

"But if some of the men went along?" old Wilhelm persisted.

"Out of the question. Any able-bodied man is subject to immediate deportation, you know that. If the guns are to be moved, it is up to Lillian and myself. Tonight I go to the Nazi and get the necessary credentials. You will advise Hendrick that we will be in Zaandam tomorrow night. Now I must hurry. The Nazi expects me."

Old Wilhelm pursed his lips. Then he thought better of what he had been about to say. His gnarled fingers clenched into a hard fist at his side,

THE SS-OBERSTURMFÜHRER was young – no more than 19. As Beatrix stood before him in his billet, his very youth made him all the more disgusting.

"I came as you ordered," she said n a small voice.

He watched her, a cruel look of cunning darting from the small eyes. "Ah yes, the matter of your grandfather's burial, is it not? Tell me, *Fraulein*, just how important is this matter to you?"

Beatrix knew the answer he expected. She fought to keep the loathing out of her voice as she replied, "I will do anything that is required of me in return for the travel permit."

"*Gut*," the Nazi smirked. "We understand each other. If I find you satisfactory, perhaps something can be arranged."

The Dutch girl nodded. Without a word, she reached for the buttons on her blouse. The Nazi's lust-crazed stare filled her with a sickness. Yet she removed her blouse, allowing the man to savor her breasts which were covered only by a filmy bra. Gracefully, tantalizingly she worked her hands down over the smoothness of her skin. Her fingers found the belt of her skirt and the garment fluttered to the floor like a mortally wounded bird.

The Nazi hurled himself upon her, ripping at the thin silk of her skin tight black panties. His breath was a savage grunt. His grasp was a thing of torture, bruising her flesh, stripping away her dignity with her clothing. Even though she had come of her own free will and denuded herself before him, he insisted on taking her by force.

As she struggled to respond to his demands, she thought of Hendrick now waiting for the arms shipment in Zaandam. There was a startling physical resemblance between the two men. Both had the lean muscular bodies of athletes. Both had the shock of blond hair, closely cropped. Both stood well over six feet.

But in the brutal grasp of her German "benefactor" Beatrix also marveled at the difference in two men.

Her mind was 30 kilometers away with the Dutch Resistance Leader. Even as her back arched to the SS-Obersturmführer and she cried out in mock response, the image of Hendrick Harelbeke swam through the red mist of her pain and defilement.

She thought, "*There is no other way. We do what we*

have to. But will I ever be free of the smell of this beast? Will I ever be able to feel clean again?"

His lust spent, the Nazi strutted arrogantly around the room. "You can leave now," he said.

"The permit," Beatrix replied. "You promised it."

"I can't be bothered with paperwork at night. See me some other time."

"But my grandfather must be buried. I have done everything you asked of me." Beatrix felt the convulsive fear flooding through her. She was not afraid for herself. However, if she were unable to move the man, the guns would not move into Amsterdam.

She stood before him, once again clad in the sheer lingerie. Her tears were not faked, they fell in twin rivulets down the smoothness of her cheeks.

"You said that if I came to you tonight…" she began again.

His hand lashed out, crashing across the side of her face.

"Do you know my name?" the Nazi demanded.

"No! But what has that to do with it?" she whimpered, clutching on the foot of the bed for support.

"I am Richard Zoepf. You may have heard of my relative."

Instant recognition quivered through Beatrix's brain. Who in The Netherlands hadn't heard of SS Captain Heinrich Zoepf, who headed Adolf Eichmann's Hague Office.

"What has that to do with me?" Beatrix was dumb struck by the turn of events.

"You must realize that as a member of the SS I have violated my oath by becoming involved with a woman of inferior blood. Such violation could be embarrassing to me, were it to be made known. I'm sure Captain Zoepf would find cause to censure me. All this is unfortunate for you, since I must now place you under arrest as an enemy of the Reich."

The words had the sibilant hiss of a puff adder. Zoepf's eyes had become the merest pinpoints. He squinted at Beatrix as the color drained from her face. "You will finish dressing and I will conduct you to SS Headquarters for further interrogation," the Nazi ordered.

"You must be joking. I came to you because you said it was the only way to get the necessary credentials. If you were my lover, I couldn't have been more responsive. Certainly have no reason to suspect me of any acts against your authority."

Zoepf grasped her long blonde hair, dragging her to him. She was so close that she could see the slightly enlarged pores of his nose. The mask of cruelty that was his face was all the more depraved because of its youthful quality.

"You represent a personal threat to me," he sneered. "We of the SS work together in protecting each other from personal threats. Do you think for a moment that I would allow a night with a Dutch peasant to stand in the way of promotion? As of this moment, you are a spy *provocateur* who is being brought in for questioning. You will now finish dressing."

THE ALMOST deserted street rang to the click of Zoepf's boots as he marched Beatrix before him. With less than a half hour to go until curfew, the few pedestrians who were still

about scurried from the path of the SS man and his captive.

Beatrix considered making a break. The bizarre quality of developments had yet to register completely for her fog-enshrouded mind. Of all the dangers she had faced in her work with the underground, this was the most absurd. The bitter irony of it caused her to smile despite her situation.

A mad youth, fired with sick ambition, found it necessary to destroy the women he had forced to bend to his will. He considered that by so doing, he protected the pure Aryan status of his blood. Had he but known, he could have had his victim shot for any number of real offenses against the Nazis. Instead he had hit upon a trumped-up charge.

The smile vanished as quickly as it had come. With growing bitterness, she thought of the coffin and the British machine guns which would not get to Amsterdam. The fact that she was about to suffer some unknown horror at the hands of her captors was incidental to the sense of defeat which chilled her.

Zoepf prodded her onward. The hard metal of his Mauser digging into the small of her back caused pain to shoot down through her trim legs. An elderly woman looked at the tableau and scurried deeper into the shadows.

A stooped man moved across their path, trundling a hand cart before him. For just an instant he lifted his eyes and caught Beatrix's glance. Frantically the girl looked away. *"Go away, Wilhelm!"* her brain silently screamed. *"Go away before he suspects you!"*

Wilhelm placed his old gnarled hands on the handle of the cart and pushed mightily.

"Old one, you will make handsome bar of soap," Zoepf spat after the disappearing figure.

Then Beatrix was being propelled into a small stone house from which the hated Swastika hung limply. An SS enlisted man jumped to attention, his right arm angling out in the Nazi salute.

"A spy-*provocateuse* for questioning," Zoepf growled. "You will accompany us and prepare her."

"Jawohl, Obersturmführer!" the man snapped to. His claw-like hands closed around Beatrix's arm, causing her to cry out in pain. "The *fraulein* cries easily," he smirked. "She will find much to cry about."

Brutally the girl was dragged down a narrow corridor, then into a large room.

"Strip her..." Zoepf ordered.

Beatrix stood trembling before her captors, feeling their horny hands working under the surface of her blouse and skirt. Their fingernails raked her skin, bringing new pain.

The blouse tore away like so much tissue paper. Then the skirt fell in a tattered heap at her feet.

Zoepf stood back gloating as the enlisted man bound the girl's wrists behind her. Then he dragged her by the hair to a bar which hung from the ceiling. The cruel iron was jammed between her arms and her back to provide a halter, and she was roped securely to it.

Slowly the bar was hoisted towards the ceiling, thrusting Beatrix's body to strain forward in a futile effort to relieve the strain on her shoulders. She felt her naked feet being lifted from the floor so that her entire weight now dangled from her outraged arms.

Zoepf and the enlisted man stepped backward, studying their victim. The forward thrust of her body caused Beatrix's young breasts to almost spill over the confines of her bra. Desperately she wriggled her toes, trying to find some purchase so that they might reach the floor.

The action caused the lithe young muscles of her legs to undulate in a ghastly rhythm.

"Behrmann will love this one," Zoepf giggled in a high pitched, womanly way. A light of madness shone in his eye, and suddenly Beatrix realized that there had been more than fear of discovery of his illicit relations with her. The SS-Obersturmführer was sweating and he kept wiping his palms on his jodhpurs as his imagination of the pain to come beat with increasing tension in his brain.

"She is a real beauty, isn't she, Otto?" he fairly purred at the enlisted man. His companion clucked in assent. There was a lunatic bond between these two – a bond of such evil proportions that no depravity would be too gross for them.

"Behrmann wants to continue interrogation of the other one," the enlisted man offered. "He has a special fondness for her."

Zoepf licked his lips. He watched Beatrix with an evil cunning. He reached out and touched her, bruising her flesh. He grabbed for her bra, wrenching it from her in one motion. Gloating over her uncontrolled gasp of pain, his brutal hands moved down her stomach, over her flanks, the clawing fingers tangling in the silk of her panties. There was a hissing sound as the cloth tore. Zoepf's laugh filled the room.

At that very instant, the huge steel door swung inward. Beatrix's eyes swung to meet the new arrival. Quickly she turned away. Never in her life had she seen anything so hideous. The man resembled nothing human. His shaven head was bullet-shaped. One arm ended in a leather covered plate from which a steel hook protruded. His chest and shoulders were over-sized enough to give him the stooping, loping gait of a gorilla. His short legs bowed outward from the weight they carried.

But worst of all was the insane, slavering expression of the face, as the man called Behrmann dragged his protesting captive into the center of the room.

The girl was in her early twenties. Her auburn hair fell in wild disarray around her naked shoulders. Although her face was already distorted with pain and fear, Beatrix had to marvel at the perfection of her features. But the alabaster flesh had been marred beyond healing. The crude brand of the swastika had been carved into her tortured skin. The code number brutally tattooed in indelible ink.

They had taken most of her clothes from her, leaving her only the delicate black lace panties, bra and pitiful fragments of what had once been a skirt.

Now Zoepf moved forward to receive his victim. His arms encircled her shoulders. His knee ground into the small of her back, forcing her inexorably forward. The girl's moans of terror were answered by Beatrix's cries of outrage as they both began to understand the hideous nature of the treatment which awaited them in the chamber.

Behrmann's over-sized shoulders bulged as he shoved

a heavy drill press into the center of the room. The unit was not unusual in appearance – it might have been a portion of any machine shop layout. The only clue to its diabolical purpose could be seen in the brownish red marks which were encrusted on the drill head.

The girl saw and realized, and then she began to scream. She thrashed and kicked in her captor's grip. She ground her heels into the floor, braking her body against their efforts to move her into position. But Zoepf was strong. He twisted her arms behind her back, shoving her wrists upwards toward her shoulders.

Beatrix heard a sound which resembled that of a chicken bone cracking. The girl screamed shrilly and the scream ended in a choking gasp. The fight seemed to go out of her for a moment. Before she could recover, they had her in position, the flat of her palm turned upward, the bit of the drill directly over it.

Beatrix closed her eyes, yet she would never be able to put the fearful sound of the scream out of her mind. It rose and rose and seemed as if it could never end. The room spun and Beatrix fell forward, mindless that the ropes which held her were chafing her flesh raw as a result of the added weight against them.

SEARING AGONY brought her back to the present. It blasted through her unwilling brain, tearing the velvet veil from her mind. The stench of burnt flesh assailed her nostrils. The torment of her shoulder sent waves of nausea flooding through her. She opened her eyes and stared into the bestial face of Behrmann.

"It is only the beginning," he gloated, as he laid the glowing iron back into the brazier. "The whips, the pincers, you will taste them all. Your flesh will blister and grow black. Your lovely skin will be flayed from you while you still live. I will hurt you in ways you never believed you could be hurt."

Behrmann had picked up a whip. He ran it through his grotesque fingers, flecking off dried bits of flesh. Beatrix tensed, awaiting the blow. Although she had thought herself prepared, she knew as the thin lash swirled around her hips that there was no way to prepare for such a shock to the nerves. Her toes curled with it. Her bound arms convulsed, ripping at the cords which held them. Pain erupted in her belly and along the columns of her legs. She fought against the crushing suffocation which blasted her lungs.

But she had no further time to concentrate on the pain. For the whip now tore into the unprotected areas of her upper body. Agony hung around her in a red fog which blotted out the sights of the gloating faces of her tormentors. Zoepf's secret of his lechery with her was now secure. He had done his job well. When they finally cut her down, no one would ever believe that she had been a woman.

But as suddenly as the whipping had begun, it stopped. Cordite fumes mixed with the stench of sweat and blood in the chamber. Somebody ripped at the cords which held her. Mercifully her head fell forward and the torture was blotted out with a dizziness she had never known before.

THE SMELL of new-mown hay brought her back to consciousness. It bore down on her, scratching at the wounds of her body. The jouncing of the cart brought new sensations of pain. She tried to move, but a hand held her down.

"Easy," old Wilhelm whispered. "You are not quite safe yet."

"The guns?" she sobbed, remembering the purpose of her visit to Zoepf.

"There will be other shipments. They will get through. We will have to use this consignment to protect ourselves now."

"You risked everything to save me?" she breathed.

"It was to save ourselves," Wilhelm answered gruffly. "No one could stand up long to the Nazis. Sooner or later you would have given us all away. We couldn't let it happen."

The words were selfish and harsh. But the old gnarled hand found hers and Beatrix realized that there was a sentiment there which no resistance fighter should put into words – a sentiment which often clouded men's judgment and made them do foolish and heroic things.

In early February, 1945, the British First Army liberated North Holland. And in the spring of the year, Beatrix Van Nostrand received a parchment bearing the crest of Wilhelmina, Queen of the Netherlands which attested to the girl's participation in underground activities against the hated Hun. As she read it and wept, Beatrix touched the ugly scar tissue of the swastika brand which still marred the softness of her flesh. Hendrick Harelbeke took her hand in his and caressed it gently. Neither one of them spoke for a long time.

"TENDER FLESH FOR THE FANGED MONSTERS"; detail from interior art, **WORLD OF MEN**, 05/63.
Art uncredited; attributed to Norman Saunders.

TNT TUCKER'S NAKED JOY GIRL GUERILLA WAR AGAINST THE NAZI TORTURERS

The longer the war continued, the more the Nazi soldiers learned to fear the "Fighting Go Girls of Gascony"!

WE'D CRAWLED THE LAST half mile on our bellies. The night was pitch black, and the freight cars parked in the railroad yards of Lyons had seemed like ugly squat monsters in the darkness. The yards were behind us now, and we crawled along a gully that paralleled the tracks.

Behind me, Françoise brushed against a tin can. It rattled noisily against a rock. I froze and hugged the ground as if it were the body of a woman. The night was cool, but I was sweating. My heart was beating overtime. If the Krauts spotted us now, it would be the end – not only the end of the mission,

but also my almost certain death. If a slug hit me, they'd never bury me. They'd never find the pieces.

I had one hundred feet of explosive primacord rope wrapped around my waist, and my backpack was filled with one-pound blocks of TNT. I should have been used to being a living bomb by now, since blow-jobs, as we used to call them in ironic fun, were my specialty and the OSS had trained me well for them. But where you get used to being shot at, you never get used to the thought of being blown into little bloody

chunks of raw meat. Your guts turn into a bucketful of mushy gravel. Your mouth dries out, and you sweat ice. And that's exactly how I felt as I lay there on my belly when Françoise caused the racket with the tin can.

Françoise was a swell girl and it hadn't really been her fault, but I couldn't help cursing her silently. Heavy German hobnailed boots crunched through the darkness about 50 yards away. The steps came closer. If we were spotted...

SLOWLY I pulled the Marlin sub-machinegun off my shoulders. Might as well go down fighting. I could hear Françoise's tortured, panicked breathing behind me. Her shoulder touched my right leg and I sensed that she was turning over on her back so that she could fire at the Nazi if it became necessary.

I strained my ears. The Nazi railway guard had stopped. He was probably listening, wondering if something funny was going on. It was little consolation to think that he was probably as scared as we were. From far away came the sound of a locomotive hissing steam. Then I could hear couplings strike. Sounds carry in a lonely night. I glanced down at the radium dial on my wrist watch. We couldn't wait much longer. The train was expected around 3 AM. It was now almost 2. It would take twenty minutes to set the charges on the rails. If the Nazi didn't give up and go away, we'd never have the time to do the job.

But we *had* to do it. All my girls were on that train. The only way to get them out of the clutches of the Nazi SS torturers was to help them escape in the confusion of the rail wreck after I blew the tracks. If I didn't have time to set the charges, the train would pass here, and the girls would be lost – bound for the joy-houses of the sadistic storm troopers in Germany.

OF COURSE, the Germans could have shot the girls right after their capture, and they would have been within their legal rights to do so, for the girls were saboteurs, guerrillas and killers. But the Germans were lechers, and they knew good female merchandise when they saw it. And my girls were just that. Sexy as hell. That's why they had been picked for the job.

For almost a year and a half they had been raising holy hell with German occupation troops in France. They would let themselves be "persuaded" to visit a Nazi headquarters for a night of fun, and while they kept the Kraut officers busy and happy, I would work undisturbed setting my explosives, and then, when I was done, we'd kill off all eye witnesses who could tell afterwards what had happened, and then I'd blow up the joint and make for the woods with my girls. Rocket launching sites, radar stations, anti-aircraft batteries and military radio relay points were our favorite targets. But that's not how it went the last time. Everything, suddenly, went to hell in a bucket.

Hélène and Denise, the most attractive of my eleven girls, had gotten jobs in a low-down joint in Lyons which, we knew, was often visited by officers from the local SS-Gestapo headquarters. What made this headquarters special was that it housed a printing plant in which the Germans printed phony ten-dollar and five-dollar bills with which they were hoping to create confusion and inflation back home in the States.

It was on our second night at the Cabaret Cornut when three officers from the SS headquarters showed up. For a while they looked bored, inspecting the local merchandise of worn-out collaborationist prostitutes, but their interest perked up quickly enough when the lights dimmed and Hélène and Denise started their act.

HÉLÈNE AND Denise came out in tight, low-cut dresses and announced that this was a contest – that the audience should decide which of them they liked better. In turn, they started to peel out of their scanty dresses. To start with, Hélène got the bigger hand for when her dress came off, she swayed seductively in a lacy little panty-skirt and a black bra that was too tight and hardly covered anything at all – and there was a lot to cover – her long legs sheathed in smooth black stockings, pinched to her white thighs by red garters. Denise, on the other hand, looked more demure in a white slip, But when Denise's slip came off, the contest was about even. The girls glowered at each other during the applause, and suddenly attacked each other. Then they wrestled, and Denise finally won, pinning Hélène to the floor, her long, stockinged legs flailing in the air while her nude body heaved under Denise. The German officers were sweating with enthusiasm and clapping loudly.

When the girls had their clothes back on, the Nazis asked them over to the table and inquired if they could not round up a group of equally talented and attractive friends for a visit to their headquarters the next evening. I smiled ingratiatingly when I stepped up to the table. The Germans did not ask me to sit down.

"We want to order a show," one of them said. "I understand that you can provide about a dozen girls."

I nodded. "First-class girls," I said. "They know all the tricks."

"Tomorrow night then," the officer said, and he gave the address of the printing plant headquarters.

"I shall need a dressing room," I said. "The girls must put clothes on so they can take them off."

The Nazi grinned. "All the details will be taken care of," he said.

I COULDN'T have asked for a more convenient dressing room. When I arrived the next night with my girls and the costume trunks – they had false bottoms full of TNT and other explosive paraphernalia – the room assigned was between a banquet hall where the show and subsequent orgy was to take place, and the big hall where the presses were. It was easy to pry the lock while the girls took their turns stripping for the SS bastards, and by the time the show was half through, I was busy laying my charges on the engraved plates for the phony U.S. money.

I'd had a glimpse of two of the girls dancing on a table through the banquet hall door when I returned to the trunks for the percussion caps and fuses, and I saw that around the table the girls who had finished their turns were sitting on the laps of the officers and cuddling up to them. Only Françoise and a little blonde by the name of Madeleine were still waiting their turns, standing inside the door, their nude curvaceous bodies covered with silver powder, the tips of their remarkable breasts covered with sequined red stars and their pretty feet in spike-heeled shoes. Their dual dance was to be the finale of the formal part of the show, and the trick was that they would come on, each carrying a purse, and out of these purses there suddenly would materialize short-barreled automatic pistols.

But it never came to that. For just as I turned to go back into the press room, a huge figure suddenly filled the door.

AN SS officer stood in the frame, a gun levelled at me in his

hand. He must have entered the press room from the other side and seen my handiwork. There was nothing else I could do. I threw myself at him, hoping to twist the pistol out of his grip before he could fire.

The edge of my left hand slammed into the side of his neck and my right hand closed around his gun in a grip designed to demobilize the muscles of his trigger finger. At the same moment my knee slammed into his groin. The Nazi grunted and his legs sagged under him, but my grip on his gun hand hadn't been strong enough, and the pistol went off in the room with a roar.

There was a yelp behind me. Instinctively I turned, only to see a blood-spurting wound gushing open between Madeleine's breasts. Françoise's hand was already in her little bag, extracting her automatic pistol.

I heard a German voice from the banquet hall cutting through the music: "Sit still everybody. Hands up, girls!" And at that moment, bullets began hammering through the door.

Françoise threw herself on the floor, opened the door a crack and began firing.

"I got one," she yelled.

"Never mind," I screamed. "Let's get out of here." I knew there was nothing we could do. We were outnumbered. At best, I might be able to set off the charges. We'd worry about the girls later. It was not nice, but it was war.

I ripped the tunic off the unconscious German officer and threw it to Françoise. She fired twice more, each a burst of three shots. Then she raced after me into the press room. I blocked the door, quickly stuck a percussion cap into a heap of plastic explosive and pulled the 10-second fuse. As we ran out of the door on the other side of the press room, I already heard heavy steps behind us. Guns at ready, we raced down a rear stairway. And then, above and behind us, the blast went off with a deafening roar.

WE GOT out of the building, all right, after gunning down a guard at the foot of the stairs who looked at us in scared surprise when the blast went off upstairs. We dashed through dark back streets and made for our secret hide-out in a small shack outside of town.

A couple of days later, Françoise made a scouting trip into Lyons and came back with the information that the girls were being shipped to Germany that night to be used in the pleasure-houses of the SS. While she was gone, I had decided that I had to do everything in my power to save the girls. Françoise agreed with me.

There were only two of us now, but with us, as with all underground fighters, the rule had always been: one for all, and all for one.

DON'T FIRE!" I hissed at Françoise as we lay in the gully beside the railroad tracks. "Wait until the Nazi is right on top of us."

She touched my leg, reassuring me. I was happy I had her along.

I waited. The German still stood out there, listening for suspicious sounds. Time ticked away. Then his distant steps in the darkness started up again. I breathed a sigh of relief. He

was walking away from us.

I gave him five minutes after the steps had receded into the distant silence, then I hissed at Françoise, "Let's go."

Still, even crouching, the next 300 yards took us nearly 20 minutes. Then, at last, we reached the switch point where the line split, one set of rails headed north toward Germany, the other to the east toward Switzerland. The train we were after would take the north rails.

We scrambled up the embankment in the dark and went to work a few yards north of the switch point, I took the TNT from my pack and piled the blocks around both rails and connected them with primacord so everything would blow up at the same instant.

I T WAS 2:50 – ten minutes before the expected train time – by the time I was ready to arm the charges. I didn't have an electric detonator, and since I didn't know the exact moment of the train's arrival at the switch point, an ordinary time fuse wouldn't do since it might split the rails before the train came and then the engineer might be able to stop the train before wrecking it. The only way to be sure was to make the train blow up the charges.

I put a clump of composition C on a rail, stuck a percussion cap into it and connected it with primacord to the big charges. When the locomotive's wheels pressed on the cap, the whole mess would go off. I was finished. I looked at my watch. It was 2:59. We'd made it just in time!

"Let's get out of here," I said, and started walking back toward the switch point from where we could get back in the ditch and wait for the train wreck. And then something happened that would only happen once in a million years. I knew the instant it happened that my luck had run out forever.

I STUMBLED over a tie and lost my balance. I tried to steady myself and set my foot down close beside a rail. At that moment, there was a loud click. It was followed by a metallic grinding and the worst pain I'd ever known in my life.

The pain shot up from my left foot. It hit my groin like a brass knuckle fist and went through my insides like hot lightning.

"My foot," I pressed out between my clenched teeth. "My left foot!"

And I suddenly realized what had happened. I had stumbled just as the switch was thrown from a signal tower in the railroad yards back toward town. The switch had been thrown by remote control for the train we were expecting. And the switch had caught my foot and crushed it, and now held it caught in its unyielding iron grip. The mash of blood and bones, mangled flesh and shoe leather was held immovably between the two rails.

I was caught – and the train was due any moment.

"I'll use a lever," Françoise said. She took her sub-machine gun and tried to pry the rails apart with its barrel. I almost blacked out then. I could hear her panting with effort through my thickening pain.

"I can't do it," she breathed. "I cannot pull you out."
I nodded.

She put her soft hand against my cheek. "Frank," she

said softly, "do you want me to shoot you?"

"No," I said. "Leave your gun. I'll do it myself."

She pressed her into my hands and then she disappeared into the darkness.

I WAS alone, waiting for death. I decided to get it over with. I raised the gun barrel to my head, and reached out with my left hand to pull the slide. My left hand brushed against the hard corners of the box of blasting caps that stuck out of the breast pocket of my jacket.

At that moment, I knew what I would try to do. It was an outside chance, but it was worth taking. I gathered all my remaining strength and will power, stood up and with my left foot still imprisoned, threw myself backward on the rail. I reached out over my head and groped for the nearest charge. My fingers touched it. I grasped for the primacord rope and pulled it out of the charge.

At that moment, the rail started shaking under me. The train was approaching.

Slowly and deliberately, in a dull trance from the pain, I tied the length of primacord around my ankle, just above where my foot was caught. I wound it around several times. Then I took a blasting cap out of the box and inserted the end of the primacord in it. I took the crimpers out of my pocket and crimped it tight.

I groped for the pistol I had put down before reaching for the primacord. I found it. I put the barrel against the blasting cap. Very clever, I told myself. I'll fire the gun, set off the blasting cap which would set off the primacord and I'd blow off my foot – and I'll be free.

By now the tracks were heaving under me, and I could hear the train. The rails pounded. I pulled back the slide, reset the muzzle on the blasting cap.

Now the train came. The locomotive came around the bend, a black shadow in the night. I pulled the trigger. The slide slammed forward.

A bright orange flame welled up at me. I didn't hear the blast. I was part of it. The explosion enveloped me, and I felt myself flying through the air and I only knew I was free. I had blasted myself free! Blacking out, I rolled down the rocky embankment.

Then all hell broke loose. With my last consciousness, I heard the huge explosion as the train set off the charges on the rail-bed above me, and then something heavy pressed down on me, and I knew the train was crushing me after all.

SEVERAL DAYS later I woke up in a familiar place. I was lying, wrapped in blankets, on the floor of our hide-out hut, and Françoise and several other familiar faces were smiling down at me.

Later I found out what had happened. The train's locomotive had blown up, and the train had been derailed. Françoise had killed the two guards on the prison car in which the girls were traveling, and then they had searched for me and found me in a small air space under the tilted cab of the locomotive. They had managed to extricate me, put a make-shift tourniquet on the bleeding stump of my leg and had carried me to safety.

I found out another thing, too. And that was that the first two cars of the train had carried German soldiers, and that almost forty of them had been killed in the wreck. I guess that's what they gave me the medals for afterwards.

"HELL-RAISING GUERILLA QUEEN WHO SAVED MARSHAL TITO"; detail from interior art, **MAN'S ILLUSTRATED**, 05/63.
Art uncredited.

NYMPHO JD'S HAYLOFT TERROR

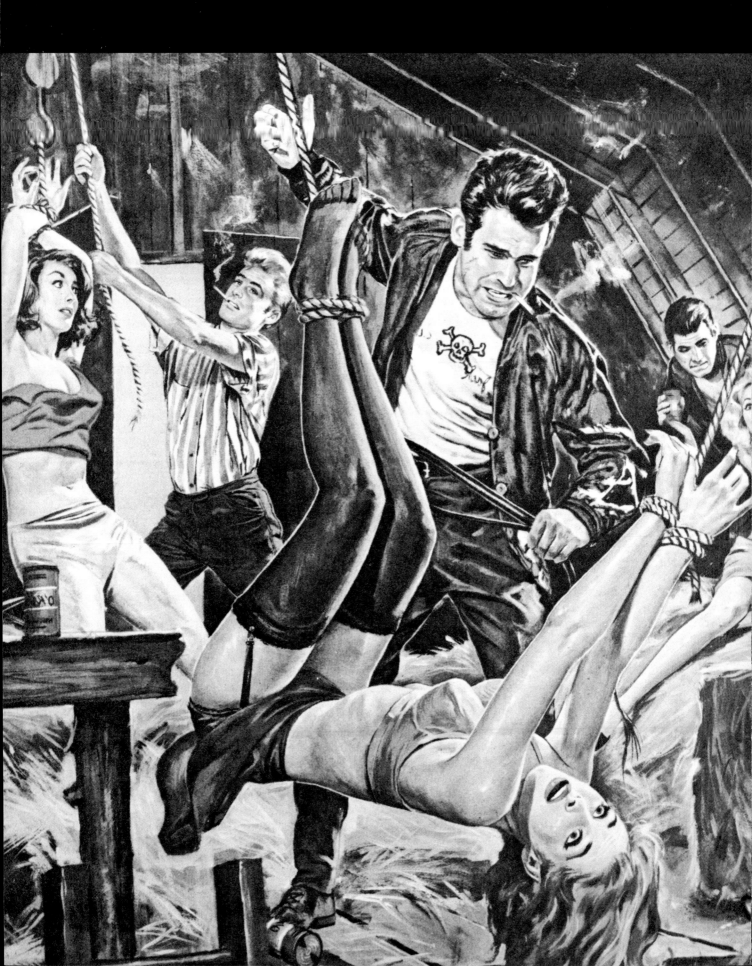

The "Three Aces" were cards all right – but what they didn't know was that the deck was stacked against them!

IT DOESN'T MATTER if I spill the whole sordid story now. If you read the newspapers last August, you might've come across a short squib because the judge forbade the press from reporting the full details in view of my so-called tender age of 17 and those of my pals, and also to protect the names of our victims. But the DA has it all down in my full confession, and since I can't do any harm to that farmer's family because they sold the place and moved to Muncie, I'm going to spill my guts here. Maybe it'll help some punk who's got big ideas but a little amount of brains.

I thought I had it made last June when I glanced back at those grim, gray walls of the reformatory, and looked ahead at Slats and Bongo, but I was only stepping out of the fire and into the frying pan. As it would turn out, that frying pan became the hot seat for Slats. After being locked up for three years for armed robbery and assault, I'd rather have had those two waiting for me than anybody else I knew. It'd been a long time since I'd seen ducktail haircuts, sideburns, black leather jackets and tight black pants. It was like our uniform. We called ourselves "The Three Aces."

BONGO FANCIED himself the Ace of Hearts because he was wild about skirts. Slats' nickname, the Ace of Diamonds, stemmed from his fondness for flashy clothes and cheap jewelry, and only the Ace of Clubs suited me because I used to work over my marks with a billy I once slipped from a cop when he tried to stop me during a grocery store stickup. We thought we were cards, three of a kind. What we didn't know was that the deck was stacked against us!

We were going to make up for those years I spent in stir, Bongo assured me as we drove away. Sure, we had a lot of catching up to do, Slats added, aiming the brand-new Chrysler down the highway like an arrow. I mistook that wild look in their eyes and slackness of their jaws for contained excitement. How was I to know they were hopped up! Nor did I realize until later that since I'd made the grade as a con, they wanted to prove they were just as good. It didn't take long for them to make their point. I wondered why they stopped about a half mile from a gas station, and told me to get out and leg it until Bongo explained the car was hot and might be recognized.

The boys planned to welcome me back with a shindig, and money was no object, especially since they didn't have any. They planned a caper at the gas station. Bongo staked himself at the pumps as lookout while Slats went inside, calling to the lone guy working on a jalopy up on the rack. The guy came out, wiping his oily hands on a rag, when Slats let him have the grease gun full in the face. The poor slob clawed at his blinded eyes. Slats grabbed him by the back of the neck and jerked him

down, while he pile-drived his knee into his groin. As the guy crumpled, a flailing arm tripped Slats. He slammed to the concrete floor. With a cry of rage, his hand snaked out and coiled around a monkey wrench. He smashed it down on the slob's face, crushing it like a piece of overripe fruit, squishing out veins and brains that looked like oozing worms. An uncontrollable shudder shook my body.

The take from the cash register was only $18.35, but that, plus a tankful of gas, was enough to take us a couple of hundred miles on Route 46 and to chow up at a fancy beanery. As darkness closed in, we knew we wouldn't make Bloomington, and there wasn't anywhere you could buy a "fix." What with that strong bit back at the garage, I was getting a little edgy and wanted to play for time to let the boys cool off, so I suggested we find a joint to bunk down for the night. Bongo wanted to keep going, but Slats sided with me, complaining of a sick headache as the juice wore off. We tooled along the road, flanked by moon-glinting potato fields until we spotted some yellow rectangles of light in the distance.

As we drove up, the farmhouse was quiet except for some muted rock-and-roll coming from a radio in an upstairs room. Bongo rapped on the door impatiently while Slats said his headache was killing him. He was retching so bad, I thought he was going to vomit right there on the porch. The door opened a crack, and an old geezer holding a kerosene lamp showed his face. That was all Bongo needed. He straight-armed him, kicking the door wide open. The old guy looked funny, spread-eagled on the floor, staring up at us with popping eyes, still holding onto the lamp. We marched in. Bongo gave the farmer a kick in the backside, sending up a squeal of pain.

A woman's voice called from upstairs, asking who was there, and then she came hurrying down the steps, knotting the cord of her bathrobe. The pair of them looked like that famous Grant Wood picture of the old farmer and his frau I once saw in a magazine ad. She stared at us for a second, scared to the marrow of her rheumy bones, then hurried to help the old creep up. Bongo said we didn't want nothing but a room for the night, but all the time his pig-like eyes were searching the joint as if he was trying to find where the family pin-money was stashed. And I was wondering who was listening to the rock-and-roll.

THE OLD jerk knew better than to squawk, so he told us we could sleep in the barn. What with his headache and being sick, that was all Slats needed to hear. He grabbed the coot by the scruff of the neck and shook him until his bones rattled, yelling that we'd take their room, and *they* could use the barn! Then he slapped him hard on the mouth with the back of his hand,

making it spurt blood, and knocking out his dental plate, which broke on the floor.

I can take a lot of things, anything that can be dished out maybe, but I don't cotton to the idea of an old man being bullied. Sure, I'd pulled some raw things on my own, like that last rap I did time for, but my victim was a young guy. And before that, Bongo, Slats and me, we "blazed a trail of terror," as one of the newspapers called it, with a series of stick-ups that started at French Lick and wound down through Hillham, Crystal and Kullerville. We had no compunction when it came to roughing up a victim, whether he resisted or not. It was just part of the sport. I don't know if we got more kicks from pushing them around or lifting their dough, but none of them was a Senior Citizen.

Maybe I didn't cotton to the idea because I was in the precinct that day and heard the way the bulls worked my old man over in a back room to make him confess to a burglary charge. I heard them push and punch him around, and when they half-carried, half-dragged him out, he was a God-awful bloody mess I didn't recognize. His nose was broken in two places, his jaw had to be wired, and he could never again work two fingers of his right hand. The bulls lied to the DA telling him that he fell down a flight of stairs, so he didn't investigate the brutality. That's why I didn't have the guts to see an old galoot being roughed up.

I SPOTTED the danger sign in Slats' wildly rolling eyes. He might've killed that farmer if I didn't butt in. I knew he was beyond reason in the grip of his uncontrollable rage, so I shot a hard right into his belly with such force, I almost felt his spine. He dropped, sucking for air, but he was my buddy and I wanted to make sure he was okay, so I helped him back on his feet. He was as sore as a boil about to bust and shook me off, but my promise to try to get him a "fix" next day cooled him off and convinced him I was still his pal.

Of course, the three of us being broke might've raised some doubts in his mind, but the old lady took care of that when she offered to give us some dough to clear out. Bongo jumped at the deal, and when she came back from the kitchen, taking $34 out of a coffee can, he grabbed it and told her he was going upstairs and didn't want to be wakened for breakfast before 10. On the way to the stairs, he spotted the phone on a table and ripped out the wire to make sure she didn't call for help while we were asleep.

UPSTAIRS, THE rock-and-roll music drew us like a magnet. Bongo pushed open the door, and the three of us stared, just stared. We'd hit the jackpot. They were obviously three sisters – Mary Ellen, Barbara Jane and Jo Anne, as we later learned. Slats whistled, "What a sister act!" They looked up at us, horrified, in the middle of combing their hair, or manicuring their nails, or sewing a black silk stocking. We stepped inside, closing the door behind us. It'd been two years since I'd been so close to a dame, and I never felt my need so much as I did then. They were cute as buttons, with their young, upturned breasts and milk-and-honey, farm-fresh complexions. My look went right through their clothes, through the peasant blouse of one of them to the soft, gleaming flesh, through the skirt and halter of another to her long thighs and lean, spirited, virginal body that never had yielded to a man's touch.

"Hey, y'ever hear the story about the farmer's daughter?" said Slats, jeering. "He had three of 'em!" His nausea was gone. He didn't need a "fix" any more. He had a craving for something else, which soon would be satisfied.

The three chicks backed away in terror as we came closer. Bongo told Slats to go back and take care of the old couple before they raised hell loud enough for someone to hear. He threw us a dirty look, then whipped down the stairs while Bongo and I eyed the three of them greedily, trying to pick the best in the lot. It wasn't tough; each one was as good as the other. From downstairs, we heard the old bag scream, then a dull thud that sounded like a body smacking to the floor, then a groan.

Slats pounded into the room, white-faced. "They won't bother nobody no more for a long time," he said, then snarled at the three girls. "The breakfast table's set for 15! Who else is here? Where are they?"

THE GIRLS exchanged secret, silent looks. He grabbed one of them by the arm and twisted it behind her back. She squealed in pain as Slats threatened to break it. "The hands who pick the corn and soy beans," she gasped. "They sleep in the bunkhouse back yonder!"

The same idea hit Bongo, Slats and me at the same time. If these broads hollered, we'd be in the soup. We could lam pronto, or, since we didn't want to give up these dolls, we'd have to make sure they couldn't raise a fuss. While I gagged their mouths with pillowcases, Bongo and Slats tore strips from a bedsheet and tied their legs and wrists. In the gloom when we arrived, I'd noticed the silhouette of a barn a few hundred yards off. Each of us threw a helpless broad over our shoulders like a sack of wheat and hurried down, and out the back door. I got a fleeting glimpse of the old folks. They were sprawled on the floor, their blood -splattered mouths stuffed with kitchen towels, their hands tied to the legs of the stove. Slats had made sure they'd stay down and out.

Inside the barn, I dumped my load and bolted the door. It smelled fresh and sweet of hay and feed. The moon, slanting through some open windows, picked out a kerosene lamp, which I scooped up and lit. Some horses stirred nervously in their stalls. I jerked a thumb in the direction of the hayloft. Bongo climbed the ladder first with his squirming chick, followed by Slats and me. I held up the lamp. No bedroom in the best hotel could be as comfortable as this joint. Bongo checked the windows to make sure they were closed, then untied his babe and removed the gag. Slats and I did the same. Hate and fear flashed from the girls' eyes as they edged back. Their white, welcoming skin gleamed in the dim, flickering lamp light.

MEANWHILE, AS I later learned, a one-man posse was after me. A social worker square named Russ Sullivan had come to meet me at the reformatory to drive me back to Lebanon and to give me a spiel on rehabilitation. Learning I'd already left with a pair of "undesirable characters," he took after me. Slats' murder of the grease monkey aroused his suspicions, which

were confirmed by a waiter at the ritzy joint we ate at. Smart boy that he was, Sullivan estimated our mileage, and with no place to make a stopover for the night, he headed straight for the farmhouse. He was a smart cookie, that square.

Anyway, Bongo grabbed the chick in the peasant blouse named Jo Anne and began to kiss her hungrily while she struggled to free herself. Bongo and me, we didn't have to choose. Each was as stacked as the other, so we hooked the ones closest to us. When I put his arm around Darlene Jean and instead of fighting him off, she began to scream. The other girls began to scream, also, knowing it was no use but it was their only weapon. Their cries returned Slats' vicious headache. He slammed his palms to his ears to shut out the sound, yelling for them to shut up.

"I'll teach you!" he hollered. "You'll be too scared to even whisper!" He knocked over his dame and tied her hands and feet, then strung her up to the rafters so she hung limp, like a slung hammock. Bongo bust out laughing and grabbed his moll and tied her to the pulley hook used to lift bales to the loft, letting her dangle about 20 feet from the floor. They pleaded to be let down, promising to be quiet, but the boys weren't through. Slats whipped off his belt and flicked it menacingly like a bullwhip while Bongo, laughing like he'd bust at the amusing sight, kept hoisting his broad up and down, warning he might just let her drop sudden-like. I didn't care for playing games. I was more interested in scoring. I pushed my skirt over into a corner, where she lay quiet and submissive, ready to surrender, when I remembered the can of beer I'd slipped into my back pocket in the kitchen.

IF I hadn't crossed over to Slats to borrow his switchblade to puncture the can, I would've seen a figure slowly climb the ladder at the far side and slip over onto the loft. He must've gauged the distance between the broad that was strung up and us, because just as I took Slats' shiv, he swung her hard. She let out a scream as she collided with Slats and me. The impact bowled the two of us over, knocking the wind out of us. Before we could grope to our feet, he kneed Slats in the chin, sending out a couple of teeth in a gush of blood. Slats let out a groan and lay still.

The lantern picked out the glint of the shiv in my fist. I lunged at the square, skimming his skull. Then, using some sort of judo stunt, he swung me off my feet like a featherweight and slammed me down. From the corner of my eye, I saw Bongo move in for the kill. He held a pitchfork in his meaty hands, and the tines were aimed straight for the square's face. He couldn't get close enough to Bongo to pull another judo trick.

But the broad hanging from the pulley wasn't wasting time. She was swinging to gain momentum.

Suddenly, her legs flashed out, crossed and locked themselves around Bongo, squeezing, pinning his arms to his sides. The pitchfork dropped from his useless, numb hands as she applied pressure.

IT WAS up to me now. I flicked the shiv in front of his face, dancing around, wary of his cunning. My foot hit something hard in the hay. I bent, snapped up with a scythe. I didn't have

to close in now. I could cut his head off from seven feet away, and he didn't dare to grab that murderous, razor-sharp blade. He started to back away, looking around for an avenue of escape. If I knew what I was doing, I'd have stopped, but something had snapped in my brain. I'd become a homicidal maniac, lusting to kill!

I heard the ominous swish behind me, wheeled, to take the pitchfork handle full in the face. There seemed to be a terrific explosion. Lights danced, and before I collapsed, through eyes leaking with blood, I saw the horrified look of my dame as she held the pitchfork down near the tines, like a baseball bat.

It wasn't until the cops got there – the girls woke some of the pickers to fetch them from town – that I was filled in on some of the details. The cops had been looking for us to match our fingerprints with those left by Slats on the monkey wrench at the garage. They had us nailed, but good.

LAST AUGUST, the three of us stood trial at Indianapolis. Slats was sentenced to the electric chair, Bongo and me, we got 10 years each. So I'm squatting here in a cell, worse off than when I left a little while ago, sick with the feeling of how my life would have been changed if that square, Russ Sullivan, had met me instead of Bongo and Slats, those two aces, who turned out to be nothing more than a couple of jokers. Deadly jokers. Maybe this'll teach some punk who's being sprung to think twice if he's got big ideas– because the bigger they are, the harder you fall!

HANDMAIDENS OF HORROR OF THE KEMPEITAI

His name meant horror to the women of Malaya – none were safe from this mad, torturing fiend.

SGT. YOSHIMURA STOOD BEFORE the assembled young women. He was immaculately dressed in a white uniform which bulged over his barrel like wrestler's chest. His bandy legs were laced tightly in puttees which reached to his knees. He stared out of myopic eyes, savoring the loveliness of his captives.

He slapped his thigh with his ever-present riding crop.

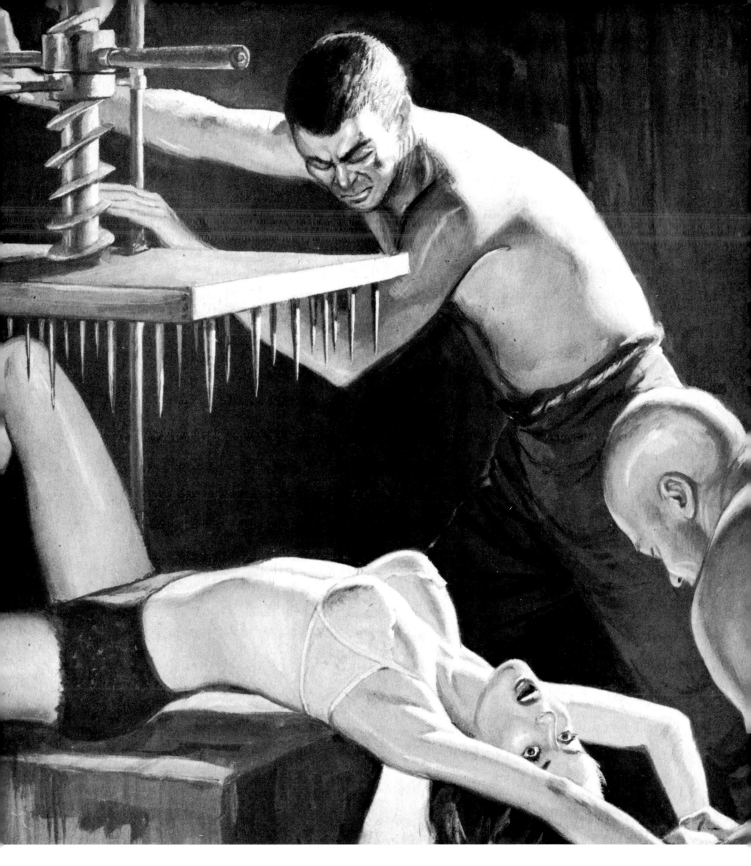

"*Ah so*," he began again. "You are spies and will be treated as such. Now you will tell me all that I want to know about the British underground in Malaya. You will give me names and places. You will talk forever about your companions."

Ava Harding, who at age 24 was the senior nurse of the four woman unit, stepped smartly forward. In a clear voice which displayed not the semblance of a tremble, she said. "We are members of the Royal Cameron Hospital Team. We are correctly uniformed and covered by the Geneva Convention. We have given you our names, ranks and serial numbers. We are not compelled to give you any further information."

Yoshimura studied her, an enigmatic smile touching the corners of his cruel lips. "*Ah so*," he repeated. His voice still held a reasonable tone. Of the five people in the room he

alone seemed unaffected by the stifling heat and fetid smells. As Kempeitai officer in charge of the Malayan city he had had ample time to accustom himself to its bestial climate.

He moved to a desk and pressed a buzzer. Immediately several other Japanese marched into the room, their faces inscrutable. Yoshimura nodded once. The men seized the four women and hurled them to the floor, brutally knocking the breath from them. Swiftly they seized the girls' arms and bound them behind their backs, attaching them to tight halters which had been slipped over their heads.

"You will now be conducted to Gopang Road. We will meet again shortly," Yoshimura barked.

For Ava Harding the trip to Kempeitai headquarters was a nightmare of pain and degradation. Her bound hands kept her from working off the truncheon blows of her guards. Tied as she was, she was even powerless to protect herself against the obscenities carried out on her lovely young body by her captors.

She tried not to cry out against the horror, realizing that only her courage stood between the four nurses and insane hysteria. She staggered forward under a rain of blows which set her hips afire with indescribable agony. When Barbara Widseth whimpered in terror and rage before her, she whispered under her breath, "It will be all right. They're just trying to scare us."

But Ava Harding knew the truth. She had known the truth even before the big Blenheim bomber had crossed the jump area and she had led her contingent of airborne nurses through the bomb-bay doors. She had known that capture would mean agonizing death. She had known it, but had refused to dwell on it.

Office of Executive Services had briefed her thoroughly. The guerillas of Cameron Highlands could not survive the ravages of *ben ben* without medical aid. There were women and children among them. Every attempt must be made to save them.

Now as the iron gates of Gopang Kempeitai Headquarters clanged shut behind her, Ava felt the tragedy of futility closing in on her. Her group had barely cleared the jump area north of Ipoh when the Jap patrol had spotted them and marched them into the city past the downcast eyes of the natives. All of the planning and training had gone for nothing.

As if in a dream, the nurse felt herself being propelled into a cell so small that she could neither sit, nor lie down. Another door slammed behind her. She heard screams and the racket of doors opening and closing, and she understood with growing panic that the four girls were to be held in solitary confinement.

The Japs had not seen fit to untie her arms. Her wrists were raw and chafed. The rope which held them to her neck threatened to strangle her when she tried to relax her cramped muscles.

He sense of time deserted her almost immediately. In the darkness of the cell, almost fainting in the brutal heat, choking on the torture knot which encased the white slimness of her throat, overwhelmed by the stench of excreta which was all around her, she waited.

"I will tell them nothing," she whispered over and over again. "I will die before they learn anything from me."

Her thoughts were broken by the sound of a key turning in a lock. The cell door inched open slowly. Sgt. Yoshimura stood framed in narrow aperture.

"*Ah so,*" he gloated through his buck teeth. "The very proper British nurse. Now we shall begin again. Who were your contacts in the Cameron? What was your destination? How many guerillas are there?"

"I have given you all the information I intend to give," Ava said quietly. The effort of speaking was exhausting. She fought for breath against the torture noose.

Yoshimura's monkey face creased into what was supposed to be a grin. His eyes remained agate-hard as they swung around in their sockets.

"You are a properly uniformed British nurse, is that correct?" he asked.

Ava nodded. Her blonde curls danced in the half light of the cell.

"We Japanese are quite proper. We would not want to cause any shame to your precious uniform," Yoshimura grinned. He stepped forward and his hands clawed at the fastenings of Ava's flight suit. His face twisted into an animal leer as he slowly ripped the flight suit from Ava's body.

Behind Yoshimura a group of jabbering men poked each other and laughed at the pitiful struggle of the white woman to cover her near nakedness from their lascivious gaze. The flight suit had been baggy, effectively hiding the softly delightful curves of their prisoner. But now the taut pink satin bra and the skin tight pink briefs left nothing to their imagination.

This was no emaciated civilian internee whose body had been twisted by malnutrition and the beatings. This was a beautiful young woman still in the glow of good health. She and the others would make delicate morsels for the engines of the interrogation room.

"And now that you have no uniform to protect, you will tell me," Yoshimura shouted. His face was inches away from Ava's. His eyes were maniacal. The cords of his neck stood out. He reached out and grabbed the girl by her hair, dragging her out of the cell and down a narrow hall. His knee jabbed into the small of her back propelling her through another door. Ava fell heavily. Yoshimura dragged her to her feet once more by the rope which ran from her throat to her bound wrists. Momentarily the room blackened before her, her head swimming with the suffocation.

"Look around you!" her torturer hissed into her ear as he pressed into the soft contours of her back. "Look around and enjoy the sight of the engines of the Imperial Kempeitai."

IN SPITE of herself, Ava Harding gasped at the horrors which the chamber contained. Arrayed on a table before her were whips and cudgels of varying sizes. The ceiling rafters contained pulleys from which thick ropes dangled. A low-slung table had been fitted out with heavy straps which would buckle over a victim's body, holding her immobile for the heated knives and splinters of the secret police torturers.

Most hideous of all was the heavy press which hovered several feet over the table top. Ugly steel spikes stained reddish-brown pointed downwards to the table top. The girl

shivered convulsively at the sight.

"You are the leader of the guerilla band, so you bear the responsibility for what is about to happen to them," Yoshimura gloated as he led the dazed nurse to a wall and chained her to it.

"I'll tell you nothing more than I already have," Ava Harding cried through clenched teeth.

"We will see." The slavering Jap grunted an order. Moments later two guards appeared in the doorway, dragging the kicking, screaming Barbara Widseth between them. One of them hit her in the face with his fist, knocking her off her feet. They squatted beside her, pinning her body to the rough stone as they stripped the flight suit from her.

The girl thrashed madly in their grip, feeling the horror of their horny touch, sensing them stripping her bra and panties from her.

"Don't let them! In the name of heaven, don't let them!" she shrieked.

Ava fought her own bonds, feeling the ropes and chains digging into her tender flesh. She bit her lip until a trickle of blood flowed down her chin. The orders of the OES colonel screamed through her mind. "In case of capture, you are to avoid giving any information to the enemy regardless of any action taken by him to obtain it." Momentarily, Ava Harding closed her eyes.

But Barbara Widseth's screams would not allow Ava to remain blind to the fearful tableau before her. The girl had been placed on the table, face upward. She writhed uncontrollably as the straps were fastened around her ankles and thighs. Her soft belly squirmed under the heavy leather bonds. Her fingers clenched and unclenched as they were drawn over her head and fastened in heavy leather cuffs.

Yoshimura stood beside Ava, his hands roving over her soft body, testing the warmth of her flesh. "You can spare your comrade," he whispered. "There is no reason for her to suffer this way."

"Go to hell!" Ava managed to gasp.

Yoshimura's hand flashed out. Pain exploded through Ava's brain. The force of the blow was beyond description. Yoshimura spun on his bandy legs and approached the table. He leaned over Barbara Widseth's lovely body, testing the straps which held her.

A Jap soldier stood beside him, a gushing hose in his hands. Viciously he gripped the girl's nose, cutting off her breath. Her mouth flew open and he thrust the nozzle deep into her throat.

Within seconds, Barbara Widseth was a wriggling, squirming column of agony. The flesh of her belly stretched taut and grew a ghastly white under the restraining straps. Her eyes bulged out of her head. Her nails clawed the air in wild jerking gyrations. Her fettered ankles drummed relentlessly against the splintery table.

Watching her, Ava willed herself to faint. But the mercy of unconsciousness was not for her. Her medical training had conditioned her reflexes to the point where she remained completely rational even in this pit of hell.

At last the beasts turned Barbara over on her face, allowing the water to flow from her mouth, easing the pressure on her tortured lungs.

Yoshimura swaggered before Ava. "We begin mildly," he gloated as he stroked the fullness of the nurse's pantie-covered hips. "But soldiers of the Emperor can be quite ruthless when they have to. The woman has yet to know the real meaning of pain. Now who are your colleagues in the Cameron?"

Mutely Ava shook her tousled head. "Forgive me, Father!" her brain cried.

Never had she realized a human being could take such agony. Barbara Widseth's nakedness glistened and thrashed as the smoldering bamboo splinters were forced under her nails. She screamed until her throat was raw and the sounds were rasping gasps when they hung her from the ceiling by her reversed wrists. Their whips curled and hissed around her magnificent young breasts and thighs until she hung senseless in her bonds. Still they had the power to revive her and go on with the exquisite pain.

Yoshimura was a madman. His dress white uniform was blotched with blood. His sweating face was a mask of evil. He swilled down huge quantities of *sake* before his straining, moaning captives, becoming more bestial with every passing minute.

Finally – it could have been hours or days later – the Kempeitai torturers restrapped the agony-maddened British nurse to the table. In her mindless ravings, she almost shouted her thanks as the sharp spikes of the press inched their diabolical path towards her flesh.

Ava saw the body disappear slowly under its crushing burden. She saw the geysers of blood squirting along the sides of the table. She heard Yoshimura's mocking voice closing in on her. "You have killed your first woman. Now you know what is in store for the two others and yourself. Tell me about the Cameron."

Crazed by what she had been subjected to, Ava Harding opened her mouth. The words formed on her lips. Then her mind moved back to Baker Street in London. She remembered the oaths she had taken to her profession, her country.

"Go to hell!" she whispered once again through cracked lips.

One month later, Ava Harding died under the same press which had claimed the other three nurses.

IN ALL the annals of bestiality, Yoshimura had no peers. An illiterate, he had gone into the Japanese Imperial Army early in 1933 in search of food and shelter. He had a completely uninspired record, being equally despised by the enlisted men and officers. A dumb brute who prided himself exclusively on his ability to tear a man limb from limb, his advancement was slow.

However, Yoshimura showed a peculiar talent for inflicting pain during the Japanese invasion of Manchuria. His interrogation of Chinese prisoners of war endeared him to the ever watchful Kempeitai, who were the Japanese equivalent to Hitler's Gestapo.

Knowing the Bushido master plan for world domination, the Kempeitai was preparing itself for the day of

battle. It needed men who were not squeamish – men who would consider it their divine duty to make their prisoner compounds veritable bloodbaths.

By the time of Ava Harding's arrest, the Japanese were going all-out to destroy resistance along the Malayan Peninsula.

Yoshimura had been placed in charge of the local Kempeitai detachment.

A Madame Kathigasu reported that she had been arrested for having given aid to the guerilla bands and was incarcerated at the Central Police Station. During her imprisonment, which lasted three months, Yoshimura subjected her to the water treatment, had hot irons applied to her legs and back, hung her upside down by one leg for hours, pushed needles under her fingernails, and had her continually beaten with bamboo sticks.

Unable to pry any information from her, Yoshimura finally outdid even himself in bestiality. The following is a verbatim description of his actions on one occasion:

"My young daughter was hung from a tree about ten to twelve feet high, under which there was a blazing fire. She remained suspended there while I was tied to a post close by and beaten with a stick until it broke in two.

"Sergeant Yoshimura kept shouting to me to speak out, but speaking out, as I and my daughter well knew, meant death for hundreds of resistance people in the hills. My child answered for me, 'Be brave, Mummy, do not tell, we will both die and Jesus will wait for us in Heaven above.'

"On hearing these words, I told the sergeant that he could cut the ropes and burn my child. I told him that my answer was still 'no,' and that I would never tell. All I can remember is that as they were about to cut the rope, God answered my prayer. A Japanese officer who had arrived on the scene took pity and ordered the sergeant to take my child down. She was sent home and I was sent back to my cell."

But to the question of whether Yoshimura was a freak among the Kempeitai or not, we have the answer of Lieutenant Colonel Cohn Sleeman. He said, "It is with no little diffidence and misgivings that I approach my descriptions of the facts and events in this case. To give an accurate description of the misdeeds of these men it will be necessary for me to describe actions which plumb the very depths of human depravity and degradation. The keynote of the whole case can be epitomized by two words – unspeakable horror.

"Horror, stark and naked, permeates every corner and angle of the case from beginning to end, devoid of relief or palliation. I have searched, I have searched diligently amongst a vast mass of evidence to discover some redeeming feature, some mitigating factor in the conduct of these men which would elevate the story from the level of pure horror and bestiality, and ennoble it, at least, upon the plane of tragedy. I confess that I have failed."

The British prosecutor was talking of atrocities in Singapore. He might have been commenting on Ipoh, Manila, Hong Kong. The record of the Kempeitai was the record of Sgt. Yoshimura. The corpses lying in common graves through the Far East bore gruesome evidence of the savagery visited on them, strangely similar to the corpses of the four British nurses who were awarded Victoria Crosses posthumously.

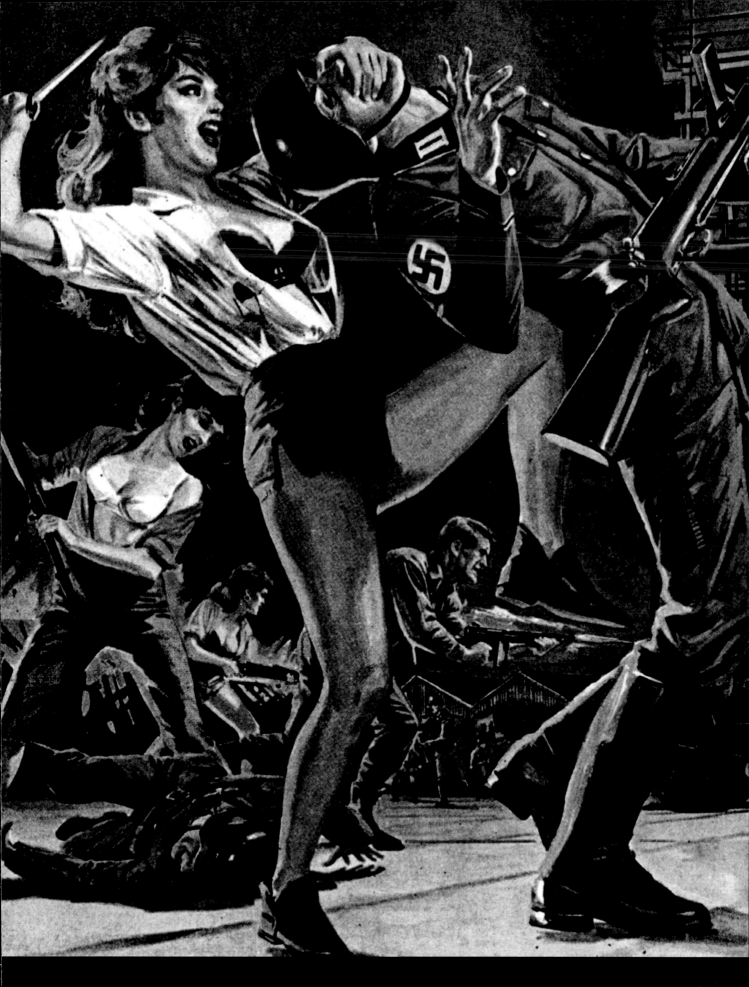

"THE WILD RAID OF GIBBON'S LACE PANTY COMMANDOS"; detail from interior art, **MAN'S BOOK**, 06/63.
Art uncredited; attributed to Bruce Minney

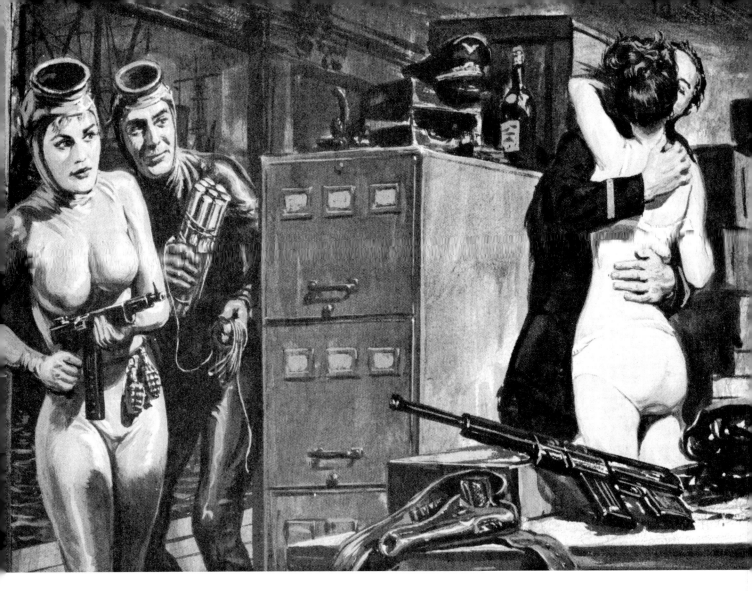

MAFIA VICE QUEENS
WHO CLOBBERED HITLER'S ELITE KORPS

These dames were sheer dynamite when it came to loving – or killing – Krauts!

"THIS IS ABSOLUTELY CRAZY! Why in Hell did I listen to you!"

Carletta pressed a finger to my mouth. "Light the fuse." She was so close I could feel her warm sweet breath on the part of my cheek not covered by the rubber hood. "It's been arranged. I'll give the signal."

Fifty feet away from us in Italy's naval headquarters, four half-naked Sicilians were loving up four drunken Kraut Leutnants. They were here when Carletta and I swam ashore at Marsala. They weren't supposed to be here. JICA said the offices would be deserted at this time of night. All we had to do was blast the safes, snatch the documents and blow. Sure.

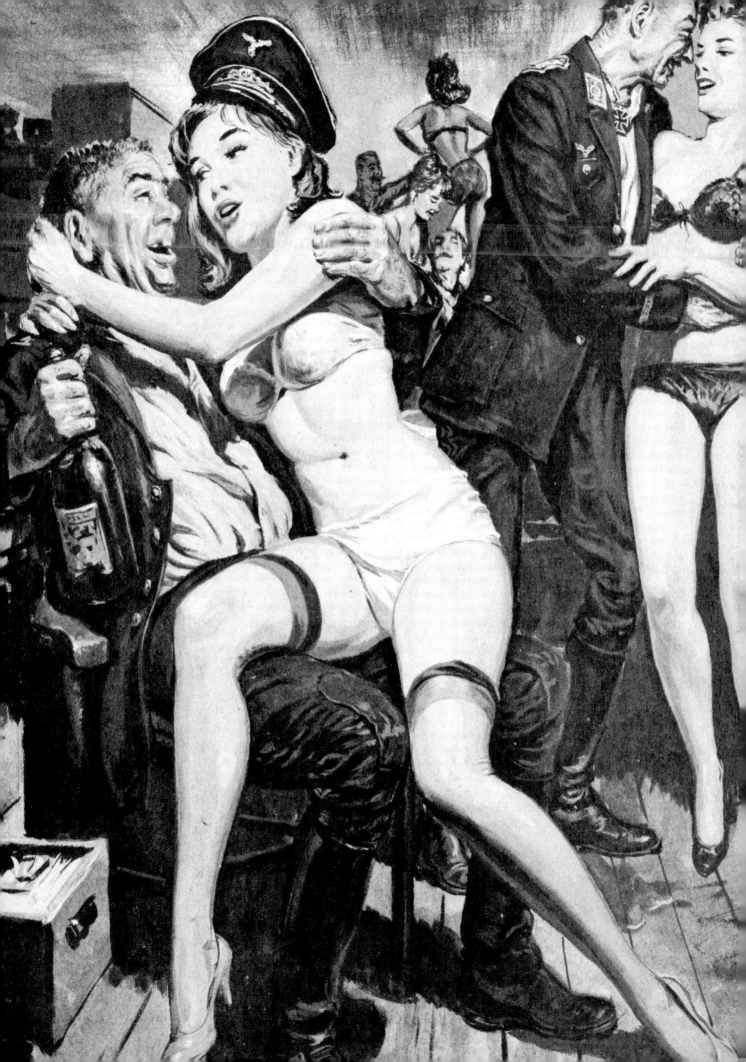

Trouble was building up fast. It was one thing to steal papers, but quite another to kill Krauts, especially these Krauts – the SS, Hitler's pride and joy.

We'd never get out of Sicily alive.

"*Light the fuse!*"

Carletta Porvoni and I were still in our frog suits.

We were crouched behind filing cabinets. Ten minutes earlier one of the Sicilian dolls had swayed to the ladies room and Carletta slithered along the floor after her. There, a plan had been devised.

Now all I had to do was to light the fuse on a stick of dynamite and blow four elite SS-men to their *valhalla*.

The fuse sizzled and sputtered. Carletta waited until there was an inch of it left, then cupped her mouth with her hands. "*Push!*"

The four girls gave their love partners knee jobs and stiff arms that had the Germans toppling backwards to the floor. I hurled the stick of dynamite over the heads of the girls who were now racing towards us.

The explosion shattered flesh and blood all over the place.

I didn't have time to survey the damage. The girls went to the bodies and examined them without even flinching. Any girl I ever knew would throw up at the sight on the floor. But not these babies. They were brought up on blood.

I was tying two grenades to the combination of a safe when I saw Carletta remove her knife from its sheath and drive it into the throat of one of the Krauts. "He wasn't dead," she said, calmly.

Two weeks before, Carletta Porvoni was slinging hash in a Utica diner. JICA ran a security check on her, then handed her over to me as a partner on this Marsala raid. Because she grew up here and knew the town better than anybody in the agency. And maybe because she didn't find it hard to slice throats.

I pulled the pins on the grenades. We ran back to the safety of thick filing cabinets and waited for the steel to stop flying. I took all the papers in the safe and shoved them under my rubber suit. The other safe blew apart just as easily and yielded more top secret stuff.

And while I was blowing hell out of the office the girls were complaining because their clothes had been ripped to shreds.

The street outside started to fill up with sleepy and curious Sicilians. Sirens sounded in the distance. We left the same way we had entered, which was out the back, and scurried through back alleys and yards until we came to what was considered one of the "safe houses" maintained by the local Mafiosi for any and all Allied intelligence personnel who needed a hide-out.

Black-out shades were drawn, two kerosene lamps lighted. I took off the upper part of the rubber suit and let the papers fall. One cursory reading was enough. I'd hit the jackpot. Here were maps showing the locations of Italian mine fields and important data on every seaport all the way up the boot. Not only that, there were even papers on the organizational operations of the Japanese Navy!

"Do you have anything for me to wear?"

I glanced up from the floor and sucked air at what I saw.

Carletta was blue-jay naked.

She glanced my way. The corners of her mouth tilted upwards. "I don't look good in rubber."

One of the girls tossed her a lace bra and panties, which she took her time about getting into while I merely sat and stared. Her girl friends found my expression amusing.

After the reverse strip was over one of the girls sat down beside me. The smell of wine was on her breath, but it was not unpleasant. Neither was the soft hand she threw across my shoulder.

"You're not the first invader we've had to... entertain here."

Suddenly, Carletta's foot was in my face, then going past it to the girl's. She shoved hard.

"Never change, eh, Tessie? Always after somebody else's man."

"Who said I was your–?"

"Shut up, Don. Your life is in our hands. Remember that!"

Those words had been spoken to me before, by some brass at the Joint Intelligence Collection Agency. I hadn't liked it then and I didn't like it now. I'd been dead set against the idea of sending a girl to do a man's job. I'd fought it right up to the moment Carletta and I were put into a rubber raft and paddled to the soft, envious whistles of a sub's crew.

This 23-year-old Sicilian's code of life had nothing to do with democracy, fascism, communism or any other ism. She belonged to the brotherhood of the *omerta*. The Mafia. It was a life membership.

I didn't trust her for a minute.

As far as I was concerned, the JICA had no business exposing me to an element that was as black-hearted as any Nazi. It was like pushing your best girl into the arms of Jack the Ripper.

Now, Carletta stood in front of me, legs apart, hands on her hips. "Are you convinced that we are on your side?"

Her black eyes rolled up into her head. Her forefinger and thumb came together and she shook her hand at me. "You Italian-Americans make me sick! Why don't you trust even your own kind?"

"Because I've seen your kind operate back in the States. You'll fight for anybody who pays off – and double-cross anybody who doesn't."

She threw up her hands and walked away. The girl named Tessie squeezed in close again. Her lips brushed my shoulder. "She is not good for you, *Signore*." Then the other three came in and sat close. They were all dark-complected. Like olives. Like exciting olives. "We will keep you amused until you leave."

"I can think of no better way to wait out a war."

THE IDYLL was broken by a Kraut boot heel slamming into a door downstairs. The four girls shot up like jacks-in-the-box. They hurried out. I jammed the papers down the front of my rubber pants and went to the door to listen.

The girls were laughing and talking it up as though

they didn't know what had happened. Tessie said, "Do you come at this late hour to play?"

SS-men circled the girls. Each held an officer's rank and a riding crop. Their spokesman used school-book Italian.

"What do you know about four of our *Leutnants* being murdered at naval headquarters?"

Mock gasps followed the question. Tessie put both hands to her mouth as though she was horribly shocked by the news. "Nothing... this is the first we heard..."

Their torn clothes were produced and thrown at their feet. "How do you explain it?"

Tessie laughed nervously. "We wouldn't be seen dead in those rags. They are not ours."

The officer's fist tightened on the crop until his knuckles went white. "Why aren't you wearing dresses now?"

"Because we are going to bed."

Her easy answers were too much for the Kraut. His face turned blood red. The riding crop swept across Tessie's bare neck. "Four women were seen with them in the street."

A red welt built up but Tessie wouldn't give him the satisfaction of touching it or even admitting it hurt. "We were here all night."

The crop struck again. Then the others used theirs on bared backs and legs. The girls tried to protect themselves, but in vain. Their bodies arched as the stiff leather lashed their flesh. Again and again the crops opened gashes on soft, naked bellies. Bra straps were split. The SS-men, led by the raging spokesman, were determined to mete out punishment for the murders. They didn't care who got it. In their fit of rage the whole town would suffer. Until the day of liberation, partisans would find it impossible to carry on their work.

And the girl responsible for it was beside me, choking on her muffled gasps.

Downstairs, the beating stopped. The circle of men widened, leaving the four girls writhing in pain on the floor. A polished boot dug into Tessie's side. "We'll expect all of you to be as charming as ever tonight." The door slammed shut and the growling sound of a motor faded away.

"Get some water, Carletta."

"We'll be all right."

"Sure you will." Kneeling beside Tessie, I saw that her lace panties had split and that some of the material had been driven into the wound. Carefully, I eased threads out of the abdominal gash. "What a mess!"

The others were just as bad off. Carletta and I worked feverishly to stop the bleeding and clean the wounds. At one point our eyes met. I used the pause to blast away at her. "This is all your fault. You know that, don't you?"

"I don't understand–"

"Don't give me that dumb foreigner routine. It was your idea to blow up the Krauts. All we had to do was to wait until they cleared out."

"No, *Signore*. It was not Carletta's idea. It was mine." Tessie squeezed my rubber-covered leg. "For months we've tried to get those Germans to open the safes for us. We gave them what they wanted. Got them drunk..." She turned her face away from me because what she had next to say was an admission no woman wanted to make. "...and degraded

ourselves." She sat up and rested her head on my shoulder, still keeping her face averted because of shame. "We knew the Allies were landing soon... those men would not suffer... they'd run away." Hot tears dropped on my arm. "*We wanted them to suffer!*"

Carletta spat angrily, "Does that sound like the voice of an enemy?"

I had no answer for her. Maybe I was wrong, but I wasn't ready to admit it. In G2 suspicion is part of the game. If you're in it long enough you begin to suspect everybody but your immediate superior.

"What did that bastard mean about your being so charming?"

Carletta suddenly went mute. Tessie dug her face deeper into my shoulder. The other three were now deeply concerned about their wounds and were examining them carefully. The silent treatment.

"Well?"

My eyes wandered to the large downstairs room we were in and actually saw it for the first time. Against one wall stood a long bar, behind which were bottles of cognac, vodka and all kinds of wine, including champagne. There were card tables, a crap table and a roulette wheel. The wall opposite the bar had been cut out and a small stage built in it, covered now with a velvet curtain.

Nobody had to explain the German's meaning.

I was on my feet and stamping across the room. "What the hell goes on here? This is a safe house? It's a damn whorehouse. Might as well surrender as stay here."

At the moment, Carletta was the only one healthy enough to fight back. "You're safe here, little chicken. Besides, no partisans out there will dare hide you now – not after what's happened."

"But this place must crawl with Krauts. Don't you see my point? I've got to stay under wraps. How the hell am I gonna do it here?" My rubber pants squeaked as I paced back and forth. "Good Lord! A whorehouse!" I glared at Carletta. "You sure fouled me up but good."

If you've never seen a Sicilian temper unleashed, you're lucky. I caught it now from Carletta. She strode towards me, her ample breasts bobbing crazily, her black eyes wide with fury. Black curses spilled from her mouth, then she said, "Where do you think your precious JICA got its information about the naval headquarters?" Her arm went straight up. If she had more clothes on she'd look like an avenging angel. "From one of those bedrooms," she screeched at me. "Tessie had to sleep with a slobbering fat German officer and do things that–" She choked on her own emotions, couldn't finish.

The silence was heavy after her tirade. Tessie finally broke it with a giggle. She pointed at the bulge in my rubber pants made by the documents I had stuffed into them. "I hope your labor is easy." She'd managed to ease the tension with the simple observation that I looked pregnant. The others giggled, and even Carletta's cute little belly jiggled with laughter.

I shook my head, staring down at how ludicrous I was with a fat gut sticking out. "Okay, okay, it's wild as hell but I'll go along with it. I'll go out of my ever-lovin' mind every time a Kraut sticks his foot in the door, but *c'est la guerre*, eh? Yeah,

c'est la guerre!" I slapped my fat gut. "And if they close in on us I'll make every damn one of you eat the papers!"

It was July 7, 1943. Carletta and I had preceded the Sicilian invasion by three days. Originally, a guy named Larry Stowe and I were to blast the safes in Italy's naval headquarters and get back to a waiting sub. But the *capi mafiosi* in New York advised JICA differently. They said we'd never make it – then offered Carletta Porvoni as an able substitute.

Whether or not she was able remained to be seen.

We helped the girls up to their rooms. Tessie was last the along in the more heavily than she needed to. I put her on the bed, as I'd done with the others, and tried to cover her with a blanket. She pushed it away. Her fingers went to my neck and ran up into my hair. "Stay, *Signore*."

"Why not?"

A gentle pressure from her hand brought our lips together. We held the kiss until our bodies met. Her arm stretched out and turned the kerosene lamp. Then the documents were scattered all over the floor. They didn't seem important now.

Minutes later Tessie sighed contentedly into a pillow. "*Dio mio*, I'd take a beating every night for this!"

I gathered up my papers. "Where do I bunk?"

"Here if you like."

"No. I have a responsibility to Carletta. She's an American citizen. I don't know what kind, but that's beside the point."

"Don't be too hard on her. She fights for the same thing you do, only in a different way."

I found her in a room at the end of the hall, a musty storeroom for trunks and broken furniture. She stood at a small window because there were no serviceable chairs or beds. The approaching dawn cast her smooth lines in silhouette – and it was a lovely silhouette.

"Marie told me to stay here. No one comes in." She spoke to the dirt-crusted window. I stood beside her in the darkness, gripping the papers with both hands. Together we stared out at the deserted street below.

"I used to play out there when I was little. Tess, Maria, Angelina – we used to beg and steal and break windows. Tess always tried to take my boyfriends and we used to fight and–"

"She tried again tonight."

"Was she successful?"

"Hmmm, fairly."

Her lips parted in a musical laugh. "She deserves any small pleasure she can get. They all do. They've lived through so much. I sat with Trina for awhile and she told me the awful things–"

I touched her arm, interrupting the flow of words. "Can you forgive this spaghetti-bender for not trusting another?"

She lowered her eyes. Color came into her cheeks, blending nicely with her natural shade of olive. "I think so."

My hand went to the small of her back, pushing that cute little belly of hers into mine. I dropped the papers and crushed her close. Our lips came together with so much force that mine stung for a second or two. Her response was eager,

matching mine. Light spilled through the window but none of it got through our welded bodies. The papers were scattered.

And once again they didn't seem so important.

WE HAD slept less than an hour when we were awakened by the sounds of shouting Germans outside. Truckloads of troops pulled into this street and others. They leaped out and raced into the houses, their rifles fixed with bayonets. A command car stopped short in front.

"Here it comes." I stashed the papers inside a ripped chair cushion that lay in a corner, then rolled up my rubber suit and buried it in the bottom of a trunk.

Maria burst in, breathing hard. "Hauptmann Dekkar is coming! Hide!" She shut the door. We heard it lock.

"Hide? Where?" The room was full of junk, but offered no security. I grabbed Carletta's hand and guided her to a rear wall. There, behind an ancient bureau, we stood and held our breath. It wasn't much, but it was better than nothing. And if this Dekkar decided not to step in, we were safe.

Hob-nailed boots clumped on the floor in the hall. Orders were barked. Doors were kicked open and then the sounds stopped a few feet from us. The knob was tried. A Kraut said, "Break it down!"

Three sharp raps with a rifle butt had the door swinging on a loosened hinge. We didn't breathe at all now. I held Carletta close. She hadn't even had time to get into her skimpy underclothing. She trembled with fear.

I clamped my hand over her mouth to keep her from giving us away with a squeal or a gasp. Then it happened.

Dekkar strode into the room.

I dropped my hand away and faced the captain. At least the documents were safe – for a while. I couldn't count on Carletta keeping her mouth shut, not after the SS got through with her.

"Who are you two?" Dekkar said in clipped Italian.

I stood at attention – probably looking ludicrous again in my brief shorts – and snapped, "Antonino Perrini, sir."

Dekkar was a big man, hefty. He had piggish eyes which bore into Carletta's. Slowly, they worked their way down her naked body. "Where are you from?" He looked at her when he said it, but I knew he meant me.

"Castelvetrano." It was the first town that came to me. But it was enough to drag Dekkar's attention away from the girl. "Oh? Are you with Giuliano's forces?"

I died a little. Salvatore Giuliano was a fledgling bandit with a small force in Castelvetrano. He was raising all kinds of hell with the Krauts and the local *carabinieri*. "No sir."

"Come here." Now I know he didn't mean me.

I felt Carletta's nails dig into my arm. She took a deep breath and moved towards the Hauptmann. He smiled as she drew closer and stopped. Her back was to me. Dekkar rested both hands on her shoulders still smiling. "You are quite beautiful." His hands slipped down out of sight. I saw Carletta stiffen, saw the smile fade from Dekkar's florid face as he probed. Spittle oozed from the corner of his mouth. If his own men weren't standing right behind him I would have sworn he'd have taken her.

Instead, he stepped back a pace. "I want you to be

downstairs tonight. I'll tell Maria." He snapped his head to me. "You will go back to Castelvetrano immediately."

"Yes sir!"

As soon as he was gone I learned against the wall and wiped cold sweat off my face. "That was close."

Carletta sank to the floor. I went to her. She was sobbing. Her wretched face was tear-stained, her eyes swollen. *"He's a pig!"*

THAT NIGHT, while the troops were still searching for the killer or killers of the two Teutonics, Hauptmann Dekkar and twenty officers from the SS strode into the downstairs room and demanded to be entertained.

The girls were with me in Maria's room. Maria was the only one fully dressed. She wore a long, gold-sequined gown that was beginning to show signs of age. I didn't get the distinction, nor did I ask.

Tessie raised a fist at Carletta. "I should give you this for that kick in the face yesterday, but I won't." She smiled. "I'll see what I can do to keep you from getting into too much trouble down there. And try to control that temper of yours."

The girls went down to the waiting Germans. Tessie stayed a moment. "You can watch from here, but be careful. From time to time we will take our partners up here. We'll keep them away from this room." She dug two fingers into the belt of my rubber pants and snapped it playfully. "Now you will see how the *Mano Nera* works."

She swayed her hips down the hall because she knew I was watching. She turned, winked and then hurried down the stairs, her arms wide open for the first Kraut she met. Drinks were poured. Most of the men were at the gambling tables during the early part of the evening, but as the drinks took effect they lost interest in the cards and dice and turned their attention to the roving girls. I still didn't know why Maria was dressed. In fact, I hadn't seen her on the floor.

Tessie wandered to the phonograph and wound it up. The record she played was loud and brassy. Then the curtain parted on the stage and Maria stood there, smiling down at the officers who were practically at her feet.

She bowed at their applause, backed up and went into a strip the likes of which I'd never seen before. Maria pranced around the small stage, hip-swaying and rubbing her hands all over herself for a starter. The tempo of the music was stepped up and so was her pace.

The dress seemed to loosen by itself and slip slowly away from her body. Her walking helped it. She kicked the garment off stage and kept walking around in her bra and panties, intermingling her steps now with bumps and grinds that had every male eye in the place glued to her movements.

She took off her bra with a sudden flourish that brought gasps of delight to the audience. A few minutes later she was stark naked before the ogling men, executing movements designed to drive them mad.

Suddenly, a young Leutnant's hand stabbed out and caught her ankle. Terror came to her face. She tried to laugh, tried to pull away, but he held on tightly.

"No... don't... it is only an act..."

The officer twisted. Maria went down hard. Laughter

rose as he pulled her close, her body half on and half off the small stage. From where I stood in the door upstairs I could see what the bastard was doing to her... and I could see Maria's knuckle go into her mouth and bite down in an effort to suppress a scream. But finally, she had to scream, her pretty face knotted up in pain.

Tessie came to her rescue. She threw her arms around the savage young Leutnant and pulled him away, laughing and kissing his ear.

Maria took the opportunity to scramble off stage. Seconds later she was hurrying towards me, her gown in front of her. She swept into the room and threw herself on the bed. Her fists beat into the pillow. "I hate them! I hate them!"

I sat down beside her. "That was a damn hot strip, Maria."

"I do it every night, almost. But now they know they'll be running soon, so they don't care how they treat us."

Her argument still wasn't valid. "Okay, but you had me panting up here. You really laid it on."

"Did he have to do this?" She whirled on the bed and whipped the gown away from her abdomen. A blackened bruise the size of a fist oozed blood an inch below her navel. Now her argument was valid.

"I tell you I want to scratch their eyes out. *Blood of a dog!* I could reach in and pull out their hearts!"

"Let the Allies do it."

"When, eh? When?" She was an inch from my face. "I hear that all the time. You tell me when." She dropped back on the bed. "We fight our war so differently, *Signore*. You lose your life, we lose our self-respect. You are fortunate."

"The invasion is set for the tenth of July. Two days away. Can you wait?"

She stared at me. "Two days? Are you sure?" She sat up. Something was racing through her mind. She was about to let me in on what she was thinking when a scream from downstairs bolted me across the room.

It was Carletta. She was backing away from Dekkar. The big oaf had spread his gorilla arms and was forcing her into a corner. He was drunk. Tessie and Trina tried to stop him, but with one sweep of his arm he tossed them to the floor.

His thick fingers curled around her bra and yanked it off. He hovered over the girl, tearing away the flimsy material at her waist. All action in the room had stopped. The men wanted to see how their Hauptmann took a woman.

Carletta was suddenly lifted off her feet and high into the air. Dekkar's huge hands held her waist in a vise-like grip and his whole massive body rocked with uncontrolled laughter as Carletta struggled to get free.

Then he hauled her up the stairs. I ducked back inside, heard him kick in the door next to this one. He was laughing when he tossed her on the bed.

Maria and I stood in the semi-darkness and listened to the stinking SS-man have his way with her.

And over and over four words kept spilling out of my mouth like a broken record.

Hours passed and the party got worse. Screams rose almost constantly. The drunken officers were like savages now, finding cruelty more fun than play. Tessie staggered up into the

room with Maria and me and dropped onto the bed. "They are madmen! Never before have they acted so... like animals!"

Maria whispered something to her. Tessie sat up and said something I couldn't hear. Then both were talking excitedly at the same time. Maria slipped into her gown and hurried out. She appeared on the stage again.

"Gentlemen, did you enjoy yourselves tonight?"

The men applauded loudly, hooting and yelling. The savage young Leutnant tried again to grab Maria's ankle, but this time she was too fast. She forced a smile. "No, no. Tomorrow... another night... And added again for allow..

"Tomorrow night we'll have more of the same. But this time bring all of your officers. My, only twenty here tonight. It was hardly worth our trouble. We like to feel your strong hands on us."

More applause followed the speech and a few of the officers promised to bring as many as they could. They filed out into the street singing *risqué* songs and leaving behind them a room that looked as though it had been struck by a twister.

Dekkar, too, was gone, but we left Carletta alone in the room and tried to shut out the sounds of her weeping.

Angelina and Trina dragged themselves wearily into Maria's room. "Have you gone mad, Maria? What was the idea of that pretty little speech? One more night like tonight and we'll be dead!"

Maria said, coolly, "Just one more night." She glanced at Tessie and winked.

THE FOLLOWING day the girls bustled about like busy bees. The large room was cleaned up and party decorations were added to brighten the place. At various times during the day partisans entered the house carrying bundles. They made no comments, but left empty-handed. By the time the fourth ominous-looking bundle had arrived I was out of my mind with curiosity. I stopped Tessie. "Hey, what the hell's going on?"

"We're giving a party. Want to come?" She tore away the paper. Inside was a tommy gun, fully loaded. She slapped it into my hands. "There's your ticket – but don't use it until we use ours."

I stared incredulously. "You're crazy! You'll get yourselves killed. Why don't you wait one more day?"

Her face clouded. "And let those pigs run away? No, *Signore*. Tonight they'll know what it is to face the Mafia." She patted my gut. "Just make sure your papers are tucked in there, eh?"

I spent the rest of the afternoon appealing to all of them to wait. They'd have no chance against the specially-trained men of the SS. I appealed to Carletta to appeal to them, but she had a deep-seated hatred for Hauptmann Dekkar and refused to listen to me. "I'll kill Dekkar tonight, regardless of what the others do."

An hour after dark the first of the officers arrived. Dekkar was among them. The drinking started immediately. No one thought of gambling tonight. The word had gone out; the girls were going to give their all for the SS. And the men flooded into the room. I tried to count them, but it was impossible.

Carletta, Trina, Angelina and Tessie circulated among them, squeezing through the mob, squealing giddily whenever they were pinched. They kept glasses filled, gave the men bottles when no glasses were available. From my position upstairs I could see Dekkar in a big sweat as he searched for Carletta, but there were so many men in the room he couldn't get through easily.

At the rate they were drinking it didn't take long for them to get drunk. When Tessie thought the time was right she went to the phonograph and started the music.

Maria stood in the center of the stage, dressed in the same violet-sequined gown. The young Leutnant was again in the same location. He reached out for her ankle and Maria shook her finger at him. "Control yourself, please. Wait until my act is over."

Maria went into her tantalizing striptease. Every Kraut in the room crowded towards the stage to watch her. None of them uttered a sound. They stood as if in a trance, hypnotized by Maria's gyrating hips, the sensuous motions of her hands playing over her body.

Then she was nude, dancing wildly now until the record came to an end. The young Leutnant was practically on the stage, crawling towards her.

Maria backed away. The smile on her face died quickly. She spread out her arms, one of them disappearing off stage. Now a hot flush came to her cheeks and when her arm appeared again it held a tommy gun.

The audience stood stunned. I couldn't see their faces, but I knew disbelief was registered on them.

Maria opened up on the Leutnant first, cutting him in half. Her gun swept across the mob. Blood splattered everywhere. The Krauts turned to run, but as they did they ran into a hail of buckshot from *luparas*.

All four girls blasted away at the same time.

I raced to the stairs and opened up with my own gun, cutting down those who tried to escape. Maria on stage kept firing without a let up.

It was a massacre. The drunken slobs didn't have a chance. We threw so much lead in so short a span of time that they didn't even have time to reach for their guns.

Only a few officers were still standing. They were so frightened by the dead around them, by the fury of the girls that they immediately dropped to their knees and asked to be spared.

One of them was Dekkar.

Carletta strode forward, listening to his babblings. The others stopped firing.

The man was crying. He was beside himself with fear. His words tumbled out so quickly they made no sense.

Carletta raised her sawed-off shotgun – and blew his head completely off his shoulders.

The others were killed on their knees.

It was all over. The brotherhood of the *omerta* had been avenged. Somewhere in the Mediterranean our forces were steaming towards the coast of Sicily. The girls and I barricaded ourselves in the room in case of attack, but it never came. The Krauts were already running.

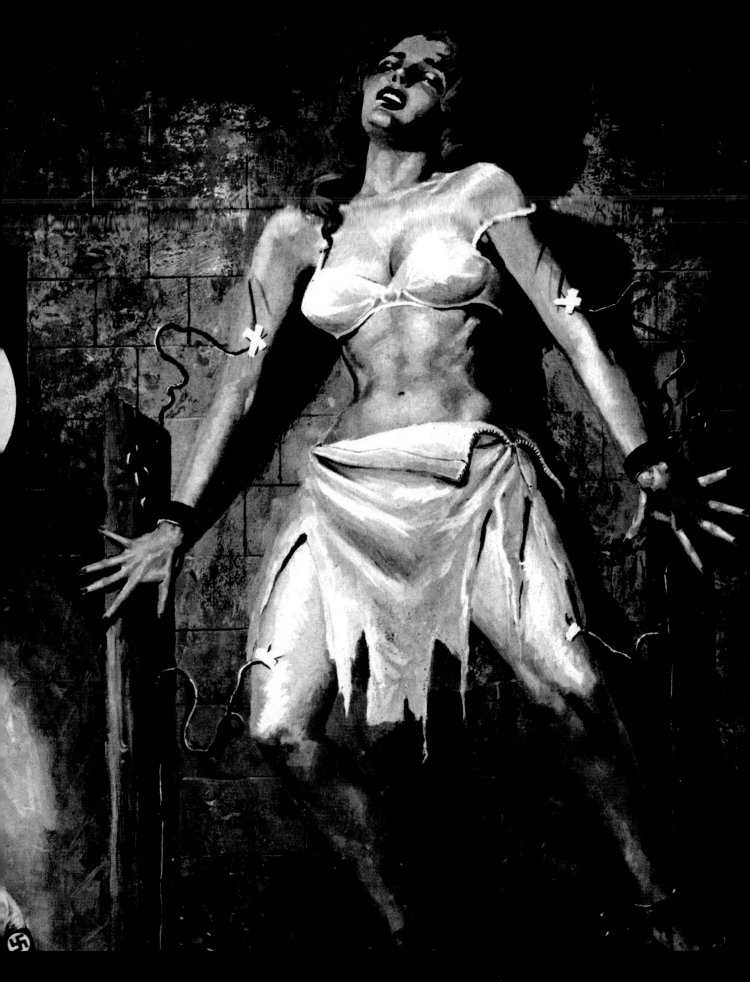

"HITLER'S HUMAN GUINEA PIGS"; detail from interior art, **WAR CRIMINALS**, 08/63.
Art uncredited; previously printed as cover art, **ALL MAN**, 09/62.

SECRET HORROR CAGES OF THE NAZI DWARF

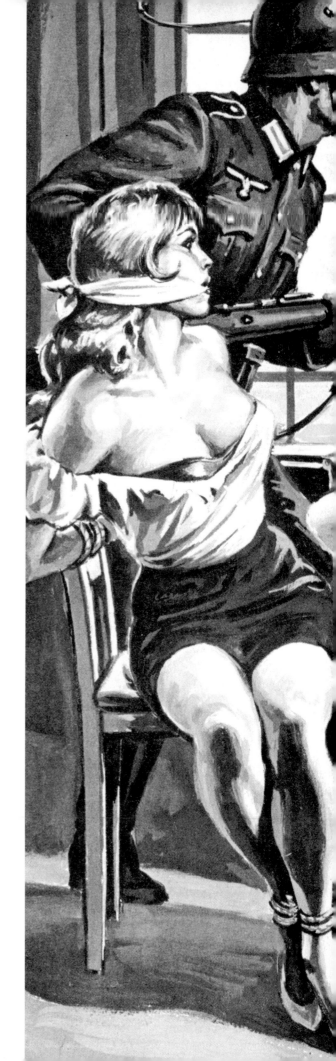

By Hitler's personal order, the evil whip-beast von Haartz was never photographed – and Sgt. Barnett would find out why the hard way.

THERE WERE FOUR OF them. They were in enemy territory – a small, quiet town in Alsace-Lorraine. *Too* quiet, Sgt. Walker Barnett thought uneasily. The windows were like blank eyes, boring into the backs of the four G.I.s.

In the lead, Barnett hugged the wall of the buildings on the right side of the cobblestone street, Moving forward in short sprints, skidding into a doorway, then going forward again.

Barnett reached the last building on the street and edged his head around the corner. Before him, in the village square, one of the most bizarre events of World War II was taking place.

A German truck was parked in the square with a cage mounted on its bed, the kind of cage that is normally used to transport wild animals. A tough Nazi trooper was wrestling a French girl into this animal cage. Just a few steps away, three more French girls were being shoved and kicked down the steps of one of the houses into the square. One of the girls tried to break away, and a Nazi trooper lunged at her. His ham-like

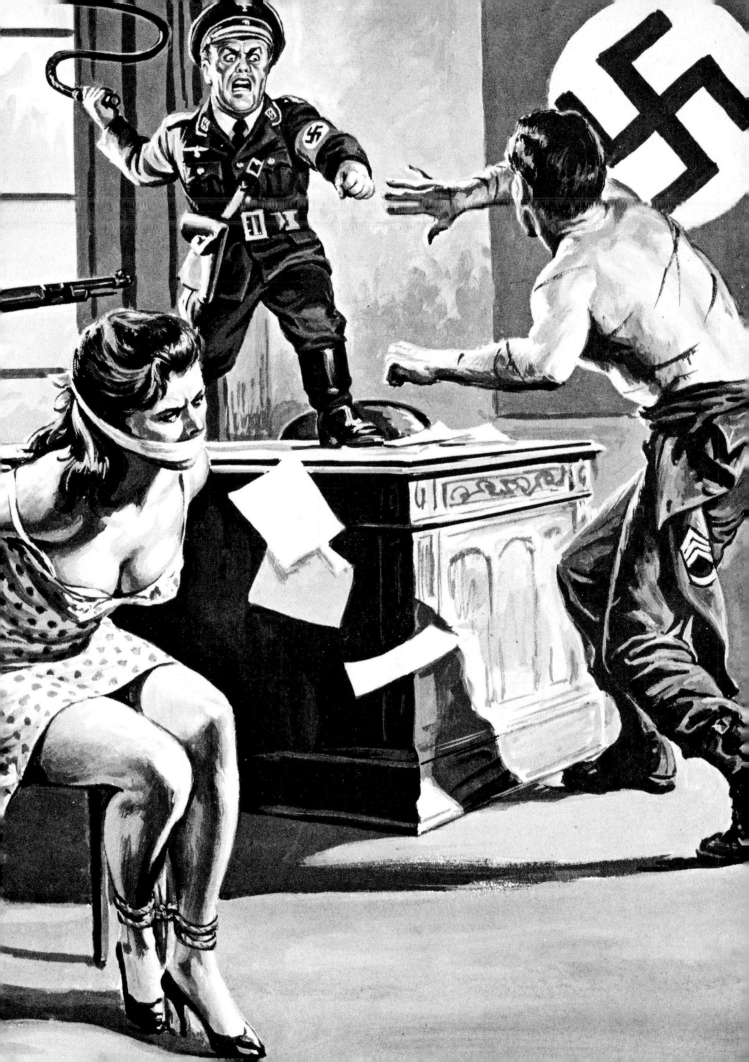

fists closed on her blouse and its cloth ripped in his hands, exposing her breasts. The girl shuddered with shame, bowed her head, and crossed her arms over her bosom. In that moment, the Nazi was on her again, locking his arms about her, lifting her off the ground, dragging her, kicking and sobbing, towards the animal cage on the truck.

Barnett hugged the corner of the building and turned to warn his men to take cover. What he saw behind him had the dream-like quality of a slow-motion movie.

His three men were bunched together at the side of the street. Just a few yards away from them, hidden from their line of sight in a doorway into which he had stepped from the house behind him, was a Wehrmacht infantryman. The Nazi pulled back his arm and threw a potato-masher grenade at the three tightly bunched-up Americans.

"Hit the dirt!" Barnett shouted.

The American sergeant stepped from the building wall into the gutter of the road and squeezed down on the trigger of his Thompson .45 sub-machine gun. The weapon bucked in his arms and the heavy soft slugs tore into the Nazi, slamming him back against the building wall, chopping his body almost in half. But it was already too late. The potato-masher had landed. It exploded and the shock wave made the road bounce under Sgt. Barnett's feet. Shards of hot metal screamed through the air, shredding the flesh of the three G.I.s. Their uniforms were torn apart, almost blown completely from their bodies, their faces suddenly crimson, leaking blood heavily. They staggered one or two steps and then went down. There was no way of saving them.

The time was early morning of November 10, 1944. Just a few hours earlier Sgt. Walker Barnett had led the three men of his regimental I & R (Intelligence and Reconnaissance) squad through the Nazi lines in the fringe of the Vosges mountains of France, only a few kilometers from St. Die. Their assignment was to locate the Nazi tank park in the area so the artillery could blast it. The grinding noise of the Nazi tank motors at night when they assembled had indicated its general location.

SGT. BARNETT knew he would have to act fast before the Nazis in the square got the jump on him. When the potato-masher grenade went off, and he saw it was hopeless to attempt to help his three men, he spun around and plunged into the village square.

Barnett caught the driver of the truck as he struggled to get out of the cab. The Nazi was fumbling with a Luger in a waist holster when Barnett squeezed the trigger of his tommy-gun. Three slugs caught the Nazi in the chest, spinning him around as he fell to the street.

Barnett ran forward as the Nazis struggled to get their weapons into action. One Nazi came running around the back of the truck. He dropped to one knee and unslung a Mauser rifle from his shoulder. He was sighting on Barnett when the first .45 slug hit him. As each slug hit the German it lifted him off the ground and slammed him back three or four feet.

The other three troopers gave up without a fight. Caught out in the open, they didn't dare reach for their weapons. They stood at the side of the truck and froze, putting their hands on the top of their heads.

Barnett sweated. He had originally spotted six Nazi troopers in the square. He had accounted for five now. Where was the last man? Was he lining up Barnett's forehead in his sights now?

"He is under us!" screamed one of the French girls. The sergeant's eyes swept the cage on the truck. He saw nothing. Was it a trick?

And then the answer to the puzzle came: a pencil flash of flame, from under the Nazi truck, fired through the legs of one of the Nazis who had given up. The slug ripped through the air, a few inches from Barnett's head.

Barnett ducked and ran to his right. He dropped to the cobblestones when he was on a line with the rear of the truck. He leaned on the trigger and a spray of slugs cut through the air a few inches above ground level. There was a loud scream of pain from under the truck – and then, suddenly, it died.

Barnett got to his feet. It was suddenly quiet in the square. He walked slowly towards his three Nazi prisoners, wondering how he would get them back through the German lines to the American side of the front.

Then, from behind him, a voice called out in German-accented English.

"Drop your gun, *Schweinhund!*"

Barnett, stunned, hesitated. He calculated his chances and spun around. His eyes searched wildly for the German, his finger heavy on the trigger – but he saw nothing.

A shot cracked out and a slug slammed home against the stock of Barnett's automatic Thompson .45. His fingers went numb with the impact, and the gun jerked crazily. It slid from his lifeless fingers and clattered to the cobblestones.

"Do not move," the German voice said.

The Nazi stepped out into the open from behind a low line of bushes in front of one of the houses on the square. Now Barnett knew why he had missed spotting the Nazi. He had been looking for a normal-sized enemy at eye level – and this man was a dwarf, in an cut-down officer's uniform.

He was all of three feet tall, his body powerfully muscled, his head huge and grotesque on his small body. In one hand he held the Luger he had used on Barnett; in the other, a whip.

The dwarf flicked his wrist and the black whip came alive in his hand. It lashed out, uncoiling rapidly, and the metal stinger on its end opened Sgt. Barnett's cheek to the bone.

"You get in the cage with the women," the deformed Nazi ordered. "No nonsense – or I whip the skin right off your body."

Sgt. Barnett started for the cage on the back of the Nazi truck, unaware that he had been taken prisoner by one of the most dreaded and sadistic members of the Nazi party – a man famous inside Germany as a nerveless monster, capable of the most senseless brutality and depravity in the name of the party. As famous as he was in Germany, Oberst Ludwig von Haartz was unknown outside the Third Reich. His truncated body, a constant source of embarrassment to Hitler, was an Aryan aberration the Nazis preferred to hide from the outside world. By Hitler's personal order, Oberst von Haartz was never

photographed, never interviewed, never mentioned in official dispatches.

Yet the fact of von Haartz's importance could hardly be denied. One of the early beerhall organizers of the Nazi party, the dwarf officer was a master political theoretician and was reputed to have originated the Nazi racist theories. It was even said that he had ghost-written Hitler's *Mein Kampf*.

But because of his deformed body, Oberst von Haartz was first of all denied a combat command — something he wanted very badly. Instead, he was officially classified for intelligence work and put in command of an "interrogation" center – one that eventually became one of the most grisly ever seen in Nazi Germany. By his brutal and relentlessly efficient methods, von Haartz was determined to prove to the Nazi chieftains that a dwarf could be more than the equal of any of the fair-haired, clean-limbed, Aryan torture artists of the SS and Gestapo. And it was to von Haartz's infamous interrogation center that Sgt. Walker Barnett was riding, on the back of a truck formerly used to haul wild animals.

As the truck moved down the rutted French roads towards von Haartz's military compound, the French girl, Helene Duclot, kneeled at Sgt. Barnett's side and wiped the blood from the whip-cut in his face with a piece of cloth she took from her already torn blouse. Barnett found himself staring at the girl, and a flush of embarrassment colored her face. But she did not stop bending over him and cleaning out his wound.

Barnett forced himself to look away. "Why did the Germans take you prisoner?" he asked, his voice thick.

The girl explained that she and her female comrades were members of one of the French underground groups, the *Réseau Interallié*. Their assignment had been to destroy the powerhouse of the village Barnett had entered with his I & R squad. The French girls had been surprised while planting their plastic explosive. They had fought their way back into the village where their ammunition had given out. With the arrival of Oberst von Haartz and his special truck, they had been dragged out of the house to the cage-on-wheels that waited for them.

WITHIN HALF an hour von Haartz's truck was rolling through the gate of a high brick wall that enclosed a large wooded area. A corduroy log road, badly mangled by tank treads, bore to the left where Sgt. Barnett could see Mark IV tanks camouflaged among the trees. Ironically, the Germans had taken him right to the spot he had been seeking – but would he be able to get out with his information and back to the American lines?

Von Haartz's truck continued past the corduroy road. Soon buildings came into sight. They were low, made of brick, and separated into compartments. Each compartment had one high wall made of thick iron bars. Some compartments had runs behind them, where an animal could take its exercise. As von Haartz's truck with its five prisoners approached the first of the buildings, two lions and a tiger could be seen pacing in adjoining compartments. The rest of the cages in that building were empty.

"The dwarf must be mad," Barnett said to the girl.

"He's brought us to a zoo."

The truck rolled on. It passed the first building and approached the second.

"Look at that," Helene Duclot said. Her fingers bit into Barnett's arm. "This place is *more* than a zoo."

One of the compartments in the second building had formerly been a monkey cage. But now there were men in the cage, wearing the uniforms of the Allied armies, British Tommies, Poles, Czechs, and Free French soldiers, swinging back and forth on the monkey trapezes, taking their exercise. A few compartments away, French civilians, who were Maquis or hostages, were pacing cages formerly used to hold big cats.

Sgt. Walker Barnett was the first and only American to enter the walls of the then unknown Hitler Stalag Zoo. The strange compound had been created almost single-handedly by the Nazi dwarf, Oberst Ludwig von Haartz, who in civilian life had frequently made his living as a circus animal trainer.

The use of a zoo as a military compound for captured prisoners-of-war, spies, intelligence agents, and resistance fighters, was a logical extension of the insane Nazi philosophy, and its penchant for sadistic and brutal torture.

The Nazi racist theories held that all non-Aryans were less than human, and therefore a kind of lower order animal that properly belonged in a zoo. The teams of Nazi medicos and psychiatrists who visited von Haartz's Hitler Stalag Zoo in the years between 1941 and 1944 were delegated to find "animal characteristics" in the prisoners. When an imagined similarity in facial or body structure was found, the unlucky prisoner was thrown into a cell with the animal the Nazi physicians believed he resembled. One burly underground fighter was actually thrown into a cell with a female gorilla. He was torn into small pieces. Similarly, human females, notably one British female spy, were thrown into cells with male gorillas.

Nazi surgeons also actually performed operations in the name of "science" on prisoner-subjects to emphasize the similarity they bore to lower order animals. Victims were given definite "lion" faces, some had tails grafted on their lower backs, and still others were bound in devices that forced them to walk on all fours.

The Nazi gift for improvisation in refined torture was not neglected at the zoo-prison. Prisoners who refused to betray accomplices and secret plans under the most excruciating of physical tortures – beatings, burnings, near-drownings – readily spilled their guts when subjected to the horrors of the zoo prison. Men were caged with gibbering monkeys, venomous reptiles, boa constrictors – enough to drive any man screaming mad.

But the Nazis and their prize dwarf, Oberst Ludwig von Haartz, did not stop there. With their gift for the bizarre in refined torture they staged spectacles not seen since the days of the Romans. Nazi bigwigs were entertained at the Stalag Zoo in arenas built by special pioneer assault engineer battalions – arenas in which battles were staged between unarmed prisoners and half-starved lions.

WHEN THE truck ground to a halt in front of the Stalag Zoo's headquarters building, Sgt. Walker Barnett was separated from

the French girls. He was taken to an all concrete room, the walls of which held metal rings to which other prisoners had obviously been locked like oxen. There were blood splotches on the walls and stacked sledge-hammers that had apparently been used to bludgeon the men.

Oberst Ludwig von Haartz ordered his troopers from the room. The American sergeant grudgingly admitted to himself that the little man had guts, closeting himself alone and unarmed with a normal-sized man who was desperate enough to wring his neck or batter him into immobility with one of the sledge-hammers if there were any chance of escaping.

"What is your mission behind German lines?" the dwarf barked. "You are obviously an elite agent sent to gather intelligence for the American 7th Army–"

At that moment Barnett launched himself at the dwarf, aiming to tackle him about the hips, just about where the ordinary man's knees would be. Things happened fast. Barnett found himself sliding across the floor, scraping his chin and chest, while the Nazi, acrobatic and powerful, back-flipped halfway across the room, out of reach.

Barnett painfully got to his feet. His arms outstretched, he began to stalk the little Nazi, determined to be more careful this time. The dwarf backed away, towards a desk in the corner. Suddenly he plucked a whip from the desk top and Barnett rushed him. At the last second the dwarf lifted the chair from behind the desk and deflected Barnett's rush.

"Now," von Haartz shrilled, "I will flay the skin from your body. You must learn obedience!"

The whip cracked out. It struck Barnett in the chest, burning like fire, and drove him back against the wall. He remembered seeing the whip rise and then fall, smashing across his face, and then rise again. Over and over the Nazi's whip snaked out and struck. Barnett staggered in excruciating pain, and finally, mercifully, lost consciousness.

When Barnett came to, it was night. Nazi troopers opened a gate in a high barred wall and pitched him through to land on some rocks. He passed out again and was only dimly aware of the French girls bending over him.

When Barnett came to a second time he was on his back in a rock tunnel, and the French girl, Helene Duclot, was separating his shirt from his blood-clotted skin. Her fingers were cool and light on his burning body.

"Where are we?" Barnett asked.

"In the zoo's polar bear compound," she said.

"Is there any chance of getting out of here? I must get back with the location of the Nazi tank park."

"It is impossible," Helene Duclot said bitterly. "On three sides there are high barred walls, one of which contains a gate that is locked and barred. On the fourth side, there is a moat of water where the bears used to bathe themselves. Beyond that is a wall of stone and concrete, about fifteen or twenty feet high." She sighed. "It does not look good, my American friend," she said.

While she talked, the French girl worked at Barnett's body. She laved his burning flesh with a dampened swatch of cloth, torn from her own blouse. And he could feel his body coming alive under her gentle fingers. She looked at his flayed skin with sympathy in her eyes. "What you went through," she murmured sadly, "for my country." She bent down and kissed his lips. And then she was joining him on the rock ledge, pressing herself against him, putting her lips to his and returning his kisses.

Some time later that night Sgt. Barnett pulled himself to the cave entrance and looked out. He saw the moat, the rock wall, and above, the sentry leaning back against the railing at the top of the wall and yawning. Barnett realized then that there was now a chance to escape – and that it might never come again. A plan growing in his mind, he went back into the cave and wakened the French girls. In as few words as possible he outlined what he had in mind, and asked them if they were willing to risk it.

"We will do anything you ask," Helene Duclot answered.

A few minutes later Sgt. Barnett slipped out of the cave and crept silently down to the moat. He went into the water directly under the sentry. At the wall he braced himself. The water came up to his chin.

One after another the French girls followed Barnett into the moat. One by one, they climbed up his body, each girl climbing past the one who preceded her to stand on the shoulders of the one below, until they made a human ladder up the wall.

The last girl, the one who went to the top of the ladder, was Mademoiselle Helene Duclot. She rose like a ghost behind the sleepy sentry. And suddenly she lunged out, locking her arm around his neck, jerking him back, using the railing as a fulcrum against his body. The sentry choked and then pitched back in space. He fell past the human ladder and plunged into the moat, striking his head on the bottom under water.

One by one the members of the human ladder came sliding down. Then, to make sure the sentry would be no threat, Barnett drowned him.

With the bayonet he took from the sentry's rifle, Sgt. Barnett cut stepping holes in the mortar between the rocks in the wall. Using these holes, the four French girls followed him up the wall and over the railing to freedom inside the Stalag Zoo.

THE AMERICAN sergeant and the four French girls had almost reached the wall that enclosed the zoo when the sirens went off and the searchlights came on. The group quickly ducked into a patch of trees near the wall and looked back.

Oberst Ludwig von Haartz had been hurriedly summoned from his sleeping quarters. His pajama cuffs tucked into his tiny black boots, a whip in his hand, the dwarf officer was directing the search for the escapees. Suddenly he was seen to run to one of the cages where the wild cats were kept. The mad dwarf released a black panther – and even his staunch Nazi troopers quaked at the sight, and scattered to positions of safety.

The dwarf controlled the big black cat with his whip. He drove it to the polar bear compound, where it took the scent of Barnett's fresh wounds, raised its head, sniffed the air, and then bounded across the zoo in the direction of the patch of trees where Barnett was hiding with the four French girls.

Barnett felt Mademoiselle Helene Duclot's fingers

biting into his arm. "You go," she said. "Take my comrades with you."

And then she was slipping away from his arms, before he could stop her. There was nothing to do then but to make a break for the wall, with the other French girls hot on his heels.

On the top of the wall, before dropping to the other side, Barnett turned and looked back. The panther had already savaged Helene Duclot's body. The big cat straddled her chest, which it had torn open with one of its claws. Its attention was now on its tormentor, the dwarf, balefully staring as he approached, lashing out with his whip, trying to drive the wild animal after the other escapees.

The panther sprang. Its jaws clamped shut on the dwarf's torso. The whip went flying into the air. And the last thing Barnett saw before he turned and dropped to the other side of the wall, was the dwarf's blood, leaking over the cat's fangs and chops.

Sgt. Barnett did not wait to see more. He was over the wall and running before the dwarf's screams had died into silence.

The three French girls led Sgt. Barnett into hiding in the barn of a nearby farm. A few hours later, alerted Maquis members led him through the German lines into the American sector.

As a result of the information brought back by Sgt. Barnett, 7th Army Artillery destroyed the Nazi tank park and the Stalag Zoo in which it was hidden at dawn of November 11, 1944. As a result of this action, American infantry successfully launched the attack which drove the Germans out of the town of St Die later the same day.

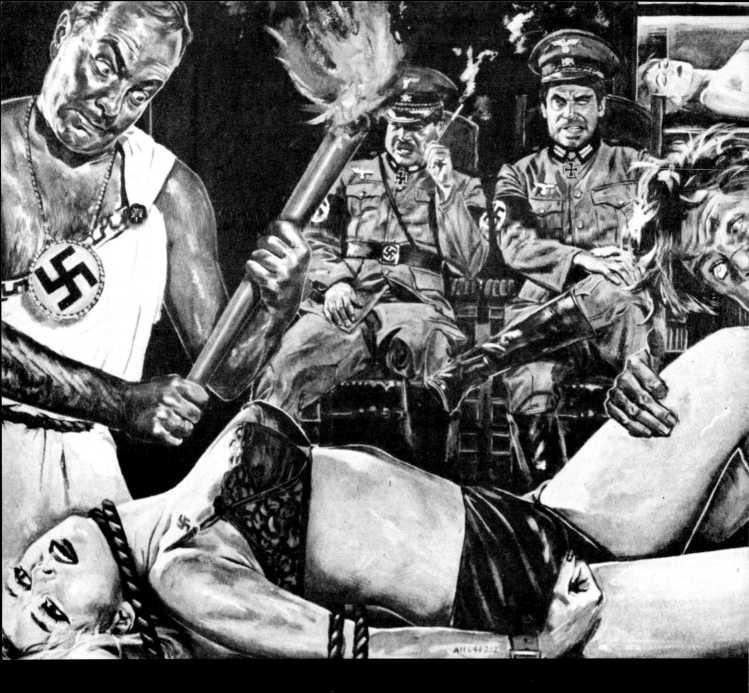

SOFT BODIES FOR THE NAZI'S HALL OF THE LIVING DEAD

The strain of madness in the Nazi's family was in evidence now as he assumed the role of an ancient tyrant and forced Lani to bow to his craven will.

THE MAN WAS GROSS and ugly. His hands trembled with palsy. His pupils were the merest pinpoints. He circled around the chair to which Lani Meister had been shackled. With an imperious wave of his pudgy fingers he dismissed the female RHSA stenographer.

"Ach, *Fraulein*, this is a great shame," he said after the woman clerk had left the interrogation chamber.

He touched Lani's wrist where the skin had been chafed by the tight handcuff. "Such marble-like flesh was not meant to be bruised. One who is faced with the ugly realities of the world comes to appreciate beauty. Certainly, *Fraulein*, a few more or less American fliers are of little consequence. They are not worth your becoming my enemy."

Lani sat rigid. Her back was ramrod straight against the hard surface of the chair. Little things played in her mind and surprised her.

She was amazed at how quickly she had grown accustomed to her enforced nudity. The Gestapo always removed a suspect's clothes when they were conducting an interrogation. It was supposed to remove the last shreds of human dignity and make the culprit consider herself the inferior of her inquisitor.

The fat man leaned closer to her, his narcotics-contracted eyes studying the angry cigarette burn in her shoulder. He traced his fingernail over the mark. Lani Meister flinched in spite of herself.

The burn had hurt, but she had not screamed. She was proud of the fact. Being questioned by the Gestapo did strange things to one's reactions. It became very important to her that she thwart this fat man who pressed his rolls of flesh against her.

"You are a very lucky young woman, *Fraulein*," the man continued. "Do you know who I am?"

Lani shook her tousled blonde head because she knew the man expected her to. She wondered about him. Some of the people in the underground had said that there were Germans who were good and kindly. Perhaps the fat man was better than the other Gestapo people who'd bullied and shouted at her.

She remembered that it had been the fat man who'd ordered them to stop using the lighted cigarettes on Lani's flesh. She stiffened her back once more. She knew this was part of the Nazi plan. The fat man's approach would be one of sweet reasonableness. The Gestapo often used the change of pace in questioning suspects to its advantage. Let her be damned eternally, she would not succumb to their tricks.

The fat man's face grew red as he wriggled one over-sized buttock onto a huge mahogany desk which stood in the center of the room.

"I am Reinhard Goering," he blurted through his puffed up cheeks. "I am a second cousin of the Reich Marshal himself."

The fat man who called himself Reinhard Goering was almost comical. He appeared absurdly anxious to please. He reached behind him and picked up a small pill box. Placing a white capsule under his tongue, he said, "The murderous raids make us nervous. You understand."

Lani nodded. She felt the cool air playing around her nakedness. She wondered how long the questioning would be carried out in this manner. Sooner or later the Gestapo would return to its rubber truncheons and burning cigarettes.

"I am but one soldier in the battle against the Nazis," she told herself. "I have little enough to offer to the people who fight for our freedom. I will offer it gladly."

She wondered about the pain. How much did it take before a prisoner gave in? The Gestapo would not stop. The torments would become more pronounced. As long as there was a chance of betrayal, they would work on her.

STILL THERE were worse things than dying in an R.H.S.A. cell in Arlon, Luxembourg. There was the thought of having to live the rest of her life tortured by the knowledge that her lips had sealed the doom of the American pilot who even now was being sped to Ostend for a rendezvous with a British torpedo boat.

Reinhard Goering was talking again. She didn't listen to his words. "If I make my mind blank to what is happening here, they will not be able to break me," Lani's mind told her.

A small smile played at her trembling lips. Things remembered flitted before her vision.

Once again she stood in the open field watching the American Mustang trailing a long plume of smoke as it raced northward. As she squinted into the dying sun, she saw the billowing cloud of nylon and the lanky figure of the pilot dangling in the harness.

In a matter of seconds the man was on the ground, fighting the shroud lines to spill the air from the chute. Without thinking of the danger, she was beside him, working furiously to collapse the huge white umbrella.

"Much obliged, ma'am," the American said.

She'd placed her slim finger to her lips. "No time for talk," she'd whispered breathlessly. "The *Volkssturm* will surround the place. They follow the bullet decree. One must be away from here."

The American didn't question her fluent English nor the urgency of her words. He followed her automatically for a step or two and then he had collapsed onto the ground, his face contorted by pain.

"I'm all right," he grunted. "Don't know whether I broke something or not. It just won't hold me up."

From a hidden reservoir of strength, Lani had managed to lift the man to his feet and swung his arm over her slender shoulders. Looking like a couple of children participating in a sack race, they had somehow managed to make it to the small house at the side of the road.

The door had scarcely closed behind them when they heard the distant growl of motorcycle engines.

"*Volkssturm* bastards!" a man said behind them.

The American pilot whirled swiftly, his hand darting towards his holstered .45.

A slow grin of recognition and acceptance spread across the pilot's face at the sight of Max Bruner. Bruner was at once a comical and a terrifying figure. The livid scar which ran across his cheek gave his mouth the appearance of carrying a perpetual sardonic smile. He was built along slim lines, but there was no mistaking the corded sinews which stood out on his bare arms.

Bruner stood at the window paring his nails with the tip of a hunting knife. He watched the two Waffen SS men racing past the small house.

"It is all right, my friend," Bruner finally said. "They do not suspect as yet. I suppose I play the role of the Nazi informer well enough to keep the wolf away from our door, eh Lani?"

Lani's smile was brief. The American pilot studied it, saw the way it wrinkled her pert nose and made the lights in her eyes blaze.

"I appreciate what you are doing for me," the pilot said. "But I don't want you to take any unnecessary risks on my account. I could give myself up to these *Volkssturm* people. That might be the simplest way."

"Do that, my friend," Max Bruner cut in. "Do that and see what they will do to you. They have their orders from the *Luftwaffe* itself. All American pilots are to be executed."

THE FLIER didn't press the argument. He allowed himself to be led to the stuffy wine cellar of the house. There as he sat on a rickety cot set behind a group of packing cases, he devoured a bowl of cabbage soup Lani brought him.

It was between gulps of the hot liquid that Lani Meister had learned about her guest's background. He was Lt. Jack Morrison, 314 Fighter Squadron, Eighth Air Force; hometown, Lubbock, Texas, preferences, working oil rigs and jitterbugging.

They had chatted gaily, the way a young man and woman do. Their conversation had turned serious as Lani had told him of her life under the Nazis, of her family scattered to the four corners of the Reich.

"One cannot tell where they are. My parents were recruited for a work battalion. The Gestapo told them that if they volunteered, my sister and I would not have to leave Arlon." However, it hadn't been two months after the weeping family farewell that Lani's sister had disappeared.

Lani had gone to the Gestapo to plead for news. They had listened impassively and shrugged their shoulders. "We are sorry, *Fraulein*. There are no records. She may be visiting in another city or may be in a missing persons bureau you know. There is absolutely nothing we can do to help you in your search. Now don't take up any more of our time."

There never were any records of women being forced into the *feldhure* units to service Nazi personnel. They merely disappeared under cover of night and never were heard from again.

Jack Morrison had listened to her story. His face had grown grim and he'd touched her hand in an attempt to brush away the hurt.

He wasn't the first American flier who had been spirited into Max Bruner's basement. But he was different. He was one Lani felt she wanted to talk to rather than joke with. His feelings were not all on the surface. He wasn't brash. He didn't have a compulsion to talk. He could listen quietly and make his sympathy understood with the touch of his hand.

On subsequent visits to the cellar, Lani found a new sensation growing within her. The only men she had known were the Waffen SS, who had made her pay for her continuing freedom by submitting to their depraved lust.

With them it had been necessary to close one's eyes and try to blot out the horrifying image of what was taking place.

Jack Morrison made all that seem far away like some half-remembered nightmare.

The first time with Morrison had been unexpected. He had been limping around the cellar, gingerly testing his injured ankle.

"I think I'll be able to move around on this soon," he'd grinned. "Max tells me once I can, he can get me up to Ostend."

"We'll get you there," Lani had said, anxious to make certain that Morrison regarded her as something more than a cook. "But do not be in too much of a rush. The leg is still not what it should be."

"Why look, Lani, I can practically dance a jig on it." He'd grabbed her around the waist and whirled her into the air. His hands were sure and she felt the excitement of their touch exploding within her.

BUT MORRISON'S leg had not been as strong as he'd believed and they'd collapsed in a laughing tangle of arms and legs on the cot.

Lani's skirt had twisted around her waist. She'd felt Morrison's fingers brushing the nakedness of her thighs. Quickly she had seized his wrists, holding tight for just an instant. Then the instinctive womanly resistance had melted. Her own fingers had relaxed. Morrison's eager arms had encircled her hips, crushing her body to him. She'd felt the

corded muscles of his forearms. Her breasts pressed against his chest.

Without a word, Lani had guided him to the fasteners of her dress, then to the hooks at the back of her pink bra and finally to the thin elastic which held her delicate panties in place.

She thought of Morrison now and wondered where he might be. Watching the gross face of the man who called himself Reinhard Goering, she wondered whether Morrison and Max Brauer had been apprehended or whether the R.H.S.A. section of the Gestapo was merely on one of its fishing expeditions.

She weighed the evidence carefully. When the Nazis went in for street corner round-ups as they had only a few hours ago, it meant that they had no real clues to go by. These were typical Gestapo tactics. Bring everybody in. Torture all of your prisoners. One of them knows something. As for the others, they will never be missed. Less mouths to feed, less danger of potential resistance activities.

"They don't know the whereabouts of the American," Lani told herself. "Otherwise I would not be just one of fifteen women herded into a van and brought here. They couldn't possibly know." The thought added to her burden.

The man called Reinhard Goering studied her. "My dear *Fraulein*," he began again, "you are a diabolically attractive young woman. And I am a man of fine tastes. Because of this, I have arranged for your transfer. You will not have to wear coarse prisoner's garb. You will be conducted to Special Stalag 182 where I am in sole charge. You must consider yourself quite fortunate."

His pudgy hand moved to a key on the desk. It lingered along the circumference of her arm as he unlocked the cuffs which held her. Experimentally, he touched the flatness of her stomach. Lani held her breath, trying to hide her reaction to the loathsome caress.

The hours which followed were a surrealistic tableau of all that was bizarre and demented in the Nazi mind.

They took Lani back to her cell and returned her clothes to her. Reinhard Goering stood fascinated by the sight of her redressing. Then with six other young women – all strikingly beautiful – she was conducted to a barred Gestapo van and heard the door snap shut behind her.

THE RIDE seemed interminable. Several times the van left the road and Lani could hear the muffled roar of aircraft overhead followed by the *whump whump* of explosions.

Finally the van stopped and blinking in the bright daylight, Lani Meister was marched into a castle-like structure which stood precipitously at the edge of a large cliff.

Hard-faced guards marched the women down a long flight of steps into the very bowels of the building. The corridors had the dank muskiness of the tomb and were lit by flickering torches.

Unceremoniously Lani was shoved into a small cubicle and the iron door was slammed shut. There was no possibility of communication with the other prisoners through the thick stone walls.

The hours dragged by. Gnawing hunger and fear entwined in Lani's stomach. For some reason, she had been singled out for special treatment. Did it have to do with the search for the American or was there some even more diabolical purpose for what was taking place?

When the answer came, Lani was totally unprepared for it.

The cell door clanged open and Lani was blinded by the flaming torch which cast its eerie light through the cell. In spite of the mounting peril she felt, Lani could not suppress the hysterical laughter which bubbled from her lips.

The man called Reinhard Goering stood before her, dressed in a replica of a Roman toga. One flabby shoulder and the roles of flab of his torso stood bare to her view.

He had rouged his cheeks to give them an unhealthy reddish tinge. His lips were compressed with anger and the pinpoints that were his pupils traveled over her young body.

"*Fraulein*, believe me you will find nothing to laugh about," he grunted as he moved towards her. "No one laughs at the second cousin of the Reich Marshal. I am a Goering. That entitles me, just as it entitles my Cousin Hermann."

The man was hopelessly mad. The sweat of his insanity oozed from every pore. He lurched forward, his palsied hands hooking in the neckline of Lani's dress.

Trembling with terror, the girl jammed her knee into the madman's groin. She heard him gasp. Immediately she was seized by two guards who had charged through the door. Violent pain shot through her arms as they were twisted behind her. Inexorably she was forced forward into the corridor and towards a huge room.

Her cry of agony and disbelief was pitiful as she saw the array of glass coffins with their macabre contents.

Each coffin contained the figure of one of the young women who had shared the van trip with her. Their arms had been carefully folded over their naked breasts. They had been stacked like so many cords of wood.

In the center of the room, two grotesque-looking figures sat ensconced in throne-like chairs. Their beady eyes took in every movement of Lani's struggling, almost naked body. They wore the insignia of Standartenführers.

BY NOW the man called Reinhard Goering had recovered his aplomb. He minced around Lani, touching the sheer silk of her pink panties, letting his eye rove over the swelling, agitated upthrust of her breasts in the tight confines of their bra.

A small gnome with a huge hump on his back pranced around a low slung wooden table, testing straps and ropes.

He barked a series of high pitched orders. The guards who held Lani lifted her high in the air and let her crash to the table's splintery surface.

Immediately her arms and legs were seized and strapped to the table. A cruel rope was twisted around her throat, almost completely cutting off Lani's air supply.

Through it all, she saw the impossibly grotesque figure of Reinhard Goering leering down at her. Spittle flecked his lips. The cord-like arteries in his head throbbed with an increasing tempo. His addict's eyes drank in the twitching spasms of Lani's helpless body.

His giggle was high pitched. With diabolical delight

he moved the torch ever closer. Its first kiss tore a heart-rending shriek of pain from Lani's lips. She thrashed against her bonds, heaving her body upward, arching her back, fighting the ropes which held her.

"I am Reinhard Goering," her tormentor cackled. "I have the rights given me by the Reich Marshal himself. Cousin Hermann has his Karin Hall, very well, I will have my own edifice."

Through the waves of agony which tore at her nerves, Lani knew the truth and it almost made her happy. The entire Gestapo round-up had been for no military purpose. It had been designed merely to give this maniac a chance to pick and choose his victims.

Only the young and the beautiful would find their way to Reinhard Goering's lair. The rest would be committed to the labor gangs and the concentration camps.

"I will be somebody!" the fat man shrieked. "I will be as important as the Reich Marshal. I am just like him. I have rights."

The other Nazis looked knowingly at each other. But they made no move to stop the fat man's abominations. They realized he was a lunatic, but just possibly there was an element of truth in his pretensions of kinship to the Reich Marshal. It would not be well to investigate the matter too thoroughly. Strange transfers could be issued under the right circumstances.

Besides, there was some interest for them in watching the pain-ridden spasms of a lovely young girl who lay completely denuded before them. After all, hadn't they taken a blood oath to join the R.H.S.A. – an oath which forswore all signs of weakness? Wasn't being able to withstand the sights and sounds of torture a reaffirmation of the oath?

The flaming torch continued its journey over Lani's flesh. Her mind whirled in a multi-colored sea of agony. She screamed until her voice was merely a hoarse rasp.

At last, just as the pounding of her heart told her she must die of exhaustion, she saw the needle coming towards her. She felt herself sinking slowly into a black veil. Rough hands cut away her fetters and she felt the coldness of the glass pressing up against her recumbent back.

She was still conscious but unable to move as the fat man bent over her, arranging her hands in the position of death. The way he fondled her showed his perverted morbidity.

Fighting to breathe, Lani saw them placing the heavy glass lid over her. There was only the smallest opening for air between the lid and the sides, of the coffin.

ENTOMBED AS she was, Lani could not hear the roar of the onrushing planes. Drugged as she was, she couldn't feel the bomb concussions. She could not see the stone walls cracking, nor the torture table being hurled through the air to crash with a sickening thud into the fat man's head.

She knew of none of these things nor the lightning raid of the Resistance group which moved into the castle under cover of the Allied bombing to carry out its rescue operations.

For weeks after, Lani hid in a small house not two kilometers from Max Bruner's. Slowly her strength came back to her. But even when it did, she refused to reveal the details of her experiences. "One would only consider me mad," she told Bruner.

Often she thought about the American and whether he had made good his escape.

She received her answer several months later when the first shock troops of the Canadian First Army had blasted their way East and a forward air strip was constructed outside of Arlon by the Eighth Air Force.

A young pilot, wearing the emblem of an American Flag on the sleeve of his leather jacket drove his jeep into her front yard.

His grin was big and friendly and his appraisal of Lani was just slightly hard up. He was unhappy that Lani Meister was not just another liberated girl who'd do anything for one G.I., chocolate bar and a pair of silk stockings.

But the feeling changed as he handed her the note from Jack Morrison and watched the tears run unashamedly down her cheeks.

Finally she folded the note and slid it under the bodice of her dress. "No matter how long it takes, I will wait," she whispered.

The pilot with the flag on his sleeve tapped his overseas cap briefly with a finger. "I guess that takes care of the favor I owe Morrison," he said as he drove away.

"REVOLT OF THE LOVE SLAVES"; detail from interior art, **WOMEN IN WAR**, 11/63.
Art uncredited (previously published as cover, **MEN IN CONFLICT**, 02/63)

GOLDEN NUDES
OF THE MAD NAZI SCULPTOR

In a foul crypt, the Nazis' mad experiment sentenced their victims to the ultimate in torment.

THE BIG MERCEDES LIMOUSINE with the twin Swastikas flying from its fenders probed tentatively through the rubble-strewn street. Overhead, long fingers of light swung back and forth, bouncing off the low scudding clouds. The whining siren continued its plaintive wail.

Erikka Froelich watched the sky. She noticed the flakes of snow cascading around the car. She huddled deeper into her furs, cold despite the warming waves which swept back from the limousine's heater.

A wry smile flitted across her full, pouting lips. What irony, she thought, as her glance moved towards the gray lowering sky. What impossible irony if one of those bombers up there should end my mission now

She studied the back of the driver's bull neck. His over-sized head rested on massive shoulders. His cold eyes reflected in the rear vision mirror. Brutal, stupid, impassive, he was the personification of what Rosenberg and Schacht and Streicher and all the rest called the perfect Aryan.

Erikka thought about him. How many women had he raped on the eastern front? How many children had he tortured and killed? What barbarities had he committed to entitle him to the Order of Hermann Goering which now hung from his chest?

They were all the same – the big ones with their, castles and their obscene parties; the little ones with their back alley rapes. It didn't matter who they were – the malignant infection that was Nazism had touched them, and once touched they had been reduced to killing automatons.

She wondered about tonight's party. Would she be able to stand one more evening of being pawed by the pervert Streicher? Would Fatso Hermann be there, his eyes the merest pinpoints, his gross body stinking from the narcotics he had swilled down? Would club-footed Goebbels insist that she accompany him upstairs where she would feel the sting of his ever-present riding crop?

The pictures which flooded through her brain made her stomach turn queasy.

Erikka Froelich crossed her arms over her upthrust breasts. "We are not all the same," she whispered to herself, seeking the absolution that the words should give. "There are some of us like Hans Bodenheim and Manfred Einsman and Erna Schwarzkopf, who fought the disease with whatever implements we had." Perhaps they would form a new Germany some day when the madness had ended. But would the madness ever end?

"It's not for me to say," Erikka told herself. "I have only one responsibility. I must observe and remember. My information must get to the *Amerikaner* with the short-wave transmitter. He will know what to do with it."

Even as the car sped past No. 13 Prinz Albrechtstrasse a shiver of revulsion raced through Erikka. Not for what was going on inside the Gestapo's main torture chamber, but because she had accepted it for so long without raising her hand to do anything about it.

But like so many others, Erikka had made herself blind. She was not one of them, so she had no responsibility for their actions. Life was good and her career as an actress had been all that concerned her. The talk of concentration camps and mass killings had been pure lunacy. The Germans were civilized people. Hadn't they given the world Beethoven and Freud and Ehrlich?

It had been a good opiate. It had almost worked. If she hadn't seen the Gestapo come for Sigmund Leichter and hadn't seen his own son point the finger of accusation at the trembling old man, she might have been able to accept it. It could have remained something far removed and impersonal.

But you couldn't be impersonal about Sigmund Leichter. The old doctor had been the soul of gentleness and love. His precept of life had been, "Who needs me and where is he?" Even when the man calling him was a Jew who had escaped a cordon on Unter Den Linden and had fled to a cellar, the blood oozing from his wounds, Leichter had not stopped to think of repercussions. He had packed his supplies in the black bag and gone to keep his death watch over the mortally wounded man.

And the Gestapo had come because Leichter's son was one of them, and the disease that was Nazi Germany was more powerful than a son's love and respect for his father.

Dr. Sigmund Leichter had not screamed when the Gestapo had broken his arm before his wife. His eyes had been serene as he had looked at his wife and only child and said, "I will never see you again, my darlings. But remember this, nothing on this earth or in hell itself can ever affect my love for you."

He had walked down the stairs between his captors, his arm held limp, the hand at a crazy angle, his head slightly bowed. His son had shuffled alongside of him, his face inscrutable, as were the faces of all uniformed Gestapo men.

It had been that night, as Trudi Leichter had sobbed in Erikka's arms over the loss of her husband and the even more hideous loss of the child which had been spawned in her womb, that Erikka knew she was no longer untouched by the horror that was Hitler's New Order.

Now she thought of the others. She remembered Karl Hoffner and the night when she had gone to his flat to offer her services. The man had been gaunt and shown the strain of his

clandestine life. He had not been handsome in the usual sense of the word, but there had been an intensity about him which had swept her up into the urgency of the Berlin underground.

He'd paced back and forth before her, watching every breath she drew.

"Why?" he asked, "Why should we trust you? Where have you been all this time? What kept you from coming to us for so long? How can I be sure that you are not one of them sent to spy on us?"

Erikka had reached into the bodice of her dress and produced the tear-stained sheet of paper with Trudi Leichter's brief message on it.

Karl Hoffner had studied it, turning it over in his thin hands. He laid it on the bare table. For long moments he'd remained silent.

"I studied under Dr. Leichter. He was more than a man to me. He was a god. I always believed him to be immortal. But there can be no immortality in a nation that has gone mad. It will take Germany a thousand years to produce a man like him."

There had been no answer for Karl's words. The enormity of what he had said had left little room for answer.

AT FIRST, even though he had accepted Erikka as a recruit, Karl had remained cold and aloof. He could not bring himself to accept this beautiful young woman who had known the fawning attention of high Nazis completely.

He had forced her to continue her relationships with her "protectors" as she had done before. When she had asked for another assignment, he had become irate.

"Do you know what we have to go through to place somebody in your position? Here we have a ready-made situation and you are becoming temperamental. We have no need of couriers or side-street fighters. There are many to do that work."

"But you don't know what it is," Erikka had cried. "To accept their advances. To have them lead you to their beds and smell the stench of blood on their hands."

"There is nothing pretty or noble in what we are doing," Karl shot back. "There will be no medals. Nobody will ever care. As long as we live, we will remain Germans in the eyes of the world. There is no worse stigma. Yet we go on, because we have to. If you are too weak to accept this fact, then leave us now before you bring ruin to us."

Erikka had sat in the chair, her knees pressed tightly together, the excruciating pain mounting in her breast until she almost strangled on it. The tears had flooded down her cheeks. Her body shook violently with the force of her silent sobs.

Karl Hoffner had stood rigidly over her, staring down. A muscle in his cheek had twitched noticeably.

At first she had not felt his long, slim fingers on her shoulder. She had not been aware of his closeness.

"Once I was a physician like Dr. Leichter. My life was dedicated to helping man – the good, the bad and those in between. But then the Nazis came and found out I had a Jewish grandmother. They would not allow me to practice medicine any longer. But they let me live freely. They even gave me a job as an attendant in the Berlin Clinic. I should have spat in their faces for the affront. Instead I took the position and thought myself lucky not to be sent to Belsen. It took time for me to learn that men can fight. It took a great deal of time."

Erikka glanced up at him. His fingers closed over her shoulder. The feeling was delicious. His face was tense. But the eyes were softer than she had ever seen them.

"There aren't many people like Dr. Leichter who know the difference between right and wrong from the very beginning. One must learn from what he experiences."

His right hand touched her cheek, moved downwards, finding the hollow of her throat. His touch was gentle – ever the gentle physician. How strange it felt after the way the Nazis had used her body.

She hadn't thought as she had risen to meet his embrace. Suddenly she was in his arms and his mouth was hot against hers. Her hips writhed, responding to the urgency which his body sparked.

"I am filthy," she sobbed against his chest.

"None of us are any different. We all tried to live with them. It was only human nature."

His fingers slid down her spine. She pressed ever closer against him. She reached behind her, touching his hands, guiding them insistently towards the buttons at the back of her expensive Parisian dress.

In a blur of tears, she felt the dress fall away from her trembling body.

Her black lace bra and briefs were gauze-like in the harsh light of the overhead fixture. She felt something now that she had thought the Nazis had killed for all time. She felt a sense of modesty and shame standing almost nude before Karl Hoffner.

His arm had tightened around her waist. The fingers had moved to the waist band of her panties and remained there for a long moment.

Then he'd reached for the cord which hung from the naked bulb. The barren room had been plunged into darkness. With measured steps they'd walked hand in hand to the studio cot.

In the darkness the room had become a fairyland of enchantment for Erikka Froelich. She'd given her womanhood to Karl Hoffner without reservation and without guilt. The moments of magic had cleansed away the months of filth which had been piled on by the Nazis.

After that, Karl Hoffner's attitude had changed. He had become first warm, then protective. He had tried to keep Erikka from continuing her meetings with the Nazis. However she had forced him to agree that the small fragments of information she gleaned at the debauches were of importance to the Allies. Time after time she found it necessary to resist his words, "We have enough couriers and street fighters."

The situation had grown rapidly more critical in Berlin. The last Nazi offensive at Bastogne had been blunted and then turned back with heavy losses. The American Armies rolled forward once more, gaining momentum.

Russian and American heavy bombers took turns at clobbering the German capital. Where buildings had once stood arrogantly, now piles of rubble hid the dead from all but the prying eyes of the rats. The rodents went about their business

of devouring the cadavers without caring that Hitler's Thousand Year Reich was being crushed into oblivion.

And the hierarchy of Nazis abandoned Salon Kitty, Gestapo Chief Mueller's bordello of espionage, in favor of more out-of-the-way edifices in which to carry out their debaucheries.

Now the information that Erikka Froelich obtained had to do with plans for the Fourth Reich, which would rise from the ashes of Berlin.

The high command excused its systematic looting of anything of value on the basis that it would provide the necessary war chest for the "new war."

There was talk of Hitler's deteriorating mental condition, but there was more talk of how each man would escape the noose which closed around his neck.

And as the noose tightened, the demands of Erikka's depraved admirers became the more horrible to endure.

SHE THOUGHT of them now as the Mercedes threaded its way around a completely gutted building and the concussion of ack-ack caused the heavy limousine to sway back and forth on the narrow street.

She recalled Karl Hoffner's words to her. "Time is running out. As it does, they will become even worse. Nobody in Berlin is safe from them. They are turning on each other. They will stop at nothing if they suspect you. Be careful."

He had held her even tighter last night as if he had some premonition that this would be their last meeting.

This afternoon she had gone to his flat but the place had been deserted. The fact had set a gnawing pain in her bosom which had grown until it ate away like a cancer.

She managed to shove the dread back into the recesses of her mind as the uniformed chauffeur managed to guide the car up a narrow path towards a grim-looking house just north of the city.

No lights shone from the windows of the house, as the most stringent of blackout restrictions had been placed into effect.

Once inside the grim edifice, the scene which greeted Erikka was quite different. Lights blazed and uniformed men moved back and forth, huge goblets of champagne in their hands.

Women in various stages of dress and undress fitted among the guests. Now and then a high-pitched laugh would bubble over the general conversation.

A lovely-looking girl who could have been no more than nineteen giggled stupidly as a Gestapo officer gripped the bodice of her silken gown with his two fists and ripped it slowly down the front of her body. The girl wriggled her hips sensuously as she worked her panties down over the symmetry of her legs and tossed them to the crowd. Now completely naked, she leapt into the Gestapo man's arms and smothered him with kisses.

Erikka felt the bone-crunching grip on her shoulder. She spun around to see Julius Streicher's bloated face regarding her. His expression was one of evil incarnate.

"Good evening, Fraulein Froelich," he grated through his thin lips. His eyes were those of a cobra regarding a twitching rabbit. "I am so glad you came. We are preparing a special entertainment tonight one that I'm sure you would not want to miss. We are about to have a demonstration combining science and art. No doubt it will prove of inestimable interest to you and your Jew friends."

Erikka's heart thumped wildly within her heart. She knew at that moment that something had gone wrong. The knowledge crowded in around her, making it difficult for her to breathe.

Streicher seized her arm, his nails biting into her tender flesh. He half dragged her up the ornately decorated marble steps which looked down on the main salon. His body pressed into her back. His hands roved over her body at will. Erikka was like stone, willing herself to disregard the indecency of the gross man's pawing.

His voice rose to a shout as he commanded the other guests to silence.

"Tonight!" he shrilled, his voice high and cracking, "we are going to conduct an interesting experiment in metallurgy. If it works, it may prove the means of transporting gold and other precious metals away from the Allies. With this in mind, I have requisitioned six prisoners from Dachau who will be used to prove the merits of the plan.

"However, what is even more delightful for our purposes is that we have a seventh experimental prisoner. She has accepted our hospitality and then sought to betray us. We have had her and a certain male Jew under surveillance for weeks. I am happy to tell you that the Jew was taken into custody this afternoon. Before he expired, he provided us with all the information about Erikka Froelich that we find necessary. You see, we are not exactly asleep when it comes to traitors like Karl Hoffner, nor the sluts who share their beds."

The news of Karl's death was worse than the fear which now surrounded Erikka. How much pain had he withstood before he'd moaned her name through his shattered lips?

Erikka stood straight and slim before the converging mass of Nazis. She remembered the sight of Dr. Leichter on a staircase so many months ago. He had gone to his death with an air of dignity. She would do no less.

The tears which coursed down her cheeks now were not for herself but for her fallen lover who had shown his only sign of weakness when he could no longer stand the agony inflicted upon him. Somehow his lone act of human failure made him that much more precious to her.

With a peculiar air of detachment, Erikka felt her gown being stripped from her. She heard the obscene remarks concerning her panty-clad body, but the words had no meaning to her. She was even beyond the pain caused by the bite of the ropes which were quickly secured to her wrists and ankles.

With her arms tied tightly behind her, she was lifted high in the air by two heavy-set men who wore the black uniforms of the SS.

Slowly, like some pagan sacrificial procession following a bound virgin, the Nazis and their women moved behind her as she was carried into a stone cellar. Unceremoniously she was roped to a thick beam which supported the ceiling.

The sights and the sounds of the room were beyond

belief. A huge cauldron bubbled evilly over a white-hot fire. Its contents glowing yellow and thick erupted over the sides and slid into a trench-like stone trough. Now, as she stared around her, Erikka saw other naked women, their young bodies similarly bound to the cellar beams. Their bodies glowed with a sheen from the intense heat and their eyes were huge with the terror of the waiting cauldron.

Streicher raised his hand for silence. "They are really quite attractive for their lot, are they not? How much more beautiful they will be when their bodies are gilded with gold. They will be transported to Bavaria where they will be hidden in caves. Then when the time comes, the statues will be melted down once more. The Führer will have all of the precious metal he needs to carry forward to total victory. And now my friends, we shall commence."

In mounting horror, Erikka watched a beautiful dark-haired girl cut from the restraining ropes. The girl moaned pitifully as she was placed into the trough and her wrists and ankles strapped spread-eagled to the device's sides.

One of the Nazi torturers reached down and the pitiful remnants of the girl's clothing were snatched from her. She heaved mightily against the confining leather as she watched the huge cauldron being slowly tipped so that its beaker hung over her.

Her cry of mortal agony was drowned out by the hissing geyser of steam as the molten gold spread slowly across her nakedness. The full operation took long moments, each etched with a blistering torture.

One of the watchers giggled. Another moved forward for a closer view. Erikka found herself concentrating on the expression of the torturers. Anything was preferable to watching the death throes of the damned beauty in the trough.

There was no mercy in the eyes of the lecherous, depraved audience. Brutality and drugs had robbed them of any human traits. They worshipped death and if suffering could be made exotic, they reveled in it. How much more exquisite was this display than the countless deaths in the gas chamber of Belsen.

The mob chattered gaily among itself as it waited for the gold to cool. Finally a murmur of admiration went up as the dead girl was lifted from her tub and the diabolical work came into full view. Her body resembled a statue, shimmering in its evil casing, catching the light and refracting it. It was at once the most beautiful and hideous sight which Erikka could have imagined.

Only the doomed captives screamed at the sight of the limbs already grown rigid in their metallic shroud. For each of the young women it was the final damnation which awaited her.

OVER THEIR shrieks came a new sound, the screech of a thousand air raid sirens followed by the ground concussions of heavy bombs.

"*Amerikaner* swine!" a Kripo Sturmbannführer cried as he looked up at the wildly swaying ceiling fixture.

The others fought with each other as they rushed headlong towards the stairs which led to safety. Forgotten for the moment was the diabolical diversion which had been provided for them. Reveling in the death of helpless women was one thing, but staying in a shallow cellar when an entire building might fall in on them was another.

Erikka felt that the madness had gripped her completely. She laughed wildly as the Nazis crawled over each other in their craven haste. She laughed wildly when a nearby explosion blasted the huge beaker from its mount and the molten gold spread across the floor starting little rivulets of flame where it touched. She felt the heat racing up the wooden beam which held her, but she was mindless of the pain of her own scorched flesh.

Through instinct more than anything else, she tugged at the ropes which now smoked furiously. The heat-weakened hemp gave way.

Without knowing it, she was running through the basement. Without knowing it, she was plunging outside of the house, racing wildly after other panic-maddened people towards the nearby public shelter.

A Berliner sympathetically draped a blanket over her shoulders. He raced away without asking questions.

The Allied raid of January 25, 1945 ushered in two weeks of sustained pounding of the German capital. In the chaos which accompanied it, Erikka Froelich was able to avoid recapture.

Four months later she told her story to the incredulous AMG officers who had not yet been able to comprehend the depths to which man can sink. Perhaps they understood it better when they visited such Nazi shrines as Ravensbruck, Belsen, Dachau and Buchenwald.

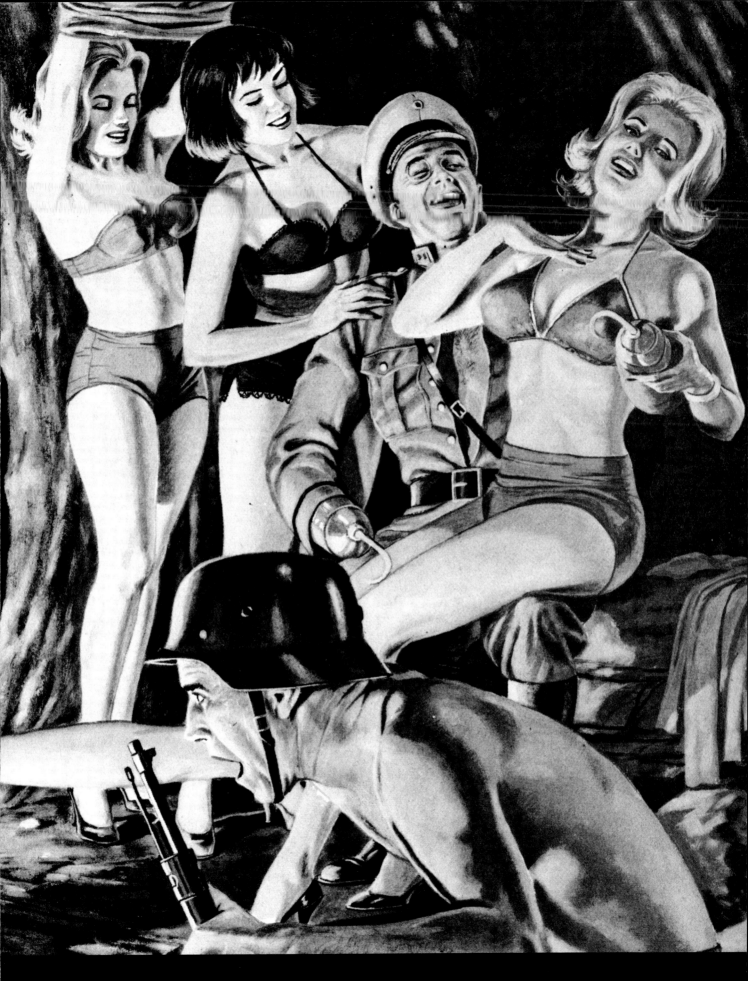

"THE KAISER'S TUNNEL OF DEATH"; detail from interior art, **WILDCAT ADVENTURES**, 11/63.
Art uncredited.

THE SHACKLED NUDES IN HITLER'S
CRYPT OF TERROR

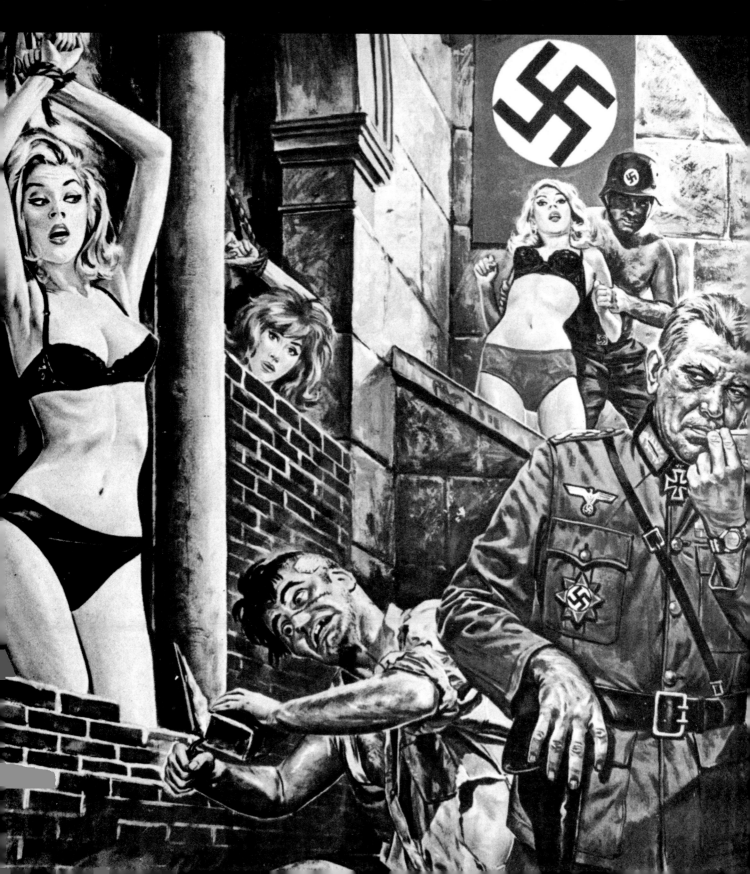

Like a vicious beast, Heinkel had dragged the girl to his diabolical lair beneath the stricken city. Here, she learned the true horror of the Hun.

"YOU *LIE!*" HEINKEL SPAT little bubbles of saliva with the words. He reached out and slapped Felice Lebois across the face. Her head rocked. Tears started at her eyes. She managed to blink them back.

"Reinhard, how can you say that? You know there is no other," she whined.

Heinkel strode to where she sat. "I gave you silks and satins and you betrayed me. I kept you away from the deportation lists and you ran to the arms of another man."

The Nazi bent over Felice. He clawed at the collar of her dress, shredding it down the front of her bosom. She stared at him, making no move to cover up her nudity.

"It was a chance meeting in a café. It couldn't have been more innocent, my sweet," she said, trying to soothe away the maniacal fury of her "*protecteur.*"

"Did you think that I would be stupid enough not to have you followed? Did you think I would not have powerful facilities at my disposal? I am an important man. When I give orders, people jump."

"Believe me, my friend, you are getting yourself completely worked up over nothing. No woman could have been more faithful to you. It is merely this hellish war. It has clouded your brain with fatigue. How long has it been since you've had leave?"

"So I am a paranoid? I imagine things. You were not billing and cooing with the Frenchman."

Felice stood up she put her cool hand on Reinhard Heinkel's shoulder. Everything depended on her making him believe her.

"I hadn't seen the boy since before the war. We were classmates, nothing more. We met for a moment, sipped an aperitif. Then he went his way and I went mine. Certainly there was no disloyalty to you in any of this."

"You flouted me before my own inferiors. Read this report. Does this sound innocent to you?" He shoved a sheaf of onionskin papers at her.

Felice's eyes grew wide as she read.

The woman in question entered the cafe and took a seat at the back. Several minutes later, the young man followed her into the cafe. They sat together, talking and embracing. The man left alone. The woman was apprehended as she emerged from the building.

Felice shrugged her shoulders. "One meets an old acquaintance. One embraces him. It is the way of the French, *n'est-ce pas?*"

Heinkel's fist lashed out. It caught Felice on the side of her head. The room swam before her. She felt her knees give way. She huddled stunned on the floor.

"And that is the way of the German who has been made a fool of, my devoted little pigeon. The Reichsführer was right. You French are without morality or loyalty. You are not to be trusted."

Felice stared up at her accuser. Her skirt had twisted around her plump hips, showing off the smoothness of her thighs. Her agitated breathing lent a trapped doe quality to her patrician beauty. Her hands fluttered to the shredded bodice of her dress. Although Reinhard Heinkel had seen her naked many times before, she could not stand his lecherous stare at this moment.

"Don't bother, *Fraulein!*" Heinkel shouted. "Where you are going there is no need of clothes. My assistants will see to that."

The Kripo Obersturmbannführer reached down. He seized Felice by her long blonde hair and dragged her to her feet. The undercover FFI girl felt the pain tearing at her scalp. She put a tentative hand out to touch Heinkel's cheek. Brutally he smashed it away.

"It is too late for that, *Fraulein!*" he spat. "Save your strength for the caress of my interrogators."

Heinkel forced a knee into Felice's back and propelled her towards a desk. His arm circled her slim throat as he dialed a telephone.

"*Achtung!*" he shouted into the mouthpiece. "Send a *kommand* car to the Hotel George V, immediately. I will wait for you in my suite. Of course, *dumkopf*. This is Obersturmbannführer Reinhard Heinkel. You are not to question my orders."

HEINKEL'S FOUL breath surrounded Felice. She might collapse at any instant. She stood on shaking legs, managing to support herself against the desk's edge.

The events of the last few days raced through her mind. It had been madness meeting Gaston Rouen in the open. Yet speed was of the essence. The documents she had pilfered from Heinkel's room would not wait. Perhaps a thousand lives depended on their being turned over to the underground.

She thought of Gaston now and a new courage flooded through her. What was her life when compared to what the gallant Frenchman would be able to accomplish as the result of her help?

Other memories came to her. She imagined herself in the tiny garret over-looking the Seine. Once again she could

hear Gaston's light footsteps on the creaking stairs. She recalled the door sweeping open to reveal his slim wiry frame and grinning face.

"Eh, bien, cherie," he would say. "For a little while *la guerre* will wait, *n'est-ce pas?*"

She wouldn't answer. Her voice would be lost in the lump of desire which crowded into her throat. Her little feet would carry her to the Resistance leader. She'd feel his arms tighten around her. His fingers would move gently up and down her spine as she ground her hips against his and covered his mouth with feverish kisses. Gradually the emotion would subside for a moment.

Breathlessly Felice would step back. Behind Gaston was the old-fashioned brass bed.

"One must hurry," Gaston would whisper. "There is never any time."

Quickly Felice would wriggle out of her dress and stand before her lover. She'd sense the power of his biceps as he lifted her from her feet and carried her to the waiting bed. Even as he was moving across the room, her hands would move behind her, unhooking the clasps of her satin bra. She let the garment drop to the floor as he lowered her to the soft mattress.

Felice's blue eyes would search Gaston's face, urging him to hurry. Her hips would rise and she'd sense his touch on her bare skin. Almost reverently he would remove her black panties.

How different it had been from the occasions with Heinkel. The Nazi had done nothing to veil his sadistic lusts. Her experiences with the German had left her hurt and bruised, and hating herself for having submitted to him.

Yet Gaston had made even that seem right. "One must do unpleasant things," he'd whisper in the darkness. "Armies fight in glory. We fight like the rats of the Seine. We live in sewers and we do hideous things. But the nobleness of our purpose is all that matters.

"Go back to the Boche. Learn what you can from him. There are women as young and innocent as you who are now chained below the ground. Heinkel is our key to them. Perhaps he will give away some piece of information which will allow us to save them."

"I can't go black," Felice would weep.

"But you must. It is only for a short time. Soon Paris will be free. It must come to that. Already Cherbourg has been secured. The Allies are moving inland. Nothing can stop them. But they may arrive too late for those who languish in the dungeons. It is our duty to try to liberate our countrywomen. We cannot think of ourselves and our own sensibilities. Fate will not allow that."

Felice had gone back to Heinkel, and the break had come when she'd discovered the tracing of the sewer cells of Fresnes Prison.

It had been only twenty-four hours ago. Heinkel had spent himself and was asleep in the large suite when Felice's eye had caught the mimeographed papers on his desk. There had been fifty copies carrying the words, "Plans for the removal of political prisoners and other undesirables from the underground dungeons".

Somehow Felice had managed to place one copy of the document under her clothing and spirit it away from the hotel. The urgency of the find and the flush of her success had been her undoing. She had gotten word to Gaston Rouen to meet her immediately.

Now she realized that Heinkel had ordered his minions to spy on her. She wondered whether they had seen the actual transfer of the papers or whether his rage was merely caused by what he considered a woman's betrayal of him.

There was no way of telling. She could only hope that she had taken sufficient precautions. She recalled now how she had gone to the little café on Avenue Foch and had immediately repaired to the ladies' room. She remembered placing the papers on top of the old-fashioned tank. She remembered Mama Foulard winking at her as she had emerged from the ladies' room. Now all she could hope for was that Mama Foulard had not been under surveillance and that she had completed the transfer to Gaston.

HEINKEL'S KNUCKLES ground into Felice's neck, bringing her back to the present. "The fools who followed you were too busy to pick up your lover. But that will come in time. You will have the opportunity of betraying him to us. And do not think you won't. We have our ways."

Was this an admission of failure or was it some kind of a trap? Felice bit her lip and said nothing. Reinhard Heinkel prided himself on being a very proper Kripo man. Often he had gloated, "We Germans are a very civilized people. We do not cause pain for the sake of causing pain. We can be very gentle with our friends, although we find it necessary to treat our enemies with unrelieved ruthlessness."

Perhaps he would be satisfied merely to torture her for her indiscretion with Gaston. Perhaps he would not seek any information from her. Seeing her agony might be enough to sate his animalistic desires. Who could say?

The knock at the door ended her speculation. Two black-shirted men marched into the suite. They held one hand hooked under their wide leather belts. The right arm shot out rigidly.

"*Heil Hitler!*" they chorused.

Heinkel returned the salute. He dragged Felice across the floor and hurled her at the Geheime Staats Polizei representatives.

"This one is suspected of high treason against the Reich," he barked.

The men stared impassively. One of them produced a pair of thin handcuffs. The other spun Felice around, gripped her wrists and held them tight against the small of her back. That was all there was to the arrest. The click of metal; the bite of steel on flesh; cruel fingers twisting the soft skin of a woman's arms; nothing more.

The woman elevator operator risked a look of sympathy. But she was powerless to do more for Felice. Outside the hotel, people scurried from the path of the Gestapo men. Once at a safe distance, they turned to stare at the hapless victim who was being hustled into the Benz *kommand* car.

Felice felt the hot August sun blazing through her torn dress. She felt Heinkel's fingernails digging into her exposed thighs. She heard the sounds of birds and the coarse breathing

of the two black-shirted men who rode in front.

"Make a fool out of me! Cause my inferiors to laugh at me! And now, my little pet, you will learn what your infidelity will cost you. Oh, you will love your new home. Do you know what will happen to you?"

Felice stared straight ahead. Heinkel gripped her chin, forcing her eyes to meet his.

"It will be cold and wet. So cold that you will grow numb and shiver. There will be nothing to protect you, no blanket, no clothing. But then will come the heat. You will without welcome the lash and the fires. They will bring back sensation. Soon you will be shrieking with the pain. You will go mad with it. You will beg to die, but the pain won't allow you. It will be all around you. You'll thrash against it. But the cords will hold you and the pain will go on endlessly."

The man was mad. His ravings went on in a high-pitched cacophony of horror. It mesmerized Felice so that she was not aware of any other sound. She had been driven through a gate and taken from the car and forced to stumble down a long flight of stone steps. Yet she had no recollection of these things. Only the voice.

They stood her in an unlit room which had been hewn out of bed-rock and they clamped an iron collar around her neck. Then they spread-eagled her arms and legs to rings in the wall and left, her there.

At first Felice was surrounded by complete silence. Then little sounds came to her. The furtive squeal, the scurrying of soft feet, the rubbing of coarse fur against her insteps.

Terror welled within her. She stared down at her feet. Was it her imagination, or were there beady little eyes staring up at her from the stone floor? Searing pain lanced through her ankle. Felice slammed herself against the wall. Her chains gave a little. But scant inches were not enough. The rodents moved in, becoming more daring now that they sensed their victim was powerless to kick out at them.

The wall was damp against Felice's back. She felt the icy moisture seeping through her clothes. Its evil ooze chilled her flesh. The damnable darkness was unendurable. She lost count of time.

She tried to force herself to think of other things. How many women had died this way, chained to the stained walls of the Paris sewage system? What had it been like for Victor Hugo's tragic hero, Jean Valjean to live here as an escaped prisoner?

Her thoughts became muddled. The cold made everything else seem of no importance. How long would Heinkel leave her here? When would they come and what would they do once they arrived? The word "they" filled Felice's consciousness.

Her knees buckled under her. The rats scurried around her. She felt the collar digging into her throat. The gyves around her wrists scraped the flesh raw.

"Do not let me betray Gaston?" she whimpered. "Do not let them make me betray him."

THE AGONY went on endlessly. There was no way of judging time. Did fifteen minutes seem like a day? Or had a week already passed? In the Nazis' black dungeon below the Paris Streets nobody could be sure.

Fatigue finally overcame her. Felice hung limp from the chains, mad dreams tormenting her. Suddenly the dreams exploded into pinpoints of life.

Reinhard Heinkel stood before her. His face shone in the reflection of the electric torch he held. His teeth had the sharp, jagged appearance of a rat's. His beady eyes sparked with diabolical intensity. His foul breath was even more sickening than the smells of death and blood which hung in clouds from the slime-filled walls.

"I trust you slept well, *Fraulein*," he giggled. "But now it is time to awaken. We have some most interesting plans for you."

Felice's blue eyes blinked in the sudden light. She felt the irons being removed from her limbs. Slowly she sank to the muck-coated stone floor.

"On your feet!" Heinkel screamed. The heavy toe of his boot blasted into her side. Felice rolled over, gasping and sobbing. This was the Gestapo in action. Tear a prisoner apart with fear. Strip her of the dignity a human needs. Begin the kicking and the stomping even before the formalized torture. It was all part of a master plan handed to the guardians of the master race from Number 13 Prinz Albrechtstrasse in Berlin.

A grotesque gnome-like figure with an ugly patch on the side of his head slithered up to Felice. She felt him lifting her from the floor. She felt the obscenity of his caress against the nakedness of her legs. She saw the lights growing brighter as she was carried forward.

The room which awaited her had been designed in Hell itself. The simplicity of its implements made it all the more hellish. A chipped bathtub stood to one side. How many French women had been drowned in that bathtub, their heads held under the filthy water until their lungs burst? How many had hung from the single rope which now swung from the overhead rafter?

The gnome-like little dwarf raced around Felice, gibbering insanely as he made his preparations. Heinkel held his erstwhile mistress tightly in his arms as the little fiend he called Brandt scurried through the room.

With sickening clarity, Felice watched the preparations. She heard the ripping of cloth and realized that they had taken her dress from her. Brandt raised himself to his three and a half feet. His arms were elongated as they reached towards Felice's bra.

Cold, numbing and wet, circled her breasts as their last covering was denied them. She cried out pitifully as Brandt stripped the gossamer panties from her flanks.

Seconds later they were attaching heavy weights to her feet. Her arms were manacled behind her and the manacles were attached to the overhead rope.

The pain did not come all at once. It intruded slowly as her body was pulled from the floor. It lanced through her outraged shoulder and back muscles. It slithered down her sweating flanks and thighs as they were drawn to the breaking point by the weights. It crushed in on her bosom and belly.

Hands reached up to her, twirling her slowly. The rope above her danced. Suddenly she began spinning in the opposite direction. The momentum grew with a dizzy force until she

could no longer breathe. At that moment the tip of a barbed lash snaked around her exposed hips. A second later it lit fiendish fires in her soft thighs.

Heinkel's glee came to her through the waves of her own pain. She had no way of stopping his voice from crashing against her brain.

"Let me not betray Gaston," she moaned to herself.

FELICE WAS not aware of the two men who entered the torture chamber and spoke hurriedly to Heinkel. She was not aware of the deathly white pall which covered his face. She was only dimly conscious of being cut down from the rope and shoved down a flight of stone steps into the very bowels of the earth.

Like in a dream she heard Heinkel's voice coming to her. "The French pigs attack. Very well, they will find no evidence. Of that you may be sure. They will find only sealed up walls of brick."

The words had no meaning as Felice plunged into an abyss of darkness.

But the mercy of unconsciousness was to be denied to her. Slowly she regained her senses. She tugged at her arms. However, they'd been securely roped to a ring above her head. Little bits of the tableau came to her. She saw the fiend called Brandt kneeling before her, a trowel in one hand, a chipped red brick in the other.

It didn't make sense. Then she gazed at her knees. Her cry of horror pierced the tomb. Heinkel stood smoking a cigarette and directing the scene.

There were two other women in the crypt. They had been dragged here to be walled up in a tomb, gradually to suffocate as the air which surrounded them became poisoned with their own breathing.

Felice cried out once more, then fell silent. A slight smile played across her lips as she began to understand that she would die without betraying the Resistance. The Nazis had run out of time.

Sweat stood out on Brandt's face. Heinkel cursed him, demanding that he work faster. Inexorably the wall grew around Felice. Soon it would shut out all light and air. But she no longer cared. It was a better death than what she had hoped for.

Agony still exploded in her bruised shoulder joints. She wished she could lower her arms to ease the pain. Yet even that was not as bad as the agony she would have suffered had they been able to make her betray the others. She stood silently waiting to die.

Somewhere above a shot rang out.

Then another. The corridor was filled with Gallic cursing and the shrieks of mortally wounded men.

Felice slumped forward, dangling from the ropes which held her wrists.

Outside the sun blazed down on a scene of utter madness. No longer was the FFI waiting for the liberating troops. Paris had been sold into slavery by Frenchmen. It would gain its redemption through the bravery of Frenchmen who were willing to die for honor. The battle for the liberation of the French capital had begun.

Felice Lebois knew nothing of this as Gaston Rouen's men tenderly carried her naked unconscious body to the surface. For days she was to hang between life and death, reliving the hours of torment. In a way she was fortunate, because she was spared the grief of knowing that Gaston Rouen, *soldat du France*, had died in the muck and slime of the sewer dungeons, his hands still wrapped around the throat of Reinhard Heinkel.

Like so many thousands of other French women, Felice Lebois was to know the happiness of mourning for a fallen hero. And she was to dedicate her life to helping the orphans who'd been denied the right to parents by the marauding Hun.

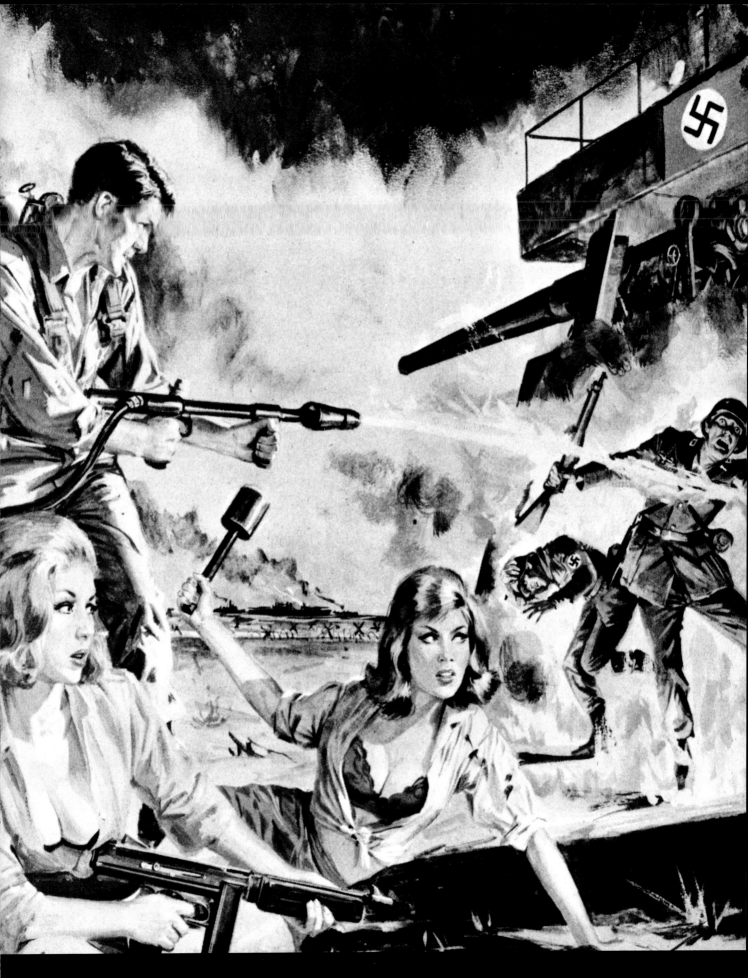

"I LED FRANCE'S FLAMING DOLLS OF DEATH"; detail from interior art, **WORLD OF MEN**, 12/63.
Art uncredited; attributed to Bruce Minney.

HELPLESS PLAYTHINGS OF THE MONSTER LOVER

Quivering in horror, the nude captives felt his diabolical eyes feasting on their bodies.

THE WOMAN TRIED VAINLY to free herself from the coarse ropes which bound her tightly to the great column. Naked, her body gleaming with the sweat of fear, she struggled helplessly against the bonds which cut into her flesh, bruising her and even drawing lines of blood where the ropes bit cruelly into her skin.

Watching her, Adolf Feleind smiled, his mouth twisting quickly as his eyes gleamed. This one, he thought, was really a beauty; a young girl, fresh – she would last a long time. She would be satisfying.

The prisoner gasped out a few words. "Please – let me go – I've done nothing..."

"Nothing?" Feleind snapped. "Did you not attack me? Did you not attempt to strike me? Me – who will now force you to pay for your foolishness!"

"But you were..." the girl hesitated. "You tore my dress... you wanted me to..."

"I am master here!" Feleind shouted. "I am to be obeyed!"

Once again the poor girl pulled at the ropes. But they

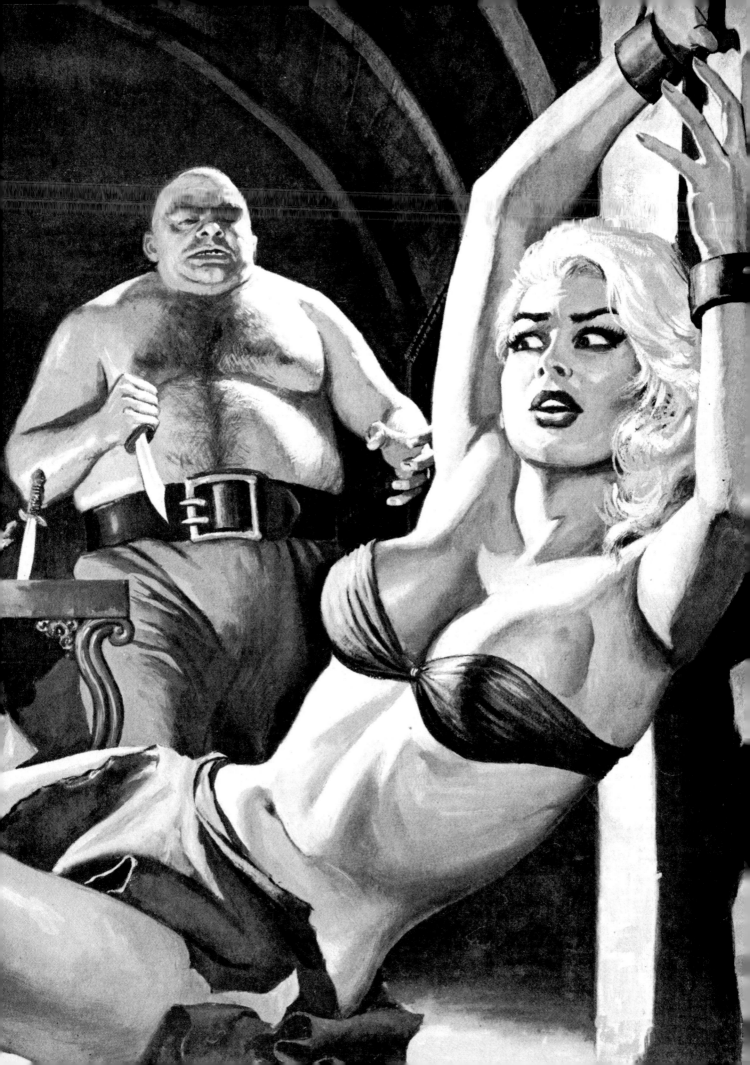

were heavy and strong, and had been tightly tied. Every movement now caused her pain as the ropes rasped against tender flesh. "I'll... I'll be good," she whispered at last. "I know you are the master... I will obey..."

"Yes," Feleind told her flatly. "You will obey – because you will be taught to obey!" He turned and shouted suddenly: "Otto!"

The girl gasped even before the great, hulking figure came out of the shadows toward her. Otto was well known in the castle of Adolf Feleind, as the gigantic brute who lived only for the will of his master, who was capable for any action, even the most horrible.

Now Otto, unsmiling, a giant whose hands hung loosely and easily at his sides, a bullet-headed cretin nearly seven feet tall, stopped before the girl. Only his eyes glittered faintly as he stared at her nakedness, and the girl felt herself shiver.

It was impossible for her to withstand the touch of this horror, she told herself; she would die if he put those gigantic white hands on her body, if he came an inch closer.

But he merely stood, waiting. Soon his orders came, snapped out in the only voice Otto had ever learned to obey.

"Otto – get the knives!"

The great idiot nodded slowly and shuffled slowly to one side of the room, where a set of tiny, brightly-shining knives waited glittering on a small table. Feleind watched him carefully.

"Select them, now," he told the slave.

Otto took up several of the shining knives and stuck them into his belt. The girl watched with terror, unable to force herself to imagine what was about to happen to her. No one spoke of the punishments carried on in the cellar of Feleind's castle: those who had not suffered them knew nothing, and those who had been subjected to his disciplines often could not speak for days afterward, and then screamed or wept when the cellars were mentioned.

Few had suffered the punishments more than once, though the girl remembered a maid in the castle who, in her nervousness, had dropped a serving-dish some weeks after a session in the cellar. Feleind had had her carried below, the girl recalled, and her screams had been heard for hours upstairs.

Yet she had not died: she was recovering, now, delirious and covered with the marks of torment, in a small upstairs room.

Her eyes glazed, her head rolling, she could only repeat, over and over: "Don't hurt me... please don't hurt me any more..." Sometimes she pleaded for death, and sometimes screamed hoarsely.

The maid's young man, to whom she was to have been married, had been forbidden to see her. She might, the castle's doctor reported, recover in a few weeks – or she might remain mad, lost in her nightmare of torture.

But she had not died. Adolf Feleind did not kill those he punished.

He only made them beg.

Otto, now holding a knife in one hand, came shuffling slowly forward in the dim candle-light of the cellar room. Seen in that smoky vagueness, he seemed a monster out of nightmares, a hulking, nodding beast who padded silently, relentlessly toward the gasping, terror-stricken young girl.

She heard his breathing, the snuffle of his nostrils, and thought again that if the monster touched her she would die. But behind him, standing, ready to shout out his next order, she also saw the little, trim figure of Adolf Feleind, his face a single sharp smile in which a few muscles twitched uncontrollably, his eyes a glitter in the candle light – and she knew in that one second that her last hope was gone. She knew there was no mercy in that man – nor in the beast he controlled.

But even before Feleind barked his order the girl screamed. "No – please!"

Feleind paid her no attention. "Otto – to work!" And the cold metal of the knife touched the girl's warm, shivering flesh. She tried to escape – in vain – and she screamed again, and again. The knives did not stab deeply, or cut in great slashes. Instead, the girl was to be skinned alive - slowly, agonizingly.

The girl's mad shrieks grew as the knives continued their bloody work on her sensitive flesh. Otto, gasping, unsmiling, replaced one knife by another even more delicate, continued his terrible work – and Adolf Feleind stood by and calmly, smiling, watched.

BEFORE THE rise of Count Otto von Bismarck in Prussia, and the final stabilization of a system of rank and title for the Prussian, and soon for the German, nobility, a scheme like Feleind's was practicable. It was never easy, and it was never more than a slim single chance of wealth and success – but a few others tried it, in the seventeenth and eighteenth centuries, and more may have succeeded than the records show.

The only ones about whom history can with certainty decide are the unsuccessful or, like Feleind, the unlucky. For his scheme seemed surely at first to be blessed with triumph.

We do not know Feleind's true parentage, or much of his early history. He first appears in the small Prussian town of Gerstein, where his plan is already formed and in action. He is determined to make himself a Lord, and to put into his own control the castle of the local Count.

When Feleind arrived in Gerstein he had a little money saved up, and he used it to maintain himself without work for some weeks until he had a good idea of the castle itself and of the traffic which went on in it. Then, one evening, as a part of a large group of laborers which had gone out into the neighboring forest to gather firewood for the castle, he sauntered in past its gates.

No one noticed that one more laborer had gone in than had gone out that morning. Feleind was safe within the castle walls, waiting for his next move.

Incredible as it sounds, Feleind lived for three weeks within the castle walls without detection. His feat was aided by the complicated construction of Schloss Gerstein, and by the fact that he was already at work subverting those loyal to the Count.

He offered rewards and glowing promises to a few hand-picked key servants; he got their backing in the event of a sudden move. And then, one night when the moon was down and the castle dark, his move came.

Stealing to the private chambers at the interior of the place, Feleind found the Count's bedchamber easily – and killed the Count with a single knife-slash. He signalled to a member of the Count's private guard – and it was all over.

Feleind had power. The guard secured the castle, sealing up the Count's wife and daughter, and the servants, once they had been persuaded that the new regime would be no worse than the old, put up no great resistance.

A few were loyal to the old Count. Feleind had them killed out of hand.

Then, comparatively secure in his power, he considered what to do with it.

His first exercise was on the wife and daughter of the dead Count. These, too, he killed – but with methods that took many days. Power seems to have given Feleind the ability to exercise sadistic tastes which had been growing in him for years – and power gave him an assistant.

Otto Fremd was virtually an animal. No true spark of mind inhabited that great skull. But Otto was persuaded by gifts and good treatment that a place in the Count's stables was no longer the height of ambition. Instead, he was to aid Feleind, the new Count, in the secret horrors of the cellar rooms. Otto wanted the new pleasures Feleind provided for him, sometimes paying women from the town to satisfy this giant, sometimes simply adding more food to his ration. Otto was willing to do anything to keep the pleasures.

The townsfolk didn't object to Feleind's accession to power. The Count himself had seldom come under their direct notice, and relations with the Schloss remained pretty much the same under the new ownership. The stories which reached the town were, in any case, garbled, and there was some talk that Feleind was the actual Count, who had been deposed as a child and returned to gain his inheritance. A few stories seem to have been even more romantic – but the net result of all was to reduce all action to confusion, and all motive to puzzlement.

And Feleind, in power, began to consolidate his position.

A bad crop year helped him. It meant that workers and servants in the castle would find it more than normally difficult to find new jobs elsewhere – and it was never exactly easy to do so. The men and women inside the castle were under his power.

He began to "train" them.

When a maid or a cook or a serving-wench made some small error, Feleind set an hour for punishment. And punishment took place in the cellar where, long before, the Countess and her daughter had screamed and suffered, cursed and pleaded and gone mad with never-ending pain, and at last had died.

There was the girl who had failed to make up an extra bed in a guest room. Feleind had her lashed with two hundred strokes of a rawhide whip, until the girl had fainted twice and was nearly insane with torment.

It took her two weeks to recover – but she never made another careless error. The very thought of the cellar was enough to send her into a hysterical panic of making sure that all of her work was done.

Two hundred strokes of a rawhide whip – a punishment more severe than many handed out by the Inquisition in the century before – had trained her to do the bidding of her master, and to do it perfectly.

There were others – tied in strained positions for hours while their muscles shrieked for release, burned with heated irons until they fainted, strapped to tables studded with small spikes and then whipped so that the jerkings of the body under pain made the spikes tear into flesh.

Feleind experimented, and invented new torments. Otto aided him.

And, at last, came the girl who had refused him, the girl who now screamed under the hands of the monster.

OTTO'S HANDS, well-trained, manipulated the knives with delicate strength. The girl's body was marked by raw weals where the flesh had been painfully stripped away. Her mouth pulled open by agony, she screamed constantly as the incredible torture went on.

Feleind watched, estimating her strength – but there would be no need, he knew, to cut this "punishment" short. The girl was strong. Even after she fainted, she could be revived and tormented without danger.

He had no desire to kill his servants – new victims, after all, were not easy to get.

And he wanted those he tortured to anticipate torture again – to prolong and increase their pain.

The girl's howls of sheer agony rose in pitch as Otto's knives moved to a new and sensitive section of her body. Careless of the ropes tearing at her, she jerked madly in her bonds, her head banging against the column in some vain hope that she could knock herself out and escape the pain.

Feleind himself came forward and held her head away from the pillar. She would not escape so easily.

Her body was jerking and vibrating in constant agony. Otto's knives travelled over her body from head to toe, inflicting torment wherever he willed them and the girl, careless now of her nakedness, knowing nothing but the mounting pain, writhed and screamed as the torture went on.

Long moments of agony, moments that seemed like years or centuries of impossible torment.

And then there was an interruption.

The door at the top of the cellar stairs burst open and a man clattered down in a mad rage, a man carrying a small sword, with the fixed grin of determination on his face.

Feleind whirled, saw him and summed up the situation in an instant.

It was the man affianced to his last victim – to the girl who lay in an upstairs room, half-mad with her torture.

He had heard these new screams, and control had left him. He had come to kill.

Feleind barked: "Otto!" and the giant stood back, blinking. The girl tied to the pillar shuddered and sobbed, her breath coming in long moans.

But even Otto was too late.

The sword stabbed in and out once and the great giant swayed, stood and then, very slowly, began to topple. The newcomer, bent on revenge, had pierced him to the heart with a single thrust.

He turned on Feleind, who gaped at him. In the torture room were weapons in plenty – whips, branding irons. Feleind backed toward a wall on which the whips were hung, and his enemy followed with a sword.

"Back!" Feleind spat. "Upstairs – go where you belong–!"

"What you have done to Madga will be repaid," the servant said coldly, "As I have rid the world of your accomplice, no pain, too, and too merciful"

He lunged forward, but Feleind slid out of the way, and with his reaching hand grasped a single braided whip. He struck out with it in one motion and caught the servant's sword-arm.

The man gasped with pain, and his arm dropped, but came up again as he feinted with his weapon, backed Feleind again to the wall.

Feleind slashed out with the whip and cut his attacker across the face, but the sword stabbed out once more and this time Feleind was too late. Gasping with the pain of the lash, his attacker blinked back blood flowing into his eyes to see Adolf Feleind, his eyes staring with a sort of shocked surprise, plucking at the sword which protruded from his chest.

The reign of Feleind was over.

The name of the servant was Gerd Wilheim – a name which became inscribed on the records of Prussia within a very short time.

Unlike Feleind, he did not take power. But the Prussian aristocracy, noting that a vacancy now existed in Gerstein, unanimously raised Wilheim to the honored place in a series of rapid decisions.

He ruled for thirty years – but he ruled alone. Both the girl for whom he had risked his life in the castle, and the girl he had rescued during her torment by Otto died in lunatic asylums, permanently maddened by their experience with the monster of Gerstein, Adolf Feleind.

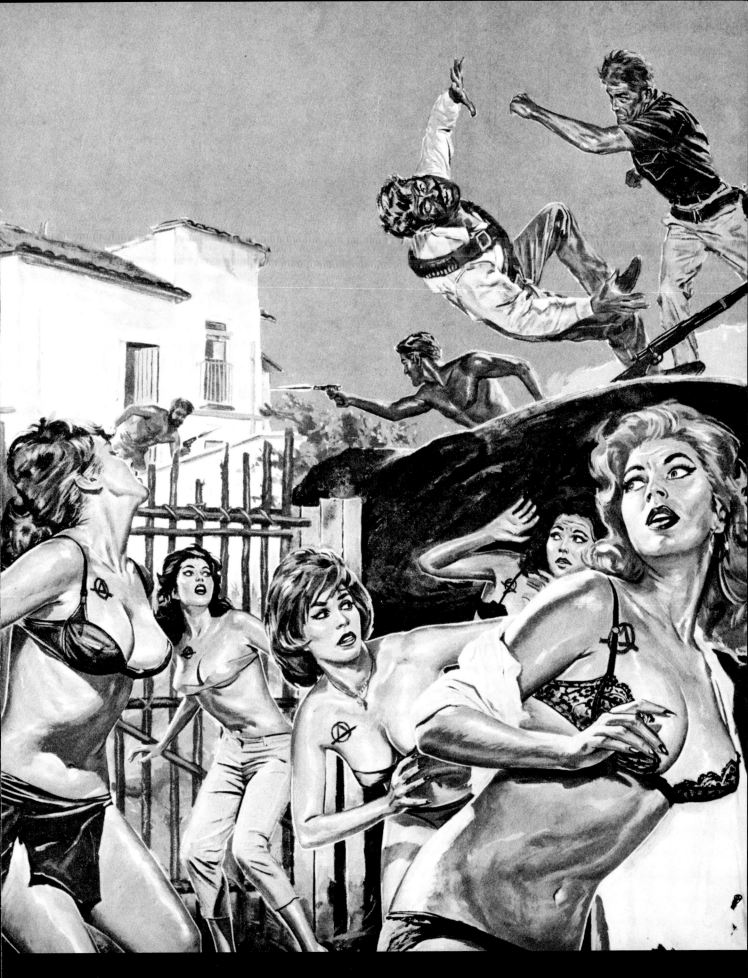

"I SAVED THE LOVE GODDESS FROM THE VOLCANO HORROR!"; detail from interior art, **MAN'S PERIL**, 01-03/64.
Art uncredited; attributed to Norm Eastman (© 1963).

SIN SLAVE
OF THE REDS'
HIGH PRIESTESS
OF LUST

In their grisly compound, the wanton jungle hellions spun a web of passion and death.

AMBUSH! **THEY MATERIALIZED FROM** the jungle on both sides of the Ibague-Anzoategui Road. Machine-gun bullets passed inches above my head. That was to let me know they meant business. I braked the jeep – which was the wrong thing to do. If I'd been properly briefed on what was happening here in Colombia, I'd have run them down.

Regardless of the fact that they were women.

They came at me screaming and waving machetes. I tried to reach my gun in the compartment and nearly had my arm chopped off. One yelled: "His head's mine!" Fingers dug into my hair and snapped my head back. I saw a machete being raised above me.

The jeep was still in third gear, and I had my foot on the clutch. I pressed hard on the gas pedal and released it. The woman lost her balance and fell in the back seat. Two others grabbed me. Another was pulling my head back for one more attempt to decapitate me. The blade was raised up. I slammed on the brakes and the woman toppled over the windshield, landing on the hood with a terrific thump.

I sped forward, then braked hard, keeping my attackers off-balance. Nevertheless, fingernails raked me and more than once I heard the deadly swish of a machete as it barely missed my neck.

One of the women fell across me, practically on my lap. She thought she had me now. She held her *bolo* with both hands and started her swing. My fist sank deeply into her soft

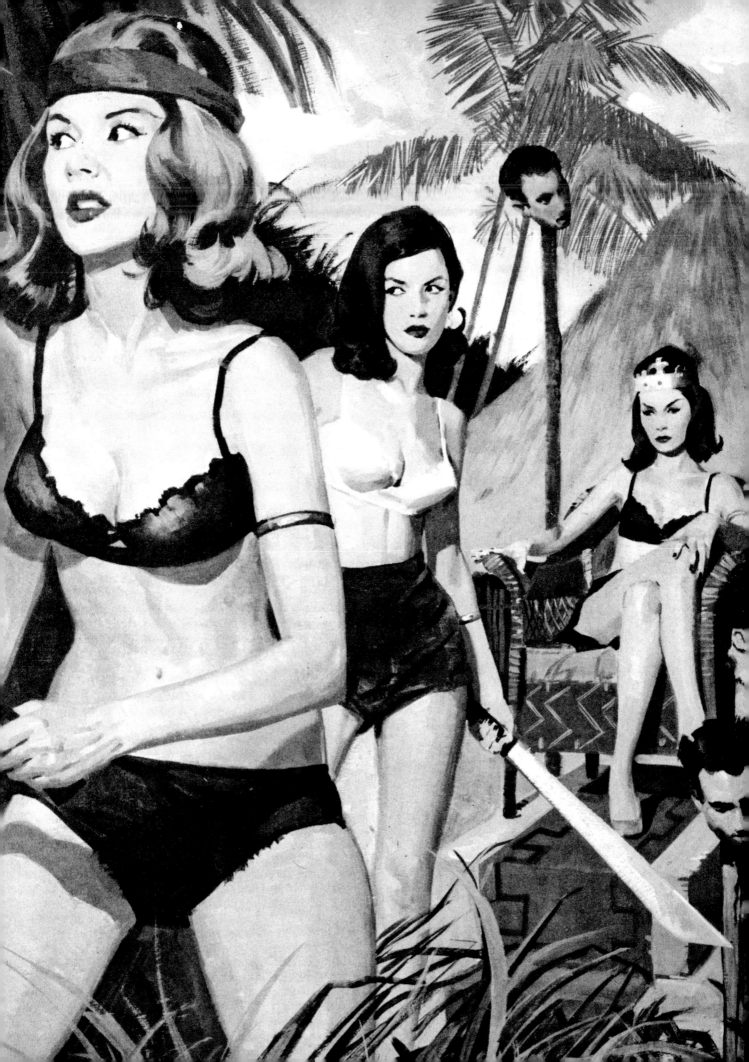

belly. She passed out. She was draped half in and half out of the jeep.

I grabbed a pair of wrists, drew this woman close, dug the heel of one hand into her abdomen and shoved her like a shot-put. She landed on her rump and the fight went out of her.

Two more were struggling for the chance to cut my head off. I jerked the jeep forward and stopped it fast. They sailed into the windshield.

I was running ~~██ ██ ██ ██████ ████ ███ ███ ██ ███ ██████~~ and get the hell back to Bogota fast.

That's the way I'd had it figured. But it didn't happen like that at all.

The muzzle of a machine-gun was pushed into my face.

I shut my eyes. I didn't want to see the muzzle blasts that would shred my head. Nothing happened. I opened them. The woman who held the gun was sneering at me. Her gaze was loaded with contempt, yet I thought I saw admiration in her eyes, too. Though I didn't know why.

The other women pulled themselves together. They were ready to attack again.

"No!" The woman with the machine gun held up one hand.

Her *companeros* were stunned. But not into speechlessness. "Sangre, are you *loco*? How often do we get a blond head such as that to hang in our camp?"

"How often do you meet such resistance?"

"What has that to do with–?"

"Do the *campesinos* fight back? No. They submit to slaughter like cattle." Sangre used the muzzle of the gun to strip away the shreds of my shirt. "Only a *gringo* fights hard to live."

The other women glanced at each other and shook their heads. One nearly as tall as Sangre asked slyly, "What are you going to do with him?"

"Kill him – but not yet. He may offer amusement, for a while."

"*Personal* amusement, Sangre?"

It happened so quickly I was not aware that someone had been slapped until the woman behind Sangre put her hands to her lips and brought them away bloody. Sangre was fast. Like a jungle cat. I didn't want to think what my chances would have been had she joined in the fight instead of standing aloofly aside.

She stared at me for a long time, particularly at my blond hair and light features. I felt like a freak. She moved a few steps until she was behind me. Her fingers went into my hair to feel the texture. I jerked away from her. My thoughts were on the gun in the compartment. If I could reach it before– No, it was impossible. Sangre was too fast.

She stood in front of me again. She threw her shoulders back to emphasize her bust line, which was impressive. Her lips were curled. Her eyes went over me as though I were dirt.

Her hand darted out and closed on my neck. I was yanked sideways and went sprawling to the ground.

"Search him!"

Three of them piled on top of me. They didn't dip into my pockets, they ripped them. They were fumbling with my papers. If they could read English I was as good as dead.

One paper was my license to fly a helicopter.

The other one, even more damaging, was a carbon copy of my letter of acceptance to the Commandant of a Colombian Lancer Unit. In it I said I was willing to work with his outfit as a pilot. I told him I was more than happy to join in Colombia's fight against the Communist menace.

Right now those words were condemning me.

~~██████ ███████████ ██ ████ ██████ ████ █████ ██ ███████ ████~~ again while the others waited for her to speak.

"Well, what does it say?"

Her black eyes met mine. Anger or some other dark emotion was causing her breasts to rise and fall rapidly. Her olive skin had a tinge of red to it now. She appeared to be having a mental battle with herself.

"Sangre, you know we can't read English. Don't keep us in suspense."

The woman sighed with sham boredom. She held my license high. "This one says he is allowed to drive a car in Colombia, and this one says he is applying for a job as a coffee-taster in Bogota."

I exhaled. I didn't know why she'd held back the truth, but it was enough for me that she had. She stuffed both documents into her bra. To compensate for a show of weakness before me, she lifted her foot and kicked me. "Get up, coffee-taster."

Another one kicked me. "You heard her. Get up!"

Two more decided to get their licks in. I stood up before the rest of them crowded around. Hands shoved me into the jeep. Sangre took the wheel, handed the machine-gun to somebody behind me. I sat beside her, with the compartment only inches from my knees.

WE HEADED toward Tunja, a sizeable town northeast of Bogota. At first, the machine-gun was pressed against my back, but the woman holding it grew lax after awhile. Looking out of the side of my eye I could see that the weapon now lay across her lap.

My .38 was only inches from my fingers. All I had to do was to open the compartment door, reach in, grab it and whirl around. If I were successful to that point I'd have to blast the one with the gun. Then methodically kill the other four.

I didn't entertain any doubts that I could do it. I'd *have* to do it. These women were no better than the Communist-inspired bandits who roamed the coffee-growing department of Tolima. I still had my head only because I'd used it.

My fingers drummed on my knees. I glanced at Sangre. She was another reason why I had to try to stop this thing before it went too far. She had something planned for me that couldn't possibly do me any good.

I took a deep breath. The prospect of killing five women in cold blood left me trembling. But it was them or me.

My hand shot forward. The door fell away and I reached inside.

My hand groped unbelievingly... It was empty.

A woman in the back seat leaned forward and tapped my shoulder. "You looking for this?"

My .38 was pointed at me.

The machine-gun pressed into my back. To add to my misery the woman scraped the front sight down my spine, giggling as warm blood pulsed out. Sangre's hand swept across my face with the same uncanny speed as before.

"*Americanos* die so hard!" She shouted it above the roar of the engine, then slapped my arm. "Roy, coffee-taster, you ride with killers. Look, behind you is Lojaya. She has killed forty *campesinos* by herself. Next to her is Militina. A head collector. She stinks up our *hacienda* with her rotten heads."

The bragging went on and on, and was so graphic in parts that I was nauseated.

Militina leaned forward. "Don't tell him, Sangre. *Show* him."

"But we need heads."

"Over there."

Our eyes followed Militina's naked arm. She pointed to a group of five farmers rounding up cattle. Suddenly, the jeep bounded over the shoulder of the road and sped bumpily toward the puzzled men.

The cattle scattered. Sangre pulled the ignition key out and buried it in her cleavage. She and the others quickly surrounded the *campesinos*. They were herded to the front of the jeep. Their caps were yanked off and thrown away. They were young men.

Frightened now, they looked at me, then at the women. Their sun-parched lips made unintelligible mutterings. Militina and Lojaya stripped them to the waist.

The stripping was done slowly, as though it were a part of some weird ritual. Sangre stood on a small rise, viewing the process of baring the men with the dignity and aloofness of a priestess. I saw her breathing quicken. Her eyes were bright. I detected impatience, but she held herself in check. The others seemed to be following a rite created by Sangre. Once Militina stripped a shirt too quickly, and she glanced apprehensively at her leader.

Finally, it was done. The men stood with tears streaming down their cheeks.

"First, *gringo*, you will see the *corte de franela*."

Three of them became so weak with fear they fell to their knees.

"Militina, you first."

The woman stood behind a kneeling *campesino* and hacked away with her machete. She followed roughly the contour of an undershirt. The man screamed. His *compadres* gagged in horror.

Militina dug her fingers into the man's hair and lifted the head from the shoulders. She shouted, "*Corte de franela!*"

The headless body still knelt. The men beside it screamed. One fainted. Another tried to run. Sangre let go with a short burst from her gun. The bullets thudded into the dirt in front of him. He flattened out and buried his face in his hands.

Sangre laughed. Her eyes flashed. Her body trembled with a strange kind of ecstasy. "Lojaya, the *corte de corbata!*"

The woman's arms went up at the news. "Ah, which one will I select?"

The men groveled at her feet, begging her to spare them.

"No!" Her machete rested on a naked shoulder. "I select you."

I lowered my eyes when I heard him scream for mercy. I didn't see what Lojaya did, but when she stepped away from the corpse the man's tongue dangled from an incision in his throat, like a red necktie.

I turned away from the grisly scene. My stomach was in a state of upheaval. The men still alive pleaded for their lives. Listening to them was like having my heart torn out. It didn't seem possible that any human could ignore their pitiful cries.

But it was happening. And not only were their pleas ignored, they were laughed at.

Sangre shouted, "Trina, the *corte de mica!*" I heard the swish of a blade and then the ugly sound of its cutting into meat. I winced as though the machete had dug into my own neck.

Sangre's arm went around my head. She forced it up so that our faces were inches apart. "*Hoy, gringo*, you have a weak stomach? You must look so that you can select your own way to die."

"Crazy bitch!"

Her arm tightened. The smile on her face was frozen. I felt the muzzle of her gun dig into my stomach. She spoke softly. "For you it will be the *corte frances*. Scalping. When the time comes."

Loathing turned to defiance. It was unbelievable that women so lovely to look at could contain so much lust for blood. Their simple beauty was disarming. The five men had not suspected anything like this. And frankly, neither had I. But now, locked in this savage's embrace, I seethed with a desire to see her dead.

Sangre laughed suddenly, as if she read my mind. "I have a special hate in my heart for *gringos*." The smile died and she looked away, mumbling, "And sometimes a special love."

"Why didn't you tell them the truth?"

Blood rushed into her face. Her black eyes went over me. Her rich olive skin seemed to glow a coppery color in the fading sun. "You will know... later."

THE FIVE men were dead. Sangre's women danced around the corpses with all the abandon of jungle savages. Heads dangled from their hands – heads that still expressed the final horror of decapitation. The bloody things were dumped on the floor in the back of the jeep. Militina looked at them, then at me. Her fingers circled my throat. "Now him, eh, Sangre?"

"No."

Militina snapped her hand away angrily. "What is it between you and the *gringo*, eh? It is not *him*, you know. It is not the one that–" A flash of copper went past me. Sangre drove the other woman to the ground. I saw a flurry of arms and legs. Militina fought defensively. Fear contorted her face. She kept saying, "Sangre, no, I didn't mean it." But the other one wouldn't be stopped. Her fingers went around Militina's throat and squeezed. She leaned her weight on the slim, olive-colored column until Militina's face turned blue.

Lojaya and Trina converged on their leader. "No, Sangre. You will have to answer to the commissar. It isn't worth it."

She relaxed. Her hands came away from Militina's throat. She nodded to Trina. "There is always some man to answer to." She got up and kicked her foe in the side. "Watch your tongue!"

Militina scurried away. I saw hate building. She picked up her machete and her fingers went white around the hilt. She glared at Sangre. For a second or two I thought I was going to see another beheading, but discretion conquered Militina climbed into the jeep with the others.

We rode away from the scene of ugly, senseless killing and twenty minutes later pulled up in front of a large *hacienda* at the edge of the town of Tunja. Three women peasants gave us wide berth, blessing themselves as they quickened their pace.

I was shoved into the *adobe* brick building, with Militina doing most of the shoving. She brought her mouth close to my ear. "I will kill you, coffee-taster. And her, too."

"I'll tell her what you said."

"She won't believe you. She thinks we live in fear of her." She spoke rapidly. "She thinks she's a goddess or—" The words died in her throat.

Sangre stormed across the room and pushed the female Judas away. "Killing him will be my pleasure, do you understand?" It didn't seem possible that she could have heard Militina, but obviously she had guessed what she'd said.

I jerked a thumb at the would-be traitor. "She wants to kill you, too."

A hush fell. Militina glared at me. If it was in my power to get the female maniacs clawing at each other I'd certainly try it. But Militina was right. Their leader chuckled. "She wouldn't dare." She turned and strode to a throne-like affair at one end of the room. She sat down on an ornate, elevated chair and ordered them to bring me to her.

It was then that I became conscious of the sickening odor. Trina and Lojaya held my arms and pulled me forward. Someone with the machine-gun at my back hastened the trip. I saw the heads dangling from strings like ornaments. They were the heads of peasant men. Five more would be added to the collection. Sangre laughed at the horror that was visible on my face. "Soon your head will hang in here."

I said nothing. It was safer to keep quiet because I was convinced Sangre was a psycho. Piecing the puzzle together wasn't difficult. She must have been jilted by an American. The loss unbalanced her. Now she hated all men, *gringos* in particular.

The only part of the puzzle that did not fit was her deliberate cover-up of the true nature of my papers. If she hated me so much, why protect me?

"Kneel!"

The sharp command brought me out of my thoughts. "Like hell I will."

The flat side of a machete smashed across my back. Another struck my legs. I turned to swing at the woman and faced the machine-gun. Lojaya held it. She was anxious for me to attack so she'd have an excuse to pull the trigger.

Every fibre of my being was outraged. But the blades were poised above my head. I had no choice.

Sangre's lips parted in a satisfied smile. She was enjoying my supplication. She leaned forward in her chair and spoke to me as though I was beneath her station.

"Soon you will crawl on the floor at my feet and beg for death. You will know unbearable pain."

Trina said: "Our liberators would enjoy seeing it."

"We can arrange for them to be here."

Lojaya added: "We can make him our slave."

"*Yanquis* detest slavery. It will drive him mad."

Sangre was beside herself with the anticipation of turning me over to their whims. Her dark eyes flashed. Her breasts heaved as her breathing increased its rate. She was becoming ecstatic over the idea of making a slave of a *gringo*.

I didn't stop to think whether or not it made good sense to open my mouth now; I simply couldn't resist striking back. "Why take it out on me because some other American brushed you off?"

The silence was heavy, electrifying. Sangre looked quickly at Militina.

"I told him nothing, I swear it."

I'd started this wave of foolishness and couldn't stop it. "Did I destroy the illusion for you, priestess?"

Sangre made a sign to somebody behind me. Something hard cracked into my neck and everything whirled in a dizzying spin. I woke up in a dark, windowless room. I was on the floor. Harsh scraping sounds came through the wooden partition. I heard a gruff male voice say, "Who owns the jeep?"

Sangre spoke up. "A *yanqui*. He's a special case."

I stood up and peered through a crack in the door. Thoroughly cowed *campesinos* were dragging large crates into the house. A Red Star was prominently displayed in several places on each crate. Four well-dressed men of Latin extraction were making time with the women. The fifth concentrated on the delivery. "You have guns and ammunition here." He tossed two black bull whips on top of one of the crates. "If you enjoy the sport—"

Militina extricated herself from her companion's embrace and picked up one of the whips, snapping it expertly. "For the *gringo*, eh, Sangre?"

A chill went through me. The black leather thong could gouge an area of flesh a half-inch wide and equally as deep. With Militina wielding it I'd be lucky to survive the first beating.

She dropped the whip and hurried back into the arms of her lover. The fifth man approached Sangre. His hand moved slowly across her shoulder. She stepped away. He laughed at her. "Still the man-hater, Sangre?"

She didn't answer him. She walked to her throne and sat down. The man followed her and *salaa*med in a mocking way. The gesture infuriated her. "I'll report you to the commissar."

He tossed his head back and laughed. "He thinks you're *loco*, too. But who cares as long as you work for the cause?" He left the house then, leaving the others to enjoy themselves. The couples disappeared into various rooms. And Sangre was alone.

I watched her brooding. In repose, and without any show of rancor, she was a truly beautiful woman. But a troubled woman. I could almost tell what she was thinking by the way her hands opened and closed and then pounded the

arms of her chair. Her lips were compressed. She tilted her head back. She rolled it from side to side. She looked as though she were ready to scream.

There was no doubt about it – Sangre was carrying the biggest damn torch in the world.

The guy – whoever he was – sure ripped her heart out. The only trouble was he'd left her a savage.

I moved away from the crack in the door. I had more important things to think about – mainly my escape. All of these dames were as *loco* as Sangre. Maybe in different ways, but nevertheless, *loco*. Frankly, they scared the living hell out of me.

It didn't take me five minutes to determine one sickening fact: the room was escape-proof. I'd need a jack-hammer to break through the *adobe* brick that stood between me and the outside world. I went back to take another look at Sangre.

She was standing up now. She stared at my door. Her hands went behind her back and the tight bra suddenly loosened and fell away. She slipped out of the panties and stood for a moment, stark naked and staring hard in my direction. Then she stepped off her throne and moved towards me. She held my gun in her right hand. The expression on her lovely face was one I'd seen earlier, when she was directing the execution of the five peasants. It was lust. Then it had been a lust for blood. Now it was a different kind – and one that had probably been suppressed since that guy had walked out on her.

And the last part of the puzzle slipped into place.

The lock snapped and the door opened. We faced each other. In her warped mind she probably expected me to lose control and take her forcibly. But as far as I was concerned she was only a cut or two above an animal.

"This why you lied about my papers?"

She nodded. "You look so much like... *him*."

I walked away from her. "Don't try to recapture any lost love."

Sangre stepped up behind me and drew the gun across my back so viciously that I almost swung at her. I stiffened with the pain. She pressed the muzzle into my chest. "I'm all mixed up inside. I should have let them kill you."

She slipped closer, holding her, mouth up to mine.

"You're stepping out of character."

She ignored the cut. Her naked arm went around my shoulders. I felt her trembling fingers bury themselves in my hair. She pushed the gun deeper into my flesh, frowning because I was not responding to the urgency of her needs. I was beginning to understand how closely the two emotions of love and hate were allied.

Suddenly, her lips went tight across her teeth. "I'll enjoy killing you as much as loving you."

I still held back. For some reason I thought she was bluffing.

Her face flushed. She stiffened. An uncontrollable rage was starting up. She scared me now. Once scorned, a woman was dangerous enough. Twice was too much. It wasn't worth the risk to push her too far.

My arms went around her. I drew her close – so close there was no room for the gun between us. She moved it up to my chin. She was purring like a panther.

AN HOUR she stood at the door. "If you tell them what happened, I'll tell them what you really are."

It was a threat I couldn't ignore. Helicopter pilots were despised as no other type of fighter in the Lancer units. Attacking bandits from the air was often the only way to flush them out of the impenetrable jungles. If Militina had an inkling of what I was my head would roll in a second – regardless of any objections Sangre raised.

The door was locked. I spent the few remaining hours of dark pacing the floor and trying to figure a way out. I dreaded the thought of what I'd have to go through today, and now with four Commies in the house my chances were that much slimmer.

Militina was first up. I watched her through the crack in the door. She held the machine-gun. She went directly to one of the bull whips and picked it up. Then she hurried to me.

Here it comes, I thought, backing away from the door. Leave it to Militina to start the punishment early. My brain ached from working it frantically. There was just no way out for me, no way to avoid whatever these women wanted to do to me.

Militina stood in the open door, sneering at me as she looped the whip on the floor near my feet. I was desperate enough to think that maybe a quick death would be better than hours or days of torture.

I was desperate enough to be reckless.

"You want some loving, too?"

Militina's jaw fell. "What do you mean?"

"Sangre was here last night."

It was the juiciest bit of backfence gossip she'd heard in a long time. Her eyes went wide and a smile started on her lips. "So, the Exalted One does act human."

For a fleeting moment I began to hope that my shocker had made her forget about using the whip on me. But it was wishful thinking. The leather thong shot through the air and snipped a piece of my flesh as cleanly as a razor blade would do it. Blood flowed down my arm.

She flailed me again with the whip and the sound brought the others out of their beds. The men came after them to watch the beating. They were drunk. I could smell vodka on their breaths when they bent close to see the damage that was being done to me.

The moment of revelation had come. Militina could hardly contain herself. She leaned forward and spoke directly to Sangre, who sat at the head of the table.

"Was this *gringo* as nice to sleep with as the other one?"

Her words stilled all conversation. Heads turned to Sangre. Then Militina poured on more coals. "Our high priestess is not such a man-hater as you think." Her words dripped sarcasm. "All she wanted was another *gringo*."

I stood at the opposite end of the table. The women were giggling at Sangre, the men laughing openly. I'd knocked the goddess off her pedestal for all time. Now Sangre was no better than any of the other sluts here.

Our eyes met across the table. She shook with rage.

She'd threatened to expose me if I opened my mouth about us, but now she changed her plan. She was going to handle her own dirty work.

Her fingers moved towards the machine-gun beside her.

It was only a split second of time in which other vast changes took place, and all of them were made within myself. I didn't want to let her cut him in half without a fight. If I had to die, everybody in this room would damn well know they'd killed a guy who'd bucked them right up to the end.

I lifted the table high. Plates, bottles and silverware slid down on Sangre. Figures toppled backwards and crashed to the floor. I shoved the table forward and knocked Sangre off her chair. I had her pinned under it.

The machine-gun lay inches beyond her reach. She was screaming for help, but the men were too stunned and too drunk to fully understand what was happening or to pull themselves together. Militina was the first to regain her composure. She came at me with her machete held high. I ducked as the blade swished above my head and dug into the underside of the table. She tried to yank it out. I clipped her squarely on the jaw and she sagged.

The others were up now. They were coming for me, their blades; ready to receive my blood. I dived for the gun, grabbed it and rolled to the other side of the room. I heard the *bolos* chopping into the floor. My hands swept frantically over the gun in search of the trigger.

I'd rolled into a corner. Three women were ready to slash downward when I let go with a spray of lead that propelled them back across the room.

Two slugs thumped into the wall next to me. Another nicked my arm. I dropped flat and saw two of the men firing wildly. They staggered into each other. I gave them a short burst. It was their last binge. The other two were trying to barricade themselves behind the table. Which was foolish. My bullets went right through the wood. I heard their screams and knew I'd made hits.

I stood up and raced through the door. I was free. Only minutes ago it hadn't seemed possible. I leaped into the morning sunlight – and ran smack into the fifth man.

I'd forgotten all about him. He'd walked out last night when Sangre wouldn't give him a tumble. He'd slept in the car and now he was climbing out of it and aiming a revolver straight at me.

His blast came first. A white hot pain shot through my shoulder aid spun me around. He fired again and missed. I lifted the machine-gun and squeezed the trigger. He was only a blur before my eyes, but I saw that blur smash against the car and sag to the ground.

I dropped to my knees. Blood was spurting out of my shoulder wound at a too rapid rate for comfort. I'd have to get to a doctor in a hurry.

"Now it's just you and me."

I turned around and saw Sangre standing in the door and holding my .38. She had a black bruise across her stomach from the table, but she was mindless of it now as she threw her head back and laughed. "*Gringos* die hard."

Focusing my eyes was difficult. I saw her raise the gun to fire. I lifted my weapon painfully. A combination of heat haze and my blurred vision was playing tricks with me. I thought I saw her head being lopped off.

And I thought I heard another voice scream: "I told you I'd kill her!"

Then things jumbled up but good. The figure of a woman loomed large before me and the glint of a blade sparkled over her head.

I instinctively squeezed the trigger and heard the blast and saw her rise up all bloody and then fall on top of me. I pushed the body away Up close, I saw that it was Militina.

It was all over now. The only thing that continued to bug me was the urge to get into a helicopter and fight these bastards until every department in Colombia was free of them.

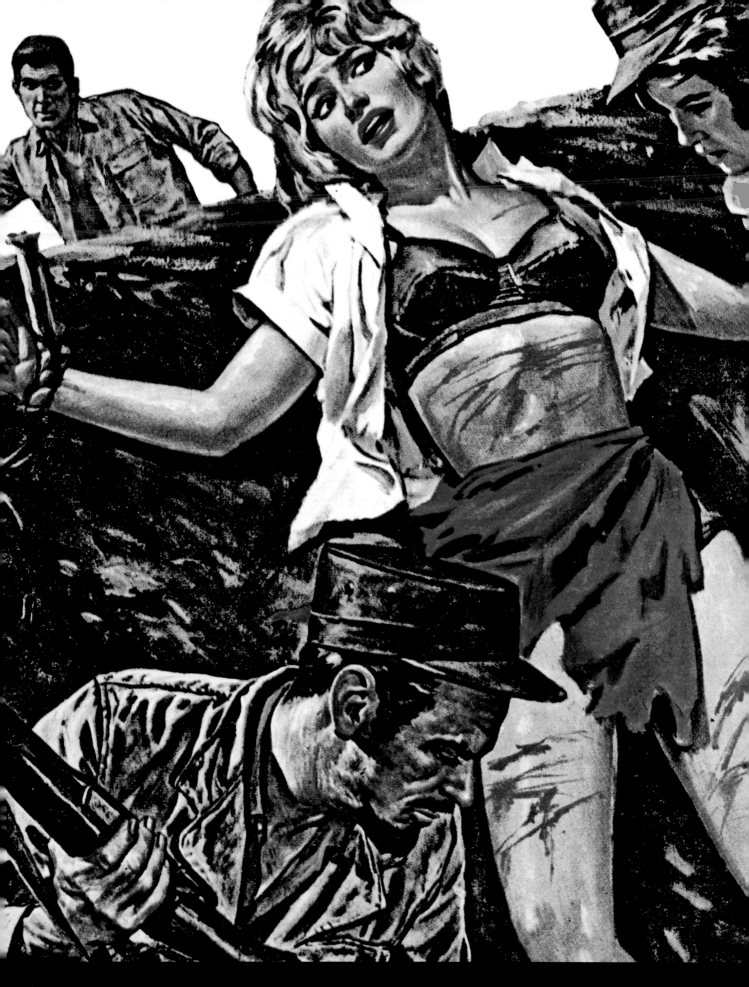

"HANDMAIDENS OF THE LASH OF LUST"; detail from cover, **MEN TODAY**, 08/61.
Art uncredited; attributed to Norm Eastman

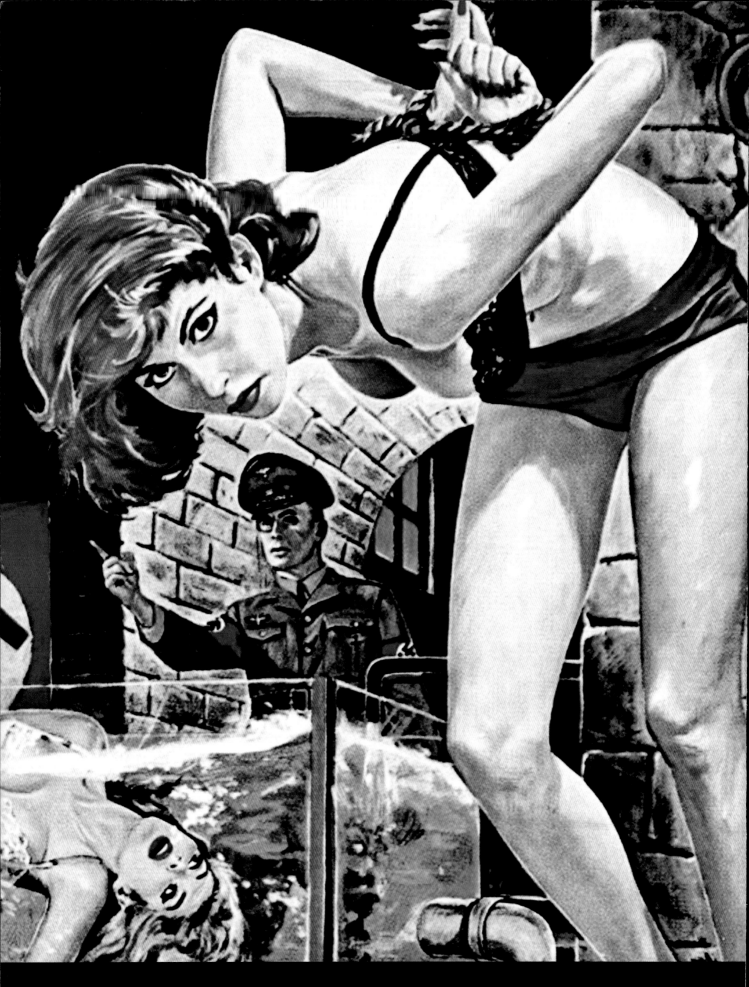

"SUFFER, MY SWEET, IN THE POOL OF AGONY!"; detail from cover, **MEN TODAY**, 10/62.
Art uncredited; attributed to Norm Eastman.

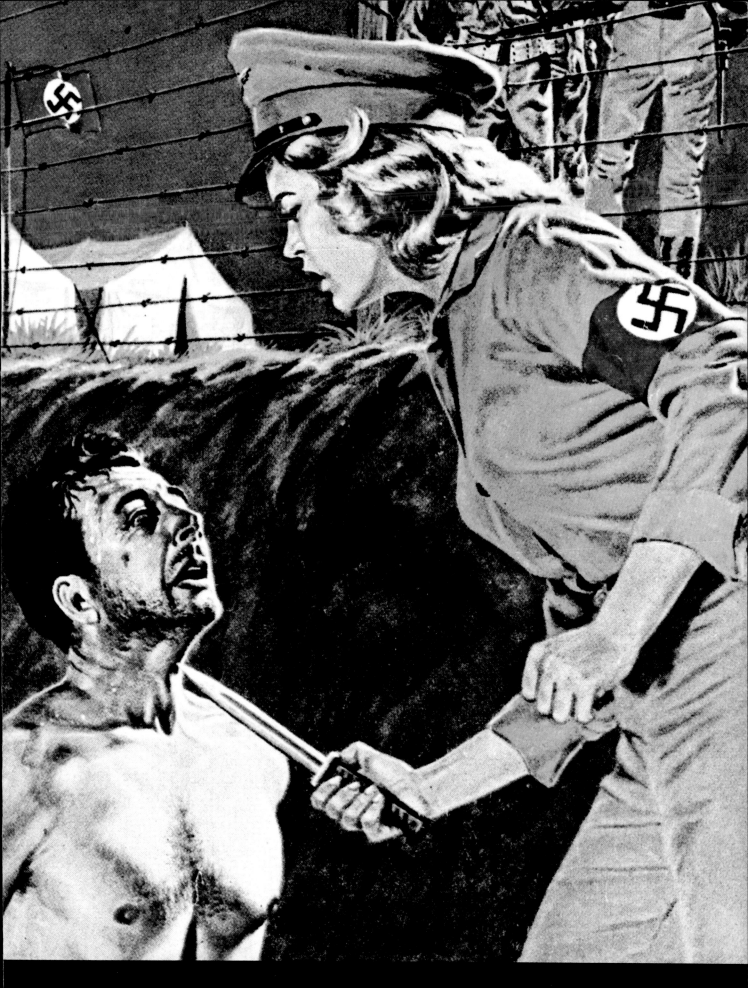

"BERT KIEFFER AND HIS GERMAN JUNGLE BRIDE"; detail from cover, **MAN TO MAN**, 04/62.
Art uncredited; attributed to Syd Shores.

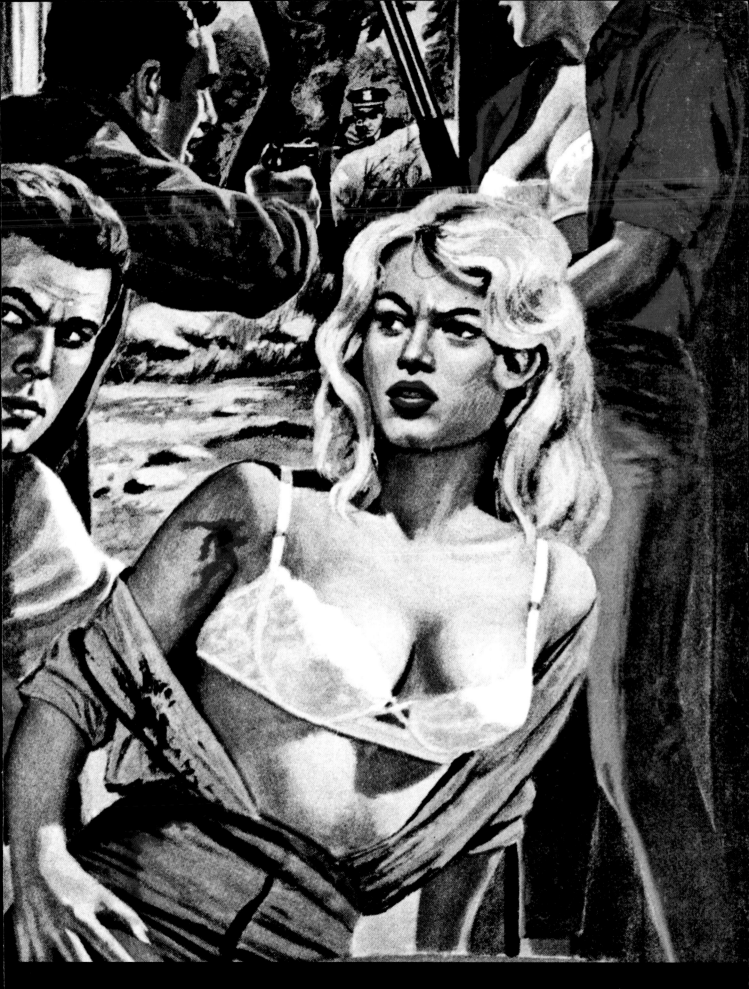

"COOL BROADS – HOT RODS!"; detail from cover, **MAN'S ACTION**, 08/63.
Art uncredited.

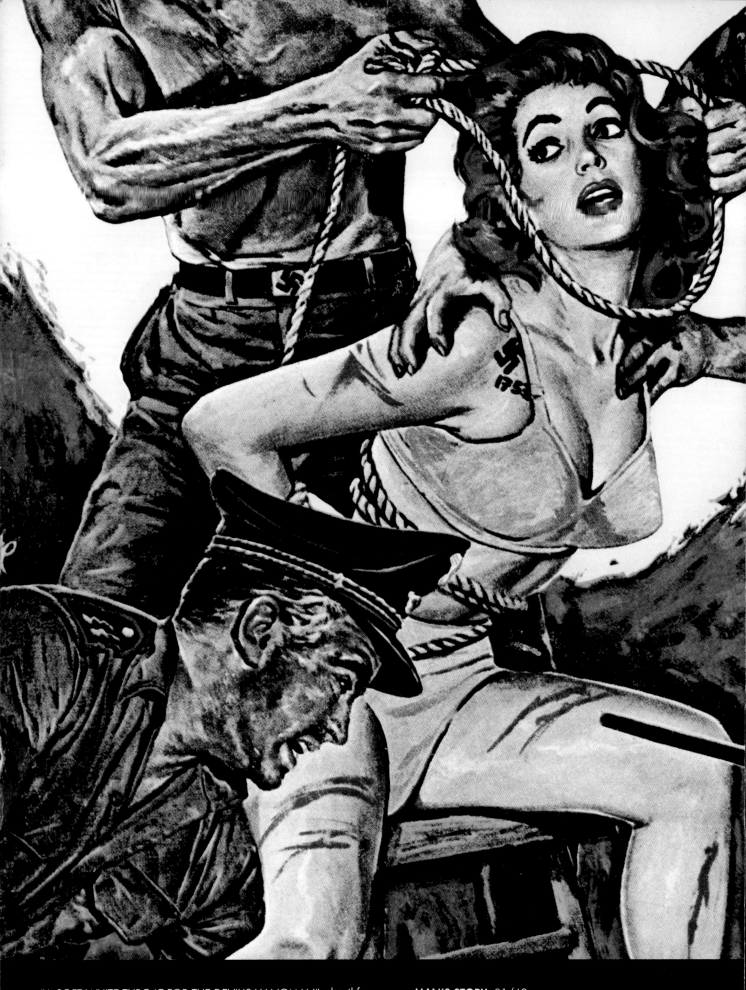

"A SOFT WHITE THROAT FOR THE DEVIL'S HANGMAN"; detail from cover, **MAN'S STORY**, 01/62.

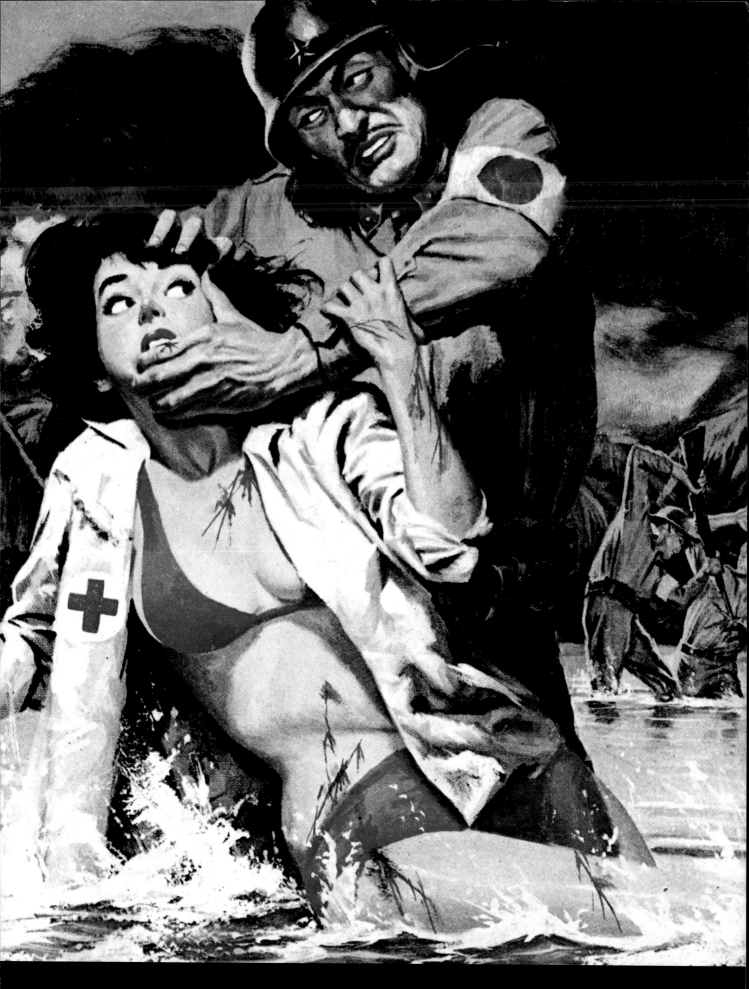

Detail from cover, **MAN'S ADVENTURE**, 09/61.
Art uncredited; attributed to Vic Prezio.

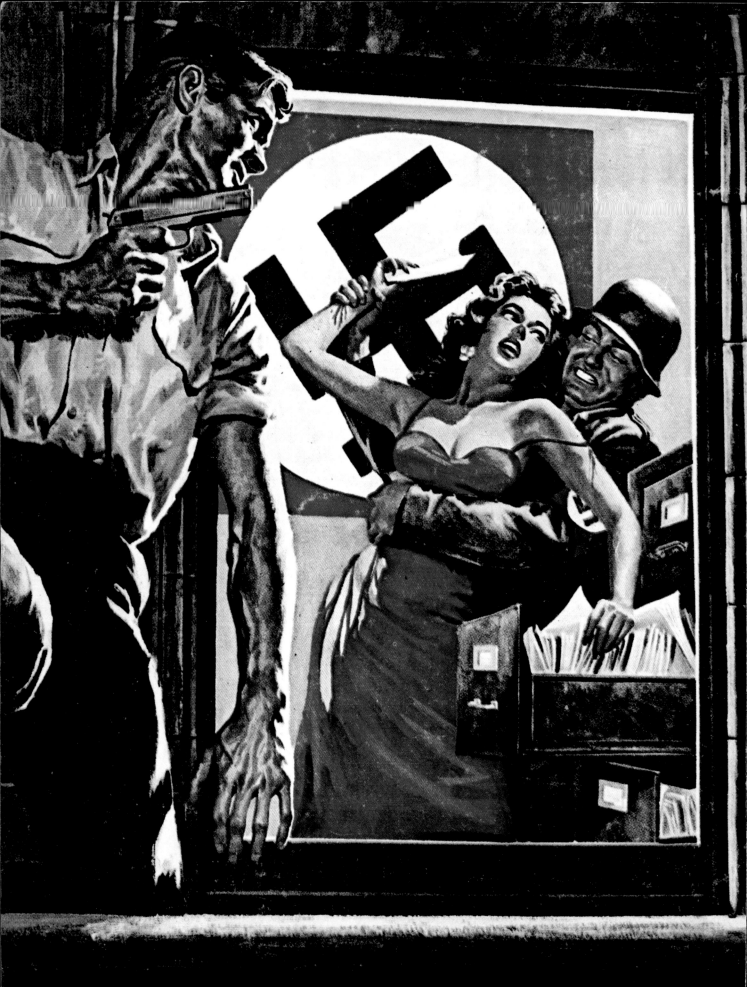